CW00586854

Caverns of Night

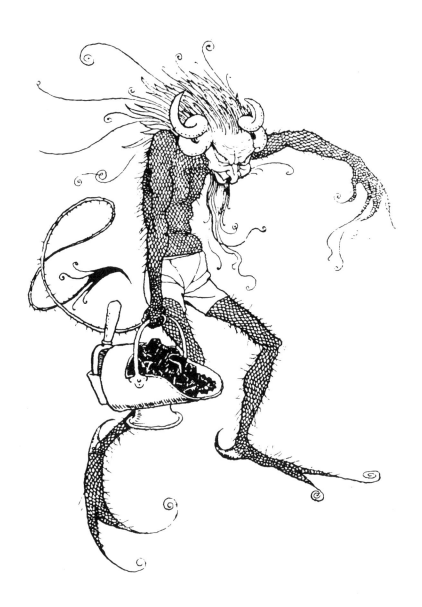

Caverns of Night

COAL MINES

IN ART,

LITERATURE,

AND FILM

EDITED BY

William B. Thesing

UNIVERSITY OF SOUTH CAROLINA PRESS

Published in Columbia, South Carolina, by the
University of South Carolina Press

Manufactured in the United States of America

04 03 02 01 00 5 4 3 2 1

Library of Congress Cataloging-in-Publication Data

Caverns of night : coal mines in art, literature, and film : a collection of essays /
 edited by William B. Thesing.
 p. cm.
 Includes bibliographical references and index.
 ISBN 1-57003-352-8 (cloth : alk. paper)
 1. Coal mines and mining in art. 2. Arts, Modern—19th century. 3. Arts,
Modern—20th century. I. Thesing, William B.
 NX650.C665 C37 2000
 700'.455—dc21 00-008952

The essay by Janet Grose was originally published in *Studies in the Literary Imagination*
29, no. 1 (Spring 1996): 35–42. This special issue on nineteenth-century realism was
edited by William B. Thesing. Kind permission is granted to reprint the article by the
journal and the Department of English, Georgia State University.

The essay by Marsha Bryant was originally published in *Mosaic* 30, no. 2 (June 1997):
69–92. Kind permission is granted to reprint the article by the journal's editor, Evelyn
J. Hinz.

The essay by Alessandro Portelli first appeared in a briefer form in *Identita e scrittura:
Studi sull'autobiografia nord-americana,* edited by Anna Lucia Accardo, Maria Ornella
Marotti, and Igina Tattoni, Studi & Ricerche 23 (Rome: Bulzoni, 1988), 209–22. Per-
mission to reprint is granted by the author.

Two passages from James Goode's *Up from the Mines* (1993) are quoted in Tom Frazier's
essay. Permission to reprint is granted by the publisher, James M. Gifford, executive
director, Jesse Stuart Foundation Press, Ashland, Kentucky. The passages are from the
Preface and the poem "Piecing the Coal Quilt."

The frontispiece illustration is by Sidney H. Sime, and is reproduced with consent from
Sidney Sime: Master of the Mysterious, by Simon Heneage and Henry Ford (Thames and
Hudson, 1980). It is taken from a nineteenth-century periodical.

Contents

Acknowledgments

I wish to thank the many individuals who believed in this topic over several years. First of all I am grateful to the selections committee of the MLA (Modern Language Association) for approving the special session for the program at the annual convention that was held in Washington, D.C., in December 1996. From that small beginning, three papers expanded to the nineteen included in this collection of essays as interest in the topic and various approaches gathered momentum over several years. Encouragement, good humor, and generous patience were offered to me by USC Press's superb acquisitions editor, Barry Blose. I am also grateful to the two anonymous readers for suggestions that have improved and helped shape this volume. The entire editorial endeavor—thanks to the patience and professionalism of Barbara Brannon and Christine Copeland of USC Press—has been both an edifying and humbling experience.

During the many years of the production of this book, I have received some assistance in postage, photocopying, indexing, and research support from Professor Robert Newman, chair of the English Department at the University of South Carolina. The following graduate research assistants worked hard to make this book readable, interesting, and correct: Sarah Barnhart, Kelly Frank, Jordan Harris, Brian Gregory, Connie Kalikoff, Jason McCullough, Randy Miller, Michelle Whitney, and Ivan Young.

Finally, I am indebted to the contributors of this book who often wrote numerous revisions of their essays and met the important deadlines for production. I also value the love and encouragement during the many months of this project that were bestowed upon me by my wife, Jane, and my daughter, Amy. I admire their hard work and the even harder work of those coal miners before them who earned their daily bread working under the earth in the caverns of night.

Introduction

Out of the sinister caverns of Night,
Out of the depths where the Hell-fires are glowing,
Cometh a cry, floating up to the Light . . .
Give us, in God's name, our wages of Bread!

Robert Buchanan

In its encyclopedic definition, it seems both simple and sublime in a biblical fashion: "Mining is the process of taking minerals or coal from the earth. . . . People have mined the earth for thousands of years" (Hustrulid 574). What distinguishes the industry of coal mining, however, is its enormous scale and its terrible human costs. From the early 1800s in Great Britain and the mid 1800s in the United States, miners began to dig up large amounts of coal from the earth's dark caverns to feed the power and light of the Industrial Revolution. From the early 1800s to the early 1900s coal was the main source of energy in all industrial countries: coal-burning steam engines provided most of the power behind the factories and transportation of the leading industrial lands. Coal played a key role in the growth of industry in Europe and North America. However, the dynamo power behind industrial might of the past has also had a high cost in human terms: few jobs were more arduous or more dangerous than that of an underground coal miner. Hazards abounded in the "sinister caverns" of the earth: the miners were injured or killed by cave-ins, falling rocks, accidental explosions, drownings, and poisonous gases. Disasters were especially frequent in nineteenth-century Europe because of fatigue and the lack of safety regulations, as well as the fact that underground mines there are much deeper, on the average, than are underground mines in the United States. As Joseph W. Leonard reports, "during the 1800s, many miners had to work underground 10 or more hours a day, six days a week. . . . In many cases, children as young as 10 years of age hauled the coal from the mines. Women worked as loaders and haulers. Over the years, thousands of men, women, and children were killed in mine accidents. Thousands more died of lung diseases from breathing coal dust" (Leonard, "Coal" 716).

Coal is found on every continent on earth. Indeed, the leading areas in coal production have shifted over the past two centuries: from Great Britain in the 1800s, to the United States in the first half of the twentieth century, to Russia and then China in the second half of this century. This collection of essays, however, is selective in locale. Although the epigraph by Robert Buchanan suggests dramatically common underground experiences and human cries for help and reward, the focus of this study is on the coal-mining enterprise in Western Europe and America in the nineteenth and twentieth centuries. Nevertheless, the aesthetic and social issues examined in these essays have an applicability to the universal human condition.

The topic of working in the coal mines has been treated by writers of poetry, fiction, and prose since the nineteenth century. With the emergence of the Industrial Revolution and the new forms of literary representation, realism and naturalism, reality and art came together in the nineteenth century. In the twentieth century, the new art form of film also takes its turn—after the paintings and sketches of the previous century—in representing workers who earned their livelihoods under the surface of the earth. In various countries and across gender and class divisions, creative artists grappled with the conditions of working in coal mines even as they sought to meet the challenge of how to represent them in aesthetic terms. It is the purpose of art—literature, films, and paintings—to explore all aspects of life, including the pain and hard work of men, women, and children below the ground in coal mines. However, very little critical discussion has been devoted to this topic. While one can find in the library such government reports as *Literature on the Revegetation of Coal-Mined Lands* and a brief chapter—"Literature as Propaganda: The Coal Miners' Unions, 1825–1845"—in Martha Vicinus's *The Industrial Muse*, few books have explored the gender, class, and ethnic implications of coal mine settings. What little commentary exists on coal mines in the arts has emphasized violent class conflict between workers and owners. While some of the essays in this collection offer valuable social and political insights, many others push the terms of analysis beyond class considerations to gender issues and ethnic experiences. For example, Daiva Markelis breaks new ground in treating E. S. Johnson's nearly forgotten short stories that vividly illustrate what it means to be a woman and a Lithuanian immigrant in turn-of-the-century Pennsylvania.

To what extent does a coal-mining site serve as a metaphor for the times or for a given region of a country? As a single metaphor, can coal mining carry the weight of literary and philosophical needs? How can an artist make coal miners and coal-mining aesthetic without making them artificial, without denaturing their authenticity? Creative works about coal mining, then, are about industrial aesthetics and identities: Some of the essays focus on the problems of translating, recoding, and fashioning the horrible conditions of coal mines

into artistic representations; other essays focus on the ways representations of coal mines raise and challenge issues of gender, class, race, and ethnicity.

Coal mining in European and American contexts poses some obvious problems in relation to aesthetic representation in painting, poetry, fiction, and film. To many thinkers, coal mining represents an anti-aesthetic abyss, an impossible challenge to conventional notions of beauty and art. However, the purpose of this book is to explore the range and complexity of the different solutions that writers, artists, and filmmakers worked out over two centuries on two different continents. Some of the contributors conclude that aesthetic representation may not approach the reality of the coal-mining experience directly or fully enough. Others conclude that art masks the raw reality of work in the dark caverns underground. All essayists, however, find a value—to varying degrees—in aesthetic representation of coal mining and coal miners. All of the essayists struggle with the question, to what extent can art help us to know more about what coal mining and coal miners are really like?

This collection of essays delineates four main categories of different aesthetic issues that a focus on coal mining can consider: geographical spaces, soot and smoke, social reform, and gender and race.

The first category is the various portrayals of coal mines themselves as geographical spaces. In journalistic and scientific detail, such an author is concerned to present faithfully the regional habitat and geological details of a specific coal mine. The second category is the portrayal of soot and smoke. Sometimes these artistic representations depict harmful pollution, but at other times they achieve positive atmospheric effects, as in several Monet paintings. The third category is the use of art for the purposes of social reform. Here the focus is on the dangers and exploitation of labor, including industrial hazards and accidents. Some mining disasters involved hundreds of human victims and were forever ingrained upon the collective public memory. The connection between such traumas in the public sphere and cultural memory is a disturbing but fascinating topic. Here the issue is the use of art for propagandistic and political purposes. Is it possible for an artist, novelist, or poet to be effective in his or her craft and also demonstrate comparable success as a social reformer? The fourth category involves a focus on the issues of gender and race. Sometimes these areas of human experience overlap issues of labor and social class, but sometimes they do not. These four categories encompass the aesthetic problems or challenges posed by coal and coal mining. Ideas about art collide, flounder, and triumph in the caverns of night. The reader and student who uses this book should keep these categories in mind while reading or studying the various essays. Because the topics and particular texts focused upon in the various essays often use one or more of these categories, it would be difficult to use them as an organizing device for the table of contents. Instead, the arrangement of the essays is based upon geographical and chronological

principles. This plan should be the most convenient and accessible for the majority of readers.

The reader should also be sensitive to the conditions of the worker as a human being who labored daily under the earth in the mines and lived with his or her family in a mining community. From the outset, this project has taken a broadly humanistic view. Many of the essays reflect that attitude. Over two centuries, then, it is important to remember and reconstruct the actual, day-to-day mining experience. Workers labored for twelve to fourteen hours per day in the mines, but they also lived in mining communities.

Early-nineteenth-century mining methods required long hours of exhausting human labor. Gradually over the decades of the nineteenth century, the steam engine and locomotive came to be used at colliery sites. Mechanized coal operations—punching machines, chain-type cutters, coal and rock drills—eased somewhat the burden on human workers. New safety measures were also introduced after a series of disasters that brought about various government inquiries. On October 14, 1913, 439 miners lost their lives in a coal mine disaster at Universal Mines, Senghenydd, Glamorgan. By the 1920s, loading machines were fully mechanized as the fixed conveyer system replaced the shuttle car that had been pulled by boys and teenagers (Crickmer 3–4). As Duckham and Duckham point out, by the twentieth century, "no industry was more investigated, reported on and made subject to legislation and inspection than coal mining" (189).

Any coal miner faced safety hazards. One study concluded that a worker in a mine was nine times more likely to be killed there than in a factory (Duckham and Duckham 197). There were many deaths from the falling of roofs and sides and from haulage accidents. There were many explosions. Burns and amputations were all too frequent. There was pollution of air and water that led to such diseases as black lung. Pay was low; hours were long; respect from management was minimal. Beyond physical sufferings, there was the day-to-day tedium of working in the coal mines. When accidents, disasters, lay-offs, or strikes occurred, there were widespread emotional tensions in mining communities in Great Britain, France, and America. As Duckham and Duckham point out, "a colliery disaster strikes and withers a whole community" (14). Rituals of mourning recognized the fragility of human life in any coal-mining community. Colliers' wives felt anxiety each day; colliers' widows felt grief, loss, and the lingering effects of poverty. Art, in a variety of forms, attempts to capture and relate the human story of some of these coal-mining experiences.

No collection of essays, however, can hope to include every film or piece of literature about a topic as extensive as coal mining. Some works whose authors experimented as early pioneers with the topic include the following: Emile Zola's *Germinal,* a French masterpiece of social commentary and naturalistic fiction; D. H. Lawrence's British short story "The Odor of

Chrysanthemums" and novel *Sons and Lovers;* and the Welsh writer Richard Llewellyn's novel *How Green Was My Valley.* Even Dylan Thomas in some of his poems set in Wales captured the deterministic environment in which coal miners found themselves as they tried to control their lives.

But France, Wales, and England were not the exclusive locations of the world's coal mines. From the 1870s on, American realistic and naturalistic writers used the coal-mining industry as a theater to demonstrate the harshness of the lives of individual men and women. The naturalistic muckraker Upton Sinclair brought coal mining to the forefront with his *King Coal* (1917). The substratum of Appalachian literature has produced such fine works on coal mining as Kentuckian James Still's *River of Earth* and West Virginian Denise Giardina's *Storming Heaven* and *The Unquiet Earth.* For two centuries and in various lands coal mining has been a thematic center for realistic and naturalistic literature—yet it is a topic that has to date received only slight attention in scholarly presentations or publications by critics.

EUROPE

The essays in part one of this collection focus on the European scene during the nineteenth and twentieth centuries, depicting artists' and writers' portrayals of coal-mining conditions in England, Wales, and France. Various genres and art forms represent the horrific and often disastrous conditions in coal mines of the previous century.

Artists throughout the nineteenth century depicted the mining and burning of coal on the industrial landscapes of Europe. Martin Danahay's essay illuminates how the British painter J. M. W. Turner and the French Impressionist painter Claude Monet struggled with the aesthetic challenge of how to represent on canvas the smoke and soot of an industrialized landscape. Danahay makes convincing links to concepts of race (blackface performances) and experiences of colonial oppression and exploitation in some of the images that he analyzes. He ranges across many different media, from poetry and fiction to art and photography. He depicts Arthur Joseph Munby's curious fetishes that led him to supervise the representation of models in photographers' studios.

The world of the coal mine and the art studio came together in cruel and demonic images in artist Sidney H. Sime's vision. Sime was forced by his parents to work as a pit boy in the coal mines during his formative years. Later in his life, William B. Thesing's essay argues, he depicted in his drawings devilish imps at coal-mining sites in order to work out the feelings of revenge and horror that he experienced as a child. Darkness and surrealism fill his coal-mining canvases as he seeks to reveal deep-seated psychological tensions of growing up under oppression and economic exploitation in the Victorian

period. Later artistic representations extend the menacing nightmare to Britain's Oriental Empire on the other side of the world.

The literary genres of poetry, nonfiction prose, and fiction all dealt with conditions in the coal mines during the nineteenth century. Poets and social reform are the focus of attention in the essay by William B. Thesing and Ted Wojtasik. They explore how several Victorian poets—Elizabeth Barrett Browning, Thomas Llewelyn Thomas, and Joseph Skipsey—used public occasions of accident and grief to comment upon coal-mining hazards. In March 1860, for example, a great explosion in Northumberland trapped, burned, and killed seventy-two coal miners. In January 1862 in the Hartley Colliery in Northumberland, 204 coal miners were buried alive. Outrage was publicly expressed; the deaths implicated every British family that used coal for heat and light in their homes. In 1863 an undergraduate at Oxford University, T. L. Thomas, won the Newdigate Prize for poetry with a poem titled "Coal Mines." He turned a pressing political event (clamors for reform) into an aesthetic statement that was recited in the Sheldonian Theatre, Oxford, on June 17, 1863. The poem exhibits an affinity with other such poems of the nineteenth century, specifically E. B. Browning's "The Cry of the Children" and Joseph Skipsey's "The Hartley Calamity." It is significant that poets with various class and educational backgrounds were able to use the genre of poetry to treat social issues, justice, and politics in the nineteenth century. Yet the social class and educational backgrounds of the authors make the strategies of representation of working-class experiences and voices quite different. A similar impulse of social reform fueled the investigative reports and journalism of writers such as Richard Hengist Horne, who, as Alex J. Tuss explains in his essay, captured in precise prose the workers' conditions in the Victorian periodical *Household Words*. Tuss demonstrates how nonfiction prose was a potent instrument of social commentary.

Certainly fiction was a dominant literary genre in the nineteenth century. Janet Grose's essay deals with the hugely popular tales of G. W. M. Reynolds. The dimension of veiled eroticism in these coal-mining escapades is explained by Grose as she sorts out the mixture of Victorian myth and realism. Reynolds's radical views, acute awareness of the corrupt state of the poor, and penchant for the grotesque are especially evident in the underlying calls for social reform in "The Rattlesnake's History," a chapter in his voluminous *Mysteries of London*. In this detailed story of the horrendous conditions of British coal mines, based on the English Parliament's *1842 Report of the Children's Employment Commission*, Reynolds's strength as a social reformer is clear. He personalizes and sensationalizes the realistic details of the Parliamentary Blue Book to enlighten the public about the abuses of women and children in coal mines and the moral decay such horrors cause in individuals and society.

Perhaps no other writer captured more vividly the plight of nineteenth-century coal miners than the French novelist Emile Zola. His naturalistic fiction

focused intensely on the common man and the deterministic environment in which he dwelled. Thomas E. Mussio's essay examines in full detail the coal mines in Northern France that Zola depicted in his controversial novel *Germinal* (1885). It is one of twenty novels in the writer's Rougon-Macquart series, which followed the history of one family during the period of the Second Empire. As the novel participates in Zola's greater plan of the examination of the human condition, its portrayal of coal miners in northern France during the mid-nineteenth century focuses on broad themes: the rigidity of class hierarchies, the tyrannical deity of machinery and capital, the detachment and lack of passion among the owner classes, and the ideas of worker solidarity and revolution. In the course of exploring the role of free indirect discourse (FID) in *Germinal*, Mussio's essay examines the connections between Zola's narrative technique and his general depiction of the coal miners' lives. Mussio shows that Zola's journalistic accuracy in describing the intricacy of the mines' workings is counterbalanced by his theoretical interest in exploring the gulfs between social classes.

Peter Balbert's essay brings us to the twentieth century and he applies the critical approach of masculinist studies to analyze the writings of D. H. Lawrence concerning the coal-mining experience in the Nottinghamshire region where his father worked as a coal miner. Although feminist critics have recently all but dismissed Lawrence as a writer of interest, Balbert makes new discoveries as he applies the larger scope of gender studies to a writer who was both controversial and famous in the early part of the twentieth century.

Masculinity is also examined in Marsha Bryant's essay. She examines various poetic and cinematic versions in 1930s Great Britain. Cultural constructions of gender shape documentary practice in the 1930s. "The documentary method," asserts filmmaker Paul Rotha, produces "the most virile of all kinds of film." Moreover, documentary's male-on-male gaze constructs Britain's coal miners as sites of bourgeois male identification and desire. This gendering of the genre reflects the crisis of masculinity that accompanied the decade's social crises of economic depression and approaching global war. Documentary film and literature focus representations of industrial Britain on men, especially coal miners. Muscular men of Britain's industrial north animate W. H. Auden's early poems, the documentary films *Industrial Britain* and *Coal Face,* and George Orwell's *The Road to Wigan Pier.* These images of coal miners unsettle boundaries between cross-class scrutiny and homoerotic looking.

Ed Madden examines coal-mining strife in twentieth-century Great Britain. His initial focus is the 1984 coal strike in Leeds, England, but his wide-ranging mind moves out to link Tony Harrison's poem "v" to issues of cultural decay (from victory to vandalism) and to the past poetic works of Thomas Gray and the more recent works of Philip Larkin. Madden uses linguistic, rhetorical, poetic, and political methods of analysis. Like the roving eye of a

modern television camera, he zooms in on the modern world's class divisions, sexism, and racism—all evident in the coal miners' strikes of the mid 1980s in Great Britain.

AMERICA

In one sense, the coal mines of the nineteenth-century American landscape represent common and central themes of the American experience. European immigrants sometimes found that their only choice in their new land was to begin anew below the ground the hard trade they had practiced in the old country. Other American farmers sometimes were forced to turn to the coal mines for their livelihood after a series of crop failures.

The essays in part two of this collection focus on the American scene during the nineteenth and twentieth centuries. Filmmakers and writers depict coal-mining operations in the regions of Appalachia and the American South: West Virginia, Pennsylvania, Kentucky, North Carolina, and Alabama. America's melting pot was both social and artistic. Lines between centuries and art forms blur in the United States to a far greater degree than is the case with representation of the British coal-mining experience. That is, twentieth-century writers often look back to a previous century or to previous decades to tell the stories of coal fields and mine workers. Likewise, books that begin as novels or even autobiographies (as in the case of the popular country-music star Loretta Lynn) are later transformed into larger-than-life images projected on the silver screen. So, although the order of the essays in this section is essentially chronological, the line of development in grappling with aesthetic challenges is more jagged than in the British representations in part one. The American experience tends to work with more diversity, and the melting pot seems to be far larger.

The retrospective story of the Mollies in a mining valley of Pennsylvania in 1875 is the topic of Robert Morsberger's essay. He compares Sir Arthur Conan Doyle's The Valley of Fear (1915) with the Martin Ritt film *The Molly Maguires* (1970). As Doyle portrays them, the Molly Maguires are simply gangsters out for extortion and protection money, though he establishes an effective atmosphere of terror created by their not-so-secret society. His story does not involve any oppression by the mining companies, but only by the Scowrers. The film *The Molly Maguires* has a similar plot of a Pinkerton agent infiltrating and betraying the Mollies, but the treatment is far more complex and certainly shows the miserable conditions under which the miners work. Its portrait of Jack Kehoe (Sean Connery), the leader of the Mollies, is more complex and sympathetic than any of Doyle's Scowrers, and the relationship between him and James McParlan (Richard Harris), the undercover agent he befriends and who betrays him to the gallows, involves considerable moral ambiguity. Neither man is an out-and-out hero or villain.

Maurice Collins's piece also takes as its subject the Molly Maguires, but his critical approach is quite different. Drawing on the works of such critics as Leo Marx, Takaki, Roediger, and Ignatiev, Collins uses some of the same material in applying the techniques of ethnohistory while stressing the formation of Irish ethnic identity in nineteenth-century America. The prejudices against miners that he uncovers are often anti-Irish and anti-Catholic. He adds an analysis of Allan Pinkerton's *The Mollie [sic] Maguires and the Detectives* (1877) to expand the scope of his argument.

The step from the world of film and detective fiction to the trade of investigative reporting is a rather small one. The surprise here is the case of a nineteenth-century practitioner who is better known for his fiction about Civil War heroes and urban prostitutes—Stephen Crane. He recorded his observations of coal-mining activity in late-nineteenth-century Pennsylvania in his journalistic report that was laced with social commentary—"In the Depths of a Coal Mine" (originally published in *McClure's Magazine*). Patrick Dooley's analysis interweaves the disciplines of philosophy and textual editing. In comparing various versions of Crane's text, he unravels the writer's definitions of the nature of reality and perception.

The traditions of American realistic and naturalistic fiction writers are Tom Frazier's focus. While he sees clear links to the pioneering French writer Emile Zola, Frazier delineates the unique naturalistic motifs of American literature. Although once powerful and controversial blockbusters, Upton Sinclair's *King Coal* and *The Jungle* and Frank Norris's *The Pit* and *The Octopus* are worth reexamining in light of the aesthetic challenges of viewing coal mining as a literary metaphor. Frazier places coal mining at the raw, beating heart of industrial America.

Daiva Markelis makes new discoveries in treating five short stories by the turn-of-the-century woman writer E. S. Johnson. Her fictional sketches originally appeared in the *Atlantic* and *American* magazines between 1906 and 1908; the works have never been collected or critiqued in the twentieth century. But through the liberating attentions of feminist and ethnic criticism, readers can expand the horizons of their experiences to see the value in studying coal-mining operations from new angles: the gender perspective of the woman left at home to manage the male worker's household and the ethnic perspective of Slavic and Lithuanian life in a new land—what one character bitterly refers to as the trials of living in "this America." Markelis's essay blends these ethnic and gender concerns as she explores representations of immigrant women and such rigidly defined "Old World" gender roles as arranged marriages. Although information about Johnson's own life is limited, she obviously had extended contact with the Lithuanians and Slavs of Pittston, Pennsylvania, which was almost exclusively an immigrant colony.

Some historians of twentieth-century America attribute more forces of social change to the century's two great worldwide struggles—World War I (1914–1917) and World War II (1939–1945)—than to any other events. The world for women and immigrants that Markelis describes in Johnson's stories taking place before World War I seems cramped and constricted compared to the expanding opportunities developing for the American population before, during, and after World War II. This expanded scene is the focus of Mary Roche Annas's "Proletarian Disaster and Social Change: Representations of Raymond Williams in Vicki Covington's *Night Ride Home*." Annas uses the cultural studies critic Raymond Williams's concept of the "informing spirit" to explore power relations in December 1941 in an Alabama mining town. Its inhabitants directly experience a mine disaster and indirectly are caught up in the larger cataclysm of Pearl Harbor. Covington's novel is both rich in detail and far-reaching in significance in its depiction of the cultural and political resistance of mine workers in the face of a world that is collapsing daily around them. The Alabama mine is both a microcosm and a metaphor of a world in chaos.

The mine as a site of violence and political change is also detailed in Theresa R. Mooney's essay when a bombed mineshaft in Eastern Kentucky becomes both trap and liberator for the protagonist of James Lee Burke's novel *To the Bright and Shining Sun* (1970). In the sixties world of the Job Corps and other "Great Society" public efforts of the Lyndon B. Johnson administration, in a relatively unbloody era of labor relations, Mooney sees continuing tensions between public and private spaces. Her analysis examines this struggle through several characters engaged in the class warfare that pits union against owners and through Burke's main character, who must struggle also with his own violent impulses, to balance the political demands of his community and the personal needs of self-discovery, redemption, and escape.

The novels of the West Virginia writer and historian Denise Giardina are certainly worth serious critical attention. Clarence Wolfshohl discusses Giardina's novel *Storming Heaven* (1987), which describes the mine wars of 1920–1921. Wolfshohl's approach is to examine the four character narrators to demonstrate the different class, ethnic, and gender perspectives. His multicultural approach exposes the fallacy of simply trying to define the working classes as "the Others" when Scotch-Irish, Welsh, African American, Slavic, and Italian mine workers of both the male and female gender are depicted. Wolfshohl argues that "Giardina's presentation of women from the mining class as well as her multicultural narration are unique among American coal-mining novels."

Another essay in the collection examines the Queen of Country Music, Loretta Lynn, and blends together a variety of experiences and genres. The popular culture superstar's career grew out of her coal-mining origins in

Butcher Holler, Kentucky. Alessandro Portelli focuses on the contradictions inherent in Lynn's autobiography, *Coal Miner's Daughter* published in 1975. As a composite of both high- and low-life stories, *Coal Miner's Daughter* can serve as an especially rich source for both class- and gender-coded notions of country identity—insights about the narratives governing both the genre of autobiography and individual working-class women's lives. Portelli examines the ways in which Lynn, as "co"-author of her autobiography, both produces and challenges a nostalgic vision of her past. Lynn's autobiographical text struggles with the dilemma that female country performer-writers face as they enter the arena of literary discourse: the struggle to adopt a narrative voice that at once verifies and precludes an "ordinary" identity. As the life story of a "star," it is pressed to serve multiple agendas, tracking her humble origins as well as her transformation into a successful, wealthy celebrity. Lynn herself recognizes the peculiar contradictions of country stardom. Lynn's sense of her own "ordinary" identity finally entails a private, domestic life preempted and compromised, if not erased entirely, by her unique status as the hardworking "Queen of Country Music." The autobiography fulfills and rewrites an assortment of narratives concerning class and gender, in the process reconfiguring coal-mining literature.

Ina Rae Hark offers a new analysis of John Sayles's film *Matewan* (1987), which treats the massacre of West Virginia miners in 1920. The film graphically portrays the oppressive conditions of miners and the use of spies, police, and murder by the mining companies; it also celebrates new ties and bonds that are developed in conflict along class and race lines. Sayles's *Matewan* returns to a time during which poor whites were subject to considerable class oppression. By the time the film was released, however, race had replaced class as the lens through which oppression and its consequences were viewed. Can the rural, Southern white male, so often cast as ignorant, bigoted, and violent, be redefined in terms of race? The West Virginia coal miners of the 1920s acted as a collective governed by their oppressed class status, not their racial and ethnic differences. Because the coal operators ran the mines in a "semifeudal," plantation style, it is easy to represent their class oppression through the more familiar (in the 1980s) metaphor of the operations of African slavery. The fact that coal miners literally acquire black skins while on the job allows this reading of class onto race to be translated readily in the visual medium of cinema. Sayles also seeks to convey in his film a white liberal ideology of the brotherhood of man and the impossibility of fighting violence with violence. *Matewan* does a superb job of delineating the shadings of masculinity in a southern West Virginia border town. Male violence, with its tribal loyalties, vendettas, and fierce provincialism, is an inevitable by-product of class manipulation.

One of the themes running through all these essays is that coal miners and coal mining are real, authentic, even manly, whereas the aesthetic is artificial,

fabricated, even effeminate. In Europe and America, some coal miners are made into emblems of social injustice or into threats of social unrest. Coal mining is an aesthetic reality that has been ignored too long. Poems, novels, and films that awaken readers' and viewers' moral and political consciousnesses are needed and valuable. In the 1990s and past the millennium, the political and moral injustice suffered by miners is still very much a current issue. Every essay in the collection in one way or another struggles with the tensions found in the mixture of authenticity (coal miners, coal mining, the daily reality) and the aesthetic (the form, the artificial, the representation). Many of the essays use the most recent critical approaches by framing the questions in terms of gender, class, and ethnicity. In personal, political, and aesthetic terms, literary works and films about the coal mines take us to the depths of human activity—the cavern of night, the hellhole—but often for the purpose of leading readers and viewers to an illuminating light of moral or emotional revelation.

This collection makes an important beginning toward exploring a neglected topic. Examples from all types of genres are not included here because of the scope of the project. Further investigation would include reading such novels as those by Mary Lee Settle, Martin Cruz Smith's *Rose,* Alexander Cordell's *The Rape of the Fair Country,* and Lee Smith's *Fair and Tender Ladies* or viewing such recent films as *Margaret's Museum, Brassed Off,* or *October Sky.* There is also a rich tradition of coal-mining themes to be found in folk songs. Coal mining is an epic activity: as a topic for study, it is broader and richer than anything a single collection of essays can cover. Nevertheless, the essays in this book should foster discussion about the aesthetic, gendered, class-based, and ethnic representations of coal mining in art, literature, and film.

William B. Thesing

Part I
The European Scene

ENGLAND,

WALES,

AND FRANCE

1

The Aesthetics of Coal

REPRESENTING SOOT,

DUST, AND SMOKE IN

NINETEENTH-CENTURY

BRITAIN

Martin A. Danahay

The nineteenth-century reception of J. M. W. Turner's *Keelmen Heaving In Coals by Moonlight* (1835) (fig. 1) demonstrated that coal and its by-products were viewed by commentators as a negation of the aesthetic or beautiful. In 1835, a critic in the *Literary Gazette* complained that the painting represented "a flood of glorious moonlight wasted upon dingy coal whippers, instead of conducting lovers to the appointed bower" (qtd. in Butlin and Joll 192). The critic felt that moonlight was wasted on keelmen and should be shown to illuminate only love, not industrial labor. His calling the keelmen "dingy coal whippers" shows how the dirt of their occupation was used to dismiss the workers themselves as drab and thus unfit subjects for high art. This nineteenth-century reaction to coal continues into the twentieth century.[1] Discussing Turner's painting, Allen McLaurin remarked that "the coal industry is, to say the least, a difficult subject for aesthetic presentation" (28). Reviewing the exhibit *Coal: British Mining in Art* in an essay with the promising title "Black Arts: Coal and Aesthetics," Peter Fuller, rather than being sympathetic to the joining of "coal" and "aesthetics," echoes nineteenth-century criticisms of the subject of Turner's painting: "No one has ever made a great cathedral, or painted a masterpiece, in coal. Coal is uniformly black. It lacks visible variety and is filthy to the touch. It has no ornamental value. Coal is too flaky and impermanent to fashion. The qualities it possesses of use to us can only be released by destroying it through burning. Coal offers none of the pleasures of sight, smell, touch or texture which can be derived

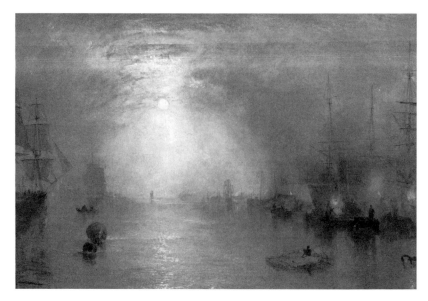

FIGURE I Joseph Mallord William Turner's *Keelmen Heaving In Coals by Moonlight* (1835).
Photograph © Board of Trustees, National Gallery of Art, Washington, D.C.

from working with wood, marble, stone, wool, leather or even paper. Coal is antipathetic to the human senses, hands and imagination alike" (200).

Fuller posits coal as the absolute negation of the aesthetic. He goes on to claim that "the rise of this anaesthetic substance symbolized the squeezing of art out of the everyday activities of life" (200). In his view coal is the black hole of all art and beauty. The rise of coal as a source of power is supposed to parallel the decline of the aesthetic. So extreme is his condemnation of coal that Fuller through his hyperbole manages to illuminate some of the motives behind the rejection of the conjunction of coal and the aesthetic. Fuller states that we can use coal only by destroying it, which makes us parasitical on its qualities. Of course, England could not have entered a sustained period of economic development in the nineteenth century without its exploitation of coal reserves, and Fuller's phrasing suggests a guilty awareness of the side effects of mining and burning coal. These side effects are not, however, the fault of coal but the processes humans use to extract coal from the ground and the smoke and ash produced by their burning it in huge quantities. Britain's wealth depended on the destruction of coal in the process of burning it to provide steam power. Fuller anathematizes coal because it represents a collective guilty conscience, and is associated with the "black" as opposed to the "white" side of the aesthetic appreciation of art. At some level he associates coal with guilt and evil, as his reference to "black arts" indicates.

While it may not be the easiest material to work with, there is no reason art could not be made from coal. However, coal is associated with industrialization and has come through this association to be seen as the opposite of the aesthetic. Turner's painting violates the separation of coal from the aesthetic on which conservative commentators from the nineteenth century on have insisted. While love and moonlight were an appropriate subject for art, coal was not. As William S. Rodner says in his study of Turner as an artist of the industrial revolution in *Keelmen* Turner "presented a routine industrial situation in a painting of aesthetic distinction" (103). Turner, however, showed a consistent appreciation for coal and steam, the engines of the Industrial Revolution in the nineteenth century, as shown most dramatically in *Rain, Steam, Speed* (1844) in which the coal fire is highlighted.

Turner set *Keelmen* at night and gives this painting a more restful atmosphere than others of his paintings that deal with industry. The intent of the painting was to provide a companion to *Venice*: to contrast "the sunlit indolence of Venice with the smoke and bustling activity, carried on even by night, of the industrial north of England" (Butlin and Joll 191). The industrial activity of the keelmen is actually secondary in the painting to the moonlight which, as McLaurin remarks, transforms industry "into something rich and strange" (35). It was this application of the transforming power of both moonlight and art when applied to industrial activity to which the critic quoted above objected. For Turner, on the other hand, the processes of extracting and burning coal could be aesthetically pleasing. Turner is in a distinct minority in appreciating the aesthetics of industrial activity, the burning of coal, and of its by-products, soot, dust and smoke in the nineteenth century; most artists and writers would concur with Fuller's ringing condemnation of coal as the antithesis of the aesthetic.

The dominant reactions to an industrial fuel like coal and the smoke and dust that it produces in the nineteenth century are either to ignore it and the industrialization it makes possible by completely focusing on the rural or natural, or to reject it as unnatural and a sign of environmental and moral decay. John Ruskin, as I have argued elsewhere, is representative of this strain in English thought in his rejection of the smoke of "pollution" produced by burning coal, understood in a religious context as a sign of the disappearance of God from nature.[2] In the early nineteenth century a few British artists, Turner preeminent among them, showed an alternative in an appreciation for rather than a rejection of coal, fire, and steam.

William Williams is credited with producing the first "industrial pictures" with a pair of views of Coalbrookdale, Shropshire, in the morning and afternoon, shown at the Royal Academy in 1778. Coalbrookdale itself, as the most famous late-eighteenth-century site demonstrating the industrialization made possible by the burning of coal, became a litmus test for people's attitudes

toward the new technology. Williams's representation sets the tone for representations in the upcoming century in that the smoke from the furnaces is filling a valley with pollution. His painting finds a literary analogue in Anna Seward's description of Coalbrookdale. Seward begins by calling "Colebrook Dale [sic]" a "scene of superfluous grace, and wasted bloom / O, violated COLEBROOK" (1–2). She then goes on to describe how the hills are covered in machinery and the sight of coal burning in furnaces:

> . . . while red the countless fires,
> With umber'd flames, bicker on all thy hills
> Dark'ning the Summer's sun with columns large
> Of thick sulphureous smoke, which spread like palls
> That scream the dead, upon the sylvan robe
> Of thy aspiring rocks; pollute thy gales
> And stain thy glassy waters. (24–30)

Seward links the fire of the furnaces to hell and damnation through her use of "sulphureous" and the screams of the suffering dead. Nature, which is invoked by the poetic epithet "sylvan," a recurrent antithesis to the industrial landscape throughout the nineteenth century, is seen as pure and innocent of any suffering. This is the antithesis that Fuller invokes even in the late twentieth century in his references to the "black arts" of coal and the "sooty clouds hanging over factory chimneys, rather than the spires and buttresses of carved cathedrals" in industrial cities, as if coal and religion were at war (200–201).

In histories of industrialization that celebrate the development of furnaces and industrial technology, Philippe Jacques de Loutherbourg's painting *Coalbrookdale by Night* (fig. 2), which was first exhibited at the Royal Academy in 1801, is often reproduced as a positive image of the flames and smoke produced by burning coal. At first glance the painting does seem to be a positive image, like Turner's, of coal being heaved on a moonlit night. De Loutherbourg worked not only in painting, but also in designing stage scenery and effects in an early form of panorama he termed *Eidophusikon* and in creating effects such as sound for theatrical productions.[3] *Coalbrookdale by Night* shows de Loutherbourg's appreciation for the spectacular effects of light and flame produced by the furnace; his interest in stage effects led him to emphasize the explosive quality of the scene. In his emphasis upon the fire of the furnaces, his painting parallels Turner's *The Limekiln at Coalbrookdale* (1797). However, as Stephen Daniels argues in an insightful analysis of this painting in its cultural context, de Loutherbourg is also drawing upon imagery of the infernal and implicitly likening Coalbrookdale to hell and the Last Judgment (212–16). De Loutherbourg thus furthers what became a familiar trope, comparing Coalbrookdale to hell and damnation. Fuller in referring to the "black

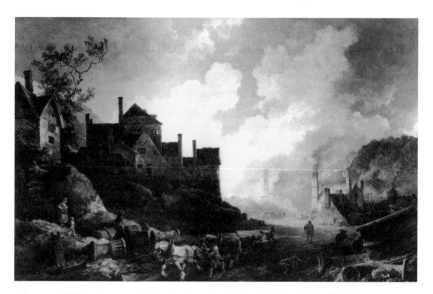

FIGURE 2 Philippe Jacques de Loutherbourg's *Coalbrookdale by Night* (1801). *By permission of the Science and Society Picture Library, National Museum of Science and Industry, London.*

arts" aligns himself with this way of representing coal. Coal is seen as the work of the devil, and thus as hell-bent on destroying God's incarnation in nature.

Fuller's remarks on the antithesis of coal and beauty recall many of the aesthetic theories in vogue at the end of the eighteenth and beginning of the nineteenth century, especially Edmund Burke's *A Philosophical Enquiry into the Origins of Our Ideas of the Sublime and the Beautiful*. Burke defines the category of the sublime as a "passion" caused "in *nature*" that corresponds most closely to astonishment (57). Burke's use of "nature" here is ambiguous and could refer to human nature or the natural world. The "sublime" conventionally was associated with awesome natural scenery, especially mountains or cataclysmic eruptions, as in the case of the paintings of John Martin, for example. De Loutherbourg's *Coalbrookdale* could be seen as an unusual representation of the sublime in industry rather than nature. However, for Burke and those who came after, only nature could provoke the emotions of astonishment and fear that attended the sublime, and which led to the recognition of a divine power at work in the world. Industrial activity would be seen as a disruption of the sublime by intruding man-made power into a scene that should evoke the power of an unpolluted natural force. Coalbrookdale was a favorite subject of artists because the Shropshire countryside around it seemed to be picturesque in the extreme and the threat of industrial pollution was more dramatic than in less striking surroundings. Seward in her poem complains that the furnaces should really be set up in some less appealing area, like

Birmingham, for instance, rather than Coalbrookdale. This threat to a pristine nature by the smoke produced by coal is the situation suggested by Williams's pair of morning and afternoon views of Coalbrookdale.

Coal was barred from Burke's aesthetic, as it was two hundred years later by Fuller's, because it is black. Just as Fuller cast coal out of the fine arts because it "is antipathetic to the human senses, hands and imagination alike," Burke does the same thing to blackness. In a section devoted to the "effects of BLACKNESS," Burke defines it as *partial darkness* (Burke's italics) and maintains "it cannot be considered as a colour" because black objects are "as so many vacant spaces dispersed among the objects we view" (147). Black, then, is an absence, a lack, not a positive color. Implicitly Burke defines black as a sort of death and links it to sadness: "Though the effects of black be painful originally, we must not think they always continue so. Custom reconciles us to every thing. After we have been used to the sight of black objects, the terror abates, and the smoothness and glossiness or some agreeable accident of bodies so coloured, softens in some measure the horror and sternness of their original nature; yet the nature of the original impression still continues. Black will always have something melancholy in it, because the sensory will always find the change to it too violent" (148–49).

Burke here sounds remarkably like Fuller casting aspersions on the inherently unaesthetic properties of coal. For Burke black is an anathematized color because he associates it with terror and ultimately death. This obviously places coal beyond the pale in Burke's schema, as it does in Fuller's. As we will see, the bad publicity that attends the color black was intensified in the nineteenth century by the colonial exploitation of "colored" people by the British Empire. Ironically, Burke's invocation of "custom" underlines that he is giving here a culturally specific account of the significance of black and its use as a color of mourning. Like Fuller, Burke could not appreciate the "industrial sublime" (Rodner 107) of a painting such as Turner's *Keelmen* because of its associations.

For one contemporary of Burke's, the color black had connotations not only of death, but also of exploitation. Where Turner used moonlight to link labor and coal into an aesthetically pleasing picture, William Blake linked soot, child labor, and victimization. Blake focused on London child chimney sweeps as the most moving victims of a callous social system.[4] Coal dust and ash from the burning of hearth fires in London became for Blake a multivalent symbol of oppression by the church and state. Blake's poem "London," for instance, is a catalogue of the misery caused by the city's callousness through its sights and sounds. Blake uses a chimney sweep as one of the symbols of oppression in London, describing "How the Chimney-sweepers' cry / Every blackning church appalls" (9–10).

The indifference of the church to the suffering of children is symbolized in the way in which the cry of anguish from the chimney sweep is transmuted

into the soot that "blackens" the supposedly white and pure exterior of the church building. The "appalls" in line 10, which echoes Seward's use of "palls" above, is both a covering that makes a building dark instead of light and a revulsion of the mind against the perception of injustice. Similarly, in one of the two poems entitled "The Chimney Sweeper" the soot-covered child is a symbol of oppression and misery and described as "A little black thing among the snow / Crying 'weep, weep' in notes of woe" (1–2).

The child is dehumanized by neglect into a "thing" and the "black" body presents a stark contrast to the white snow. A black/white dichotomy informs the representation of oppressed children throughout the *Songs of Innocence and of Experience*. One sweep is likened to a lamb whose soul is untouched even while his body is covered in soot:

> There's little Tom Dacre, who cried when his head
> That curl'd like a lamb's back, was shav'd, so I said,
> 'Hush, Tom! never mind it, for when your head's bare,
> You know that the soot cannot spoil your white hair.'
> ("The Chimney Sweep" 5–8)

Blake's use of "spoil" shows that, like Seward, he invokes coal dust and soot as symbols of sin and pollution. Unlike Seward, Blake does not idealize a "sylvan" nature but instead idealizes the natural innocence and "whiteness" of the child as opposed to the black pollution of coal. Blake reads the exploitation of child labor as symptomatic of wider injustice in the social system, so that in "London" the fate of the chimney sweep is linked to that of soldiers, prostitutes, and the citizens of London in general. In other contexts Blake did of course bemoan the impact of "dark satanic mills" on the English countryside, in the tradition of seeing industrialization as a symptom of hell and damnation (*Milton* 8).

Blake's use of chimney sweeps as representative of the injustices of child labor found an echo with the publication of the 1842 *Report of the Children's Employment Commission*. The authors of this government document seem to have been aiming for greater publicity than usually attends the presentation of such a report because they included illustrations and made it available to the public through booksellers. The use of illustrations, especially of children pulling carts full of coal down narrow passageways (fig. 3), provoked outrage and prompted some of the first legislation barring children from certain forms of labor in the 1842 Mines Act. In prose form, this report made some of the same connections between children and exploitation as Blake's poems. Like Elizabeth Barrett Browning's "The Cry of the Children" (1843), the report represented how child labor was actually killing and maiming children. This is the kind of political use of poetry that Thesing and Wojtasik describe in their essay "Poetry, Politics, and Coal Mines in Victorian England" in chapter 3 in this collection.

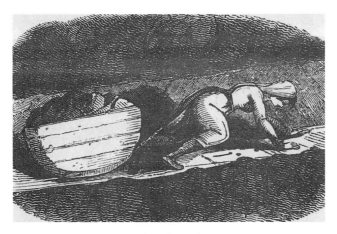

FIGURE 3 Child pulling cart full of coal down a narrow passageway (1842), illustrated in the first report of the Royal Commission on Mines. *Courtesy of Davis Library, University of North Carolina, Chapel Hill.*

Not everyone was delighted by the publication of this report, however. There was one man who spoke energetically against it and the subsequent legislation, not because he wanted to see children laboring in the mines, but because he wanted to see women continuing to work in the mines. This man was Arthur Joseph Munby. Munby stumbled upon the hearings leading up to the report by accident, and tried unsuccessfully to be allowed to speak in opposition to its recommendations:

> At 3 p.m. I went down to the House of Commons, to enquire about the Committee on Mines; & found to my surprise that it was sitting & taking evidence. I went to the room: there were no spectators, except about 6 or 8 men, all of whom looked like miners or miners' delegates. One delegate from Lancashire . . . was just finishing his testimony, & declaiming against the employment of women. Another followed, on a different matter. I waited, in a state of feverish mental vertigo, till they rose at 4, & then spoke to Fawcett, who is on the Committee. He seemed to think that no evidence but that of local people would be taken; and he was by no means cordial about it. The prospect of another false & foolish measure against women is simply distracting to me. (Hudson 220–21)

Munby viewed himself as a champion of working-class women and their "right" to labor in such places as mines. If he had been allowed to testify before the Committee on Mines, he would have spoken vigorously against their recommendations to bar women from the mines, although he may well have

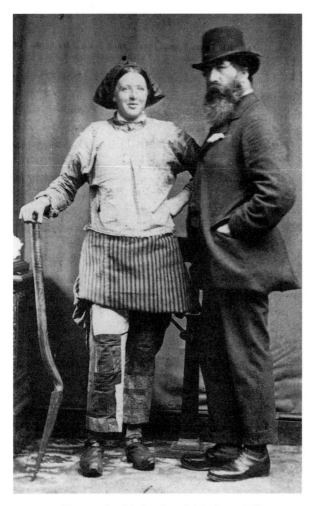

FIGURE 4 Photograph of Arthur Joseph Munby and Ellen
Grounds (1873).
By permission of the Master and Fellows of Trinity College, Cambridge.

supported the exclusion of children. Munby made several visits to mining
districts, and even took a holiday in Belgium in order to see the female mine
workers there, documenting his visits in his diaries and photographs (fig. 4).
So frequent were his visits and persistent his questions that the local "pit brow
girls" in Wigan gave him the nickname "The Inspector" (Hudson 290).

While Munby saw himself overtly as a champion of working-class
women's right to work, he actually made a fetish of collecting photographs
and interviewing them about their work. What Munby liked particularly
about women mine workers was that they wore what were conventionally

"men's" clothing and became very dirty in the course of their work. Munby's pencil drawings of women mine workers emphasize how their features were blackened by the coal. Munby acted on this desire to see women made dirty and apparently black in the course of their labor when he married Hannah Cullwick, a working-class woman he met when she was a maid-of-all-work. Munby and Cullwick lived together ostensibly as master and servant, but actually as husband and wife. In his diary descriptions of Cullwick, Munby makes clear his erotic fascination with soot and dirt:

> The parlour was all adust and in confusion; and on the hearth, in brilliant sunshine, crouched the dirtiest object of all—a woman. . . . All around her were fire irons, blacking pots and the like; and she, prone on her hands and knees, was earnestly scrubbing the fender. Her bare round arms were streaked and disfigured with soot and grime: but her face was soot all over—absolute blackness, so that no feature could be distinguished. . . . "Don't let us disturb you"; and the black woman, speaking low and in a sweet voice, answered "Never mind, Sir," and prepared to remove her offensive presence: gathering up some of her horrors, she crawled out of the room, without rising. (Hudson 361)

Cullwick called Munby "Massa" and often referred to herself as his "slave." In this encounter between Munby, a visitor, and his wife, the couple act out the charade that she is his servant. Munby enjoys Cullwick's subservience and her "blackness," referring to her as a "black woman." Cullwick herself emphasizes her subservient position, crawling out of the room rather than walking. In another entry Munby reports Cullwick saying that she was "blacking herself," and Munby realized she was making herself deliberately dirty because he enjoyed seeing her in this way (316). They referred to this as Cullwick's being "in her dirt," as if she had a personal relationship with soot and dirt. Munby also reports that Cullwick, in one of their sessions at a photographer's studio, suggested a pose that he would find particularly appealing, what Munby calls "her noblest guise," that of a chimney sweep.[5]

There has been some disagreement over whether this particular photograph represents Cullwick as a "slave" or a "chimneysweep," although the diary makes it clear that she thought of it as a picture of a sweep (133). The critical discussion of whether the photograph of Cullwick represents her as a chimney sweep or slave is ultimately beside the point, because Cullwick is interpolated *both* as a chimney sweep, someone involved in a "dirty" occupation that places the worker beyond the pale of polite society, and as a slave enmeshed in a colonial system of racism and oppression. Cullwick in this photograph is in "blackface," she is assuming a role in which she enacts her servitude to Munby by temporarily blackening her skin.[6] Munby coming

THE AESTHETICS OF COAL

home one day reports that Cullwick looked "like a chimneysweep" and that she said to him, "I'm blacking myself, Massa . . . to do the stairs" (316). Their conversation indicates how closely the categories "chimneysweep" and "black" were interrelated for them. The blackening of the skin through soot was linked by the use of "blackface" by street performers to the racial categories operative in the British Empire. The photograph of Cullwick in "blackface" underlines how Cullwick is performing an identity that aligns her both with a dirty, menial occupation and the pejorative connotations associated with dark skin color in a racist vocabulary. Munby refers to Cullwick in his diary as "my sweet *blackfaced* Hannah" (346) and shows a persistent interest in blackfaced street performers (157). Munby's descriptions of Cullwick thus show the continuity between the street performers' use of blackface and their own private theatricals.[7] Cullwick's position in the British class structure is thus defined by Munby through racial metaphors that place her, as a working-class white woman, in an analogous subject position to that of a slave in a plantation economy.

This association of dirt, coal dust, and working-class sexuality in the figure of the chimney sweep is also illustrated in Charles Kingsley's *The Water Babies*. In this story the central figure, Tom the chimney sweep, becomes lost in the maze of chimneys at Harthover House and by accident emerges in a room "that was all dressed in white; white window curtains, white furniture, and white walls," and in the bed a girl "whose cheeks were almost as white as the pillow." Tom then catches sight of a figure in the mirror who presents an absolute contrast to the white room and white girl: "And looking round, he suddenly saw, standing close to him, a little ugly black, ragged figure, with bleared eyes and grinning white teeth. He turned on it angrily. What did such a little black ape want in that sweet young lady's room? And behold, it was himself reflected in a great mirror, the like of which he had never seen before" (26).

Thanks to this view of himself, Tom "for the first time in his life found out that he was dirty." A complex series of class and sexual motifs are represented by Tom as a "little black ape" in this scenario, all reinforcing the distance between him and the white, clean bedroom of the upper-class girl. There is also a hint of sexual danger in Tom's eruption into this pristine space, and his shame is caused in part by the conjunction of dirt and sexuality. Where for Munby and Cullwick dirt was an erotic substance, in Kingsley's tale Tom is immersed in water for a period of years so that he can escape from dirt and baseness and become a good, clean, obedient, middle-class child.

Kingsley's text reinforces the identification of chimney sweeps, dirt, and the lower classes that Cullwick also drew upon in posing as a chimney sweep in her photograph. While Blake identified "black" chimney sweeps as the most innocent victims of the British social system, and Cullwick internalized the negative associations of being "dirty" in a society that emphasized cleanli-

ness as next to godliness, Kingsley sought to transcend class distinctions and translate Tom into a world where dirt could not exist because it was underwater. Where Blake imagined a reward in heaven for those exploited on earth, Kingsley creates a fairy fantasy world in which justice and morality would function in a way they did not in Victorian social reality.

Not surprisingly, given the class associations of coal, soot, and manual labor, there are very few artistic representations of coal after Turner and de Loutherbourg. William Bell Scott is one notable exception, creating a hymn to the industry and commerce of Tyneside in his 1861 painting *Iron and Coal*. His painting, like Ford Madox Brown's *Work,* turns the working-class men into heroic, statuesque figures. The painting is meant to celebrate a region of the country and link it to Victorian pride in the products of industrialization like that at the display of the Great Exhibition at the Crystal Palace. In general, however, representations of coal mining and other such occupations were the province of illustrated newspapers, not high art.

There is one exception to this general British hostility to representing coal and its products in art, and this is impressionism. The impressionists, like Turner before them, were deeply impressed by the power of such industrial machinery as locomotives, and by the architecture of iron and steel. Claude Monet, for instance, painted the Gare St. Lazare as one of his subjects. Monet also made a pilgrimage to London specifically to see the London fog, which we would now term "London smog." In the fall of 1899 Claude Monet began the first of a five-year series of visits to London to paint views of Charing Cross Bridge, Waterloo Bridge, and the Houses of Parliament. Monet was drawn to London because of its fogs and the effects of these fogs upon sunlight that produced a constantly changing, fluctuating rainbow of color and illumination.

London in the nineteenth century experienced an unusually large number of cases of thermal inversion and a correspondingly high number of fogs that peaked in frequency in the late nineteenth century.[8] The smog of London by 1900 had even become a selling point for the city; Elizabeth Robins Pennell in her guide *Homes of the Passing Show* says of the Thames that "indeed it is in its infinite variety, due chiefly to smoke and atmosphere, that the Thames is unrivalled" (11). In other words, the Thames is an interesting river precisely because of industrial pollution that produced smog to make the urban landscape more interesting. Monet himself agreed with this sentiment. In a letter in 1920 Monet explained why he found London in winter so enjoyable: "I so love London! but I love it only in winter. It's nice in summer with its parks but nothing like it is in winter with the fog, for without the fog London wouldn't be a beautiful city. It's the fog that gives it its magnificent breadth. Those massive, regular blocks become grandiose within that mysterious cloak" (qtd. in Seiberling 55).

Monet seems to suggest that if it were not for its smog, London would be

a prosaic city. While Monet was painting his smoggy views of London, he kept a journal, and one entry reveals why he was afraid of sunny weather in London, but relished the winter: "This morning I believed the weather had totally changed; on getting up I was terrified to see that there was no fog, not even the shadow of a fog; I was devastated and saw all my canvasses ruined, but little by little the fires kindled, and the smoke and fog returned" (qtd. in Seiberling 54).

Monet is "terrified" by sunshine and blue skies because he was interested in recording the effect of smoke and fog on sunlight and the different colors that the interaction of light and pollution produced. He was perfectly aware of the connection between burning coal and the London fog, and had what we might term an "aesthetics of pollution" in that he enjoyed the range of colors smog and light produced and the way in which they blurred the outlines of buildings. Unlike the poets and artists who were horrified by Coalbrookdale's being polluted earlier in the century, Monet views smoke as an aesthetic phenomenon.

Monet was not alone in this appreciation of London smog, although the artists who shared his appreciation were not British born. James McNeill Whistler was an expatriate American living in London who produced views of the city that emphasized color and arrangement of form over realist representation. Like Monet, he was not interested in realistic representation but in conveying the atmosphere, both in the sense of the visible air and the mood, of London on a foggy day. In such paintings as *Nocturne in Grey and Gold—Piccadilly* (1884) Whistler suggests shapes and movements that can only dimly be discerned, and his title "nocturne" suggests that he is interested in a music–like emotional effect rather than a realistic representation.

Giuseppe de Nittis was an Italian impressionist who created much more realistic images of London and its fog, as well as of British social life. In his *Westminster* (1878) he makes ironic reference to London's nickname "The Big Smoke." Not only does fog make the Houses of Parliament in the distance indistinct, but it also combines with steam rising up from a passing boat on the Thames and the smoke from the workers' pipes as they relax at the end of the day. All three sources of airborne interference combine to create the atmosphere of the painting. Like the other impressionists, de Nittis chooses a moment of relaxation and leisure rather than labor as his subject. Where Bell Scott and Brown tried to celebrate work and industry, de Nittis focuses on workers relaxing rather than laboring.

Like Turner in the painting with which I opened, the impressionists had an aesthetic that was radically at odds with the conventional Victorian outlook of the time. The British art establishment, like the British public in general, was hostile to the impressionist choice of subjects and their treatment of them. Only foreigners visiting London, it seems, could appreciate the changes

wrought by coal on the London climate, although Oscar Wilde in typically impish fashion suggested that it was in fact thanks to the impressionists causing the fogs that the appearance of London had changed (33–34). Apart from Wilde, very few people seemed to appreciate the "aesthetics of pollution" that led Monet to visit London to view its beautiful smog.

From the representation of Coalbrookdale through to the end of the century, coal was consistently seen as unaesthetic, dirty, and the source of unwelcome smoke. Fuller's remarks on coal represent a continuation of its bad public image. A few renegades such as Turner, Monet, Whistler, and de Nittis help to demonstrate that, given the suspension of enough popular prejudices, there actually can be an "aesthetics of coal." Given the dense associations of evil, the class and racial attitudes invoked by its color, and its production of soot and smoke, it is little wonder that coal was viewed in the nineteenth century conventionally as the opposite of the aesthetic. The artists discussed here show that coal, soot, and smoke, just as any other substance, can be used in art and viewed as aesthetically pleasing. Some deeply perverse figures such as Arthur Munby can even hint at the possibility of an "erotics of coal" that links sexuality and the aesthetics of this black, anathametized substance. As Marsha Bryant demonstrates in her essay in chapter 8 in this collection, an "erotics of coal" can be detected in some representations of the "black arts" in twentieth-century Britain.

NOTES

1. A notable exception to this generalization is the exhibition organized by Gray and Regan that forms the basis for *Coal: Mining in British Art, 1680–1980,* which surveys the various images of mining in both high art and popular culture over the past three centuries.

2. See Danahay, "Matter Out of Place." Fuller's title, *Images of God,* indicates that he is close in spirit to Ruskin's anxious examination of art and nature for signs of God, signs that were threatened by industrial pollution.

3. I am heavily indebted in the following discussion of de Loutherbourg's painting to Klingender's *Art and the Industrial Revolution* and to Daniels's fascinating essay "Loutherbourg's Chemical Theatre."

4. Gardner discusses the labor practices of master chimney sweeps at this time (66–69). As he says, Blake chooses an occupation "that was the analogy, and too often the prelude, to death itself."

5. This photograph is reproduced in Cullwick (facing 152–53).

6. Lott has examined blackface as an example of "the vagaries of racial desire" and the "permeability of the color line" (6). Similar forces are at work in both Cullwick's assumption of blackface and Munby's interest in blackface performers.

7. For a history of performers adopting "blackface," see Leonard. In my use of "private theatricals" I am influenced by Auerbach's analysis of Victorian attitudes to public and private performances of subjectivity.

8. See Ashby and Anderson, *The Politics of Clean Air,* and Brimblecombe, *The Big Smoke.*

WORKS CONSULTED

Ashby, Eric, and Mary Anderson. *The Politics of Clean Air.* Oxford: Clarendon, 1981.

Auerbach, Nina. *Private Theatricals: The Lives of the Victorians.* Cambridge: Harvard Univ. Press, 1990.

Blake, William. *Milton.* 1804. *Poetry and Prose of William Blake.* Edited by Geoffrey Keynes. Bloomsbury, Eng.: Nonesuch, 1927.

———. *Songs of Innocence and of Experience.* 1794. Paris: Trianon, 1967.

Brimblecombe, Peter. *The Big Smoke: A History of Air Pollution in London since Medieval Times.* London: Methuen, 1987.

Browning, Elizabeth Barrett. "The Cry of the Children." In *"Aurora Leigh" and Other Works,* edited by John Robert Glorney Bolton and Julia Bolton Holloway, 315–19. New York: Penguin, 1995.

Burke, Edmund. *A Philosophical Enquiry into the Origins of Our Ideas of the Sublime and the Beautiful.* 1757. Edited by James T. Boulton. Oxford: Basil Blackwell, 1987.

Butlin, Martin, and E. Joll. *The Paintings of J. M. W. Turner.* New Haven: Yale Univ. Press, 1977.

Cullwick, Hannah. *The Diaries of Hannah Cullwick, Victorian Maidservant.* Edited by Liz Stanley. New Brunswick, N.J.: Rutgers Univ. Press, 1984.

Danahay, Martin A. "Matter Out of Place: The Politics of Pollution in Ruskin and Turner." *Clio* 21, no. 1 (Winter 1991): 61–77.

Daniels, Stephen. "Loutherbourg's Chemical Theatre: Coalbrookdale by Night." In *Painting and the Politics of Culture,* edited by John Barrell, 195–230. Oxford: Oxford Univ. Press, 1992.

Fuller, Peter. *Images of God: The Consolation of Lost Illusions.* London: Hogarth, 1990.

Gardner, Stanley. *Blake's Innocence and Experience Retraced.* New York: St. Martin's, 1986.

Gray, Douglas, and Michael Regan. *Coal: Mining in British Art 1680–1980.* Drukkerijen, Holland: Veenman Wageningen, 1982.

Great Britain. House of Commons. *1842 Report of the Children's Employment Commission.* London: Clowes & Sons, 1842.

Hudson, Derek, ed. *Munby: Man of Two Worlds: The Life and Times of Arthur J. Munby 1828–1910.* London: John Murray, 1972.

Kingsley, Charles. *The Water Babies: A Fairy Tale for a Land-Baby.* London: Macmillan, 1889.

Klingender, Francis D. *Art and the Industrial Revolution.* New York: Augustus M. Kelly, 1968.

Leonard, William T. *Masquerade in Black.* Metuchen, N.J.: Scarecrow, 1986.

Lott, Eric. *Love and Theft: Blackface Minstrelsy and the American Working Class.* New York: Oxford Univ. Press, 1993.

McLaurin, Allen. "Reworking 'Work' in Some Victorian Writing and Visual Art." In *In Search of Victorian Values: Aspects of Nineteenth-Century Thought and Society,* edited by Eric M. Sigsworth. Manchester, Eng.: Manchester Univ. Press, 1988.

Pennell, Elizabeth Robins. *Homes of the Passing Show.* London: Savoy, 1900.

Rodner, William S. *J. M. W. Turner: Romantic Painter of the Industrial Revolution.* Berkeley: Univ. of California Press, 1997.

Seiberling, Grace. *Monet in London*. Seattle: Univ. of Washington Press, 1988.

Seward, Anna. "Colebrook Dale." In *The Poetical Works of Anna Seward*. New York: AMS, 1974.

Wilde, Oscar. "The Decay of Lying." In *Intentions*, 33–52. London: Heinemann, 1891.

2

Demonized Coal Miners and Domineering Muses in Sidney H. Sime's Fantastic Illustrations

William B. Thesing

Have ye leisure, comfort, calm,
Shelter, food, love's gentle balm?
Or what is it ye buy so dear
With your pain and with your fear?

Percy Bysshe Shelley

Increasingly, the field that is generally called "the history of the book" is receiving attention in academic circles and professional journals. The study of illustrations or periodical engravings from a particular period helps us to grasp the wider context of intellectual, aesthetic, and political opinions of an age. Another important area of interdisciplinary work combines the study of biography and psychology, as demonstrated in works such as Alan C. Elms's *Uncovering Lives*.

These multidisciplinary perspectives apply to the Victorian period remarkably well. The study of several examples of Victorian illustration provides a fascinating reflection of Victorian tastes and attitudes. In various formats from several decades, Victorian illustrations (in novels and periodicals) show the dominant themes of nineteenth-century life: work, love, death, eroticism, pain, compassion, and fear. A study of the illustrations and of the lives of the artists who drew them reveals much about the social, artistic, and psychological context of the Victorian Age in Great Britain.

SIME'S WORK IN THE COAL MINES

Sidney H. Sime (1867–1941) has been called "the master of the mysterious" and "the master of fantasy." Ray Bradbury once wrote that "in Sime there is no comfort. His dreams are dreams of death. . . . It is his dark imagination that pleases me most" (7). His apocalyptic visions of heaven and hell—or souls on their way to those destinations—have been compared to those of William Blake, an illustrator whose works Sime knew intimately. Various commentators on Sime's work as an illustrator of periodicals and novels have applied other descriptive labels. Walter Emanuel, artist and critic, in the *Strand Magazine* (November 1915) called Sime "a great master of the grotesque." The art critic Haldane Macfall said, "There is behind all Sime's work an extraordinary sense of one who has felt the immensity of life. There is in it [Sime's work] something of that great grim chuckle, something of that love of the human being, something of that compassion for the weak, something of that fierce desire to see behind the screen of the Unknown" ("Some Thoughts" 656).

The *Idler* was a Victorian/Edwardian periodical, an illustrated gentleman's magazine, that was published monthly between 1892 and 1911. It had several editors, including Robert Barr, Jerome K. Jerome, Arthur Lawrence, and Sidney H. Sime. Sime served as owner-editor for only a brief time, from 1899 to January 1901, when he sold the journal and its operations for only five pounds. Readers in England, Canada, and America read issues of the *Idler.* At a single sitting, the *Idler*'s pages took the reader from travel adventures in the western Canadian wilderness to cultural appreciations of events in Great Britain. The gentleman or educated middle-class reader, with curiosity and urbanity, looked forward to updating opinions and speculations by reading the most recent high-spirited articles or chuckling over the avant-garde illustrations by Sime and others (Thesing and Lewis 1–12). Sime said that he chose art as a profession because he did not have to work very hard at it. Or, as he once told Haldane Macfall, "I took to it because I did not like work. . . ." ("Genius").

From a psychological perspective, however, we learn that the real childhood world of Sime had not always been a life of leisure or that of the leather-chaired club room. The silver spoon was tarnished early by the grinding demands of the industrial world. Sime may have fully enjoyed the "leisure, comfort, [and] calm" of the first line of the epigraph by Shelley in his later life, but his early years were full of "pain" and "fear." Edgar Johnson's psychological biography of Charles Dickens outlines a similar case of hidden oppression in the childhood world of the Victorian period's best known novelist. Peter Ackroyd's biography of Dickens further elaborates the full involvement of the leading Victorian novelist's mother in deciding to force her son to work in industrial toil (77–81, 86–89, 94–98).

FIGURE I Sidney H. Sime's "More Birds of a Feather," from the *Idler,*
Mar. 1896, page 211.
Courtesy of Thomas Cooper Library, University of South Carolina.

Whereas Dickens was forced by his parents to spend five months of his
adolescence in a warehouse pasting on bottle labels, Sime's mother and father
made him spend five years underground in a menacing and uncomfortable
environment as a pit boy in the Yorkshire coal mines. It was his first job. He
described the horrors of the colliery experience in an interview with Arthur
Lawrence: "You know that when the coal has been taken out of the seam it is
shoveled into what are called scoops, holding about 5 cwt. My duty, as one of
the boys employed for that work, was to push this scoop along the rails to an

endless chain, by which it was carried to the pit's mouth and pulled up to the surface. . . . The tunnel through which we had to pull the trolley was only 28 or 30 inches high, and so we had to run along with the body bent at right angles, and if you straightened yourself up at all, the consequences were rather unpleasant" (762–63). Scoops, shovels, baskets of coal, and deathlike, weary figures in captivity are captured in his afterlife painting of eternal torments, "More Birds of a Feather" (fig. 1). Sime was forced to do manual labor in the mines for five years in his youth—a much longer time than Dickens's five-month period of humiliation pasting labels on bottles in the window of Warren's Blacking Factory. Sime told an interviewer how tedious his youthful days were: "All I did during those five dreary years was to work, eat, and work again" ("From Pit Boy to Artist").

Certainly it is true that Sime evokes feelings of wonder and horror in his incredible scenes that depict an apparently strange world. But what is his sense of actuality? How extensive are his links to the world of reality? Several illustrations drawn from the everyday world—coal mines in the Midlands and women in the act of washing stairs or clothes—show that at least some of his work is drawn from firsthand, painful experience. Sime used to scratch drawings of imps and devils on the walls of the pit in his youth. In fact, as John Lewis reports, "the boy Sime used to scratch drawings of demons on the coalface, which the manager of the pit would show to his friends with some pride" (203; see also Skeeters 130).

Sime was born in Old Hulme, Manchester, England, in 1867. While still a youngster, his parents moved to Liverpool. His father, David Sime, was employed in a furniture warehouse. His family was very poor, and as a boy, he had very little schooling. In his youth he was forced by his parents to work as a pit boy in a Yorkshire colliery. He had little inclination for the hard work, which lasted for five years. After leaving the mines, he went to work for a linen draper in Lancashire, and then as an assistant to a baker, a barber, and a shoe-maker. His escape route of opportunity came when he was apprenticed to a sign and frame maker, which involved attending evening classes at the Liverpool School of Art where he won two awards for his work. In 1887, at twenty, he went to London full of ambition but with no money. He lived alone in a Soho garret. His drawings soon appeared on the pages of the *London Illustrated News*. It was not long before he "realized that the only profitable life for a beginner was book illustrating" ("From Pit Boy to Artist"). Curiously, his statements about his work as a Bohemian artist in the 1890s are often crafted in such a way that he conveys his grown-up professional identity as that of a nonchalant, carefree decadent who never had any contact with the real world of work during his entire life.

I would like to argue, however, that in various works, in such illustrations as "The Kidnappers," "How Ali Came to the Black Country," and several oth-

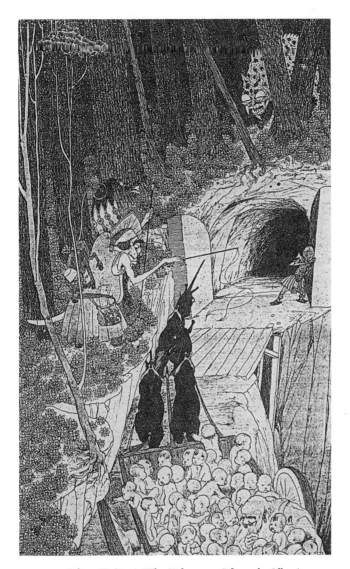

FIGURE 2 Sidney H. Sime's "The Kidnappers," from the *Idler* Aug.
1899–Jan. 1900: 490.
Courtesy of Thomas Cooper Library, University of South Carolina.

ers, he returns through the medium of memory to the central trauma of his
childhood through the use of tunnel imagery as well as depictions of demo-
nized industrial workers and domineering female figures to make specific
indictments of exploitation by Victorian mothers and capitalistic owners. His
artistic tastes usually tended toward the fantastic and the surreal. He contributed
some sinister illustrations on a variety of subjects to the *Idler*. Many of these

contain some sort of dark, devouring tunnel in the scene or sticklike demon figures of mine workers either suffering or dying. "The Kidnappers," one of his more bizarre contributions, shows a cartload of plump babies descending into the cave of a devouring beast.

There is a piratelike individual with an eye patch who is whipping the horse-drawn cart into a cavern. Over the entryway there broods a hideous monster. This shocking illustration (fig. 2) surely contains an autobiographical dimension as its subtext. The young children are going to their doom and the artist conveys the scene with uncanny pity. One impression is dominant: the tunnel is inescapable; it devours and consumes its victims. Holes in the ground and tunnels in the sides of hills are recurrent images in Sime's works. They suggest not only his memories of his childhood experiences in coal mines, but also his adolescent psychological fears of the mysterious realm of the female genitalia. The vaginal canal gives life, but it also remains to the unmarried young male artist a forbidden realm of mystery from which there may be no safe return.

In "The City of Never," the young venturesome rider comes upon the cliffs of Toldenarba with the Under Pits (a black tunnel with glistening eyes peering out). In the exquisitely detailed "Landscape Map, Land of Dreams" (fig. 3), black holes, sulphurous caves, and dark tunnels are always labeled with negative warnings: the imaginary traveler must pass over "nightmare brink" to reach the "Great Hole Full of Stardust," and prickly ghouls crawl outside the "putrid pits" of the tunnel in the mountainside. The tunnel is near "Ogre's Cave" and the entrance to the tunnel itself is surrounded by pubic-like hairs and a "bad smell." These images convey the attraction-repulsion feelings of awakening adolescent sexuality.

One other Sime illustration, for a New Year's issue, plays ironically with the proverb "The road to hell is paved with good intentions." Not only does Sime cynically undercut the idea that on the first of each year new resolutions are bound to fall to devilish temptations, he goes further in making his point that those who work on road construction projects are like devilish imps scurrying about frantically. The illustration was titled "The Great Pavement: First Consignment of Good Intentions for 1897: An Allegorical New Year's Cartoon by S. H. Sime" (fig. 4). Again, the predominance of the tunnel orifice on the right-hand corner of the scene suggests both sexual fears and painful memories of the coal mine. Workers engaged in such hard manual labor are slaves, imps, and devils. Strong and robust laborers are transformed by Sime's fantastical imagination into gaunt, sticklike demons working on material projects that further no noble intentions.

Sime did not fixate exclusively on tunnels in expressing his psychological reactions to his adolescent experience in the coal mines. He also depicted the agony of death and the indifference of the coal owner-operators,

FIGURE 3 Sidney H. Sime's "Landscape Map, Land of Dreams," from the *Sketch* 3 May 1905: 204.
Courtesy of Indiana University Library.

FIGURE 4 Sidney H. Sime's "The Great Pavement," from the *Idler* Jan. 1898: 757.
Courtesy of Thomas Cooper Library, University of South Carolina.

always dressed in black. "The Terrible Mud" shows a victim succumbing to an agonizing death in a dark mining-town setting. Dust returns to dust, but the muddied or drowned miner returns to the slime of eternity. The expiring miner is worn out and ill-clad. The onlookers are well-dressed, but largely indifferent to the impoverished victim's demise. "How Ali Came to the Black Country" depicts more pointedly the haughty arrogance of capitalistic owners who healthily stroll through the blackened landscape, totally unaware of the devastating implications of their powerful and greedy activities.

SIME'S IMAGES OF WOMEN

Realistic scenes of women slavishly washing stairs or grotesquely hanging out the laundry also are grist for Sime's illustrative pen. Additionally, he depicts

women in sacrificial roles—as domestic workers or as victims of violence—but he also shows some women as active, counter-muses, such as in the illustrations entitled "Midnight Oil" and "The Bad Girl of the Family." There are four categories of representation of women, then, in Sime's illustrations: as worker, as sacrificial victim, as muse figure, and as devouring sphinx. By far and away, the last two categories predominate in his illustrations.

In 1898 Sime inherited a small fortune and a large house in Perthshire, Scotland, from an uncle. This financial windfall allowed him, at the age of nearly thirty, to marry a fellow artist and Edinburgh native, Mary Susan Pickett. The new couple lived half of the year in Scotland and the other half in London. During the 1890s, the *Idler* had a progressive track record with regard to women's issues. The periodical managed a balanced tone of equality as it included various women writers—such as Sarah Grand and George Egerton—in the pages of its issues. Pictorial illustrations were always a key feature of the magazine's pages and women were given expanded opportunities in this area as well.

Sime, however, in his artistic representations of women tended to reinforce the most menacing and demeaning gender stereotypes of the age. Psychologically, his outlook may be linked to early mistreatment by his mother and to the later personal unhappiness in his own marriage. Sime seems to have had a weary and melancholy recognition of his infertile and loveless marriage. Simon Heneage and Henry Ford describe Sime's wife: "His marriage apparently brought him no consolation. They had no children. Mary Sime, regarded as the local beauty, was shy and introverted. She shared many of her husband's interests in art, music and the exploration of esoteric knowledge, but not his social instincts. She was highly strung, touchy and often in pain from arthritis. . . . The home atmosphere was claustrophobic, from which Sime found partial release at the pub" (30). To escape the confines of his household—and especially his temperamental, demanding Scottish wife—he would often take a seat at the end of the bar each evening in the local pub, the New Inn in Surrey. There, in his formal blue suit, he would drink with working-class patrons of the village community.

Sime's women figures are depicted in scenes of domestic toil, washing clothes or scrubbing stairs. Another motif is that of sacrificial victim—nude women are often bound or abducted by violent men from the Near or Far East. In another, predominant motif Sime displays women as muses or temples of wisdom, borrowing upon the legend of the sphinx figure. In literature, as in the realm of the visual arts, fantasies concerning women's resemblance to animals have thrived for many centuries. Such depictions suggest that women have an animal nature and are dangerous playthings. The sphinx figure represents superior intelligence for the conception and execution of evil; however, it also captures the tigerish nature of aggressive primal sexuality of women.

According to Bram Dijkstra, woman had truly become in art of the 1890s "the idol of perversity" (325), that is, the livid-eyed, snake-encircled, Medusa-headed flower of evil. His argument sees a backlash in art and literature by men as they fear the new progress and accomplishments of women in the final decade of the nineteenth century.

The sphinx figure was as threatening as the fangs of a devouring animal. Female temptresses were terrible, man-eating creatures. With regard to a typical sphinx painting of the 1890s, Dijkstra remarks, "With the hypnotic stare of a snake, the paws of a cat, lethally protuberant breasts, and the overblown musculature of a late-twentieth-century female bodybuilder, this sphinx represented a masochistic male fantasy of the ultimate dominatrix, the goddess of stony bestiality" (327). The sphinx figure—as seen in Sime illustrations such as "The House of the Sphinx" and "The Coronation of Mr. Thomas Shap" (both for Lord Dunsany's *The Book of Wonder,* 1912)—is an evil and barren aggressor: her enticing breasts and devouring claws combine bestial passion and certain death.

A curious variant of the sphinx figure is that of the Old Mother Hubbard or cruel matron figure. In "The Old Woman Who Lived in a Shoe" and in "Mother Britannia" we see the political and social consequences of the distribution of punishment and food as given out by domineering female dragon ladies.

SIME'S TRANSFERENCE OF DEMONIZING IMAGERY TO THE BRITISH EMPIRE

During the final years of Victoria's reign and continuing through the Edwardian period, there was in the pages of the *Idler* an increasing attention to the matters of empire, war, and military preparedness. Thus, in articles such as "Britannia Armed," "Great Britain as a Military Power," and "Is the British Navy Invincible?" we can trace the slow and steady movement toward the cataclysmic struggle of European nations in World War I. Here again, Sime's illustrations convey stereotypical signs of the most blatantly conservative attitudes of racism displayed toward Oriental and African peoples in the early years of the twentieth century.

Patrick Brantlinger in *Rule of Darkness* points out that "imperialism, understood as an evolving but pervasive set of attitudes and ideas toward the rest of the world, influenced all aspects of Victorian and Edwardian culture" (8). In regard to Africa, the Dark Continent, stereotypical perceptions viewed the natives as savages, childlike, superstitious, or subhuman "Sambos," relative to Britons, that is. As Brantlinger remarks, "the myth of the Dark Continent was largely a Victorian invention. As part of the larger discourse about empire, it was shaped by political and economic pressures, and also by a psychology of

blaming the victim through which Europeans projected onto Africans their own darkest impulses" (195). Passive, cowering, childlike, and scantily clad African natives are depicted in a few other illustrations done by Sime.

Besides his stereotypic treatments of Africa, Sime offered similar prejudicial images of Orientals. In various illustrations, males of the Near or Far East were seen as bearded, licentious, saber-wielding, bloodthirsty villains. The racist ideology that Edward Said calls Orientalism involves, in part, "the nineteenth-century . . . imaginative demonology of 'the mysterious Orient'" (Brantlinger 200). These two patterns are clearly present in several of Sime's illustrations for the *Idler* which contributed to the growing stock of stereotypic images available in the pre–World War I scene.

Another series of illustrations seem at first strictly surreal and fantastic in their depictions of threatening monsters and warriors, all of whom have a distinctly Oriental flare. Biographical evidence shows that a political ideology— though eccentric and murkily defined—links Sime's outlook to popular prejudices of the time period, especially the notion of a "yellow peril" or threat of Oriental aggression that reached its peak in the several decades surrounding World War I.

In the early years of the twentieth century, Sime disappeared from public view; he became a melancholy recluse in his country house in Worplesdon, Surrey, which is twenty-five miles outside of London. The local pub owner's daughter, Mrs. Wadey, recalls Sime drinking whisky every evening, and she describes Sime's political outlook on the early-twentieth-century world. He always wore the same old blue suit, and he enjoyed socializing with the local tradesmen or workers. In his political pub discussions, he announced that he despised party politics. However, he held radical and individualistic views and liked to argue for the fun of it. Furthermore, he "often uttered grave warnings against the 'Yellow Peril'" (Heneage and Ford 29). This seemingly passing remark by the pub owner's daughter reveals much about Sime's outlook toward Orientalism, both in his later years and retrospectively as viewed in some of his illustrations done in the 1890s.

Sime did a lot of illustrative work for the novels of the Irish fantasy writer Lord Dunsany. It is a mistake, however, to align their political opinions. We know, for example, that Dunsany was a vigorous supporter of the British Empire and the establishment of Eastern colonies. Frank Harris wrote about Lord Dunsany's politics, "He came to believe in British imperialism and the world-devouring destinies of the British Empire" (152). Harris explains further: "All this imperialistic foolery I put down to his Eton training and, of course, in the last resort to his want of brains" (Harris 152). Sime seems not to have shared Dunsany's political outlook. Also, Harris reveals a more broadly democratic and earthy side to Sime's political outlook. Of Sime, Harris records these impressions: "He meets lord and ploughman in the same human way;

he has had a dreadfully hard struggle. . . . He is for the workman without ostentation; yet the moment he begins to speak you realize that he sees the master's side, too—a singular and powerful personality" (Harris 153).

Sime's gender politics, then, may do no more than reflect some popular attitudes and prejudices of his day. However, when the further psychological dimension of his mercurial rise from collier to respected artist is also considered, a deeper dimension of understanding is added to his work. Furthermore, his dual tendencies toward the real and the surreal are indicative of much wider ideological tensions between realism and the eccentric that were at the heart of the development of the *Idler,* the Victorian-Edwardian periodical to which Sime was contributing. The first impression of any selected Sime artistic illustration is that of a glimpse into an utterly strange world; in fact, clear and identifiable links to the actual world of work as well as Victorian social and political reality are nearly always possible to uncover from studying the deeper, psychological shades of his actual life experiences, especially his work in the coal mines during his formative years.

WORKS CONSULTED

Ackroyd, Peter. *Dickens.* New York: HarperCollins, 1990.

Bradbury, Ray. "The Seeming Unimportance of Being Sime: An Introduction." In *Sidney H. Sime: Master of Fantasy,* compiled by Paul W. Skeeters, 6–7. Pasadena, Calif.: Ward Ritchie, 1978.

Brantlinger, Patrick. *Rule of Darkness: British Literature and Imperialism, 1830–1914.* Ithaca, N.Y.: Cornell Univ. Press, 1988.

Dijkstra, Bram. *Idols of Perversity.* New York: Oxford Univ. Press, 1986.

Dunsany, Lord. "Sime." *Fortnightly* 158 (Dec. 1942), 129–31.

Elms, Alan C. *Uncovering Lives: The Uneasy Alliance of Biography and Psychology.* New York: Oxford Univ. Press, 1994.

"From Pit Boy to Artist: Liverpool Man's Romantic Rise to Fame." *Liverpool Echo,* 24 June 1927.

Girdlestone, Arthur H. "Five Black-and-White Artists." *Windsor Magazine,* Dec. 1898, 94–107.

Harris, Frank. *Contemporary Portraits.* 2d ser. New York: published by the author, 1919.

Heneage, Simon, and Henry Ford. *Sidney Sime: Master of the Mysterious.* London: Thames and Hudson, 1980.

Johnson, Edgar. *Charles Dickens: His Tragedy and His Triumph.* New York: Simon and Schuster, 1952.

Lawrence, Arthur. "The Apotheosis of the Grotesque." Interview with Sime. *Idler,* Jan. 1898, 755–66.

Lewis, John. "The Fantasy World of Sidney Sime." *The Saturday Book* 34 (1975): 202–16.

Macfall, Haldane. "The Genius of Sidney H. Sime." *Illustrated London News,* 25 Nov. 1922.

————. *A History of Painting: The Modern Genius.* London: Jack, 1911.

————. "Some Thoughts on the Art of S. H. Sime." *St. Paul's,* 30 Sept. 1899, 656.

Muddiman, Bernard. *The Men of the Nineties.* New York: G. P. Putnam's Sons, 1921.

Said, Edward W. *Orientalism.* New York: Pantheon, 1978.

Skeeters, Paul W., comp. *Sidney H. Sime: Master of Fantasy.* Pasadena, Calif.: Ward Ritchie, 1978.

Swaffer, Hannen. "People I Know: Sime, the Prophet in Line." *Graphic,* 25 Nov. 1922, 762.

Thesing, William B., and Becky Lewis. Introduction to *Indexes to Fiction in "The Idler" (1892–1911).* Victorian Fiction Research Guide 23. St. Lucia, Australia Univ. of Queensland, 1994.

Valentine, E. S. "Mr. S. H. Sime and His Work." *Strand Magazine,* Oct. 1908, 394–401.

3

Poetry, Politics, and Coal Mines in Victorian England

ELIZABETH BARRETT BROWNING,

JOSEPH SKIPSEY, AND

THOMAS LLEWELYN THOMAS

William B. Thesing and Ted Wojtasik

In March 1860 a great explosion in the Burradon Colliery in Northumberland trapped, burned, and killed seventy-two coal miners. In December of that same year, another explosion in the Hetton Colliery in Durham trapped, burned, and killed twenty-two coal miners. In January 1862 a mining accident buried 204 coal miners alive in the Hartley Colliery in Northumberland; over a few days, after efforts to dig out those trapped failed, the 204 coal miners, men and boys, fathers and sons and brothers, died. Public outrage surfaced with vehemence and swept through England: their deaths implicated every British family who used coal for light and heat in their homes. The life-and-death conditions of coal miners touched the very core—the fireside hearth—of homes throughout Victorian England, especially when linked to new and dramatic exposés or cataclysmic disasters.

Writers who wrote about coal miners, in a rather literal sense, used "voices" from the underworld. Unlike Odysseus, however, who listens to the voices of the dead arising from the underworld so he can find an easy way home, or Aeneas, who descends into the underworld so he can speak to his father about the future glory of Rome, the Victorian poets Elizabeth Barrett Browning, Joseph Skipsey, and Thomas Llewelyn Thomas employed this sub-genre of poetry, in which the dead speak to the living, to transform the voices of coal miners in their underground world into an image of corporate guilt,

social responsibility, and political complicity. Browning, Skipsey, and Thomas used exposés of exploitation and occasions of accident and grief to comment upon coal-mining hazards.

In the nineteenth and twentieth centuries, poets, novelists, essayists, and filmmakers have used the image and the issue of coal mines and coal miners in their work. In various countries, across gender and class divisions, artists have grappled with the conditions of coal mining and with the representation of coal miners even as they sought to meet the challenge of how to do so in aesthetic terms, that is, how to give "voice" to the coal miner and to the coal-mining class. Little critical discussion, however, has been devoted to this representation. While one can find in the library such government reports as *Literature on the Revegetation of Coal-Mined Lands* and a brief chapter in Martha Vicinus's *The Industrial Muse: A Study of Nineteenth Century British Working-Class Literature*, few studies have explored the gender, class, and aesthetic implications of this important topic.

Elizabeth Barrett Browning wrote about coal mines but had never visited a coal mine in her life. The source of her inspiration for the poem "The Cry of the Children" was the parliamentary report on the conditions of children in mines and factories, published in 1842, by her friend Richard Hengist Horne, an investigator for the Children's Employment Commission. Twentieth-century criticism has tended to praise this poem for its daring rhetorical indictments of patriarchy or to condemn it for its inauthentic representations of working-class children's speech. Another dimension, however, that has been overlooked is its use of the subgenre of poetry in which the dead speak to the living for a direct political agenda.

The verbal and visual texts of this report shaped her depiction of the exploitation of children in mines and factories. The illustration entitled "Capital and Labour" (fig. 1) depicts, above ground, capitalists in decadent luxury—stuffing their faces in fancy restaurants or entertaining themselves in their bed chambers—while underground, working-class people, including coal miners, ply their trade as ghostly figures with mothers comforting their frightened babes. From this underground location the children of her poem first cry out.

On the left side of the illustration is the infamous gold-heaper who guards the trap door of life and death: it is this exact figure in the final stanza that Browning so pointedly attacks through the cry of the children, who have now been changed into hovering angels "in high places":

"How long," they say, "how long, O cruel nation,
Will you stand, to move the world, on a child's heart,—
Stifle down with a mailèd heel its palpitation,
And tread onward to your throne amid the mart?

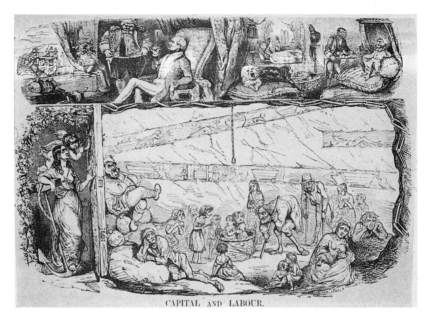

CAPITAL AND LABOUR.

FIGURE 1 "Capital and Labour," a cartoon from *Punch* July–Dec. 1843:49, based on the *1842 Report of the Commission for Inquiring into the Employment and Condition of Women and Children in Mines and Manufactures*. Britannia opens the door on subterranean mining horrors.
Courtesy of Thomas Cooper Library, University of South Carolina.

FIGURE 2 Drawing of the layout of the Hartley coal mine, from *Great Pit Disasters: Great Britain, 1700 to the Present Day,* by Helen Duckham and Baron Duckham (Newton Abbot, Eng.: David & Charles, 1973), 97.

ENTOMBMENT: HARTLEY, 1862

Surface

Staple

HIGH MAIN · SEAM

Cage

Furnace drift · Debris

YARD · SEAM

Staple

LOW MAIN · SEAM

Sump

NOT TO SCALE

Our blood splashes upward, O gold-heaper,
And your purple shows your path!" (158)

Curiously enough, the only critic of this poem who stresses that the voices of
the children are those of the "dead" is Jane Barlow, a Victorian Irish poet. In
her 1906 essay "A Literary Causerie: Against Certain of Our Poets" in the
Academy, she claims that the outrageous aesthetic tradition of having people
speak from the grave had been reintroduced by Wordsworth. She strongly
condemns poems that give continuing life and, even worse, pleasure, to dead
people who have been "buried alive" in the grave (160).

Barlow's objections are primarily aesthetic. She finds such "fanciful" poetic
practices tasteless and unsuccessful. Poets should stop this mode of writing
immediately. The most objectionable section of Browning's poem is the con-
version of little Alice from the coldness of the tomb to a bower of warm, smil-
ing bliss. Barlow finds little Alice's "deadly liveliness" to be simply "ghastly"
(161). Nor is little Alice alone in the poem, since Browning would have it that
all working-class children seek to emulate her: "Alas, alas, the children! they
are seeking / Death in life, as best to have." This "ghoulish mode," as Barlow
argues, is a "palpable absurdity" that should cease (160–61). And yet, as a
poetic subgenre, it did not cease and was used again to depict another working-
class tragedy.

On January 16, 1862, at the Hartley Colliery, five coal miners were riding
in a cage up the main shaft. A beam attached to the lift mechanism snapped.
The beam, the lift mechanism, the cage, the five coal miners, and other struc-
tures crashed down the main shaft—the five men were instantly killed.
Because this particular coal mine was set up as a one-shaft system (fig. 2), the
cage catastrophe blocked the only way out of the mine, thus trapping 204 coal
miners, ranging from ten to seventy-one years of age, in a precarious situation
underground.

For the first few days after the accident, tense excitement gripped the vil-
lage as rescue teams dug their way down while the trapped miners tried to
dig their way out. The *Times* of London (18 Jan. 1862) reported that "the
buried men have been distinctly heard to-night working in the shaft from
that seam, trying to clear away the obstruction in it from below" ("Terrible
Colliery"). The digging through the debris and the weakened supports, how-
ever, proved increasingly difficult, and soon the number and frequency of
noises from the trapped miners subsided. The *Times* (20 Jan. 1862) reports
that "the men imprisoned below were heard during the course of this morn-
ing working, and as the pitmen term it 'jowling,' in the shaft. The noise
ceased during the day; and to-night several attempts were made to signal
them from above the mass of obstruction, but no reply was obtained"
("Dreadful"). All in all, 204 men and boys were literally buried alive or, as the

newspaper termed it, "entombed." Suffocation or poisoning from carbonic acid gas finally killed all the coal miners.

The register of human emotions evoked by this event, as recorded immediately in newspaper reports, is moving and various. The *Times* (23 Jan. 1862) recounts the discovery of the men and boys: "Families are lying in groups; children in the arms of their fathers; brothers with brothers. Most of them looked placid, as if asleep" ("Terrible"). Another report in the *Times* (24 Jan. 1862) evokes a grim scene of domestic unity, a kind of family reunion that became tinged with tragedy: "It is scarcely possible to imagine a scene more touching than this—fathers and sons, uncles and nephews, after undergoing almost unheard-of misery and privation in that dreary dungeon, quietly resigning themselves to their horrid and impending fate" ("Terrible"). Even Queen Victoria, the *Times* (30 Jan. 1862) notes, who had followed the reports with increasing anxiety, sent a letter of heartfelt concern that was reprinted and distributed to individual working-class homes in the village ("Hartley").

Some coal miners themselves, however, managed to give "voice" to their own predicament. After the bodies had been recovered and buried, the *Times* (28 Jan. 1862) reports, "a large collection of tin flasks, candle boxes, and other articles which miners use, was brought up and all day long the heap was wistfully turned over by the poor widows and orphans, each anxious to discover some memorial of their lost relatives" ("Hartley"). Scrawled messages were discovered. One tin flask reads, "Friday afternoon. My dear Sarah.—I leave you." On another were scratched the words, "Mercy, oh God!" In a poignant manner, as a final gesture, some coal miners had used language itself to give voice to their situation—the voices of the dead were literally recovered from the underworld and heard above ground in these material texts.

Soon, however, even as the rescue mission began, labor agitation erupted over the issue of responsibility, accountability, and the immediate need for legislation outlawing the one-shaft system in favor of the two-shaft system to prevent further tragedies. The responsibility, though, shifted not only to the mine operators, the producers of coal, but also to the public at large, the consumers of coal. One of the canvassers, who raised funds to help relieve widows and orphans, as the *Times* (28 Jan. 1862) notes, was fully aware of this perspective: "Every one at present enjoying the comfort of a bright fireside must be reminded of the now cheerless homes of those who have contributed to that comfort, and many would gladly help to relieve them if it were put in their power" ("Hartley"). Each fireside hearth throughout the kingdom became a symbol of complicity.

The memorial site soon became a battleground for mining legislation. The Hartley Colliery disaster spawned numerous hearings and investigations and brought before Parliament clear pleas to require the double-shaft system. This catastrophe, widely reported in the newspapers and widely discussed by

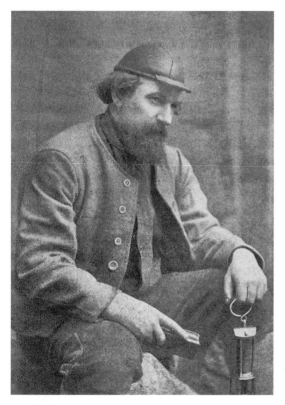

FIGURE 3 Photograph of Joseph Skipsey in his coal-mining work clothes, from *Joseph Skipsey: His Life and Work,* by Rt. Hon. Robert Spence Watson (London: T. Fisher Unwin, 1909) 54.

the entire kingdom, provided the source of inspiration for poetry by two Victorian poets: Joseph Skipsey and Thomas Llewelyn Thomas. These two poets, from dramatically different backgrounds, reached various audiences as their poems underwent two distinct routes in their publication history: Skipsey's poem was widely reprinted, while Thomas's poem sank into oblivion.

Skipsey, the son of a coal miner, became himself a coal miner for the greater part of his life. When Skipsey was four months old, his father tried to intervene to pacify some coal miners in a skirmish with special constables; at that moment, however, a special constable, mistaking his intentions, shot him dead. The Skipsey family was plunged into poverty. At the age of seven, he was sent into the coal pits at Percy Main, near North Shields, Northumberland. He worked twelve to sixteen hours a day, usually in the pitch dark. He taught himself to read and to write and eventually became known as the Pitman Poet (fig. 3).

Skipsey's poem "The Hartley Calamity" (1862) was reprinted several times throughout the rest of the century in various editions of his poetry (1881, 1888, etc.). His poem dramatizes the rescue attempt, but more important, he gives voice to the trapped coal miners:

"O, father, till the shaft is cleared,
Close, close beside me keep;
My eye-lids are together glued,
And I—and I—must sleep."
"Sleep, darling, sleep, and I will keep
Close by—heigh ho!" —To keep
Himself awake the father strives—
But he—he too—must sleep. (24)

Dante Gabriel Rossetti, reviewing this poem in October 1887, remarked that it was "written, I fancy, to be sung like the old ballads" (4). A working-class periodical, the *Mining Journal* (8 Mar. 1887), called the attention of its readers to "The Hartley Calamity" with "its graphic description of the workers in the ill-fated mine and the subsequent entombment of the two hundred" (2). Robert Spence Watson's 1909 memoir of the poet reports that Skipsey read the poem most dramatically at several fund-raising events immediately after the Hartley calamity and, in later years, in Victorian parlors, before "small gatherings of friends" (110). On rare occasions, when he recited the "The Hartley Calamity" to a large audience, Watson reports that "the emotion it awakened was almost painful to witness" (110). Thus, from the Pre-Raphaelite circle to working-class halls, Skipsey's poem had a wide-ranging distribution during the Victorian period, wherein he gave "painful" voice to the coal miners by employing the poetic subgenre of the dead speaking.

One year after Skipsey's poem, Thomas Llewelyn Thomas, a Welsh undergraduate at Jesus College, Oxford, won the Sir Roger Newdigate Prize for poetry with the poem "Coal-Mines" (1863) (figs. 4 and 5). His background, however, was quite different from Skipsey's. He was the son of a vicar and would himself become a chaplain and eventually the rector of Nutfield, Surrey. Thomas, born and reared in Wales—coal-mining country—cared deeply for its people and its culture, which he knew thoroughly, for his father required the family to associate with all social classes of their fellow countrymen.

The Hartley accident affected him as deeply as it had Skipsey. During the clamor for mining reforms after the accident, he wrote a poem about coal mines in heroic couplets, submitted it for the Newdigate prize, and won. As Harriet Thomas, his sister, points out in her memoir *Father and Son,* the aesthetic features of the poem—its style and diction—were what most appealed to Matthew Arnold, who was the chief judge of the Newdigate Prize committee

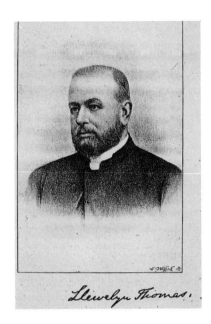

FIGURE 4 Photograph, with signature, of Thomas Llewelyn Thomas, from a book edited by his sister Harriet Thomas, *Father and Son: Memoirs of Thomas Thomas and of Llewelyn Thomas, with Selections from the Writings of the Latter* (London: Henry Frowde, 1898). *Courtesy of the British Library.*

FIGURE 5 Photograph of title page of *Coal-Mines: A Prize Poem Recited in the Theatre, Oxford,* by Thomas Llewelyn Thomas (Oxford: Henry Hammans, 1863). *Private collection of William B. Thesing.*

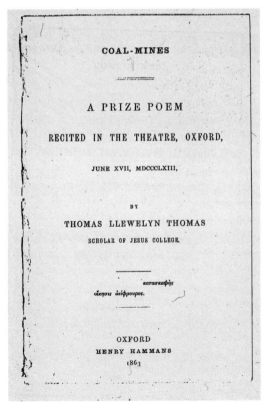

COAL-MINES

A PRIZE POEM

RECITED IN THE THEATRE, OXFORD,

JUNE XVII, MDCCCLXIII,

BY

THOMAS LLEWELYN THOMAS

SCHOLAR OF JESUS COLLEGE.

κατασκαφῆς
οἴκησις ἀείφρουρος.

OXFORD
HENRY HAMMANS
1863

that year (73). What his sister does not mention is that Arthur Hugh Clough, ten years earlier, in an 1853 essay in the *North American Review*, had criticized Arnold for the escapist deficiencies of his poetry that ignored the actualities of urban-industrialized England: "Could it [poetry] not attempt to convert into beauty and thankfulness, or at least into some form and shape, some feeling, at any rate, of content—the actual, palpable things with which our every-day life is concerned" (396). In reading "Coal-Mines," Arnold must also have been impressed with a poem "converting" the "actual, palpable things with which our every-day life is concerned" into "beauty and thankfulness."

Thomas then recited his prize poem in the Sheldonian Theatre at the graduation ceremonies of Oxford University on June 17, 1863. In the audience were the prince and princess of Wales, who were attending the university's ceremonies that year. The poem found its way into print quickly, and Thomas's sister reports that its distribution in Wales was "a great sensation" (73). He, as had Skipsey, read the poem at penny readings later in life. "Coal-Mines," however, dropped from sight and was last reprinted in 1898, in a volume edited by his sister. This poem has received no attention at all in twentieth-century canon reclamations. Virtually unavailable, it is included in its entirety here:

> Oft has the Muse on wandering wing surveyed
> The varied loveliness of hill and glade.
> She loves to tell us of the forest bowers,
> Of Spring's first buds and Autumn's latest flowers,
> To catch each transient beauty and to trace
> The fairest lineaments of Nature's face.
>
> But grander, nobler is her truest part,
> To fire the fancy and to touch the heart,
> To tear asunder all those veils, that screen
> From mortal vision mysteries unseen,
> To scan with eager and unflinching gaze
> Long-hidden relics of primaeval days,
> In things uncouth, unpleasing to the eye,
> Their latent worth and beauty to descry:
> On themes like these we pause her aid to ask,
> To bless what seems an uninviting task
> To guide our footsteps o'er th' untravelled way,
> To pour on darkest night the light of day.
>
> Where 'mid the heath-clad hills and verdant downs
> A ruined waste of blackened landscape frowns,

Where Nature seems her mourning robes to wear,
And clouds of dusky smoke pollute the air,
Where day is dark, and midnight hours are bright
With strange unearthly gleams of lurid light,
Blame not the hands, that wrought this ruin wide,
Turn not with loathing and disgust aside;
For, as the Sun, with bright unclouded blaze,
Bathed Memnon's statue in a flood of rays,
The lifeless marble felt the genial heat,
Burst into strains of music wild and sweet;
So here the Sun of Science shall illume
With rays of splendour this Cimmerian gloom;
Then a sweet voice shall fill th' enchanted maze,
Unveil the mysteries of ancient days,
And darkly tell of wonders yet to be
With the weird skill of magic minstrelsy.

Where yonder yawning cavern opens wide,
The car glides slowly down the rock's rough side,
With trembling hearts we leave the upper light,
And travel downwards to the realms of night,
With wondering eyes we watch the sun-light die,
And stars beam mildly in a noontide sky,
Then, blind at first, we grope our onward way
Through paths ungladdened by the light of day;
Then see around us, by the lamps' pale gleam,
The giant forms of some mysterious dream;
Each ebon pillar wears some phantom guise,
And changing lights and shadows mock our eyes:
So strange the scene, awe-struck we seem to tread
Some fabled mansions of the silent dead,
And start amid these shadowy haunts to hear
The sounds of human toil salute the ear.

But, where we see the blazing fire-light shine,
What words can tell the wonders of the mine!
Not such the chambers built by men of old,
The sacred bodies of their kings to hold;
Not such the mausolea, the costly tombs,
The pillared vaults and lamp-lit catacombs.
Far grander is the scene, that meets the eye,
A scene of wild, funereal majesty;

Its flickering rays the blazing furnace pours
Down dark, interminable corridors,
And on the ebon floor, the roof, the walls,
A changing light of mournful splendour falls;
Each sharp-cut angle, each projecting stone,
Shines with a hue and lustre not its own,
While here and there we gaze on shapes grotesque,
On figured forms of scroll or arabesque,
Which on the walls with ghastly brilliance play,
And with the fitful fire-light fade away.

Not such the only ornaments, that grace
The walls and ceilings of this wondrous place,
Half-buried in the solid rock we see
The fossil form of some colossal tree,
And in its stonelike blackened trunk can mark
The countless pencilled lines of wood and bark:
Primaeval tree! long centuries have sped
Since first was reared aloft its towering head,
When, with its fellows in the woodland glade,
With giant boughs it spread luxuriant shade,
And the cool zephyrs breathed from tree to tree
Through the green leaves a rustling melody.

Yes! countless years of change have passed since then!
Change to the Earth's fair surface, change to men,
Woods, hills, plains, islands, seas, are swept away,
Unnumbered states have crumbled to decay,
While 'neath the soil, a thousand fathoms deep,
The fallen monarchs of the forest sleep.

Trees, shrubs and plants, to firm consistence grown,
Form the black rock, that seems of solid stone;
Imprinted on the walls, where'er we turn,
We see the lace-like leaves of moss or fern,
And view with wondering eyes some monster bone
Of beast, to mortals of to-day unknown.

Were these primaeval relics hurled below
By some fell earthquake's wild convulsive throe?
Or did some mighty deluge o'er them heap
The sands and sea-weeds of the o'erflowing deep?

Or did they fall by Nature's slow decay,
And sink unheeded from the light of day?
No tongue can tell—'tis vain for mortal man
These hidden mysteries of earth to scan;
Vain to seek out their causes, vain to pore
O'er countless tomes of scientific lore,
Though great his wisdom, turn where'er he will,
These deeper secrets mock his utmost skill,
And buried 'neath the earth remain to be
A dark enigma for posterity.

But though deep buried oft 'neath mountains vast,
Not useless are these relics of the past:
Those blocks of seeming stone, as black as night,
Shall gladden many a home with heat and light;
And many a happy child and aged sire,
Shall throng to cluster round the bright coal fire.

Is it a fancy idle, fond and vain,
The offspring of some visionary brain?
Or is it truth, which oft, to sceptic eyes,
Seems empty fiction dressed in fair disguise,
That every flame, which cheers a winter's night,
Draws from the Sun its beams of heat and light,
That latent in the wood these beams remain,
And shine, when kindled, on the world again?
If this be true, in the bright coal fire's blaze
We view the lustre of primaeval rays,
Bask in the light, which first its radiance flung
O'er vale and mountain, when the Earth was young,
And shone in splendour over stream and tree,
Where stream and wood have long since ceased to be.

But bootless is this strain—'tis vain to sing
Of fancies fond and wild conjecturing,
To truer scenes and sadder thoughts we turn,
The inmost secrets of the mine to learn.

Hark to the hammer's click! the rumbling sound
Of huge rocks falling seems to shake the ground,
While each dim passage, like some crowded street,
Rings with the hurried tread of echoing feet;

And through the pathways of their dark abode
The patient horses drag their toilsome load.
Not theirs to sport along the meadows wide,
Or rest at evening on the green hill's side;
Not theirs at sultry noon their thirst to slake
In the cool waters of some tranquil lake:
Through these dark paths for weary years they ply,
And only seek the upper air to die.

Pale, bent, and furrowed, in this gloomy shade
The hardy miner works his thankless trade;
Half prostrate on the ground his axe he waves,
And hews a pathway through the sunless caves;
While ofttimes from some cavern dark and deep
The baleful gales of poisoned vapour sweep,
Choked by the blast the gasping miner lies,
Unseen, unpitied, in the darkness dies.

At times unwary in some noisome pass
With opened lamp he lights the subtle gas;
Through the long aisles is heard a deafening sound,
And lines of blackened corpses strew the ground.

When o'er the world a cloud of gloom was spread,
And Europe grieved, as for some loved one dead,
When all our island mourned, from sea to sea,
"The noble Father of her kings to be;"
Amidst a sorrowing nation's dumb despair,
What piercing cry of anguish rent the air!
'Twas not a cry of wailing for the dead,
For him in silent woe our tears were shed;
'Twas a loud shriek of horror at the doom
Of brave men wasting in a living tomb!

The band of miners leaves the morning light,
And soon is shrouded in the shades of night;
Some to the gloomy mine's remotest end,
To scenes of daily toil their footsteps bend;
Their labor o'er—they turn to seek in vain
The path that leads them to the light again.
The massive bars, which long have borne the strain,
Of weighty wagon-load and tightening chain,

Are burst asunder, and with falling shock
Have filled the narrow path with piles of rock.

From lip to lip is passed, with bated breath,
The whispered tidings of the doom of death;
Then first is heard the moaning of despair,
And then the sad farewell and muttered prayer,
And many a spirit from this gloomy night
Is borne aloft to realms of purest light.

Though the lone hamlet sounds the orphan's cry,
And woman's shriek of soul-felt agony;
Glad hearts are saddened by this awful fate,
And happy homes are dark and desolate;
While soon the wains, which we were wont to see
Piled with the wealth of mine or husbandry,
Through the small churchyard bear the mournful load
Of pallid corpses to their last abode.

Perchance 'twere well these painful scenes to shroud
In the deep darkness of Oblivion's cloud:
Perchance 'twere well to tune this mourning lay
To livelier melody, to themes more gay;
But still the Muse with pensive grief will sing
The soft sad notes of sorrow's murmuring.

When at the close of Winter's gloomy days,
Our hearts are gladdened by the bright fire's blaze,
When in each burning coal we seem to see
Fantastic forms of rock and cave and tree,
A sad thought lingers, 'mid our keenest mirth,
Of that dread tragedy beneath the earth;
Of that dark day when mingled tears were shed
For England's noblest and for Hartley's dead.

"Coal-Mines" is interesting for its method of giving voice to coal miners, its realistic content, and most important, its strategy of pricking social conscience by clearly implicating the fireside hearth—those who use coal—with the fate of the coal miners. Throughout the poem, Thomas struggles with the tensions between fancy and truth, imaginative notions of the past and nature, and realistic descriptions of the horror and waste of the contemporary Victorian landscape. He does not address the Hartley accident alone. Its plural title

indicates that the poem deals not with just one site or one topical accident, but with multiple sites and accidents.

Thomas's method of "voice" is related to the subtle use of a "we" perspective to involve the reader intimately in the poem:

> With trembling hearts we leave the upper light,
> And travel downwards to the realms of night,
> With wondering eyes we watch the sun-light die,
> And stars beam mildly in a noontide sky,
>
> ———
>
> And start amid these shadowy haunts to hear
> The sounds of human toil salute the ear. (5)

These lines take the Victorian reader from his or her comfortable and secure surroundings down into the dark underworld of the coal mines. We are no longer merely "listening to" the miners from above but "listening with" them as they confront darkness, suffering, and death itself.

Once down in the mines, Thomas focuses on the gruesome and realistic details of suffering and death. A common concern in all three accidents of the 1860–1862 period is the presence of poisonous gases: "The baleful gales of poisoned vapour sweep, / Choked by the blast the gasping miner lies, / Unseen, unpitied, in the darkness dies" (10)—but "seen" now and "voiced" now in his poem. The burned and mutilated bodies caused by the explosions in the Burradon and Hetton sites are also addressed: "With opened lamp he lights the subtle gas; / Through the long aisles is heard a deafening sound, / And lines of blackened corpses strew the ground" (11). Thomas employs such details to fill the reader with horror and concern, but this concern, he clearly states, is also a matter of complicity:

> But though deep buried oft 'neath mountains vast,
> Not useless are these relics of the past:
> Those blocks of seeming stone, as black as night,
> Shall gladden many a home with heat and light;
> And many a happy child and aged sire,
> Shall throng to cluster round the bright coal fire. (8–9)

Coal is the source of "heat and light" that "gladdens" many Victorian homes. Children and grandparents "cluster" around the fireside hearth in comfort and happiness. Thomas wishes to stress the human element, the coal miners themselves, in the production of coal for the British Empire. In the last stanza, lest we forget this point, he writes:

When at the close of Winter's gloomy days,
Our hearts are gladdened by the bright fire's blaze,
When in each burning coal we seem to see
Fantastic forms of rock and cave and tree,
A sad thought lingers, 'mid our keenest mirth,
Of that dread tragedy beneath the earth;
Of that dark day when mingled tears were shed
For England's noblest and for Hartley's dead. (13)

Thomas emphasizes the fireside hearth as a means to focus the emotional reaction and spiritual response in terms of fixing agency and responsibility. Not only should the reader feel horror and concern, but the reader should also feel guilt and complicity with the deaths of the unfortunate coal miners as Victorian families settle down by the warmth and brightness of their coal-burning hearths.

Of the three poems, then, the one that most directly confronts the moral responsibility of each Victorian family and the one that was awarded the prestigious Newdigate Prize received the least distribution in the Victorian period and fell into the deepest obscurity in the twentieth century. Its discovery and its recovery were a matter of sheer chance. We just happened to notice it in the catalogue of a London rare book dealer. In its unbound condition, "Coal-Mines" arrived in our hands in December 1995, just as it existed in the storeroom of its original printer 132 years ago. Despite its precarious fate, Thomas's poem exhibits a remarkable affinity with Browning's and Skipsey's poems that give "voice" to coal miners in their underground world.

These three Victorian poets from three distinct social classes—a chamber-bound aristocrat, a coal miner's son, and a clergyman's son—all attempted to give "voice" to those without a voice and in doing so to prick the social conscience of an entire kingdom: Skipsey, who moved poor widows in the coal-mining country to tears; Thomas, who recited his verse to the intellectual elite at Oxford with the prince and princess of Wales present; and Browning, who wrote poems that the queen herself most enjoyed to read.

WORKS CONSULTED

Barlow, Jane. "A Literary Causerie: Against Certain of Our Poets." *Academy* 71 (18 Aug. 1906): 160–61.

Brantlinger, Patrick. "Bluebooks, the Social Organism, and the Victorian Novel." *Criticism* 14, no. 4 (1972): 328–44.

Browning, Elizabeth Barrett. *The Poetical Works of Elizabeth Barrett Browning*. Boston: Houghton Mifflin, 1974.

"The Catastrophe at Hartley Colliery," *Times* (London), 21 Jan. 1862.

Clough, Arthur Hugh. "Recent English Poetry." 1853. In *Victorian Poetry and Poetics*, edited by Walter E. Houghton and G. Robert Stange, 2d ed., 395–403. Boston: Houghton Mifflin, 1968.

"The Commemoration at Oxford," *Times* (London), 18 June 1863.

Cooper, Helen. *Elizabeth Barrett Browning, Woman and Artist.* Chapel Hill: Univ. of North Carolina Press, 1988.

"Dreadful Colliery Accident in Northumberland," *Times* (London), 20 Jan. 1862.

Duckham, Helen, and Baron Duckham. *Great Pit Disasters: Great Britain 1700 to the Present Day.* Newton Abbot, Eng.: David & Charles, 1973.

Fox, William J. "Reports of Lectures, Addressed Chiefly to the Working Classes. On Living Poets; and their Services to the Cause of Political Freedom and Human Progress. No. 10. Miss Barrett and Mrs. Adams," *People's Journal,* 7 Mar. 1846.

Fynes, Richard. *The Miners of Northumberland and Durham: A History of their Social and Political Progress.* 1923. Menston: Scolar Press, 1971.

Galloway, Robert L. *A History of Coal Mining in Great Britain.* London: Macmillan, 1882.

"The Hartley Colliery Accident," *Times* (London), 27 Jan. 1862.

"The Hartley Colliery Accident," *Times* (London), 28 Jan. 1862.

"Hartley Colliery Accident," *Times* (London), 29 Jan. 1862.

"The Hartley Colliery Accident," *Times* (London), 30 Jan. 1862.

"Hartley Colliery Accident," *Times* (London), 31 Jan. 1862.

Jameson, Frederic. *The Political Unconscious: Narrative as a Socially Symbolic Act.* Ithaca, N.Y.: Cornell Univ. Press, 1981.

Mermin, Dorothy. *Elizabeth Barrett Browning: The Origins of a New Poetry.* Chicago: Univ. of Chicago Press, 1989.

The Mining Journal. 8 Mar. 1887. Quoted in "Opinions of the Press" in Joseph Skipsey, *Carols, Songs, and Ballads.* London: Walter Scott, 1888.

The Oxford University Calendar: 1855. Oxford: J. H. Parker, 1855.

Rossetti, Dante Gabriel. 29 Oct. 1887. Quoted in "Opinions of the Press" in Joseph Skipsey, *Carols, Songs and Ballads.* London: Walter Scott, 1888.

Skipsey, Joseph. *Carols, Songs, and Ballads.* London: Walter Scott, 1888.

Stone, Marjorie. "Cursing as One of the Fine Arts: Elizabeth Barrett Browning's Political Poems." *Dalhousie Review* 66, no. 1–2 (1986): 155–73.

"The Terrible Calamity in the Hartley Colliery," *Times* (London), 23 Jan. 1862.

"The Terrible Calamity in the Hartley Colliery," *Times* (London), 24 Jan. 1862.

"Terrible Colliery Accident," *Times* (London), 18 Jan. 1862.

Thomas, Harriet. *Father and Son: Memoirs of Thomas Thomas and Llewelyn Thomas.* London: Henry Frowde, 1898.

Thomas, Thomas Llewelyn. *Coal-Mines. A Prize Poem Recited in the Theatre, Oxford.* Oxford: Henry Hammans, 1863.

Tooley, Sarah A. "The Queen's Favourite Authors." *Quiver* 14, no. 5 (Apr. 1898): 474.

Vicinus, Martha. *The Industrial Muse: A Study of Nineteenth Century British Working-Class Literature.* New York: Barnes & Noble, 1974.

Watson, Robert Spence. *Joseph Skipsey: His Life and Work.* London: T. Fisher Unwin, 1909.

Watts-Dunton, Theodore. Review of *A Book of Miscellaneous Lyrics,* by Joseph Skipsey. *Athenaeum,* 16 Nov. 1878, 618–19.

Woodham-Smith, Cecil. They stayed in bed." *Harper's Magazine,* June 1956, 10 12.

4

Old Hell Shaft

RICHARD HENGIST HORNE
AND THE COAL MINES

Alex J. Tuss

When considering the presentation of coal miners and their lives in Victorian periodicals, a problem arises. Which periodicals and which of their contributors offer the clearest pictures of that presentation? There are major journals such as the *Westminster Review,* the *Quarterly Review,* and the *Edinburgh Review.* But the emerging reading public more often devoted itself to the more popularly oriented *London Journal,* the *Family Herald,* and *Fraser's* or *Bentley's Miscellany* than it did to the learned, scholarly reviews. So, by turning to Charles Dickens's *Household Words,* a mid-level circulation magazine edited for the middle class, a better insight into the depiction of the coal miner may develop. Furthermore, *Household Words* and its approach to middle-class readers emerged out of Dickens's earlier experiences as a reporter and editor. As a youthful reporter of parliamentary affairs for the *Morning Chronicle,* Dickens had firsthand knowledge of reporting on the events of the day. Editing *Bentley's Miscellany,* beginning in 1836, provided Dickens with background on assembling a staff and running a periodical. Later, displaying "the same firmness and decision he displayed as a stage manager," Dickens organized and established the *Daily News* for his publishers, Bradbury and Evans (Ackroyd 479). Thus, when *Household Words* appeared on March 30, 1850, the journal benefited from the expertise Dickens had acquired, sometimes painfully, in addressing the developing middle class. Dickens and his contributors, such as Richard Hengist Horne, were determined to reach that middle-class reader who, from 1850 onward, constituted an increasingly significant element in Victorian society.

Though the journal had its critics such as Elizabeth Barrett Browning, who said, as Peter Ackroyd notes, that it "won't succeed, I predict," the initial

number of *Household Words* sold quite well and the circulation steadied at approximately 39,000 per number (Ackroyd 591). Thus, while not as widely read as the *London Journal*, *Household Words* achieved a respectable and profitable circulation. And while Dickens's periodical was not in the vanguard of crusaders for social issues, "Dickens's widely read periodical brought" such issues as coal miners and the mines "attention that their sober presentation in specialized journals and in upper-class journals did not give them" (Lohrli 5). Contributors such as Horne enabled Dickens's readers to increase their awareness of the wide-ranging social concerns that *Household Words* addressed. The manner in which those middle-class readers were informed about the miners and their plight illustrates the intent of Dickens and Horne to educate while also entertaining their readers. The strategies employed in such a rhetorical stance demonstrate how the coal miner was seen as in need of assistance and support. The miners, however, were not to be seen as empowered to effect their own rehabilitation through union association.

In that regard, Dickens's *Hard Times,* published in 1854, makes clear that, while worthy lower-class operatives such as Stephen Blackpool suffered great indignities and, in Blackpool's case, death in the mine Old Hell Shaft, they were best relieved by communal association and a somewhat paternal support by those of higher social rank rather than by engaging in the sort of activities linked to the Chartist movement of the 1840s. Martha Vicinus correctly notes that, following the protest literature of the 1840s, Dickens, Mrs. Gaskell, Horne, and other authors of middle-class literature in the 1850s "all sought a solution to social problems through better understanding between the classes" (126). The failure to communicate, Vicinus continues, results from what the authors saw as individual weakness in each class (126). And it is effective communication that Horne seeks to establish. While not diminishing the horrors of the mines, Horne strives to set his indignation in a context that does not alienate the audience or Dickens, his ever watchful editor. Such an approach mirrors that of *Household Words,* a magazine Edgar Johnson sees as having aims that were "identical with those of radical reform" (703).

In the aftermath of the collapse of Chartism and given the general mistrust of union activity, however, radical reform had to address the public from a position grounded in "Christian fellow feeling and gradual amelioration" (Vicinus 126). The readers of magazines such as *Household Words* were not likely to endorse a proletarian advance as envisioned by Karl Marx or Friedrich Engels. Instead, editors and authors such as Dickens and Horne made their appeals for coal miners and their condition in the very sort of writing that Richard H. Horne frequently contributed, first to Dickens's newspaper the *Daily News* and then to *Household Words.* Horne's work, ardent in its appeal and scrupulously detailed in its presentation, sought to galvanize readers' indignation by clearly communicating the appalling circumstances while

avoiding an inflammatory and socially divisive tone. Thus, Horne's work and its appearance in *Household Words* emphasize the incremental alteration of Victorian society that the period's history often reflects.

Richard H. Horne, prominent member of a parliamentary commission to investigate the mines, minor poet, friend of Charles Dickens, Elizabeth Barrett, and others among the literati of the Victorian era, provides a valuable source for periodical reportage on the status and lives of coal miners in Victorian England. Along with Henry Morley, Horne was one of "the two most important staff members" on the new magazine (Kaplan 268). Horne offers an opportunity to observe the use of a fluid narrative, telling details, and a reasonable tone in a manner that typifies the periodicals that sought to interest the middle-class reader. And the fact that his principal efforts were made in Charles Dickens's *Household Words* further underscores the manner in which Horne's essays reflect the newly recognized middle class and the increasingly literate nature of that portion of society. In the period 1850–1852, Horne wrote nearly ninety pieces for Dickens's newly launched weekly. Drawing on his firsthand knowledge of the mines, the articles are works that directly address the issue of mines and mine workers (Kaplan 268). These essays, not unlike *Household Words* as a whole, blend elements of fiction writing with factual presentation of data. Careful examination of such writing yields insights into the careful, measured methods employed by Horne and Dickens in educating the readers of *Household Words* about the plight of the miners without appearing didactic or condescending.

As Dickens announces in the "Preliminary Word" for the inaugural number of *Household Words* on March 30, 1850, the magazine would be animated by "no mere utilitarian spirit, no iron binding of the mind to grim realities" (1). Rather, *Household Words* would "cherish that light of Fancy which is inherent in the human breast" and would proceed without any class being "excluded from the sympathies and graces of imagination" (1). This manifesto defines the exact scope and character of the journal and Horne as one of its contributors. Horne's "The True Story of a Coal Fire," which appeared in the second, third, and fourth numbers of volume 1 and his "A Coal Miner's Evidence," which appeared in the December 7, 1850, number of volume 2 both aptly demonstrate the influence of Charles Dickens, the self-described conductor of the periodical, on Horne, his friend and contributor. Dickens's insistence that *Household Words* rejected an enforced marriage between his readers and the "grim realities" quite clearly underpins Horne's "The True Story of a Coal Fire."

The title emphasizes the story's credibility, suggesting an investigative piece on coal, which the article carries out, giving the reader a fairly extensive look at the geological process of producing the coal and the means of shipping it after mining. The central section of the work focuses intently on the operation of a coal mine and the nightmare landscape in which the miners work

and live. The key rhetorical device for conducting that examination is a fictional framing tale wherein young Flashley, a rather naive young man from London, comes to coal country to visit his relatives, the Daltons, part-owners in a coal-mining venture. Falling asleep in front of a coal fire, Flashley, in a manner reminiscent of Dante's *Inferno*, descends into and then emerges from the coal mine, only to find himself the lowliest of cabin boys working on a coal collier. Awaking from his reverie, Flashley falls "into a train of thought which, in all probability, will have a very salutary influence on his future life" ("True Story" 960). The framing tale accomplishes its purpose in that it somewhat cushions the stark deprivation of mine work for the middle-class readers. The preamble deals with the geology of coal even as the main narrative points the moral to the readers through their surrogate Flashley, a well-intentioned but ill-informed young man who awakens to a newfound understanding of the truth about coal and the miners. The structure of the piece conveys the message Horne wishes to emphasize by the indirect means of its narrative. It illustrates the gradual and ameliorative attitude toward social reform that Horne's audience and editor adhered to.

In addition, "The True Story of a Coal Fire" appeared in three installments. Such an approach situates the readers in a known and comfortable format, providing Horne with a familiar means for engrossing his audience. The installments also supply Horne with sufficient time to spin out the argument for reform so that the readers, like Flashley, initiate that train of thought that would exercise a "salutary influence" when encountering debate on social reforms. Employing cliffhanger events at the ends of chapters 1 and 2 as Flashley first plummets into the mine and then returns to the surface underscores the combination of entertainment with education of the reader. And since Dickens as editor was interested in creating circulation, Horne's three installments provide a practical assist in sustaining the fledgling journal's readership over its initial numbers.

Horne's awareness of his readership evidences itself from the first. The opening sentence sets the tone for the article and in the process, highlights an approach to the subject that again underlines Dickens's stated wish not only to "cherish that light of Fancy which is inherent in the human breast," but also to popularize knowledge about social inequities that forestalled "the loving union of multitudes of human lives in generous feeling and noble purpose" (Johnson 703): "One winter's evening, when the snow lay as thick as a great feather-bed all over the garden, and was knee-deep in the meadow-hollows, a family circle sat round a huge fire, piled up with blocks of coal of that magnitude and profusion which are only seen at houses in the neighbor-hood of a coal mine" ("True Story" 26).

The invocation of elements of the beginning of a fairy tale, the coziness of a family circle, and the implicit suggestion that this family and the reader's are

equals evokes a nonthreatening, tranquil environment that distances the reader from any immediate or harsh realities. Added to that, the Dalton family falls neatly in the middle of a rural social scale, being neither farmers nor landed squires, relying on their third share in the coal mine as the source of their evident economic well-being. Horne does not rush his examination of the conditions in the Billy-Pit mine. His deliberate pace and placid scenario, which many might criticize as shallow and lacking a direct advocacy of the miners' plight, allow readers time to assimilate the circumstances before proceeding to weightier matters. Like Flashley, Horne's readers may have heard of "the wonders of the coal mines, and the perilous adventures of the miners," and, again like Flashley, "paid no attention to them" ("True Story" 26). Horne arranges his narrative so that both Flashley and the reader must pay attention, despite the fact that Flashley "had some education, which he fancied was quite enough" ("True Story" 27). Horne does not indict his audience for their complacency about social ills. Instead, he presents them with an accessible figure whose dream of the mines and their hazards serves as the vehicle for challenging the reader.

Horne also instills attitudes in Flashley that permit the reader to see the need for something to rectify Flashley's vision of himself and the world. Flashley's smug insularity surfaces immediately, for, "to Flashley, all knowledge was a sort of absurdity; his own arrogant folly seemed so much better a thing" ("True Story" 27). Furthermore, Flashley's love of "reckless ridicule burlesque had taught him to have no faith in any sincere thing, no respect for true knowledge; and this had well-nigh destroyed all good in his mind and nature, as it unfortunately has done with too many others of his age at the present day" ("True Story" 27). Horne's readers could not have failed to see that Flashley stands in great need of correction, a correction he receives from a miner deep in the bowels of the Billy-Pit mine. The correction comes after a thorough exposure to the eternal twilight of the mine, the backbreaking strain of the work done by adults and children alike, and just before a sulphurous explosion threatens to kill them all. The miner's address to Flashley and the readers serves as Horne's portrait of the British miner:

> Young man—or rather gent! . . . You are now in the bowels of old mother Earth—grandmother and great grandmother of all these seams of coal; and you see a set of men around you, whose lives are passed in these gloomy places, doing the duties of their work without repining at its hardness, without envying the lot of others, and smiling at its dangers. We know very well that there are better things above ground—and worse. We know that many men and women and children, who are ready to work, can't get it, and so starve to death, or die with miserable slowness. A sudden death, and a violent one is often our fate. We may fall down a shaft; something may fall upon us and

crush us; we may be damped to death; we may be drowned by the sudden breaking in of water; we may be burned up by the wildfire or driven before it to destruction; in daily labor we lead the same lives as horses and other beasts of burden; but for all that, we feel that we have something else within, which has a kind of tingling notion of heaven, and a God above, and which we have heard is called "the soul." Now, tell us—young master, you who have had all the advantages of teachers, and books, and learning among the people who live above ground—tell us, benighted working men, how have you passed your time, and what kind of thing is your soul? ("True Story" 72)

The speech, artful in its rhetorical cadence, impassioned in its ringing assertion of the miner's soul, constitutes a perfect example of how, according to E. P. Thompson, "in some of the lost causes of the people of the Industrial Revolution we may discover insights into social evils which we have yet to cure" (13). The miner knows he cannot match Flashley's inherent advantages of education and books. He has learned only too well the bitter lesson that "the modern industrial proletariat was introduced to its role not so much by attraction or monetary reward but by compulsion, force, and fear" (Pollard 207). In comparing his lot to the horses who worked in the pits and other beasts of burden, the miner recognizes the "significant loss of freedom" that his life entails (Long 13). Despite all these appalling realities, Horne's miner exudes an awareness of that "tingling notion of heaven," the soul. This awareness leads to the question asked of Flashley, "how have *you* passed your time, and what kind of thing is your soul?"

This central question demonstrates that desire for "Christian fellow feeling and gradual amelioration" that Vicinus accurately perceives as aligning the middle-class authors with the working-class literature written by working men (134). Horne's audience in *Household Words*, like young Flashley, conceives of itself in fairly self-satisfied terms. Like Flashley, they must be led underground by the elfin figure who appears to Flashley as he slumbers before the coal fire in the Daltons' comfortable, middle-class home. Only then can they be confronted with a world of fiery chasms, utterly begrimed and half-naked miners, and the "very little and very lonely imp," the trapper, "a poor child of nine years of age," who squatted alone in the dark, securing the passage doorways and providing the necessary ventilation for the mine shafts ("True Story" 69). This victim of "poverty, bad parents, and the worst management" must shoulder the responsibility for the safety of the entire mine ("True Story" 69). A trap door inadvertently left open could contribute to explosions and the leakage of poisonous gases.

Animals fare no better than the miners. Flashley witnesses a naked young boy driving a horse through a Stygian landscape, "like some young Greek

charioteer doing penance on the borders of Lethe," and comments that the boy, the horse, and their significance as individuals pass away into "utter darkness" ("True Story" 69). Another horse, new to the mine, is lowered down, its face "frightfully expressive" ("True Story" 70). Confronted with "the black walls and the black faces and figures that surrounded him," the horse collapses in a faint ("True Story" 70). These images of animals in cruel situations culminate in Flashley's seeing "a poor beast of another kind. . . . It was in the shape of a human being, but not in the natural position—in fact, it was a boy degraded to a beast, who with a girdle and chain was dragging a small coal-wagon after him" ("True Story" 70). Later still, Flashley observes two more boys pushing and pulling another coal wagon. The boy behind the wagon "had a bald patch in the hair, owing to the peculiar nature of his head-work behind the wagon" ("True Story" 70). Horne accumulates these details for Flashley and the reader in order to create an inexorable impression of the horrors visited on men, children, and animals in the mine operated by the respectable, above-ground Daltons to whom Flashley is related.

To complete Flashley's immersion in the world of the mine, "some detestable necromancy" transforms him, and "our young visitor—alack! so very lately such a dashing young fellow 'about town' now suddenly fallen into the dreadful condition of receiving all sorts of knowledge about coals—felt compelled to assist in the operation" ("True Story" 71). Horne leads his readers through the grueling routine of harvesting the coal dislodged from above the heads of the crew, until Flashley's elfin guide transports him to the underground cavern where the miners eat and where Flashley encounters the miner who addresses him. There, in a cavern hewn out of solid coal, "sat the miners, nearly naked,—and far blacker than negroes," their skins "of a dead-black," with the "grimness of sepulchral figures, strangely at variance with the boisterous vitality and physical capacities of their owners" ("True Story" 71). The overwhelming incongruity of the miners' liveliness as they dine in the coal pit magnifies their enduring humanity even as they labor like the animals who share their existence. Their existence is immediately imperiled by the explosion that occurs after the miner challenges Flashley about what kind of thing his soul may be. Surviving both the explosion and his time as a deckhand on a coal collier, Flashley awakens from his slumber to find that, though the coal fire has burned out, its released gases will aid in beginning the cycle of coal production once more—and with it the endless cycle of the grueling life of the mines ("True Story" 95). In "a great blaze of light," Flashley recapitulates elements from his dream, and, as he rouses himself, sees his elfin guide bid him goodbye; after which, Flashley begins that "train of thought" the narrator hopes will have a "salutary influence on his future life" ("True Story" 72).

Flashley's hoped-for reformation depends on his retaining the lessons of the journey through the coal mine and the miner's straightforward and valorous

speech. Both the experience of the mine and the docile yet determined words of the miner serve as Horne's vehicles for educating his readers. Later, however, in "A Coal Miner's Evidence," which appeared in the issue of December 7, 1850, Horne strives to reinforce and better the lesson of Flashley and the coal fire. While the narrative device remains as a rhetorical strategy, it is severely restricted, merely bracketing the central portion of the article, "the words of a miner, as related by himself" ("Coal Miner's" 245). Stripping away all but the barest essentials to establish the context for the miner's testimony, Horne constructs the piece so as to place the reader in a face-to-face encounter with the miner, a survivor of a series of mining catastrophes. The encounter thus permits the miner uninterrupted access to the reader, with Horne acting only as the medium between the miner and the reader. The article, then, much in the manner of the television magazines 20/20 or 60 Minutes, sets a tone for the piece through a rather self-effacing narrator. The narrator, like a Morley Safer or a Diane Sawyer, orients the reader before turning the narrative over to the coal miner who, again like the whistle-blowing accountant or corporate employee, gives his firsthand account of the mines and their hazards. The technique allows the readers to assimilate the honest, straightforward, unassuming, and non-threatening persona of the miner. The essay concludes with a summation and recommendations by the narrator, forestalling any sense that the miner might advocate his own course of remedies—or that the miner might, in combination with other miners, seek redress themselves, thereby posing a danger to the reader. The intent throughout "A Coal Miner's Evidence" proceeds from Horne's endeavor to enlighten, to arouse, but not to alarm his middle-class readers.

The narrator's introduction to the miner's testimonial illustrates this intent. Horne begins by invoking the common human experience of death in all its forms, normally undergone "upon the open face and fabric of our mother earth" ("Coal Miner's" 245). Yet, the narrator continues, there are deaths that startle when they arise "from a blow dealt in the darkness of many hundred feet beneath the ground," leading to a reference to the Sloughton Colliery explosion and "previous accidents of a similar kind in South Staffordshire and North Durham" ("Coal Miner's" 245). Horne employs his experience on the parliamentary commission to establish the multiplicity of accidents, thereby fostering the miner's credibility with the reader beyond the purely personal recollections of the accidents that follow. The miner, who "was in the pit at the time of the recent explosion" at Sloughton, then takes up the thread of the presentation, with the narrator omitting only "such technical terms and local phraseology as would be unintelligible; the rest is all in his own words" ("Coal Miner's" 245). Consider the way that Horne eliminates any potential jargon or hurdles for the reader, gracefully gauging the level of his audience while also reinforcing the veracity of the account of the mine disaster as the *ipsissima verba* of the miner.

Horne's miner, with a lifetime spent in the pits, immediately refers to his "providential escape from the Sloughton Colliery explosion, which all the newspapers, I'm told, are a-talking about just now" ("Coal Miner's" 245). The miner then invokes Divine Providence, a tactic that assuages readers as to the miner's religious faith. The miner sincerely avers, "I pray to my God night and day—and I am not much used to praying, neither—that I may never again go through such a scene as that night was" ("Coal Miner's" 245). The confession of not being much used to prayer deftly insinuates the miner into the reader's mind as resembling many others with respect to God, believers but not fanatics in their practice of faith. Notice also the miner's apparent illiteracy. Others tell him the papers are full of the incident. The reader can sympathize with the miner rather than fear him as a literate, potentially self-sufficient man capable of correcting his plight by himself. Indeed, the miner has labored in the mines, "man and boy, now these two-and-forty year" and so could not have received even the barest scraps of an education. This information allows the reader's sympathy to increase even as it further assures the reader that the miner lacks the essentials for success in the middle-class marketplace. The miner confesses as much when he states to Horne, "I must tell you all in my own way, from the beginning; only, as you write it down for me, be so good as make it all clear grammar-like and spelling; for I'm no great hand at that" ("Coal Miner's" 246).

Horne masterfully depicts a man fully aware of his shortcomings who humbly but unashamedly requests that Horne cast him in the best light possible with the readers by amending his rougher usages. Yet the miner insists that he possesses the mastery of the material, which he must tell in his own way. The mixture of self-effacement and self-determination heightens the image of the miner as a simple, not simpleminded, human being, totally credible as to his experience. He is someone with a definite claim on the interest of the reader precisely because the miner shares in that humanity that Horne hopes to galvanize in his reader just as earlier, in "The True Story of a Coal Fire," he sought to galvanize his reader through the surrogate Flashley. Horne seems almost to rely on the reader's knowing the earlier installments and so can proceed to further the reader's awareness by structuring a piece in which the encounter with the miner requires no filter of a fictional character. Instead, the miner can engage the reader directly, keeping in mind the elements Horne introduces into the article to reassure his readers. This unimpeded opportunity for the reader provides the means whereby Horne can lead to his conclusion, in which Horne reassumes control from the miner in order to put forward concrete steps that the literate and energized readers can press for on behalf of their less-educated fellow human.

The steps in the miner's narration of the mine and the explosion parallel much of the material found in the central section of "The True Story of a Coal

Fire." Like the boys in Horne's previous article, this miner "went down into the pit when [he] was six year[s] old" after his parents had passed him off for seven and a half ("Coal Miner's" 246). He too was put to work as a trapper, operating the trap doors that ventilated the mines. At first given a candle, the miner was later told that he could sit just as well in the dark, and so he "sat in a hole . . . twelve hours a day, all in the dark" ("Coal Miner's" 246). Such deprivation for a six-year-old can serve only to advance Horne's argument, not to mention the boys' being whipped if they should fall asleep on duty ("Coal Miner's" 246). What the narrative neglects to mention is that the boy was also not allowed a Davey lamp, the device intended to permit illumination without igniting mine gases. But such a lamp did not come risk-free. T. S. Ashton and Joseph Sykes's early landmark work *The Coal Industry of the Eighteenth Century* demonstrated that such lamps actually increased the number of explosions due to mining in deeper shafts (53). Horne's miner experiences and survives such explosions on several occasions, including the Sloughton Colliery.

Besides conjuring the memory of a youth spent alone in the dark for twelve hours a day, the miner speaks of tormenting mice in the mine by putting "the tails of three or four of them into a split stick, and then shak[ing] them together till they fought like mad," something that the miner regrets, being now a man ("Coal Miner's" 246). The implicit parallel between the plight of the tormented mice and the miner as a boy prepares the reader for the miner's "bad accident from an explosion" at age nine, when another miner's opening a Davey lamp sets off a gas explosion that scorches the boy's breast and arms, leaving him in bed for nine weeks ("Coal Miner's" 246). The boy also witnesses a cave-in that mutilates and kills several miners. Then, six months after being burned, the boy ascends the stages of work leading up to actual mining of the coal. First, he is set to "hurrying," that is, pulling a wagon filled with coal, after which he is "foaled" to his uncle as his assistant in moving larger loads of coal ("Coal Miner's" 246). The miner's equanimity while describing such events underscores Horne's appeal for change in mining conditions while his docile tone reassures the reader. The miner maintains that tone even when speaking of being lost for two days in the shafts after taking a wrong turn in the dark with a load of coal ("Coal Miner's" 246).

Having achieved adult status by being put to pick work earlier than usual due to his strength, the miner suffers a second burn from a Davey lamp that "scorched my face all over, so that the skin all peeled off. It was shocking to see" ("Coal Miner's" 247). This facial disfigurement might be seen as grounds for a strenuous outburst by the miner as to safety conditions, but instead he maintains his calm demeanor, saying, "You may cure the mine of gas, perhaps, but you'll never cure the men. Nor I don't well see how you're to cure the gas, at all times, neither" ("Coal Miner's" 247). The rhetorical strategy of

confronting the reader with such long-suffering sentiments may strain credibility, but it continues to underscore the degree to which this miner is trustworthy and in need of aid. This miner is no unreconstructed Chartist or member of a militant union association, both of which circumstances might unsettle Horne's readers.

Nor are miners drunkards, as the miner stoutly attests, before going on to detail the disastrous explosion at the Willington Colliery in Durham, which resulted in men and animals burnt to death by the gas flames and a fire in the stables ("Coal Miner's" 247–48). The explosion was caused by trapper boys' going off to play and neglecting their trap doors, thereby disrupting the proper ventilation of the mine ("Coal Miner's" 248). The miner responds to potential surprise that such a crucial task was left to children, noting that "in course the Queen's Ministers don't know anything about these underground matters," having inspected the mine eight years before, "but I suppose they kept what they found to themselves" ("Coal Miner's" 248). Horne's expertise in such parliamentary proceedings leads him to append a footnote to the article. The note cites the "Report and Evidence of the Children's Employment Commission," a well-timed notation since the official report, though public, had effected little change. For "here we are with our little trapper boys, and our explosions, and our burnt and mangled men, just as we have always been," despite the miner's desire to excuse the queen's ministers and the queen ("Coal Miner's" 248).

The futility of the commission and the unchanging nature of the mines bespeaks the inescapable horrors for the miner and his coworkers, who find themselves trapped after a cave-in at the Sloughton Colliery. The cave-in, caused once again by a gas explosion, sends the miner and his fellow workers desperately scrambling to a place "where [they] found the air could be breathed. Here [they] remained. What a time it was, good Lord of Heaven!" ("Coal Miner's" 249). That all of them did not die amid the panic, fear, and despair the miner chronicles results from the ironic good fortune that the collapsed shaft cuts them off from the fire raging elsewhere in the mine. Rescuers locate them, get them fresh air, and then bring them to the surface ("Coal Miner's" 249). Once on the surface, the miner relates how "some died from exhaustion . . . but most of us recovered, to thank God again and again in the arms of our wives and relations, who were all standing in crowds to receive us" ("Coal Miner's" 249). Not all rejoice, however, since "five-and-twenty had been killed; some crushed, some burnt to a black cinder, so they couldn't be told; some torn all to pieces, their limbs being found in different places, and the head of Anderson flung into a horse-tub" ("Coal Miner's" 249). The blame for this carnage, the miner now lays at the feet of the queen's representatives who, "when they came down here among us, said they could mend these things; but they haven't, you see. We think the Queen wasn't told" ("Coal Miner's" 249).

The miner's narration concludes at that point, bewildered by the failure of the queen's ministers to remedy a situation they "said they could mend" yet earnest in his belief that the queen herself remained blameless because she was not told. Horne skillfully injects both noble despair and patriotic loyalty in the miner's final words, leaving the reader with no illusions as to the devastation resulting from such unspeakable circumstances. And it is at just this moment that Horne resumes the thread of the argument in the measured tones of the opening, stating, "An effectual remedy for these horrible accidents is indeed most difficult to devise" ("Coal Miner's" 249). Never forgetting the middle-class mercantile and manufacturing readers, Horne concedes problems will arise but goes on to advocate a three-point plan of stringent laws governing proper ventilation of the mines, constant and unannounced inspection by both day and night, and strict registration of any and all mine accidents, particularly those involving faulty machinery or gas explosions ("Coal Miner's" 249–50). Horne completes his article by indicating that practices such as these already exist above ground, "where the difficulty of concealment must be so great" and, therefore, can only be more effective underground, "where almost any recklessness or gross abuse may be committed with impunity, because unknown, and where none of its wrong doings come to light except with these terrific explosions and waste of industrious human lives" ("Coal Miner's" 250).

The logic of Horne's argument seems unassailable, as well as reasonable. No radical talk of unions and strikes. No thought of demonstrations in the streets above ground that might incommode the readers. No, these matters ought to be enacted, Horne sums up, so that there will be no more of these "terrific explosions and waste of industrious human lives," the key word being industrious. Without denying any of the apparent sympathy that Horne and the article generate for the miner and all like him, the clinching element in the effort to persuade the reader becomes a matter of economics. These are working men and the nation's prosperity can ill afford the loss of such stalwart, well-meaning, nonthreatening miners. The miner's evidence not only highlights the terrors of his work and the need for reform. It also presents the reader with a portrait of the right sort of workingman, respectful of queen and country, laboring thanklessly for family and Britain. Such working men deserve the simple protections of the social reform Horne advocates on the miner's behalf.

Those commonsense proposals should seem no less evident to the miner, whose personal pain and degradation form the bulk of the article's argument on behalf of such measures. But he cannot speak for himself, given the audience Horne addresses in *Household Words*. Rather, he can function only as the appropriately meek and loyal example. Muted by the aims of periodicals like *Household Words*, which advance social reform but also acknowledge the

necessity of attracting and entertaining the emerging middle-class readers, the miner in "A Coal Miner's Evidence" and the miner who addresses young Flashley in "The True Story of a Coal Fire" must be content to have another press their case, for to do otherwise contradicts the gradualist approach that shapes and informs the manner in which Horne's articles in *Household Words* address Victorian social reform.

WORKS CONSULTED

Ackroyd, Peter. *Dickens*. New York: HarperCollins, 1990.

Ashton, T. A., and Joseph Sykes. *The Coal Industry of the Eighteenth Century*. Manchester, Eng.: Manchester Univ. Press, 1929.

Dickens, Charles. "Preliminary Word." *Household Words*, 30 Mar. 1850, 1.

Horne, Richard H. "The True Story of a Coal Fire. Chapter I." *Household Words*, 6 Apr. 1850, 26–31.

———. "The True Story of a Coal Fire. Chapter II." *Household Words*, 13 Apr. 1850, 68–72.

———. "The True Story of a Coal Fire. Chapter the Last." *Household Words*, 20 Apr. 1850, 90–96.

———. "A Coal Miner's Evidence." *Household Words*, 7 Dec. 1850, 245–50.

Johnson, Edgar. *Charles Dickens: His Tragedy and Triumph*. New York: Simon and Schuster, 1952.

Kaplan, Fred. *Dickens: A Biography*. New York: William Morrow, 1988.

Long, Priscilla. *Where the Sun Never Shines: A History of America's Bloody Coal Industry*. New York: Paragon House, 1989.

Pollard, Sydney. *The Genesis of Modern Management: A Study of the Industrial Revolution in Great Britain*. Cambridge: Harvard Univ. Press, 1965.

Thompson, E. P. *The Making of the English Working Class*. New York: Vintage, 1963.

Vicinus, Martha. *The Industrial Muse: A Study of Nineteenth Century British Working-Class Literature*. New York: Barnes & Noble, 1974.

5

Social Reform through Sensationalized Realism

G. W. M. REYNOLDS'S

"THE RATTLESNAKE'S HISTORY"

Janet L. Grose

George William MacArthur Reynolds, one of the most widely read of Victorian writers, has been too often dismissed by many scholars of nineteenth-century literature. His interests and literary talents were broad, including popular fiction and journalism, as well as Chartist politics and social reform. His name became familiar when he began writing sensation novels in 1835, but his reputation with the public was heightened when he became editor of the *London Journal* in 1846. For the remainder of his life Reynolds was actively involved in the writing, editing, and publishing of periodicals, including the weekly *Reynolds's Miscellany* which ran for twenty-three years, *Reynolds's Political Instructor,* and *Reynolds's Weekly Newspaper,* which still bears his name. In 1845 Reynolds began publishing his voluminous *Mysteries of London* in the *London Journal;* he continued the series of penny numbers for almost four years before shifting his emphasis to the *Mysteries of the Court of London,* which ran for seven years in weekly numbers. These tales were hugely popular, circulating at an estimated 40,000 copies per week in their first year. Louis James rightly suggests that Reynolds's popularity was "made possible by a readership concerned not just about poverty but with the economic structure of society that lay behind it" (94). Reynolds's penchant for the grotesque is clear in these "penny dreadfuls," but his work is too often narrowly categorized as mere melodrama that entertained the lower classes; on the contrary, Reynolds's radical views and his acute awareness of the corrupt state of the poor are evident in the underlying calls for social reform in his works.

An excellent example of Reynolds's complex ability to "horrify, instruct, and morally uplift a massive popular audience" (Burt 142) is "The Rattlesnake's

History," a chapter in his *Mysteries of London*. In this story, the Rattlesnake, the young female narrator, provides the background of her life and her eventual involvement in crime. Reynolds notes that his details about the conditions of the coal mine he describes in the book are based on the parliamentary blue book titled *1842 Report of the Children's Employment Commission*. This report resulted almost immediately in legislation preventing all females from employment underground in the coal mines. However, enforcement of the law was not widespread, as few inspectors were appointed to monitor the mining employment practices; Friedrich Engels remarks that the bill was no more than a "dead letter" in many regions (284). For several decades women and girls continued to work illegally in many coal mines across Great Britain. Angela V. John claims that they did so "with greater vulnerability and dependence on employers than before" (15), preferring, as Ivy Pinchbeck adds, that "hated" and "arduous toil" to "unemployment and starvation" (Pinchbeck 265). This abuse of females and extortion of their desperate need to work illuminate the relevance of Reynolds's account of the Rattlesnake almost eight years after women were supposedly out of the mines. His concentration on females in the mines emphasizes Reynolds's abhorrence of the conditions they suffered and his scorn for a government that neglected to enforce its own reform legislation.

"The Rattlesnake's History" is a curious blend of "highly ritualized sensational passages" with realistic details (James 97), of journalistic objectivity with moral outrage. Reynolds allows the Rattlesnake to tell her background in first-person narrative style, which reinforces the horror of her past and the immediacy of the need for change. The first sentence of the Rattlesnake's story is Reynolds's initial reference to the report, although it is perhaps one easily missed until later in the paragraph. When the Rattlesnake says she "was born in a coal-mine in Staffordshire," she means literally *in* the mine, rather than in Staffordshire (164). In the report, there are numerous accounts of women who gave birth in the mines; one relates, "I had a child in the pits, and I brought it up the pit-shaft in my skirt" (Great Britain 27). Many others describe their work as being "worse when we are in a family way" (27). Accordingly, Bet Flathers, the Rattlesnake's mother, has a similarly startling tale of her daughter's birth: "[My mother] worked in the pit to the very hour of my birth; and when she found the labour-pains coming on, she threw off the belt and chain with which she had been dragging a heavy corf, . . . retired to a damp cave in a narrow passage leading to the foot of the shaft, and there gave birth to her child. That child was myself" (Reynolds 164–65). The Rattlesnake is actually one of the few to survive birth in the mines; a collier interviewed by the commission states, "[My wife] worked in the pits till she was thirty. She had four children; two were born alive, but they died afterwards, and two were still-born" (Great Britain 27). The Rattlesnake's survival of infancy is equally

amazing, as Bet returns to the mines a week after giving birth, leaving a seven-year-old girl to keep her child quiet with doses of opium.[1] Reynolds's inclusion of the Rattlesnake's birth and infancy indicates his own horror at the miners' typical treatment of even those who are completely defenseless.

Reynolds intensifies the graphic details of cruelty when the Rattlesnake is taken to work in the pits at age seven. The report states of South Staffordshire, "It is common in this district for children to begin work in the pits when they are seven years of age" (9), so the Rattlesnake's entrance into the pits is average for the area. In his description of the Rattlesnake's first descent down the mine shaft, Reynolds effectively uses his creativity for the grotesque to portray vividly the intense imaginative fear of a young child, "half dead with giddiness and fright," on being immersed in such a dark and dank hole (167). The Rattlesnake remembers her terror: "I trembled lest some invisible hand should suddenly push forth from the side of the passage, and clutch me in its grasp: . . . I thought that the echoes which I heard afar off, . . . were terrific warnings that the earth was falling in, and would bury us alive: . . . I shuddered at the idea of encountering some ferocious monster or hideous spectre" (167). Another striking first remembrance is the nudity of the miners. The Rattlesnake relates her "alarm and horror" upon seeing the men "stark naked" and the women and girls "naked from the waist upwards," all of them apparently unconcerned with their display (168). The report confirms that this nudity in the mines was common: "The men work in a state of perfect nakedness, and are in this state assisted in their labour by females of all ages, from girls of six years old to women of twenty-one, these females being themselves quite naked down to the waist" (24). Reynolds's juxtaposition of a frightened girl's early childhood memories and the harsh realities of the mines obtained from the report successfully evokes first the reader's empathy, and progressively more so, his or her horror and indignation.

The actual work of both the Rattlesnake and Bet is even more minutely and accurately detailed. Between the ages of seven and ten, the Rattlesnake is required to carry or drag buckets of coal from Phil Blossom's place of work to the cart for carrying the coal to the shaft. Her earliest recollections of this work are almost identical to an eyewitness account in the report. The Rattlesnake describes her toil: "Thus, at seven years old, I had to carry about fifty-six pounds of coal in a wooden *bucket*. . . . Some parts of the passages were only twenty-two inches in height; . . . and the difficulty of dragging such a weight, at such an age, can be better understood than explained. I can well recollect that when I commenced that terrible labour, the perspiration, commingling with my tears, poured down my face" (Reynolds 168). The subcommissioner relates what he found upon examining the mines and the work of the girls: "The females have to crawl backwards and forwards with their small carts in seams in many cases not exceeding twenty-two to twenty-eight inches in

height. The danger and difficulties of dragging on roads dipping from one foot in three to one foot in six may be more easily conceived than explained; and the state which females are in after pulling like horses through these holes—their perspiration, exhaustion, and tears very frequently—it is painful in the extreme even to witness" (Great Britain 28). It is surely significantly more painful for the Rattlesnake to bear than for the subcommissioner to witness. Herein lies the great strength of Reynolds as a writer of social reform literature: he personalizes the observations of the report in his characters. Although her loads increase in weight with her age, and the distance she must haul them becomes longer, the Rattlesnake refuses to become a hurrier, having seen what it has done to her mother. A hurrier wore a belt around her waist with an attached chain that ran between the legs and hooked to the cart, so that she could drag loads of as much as seven hundred pounds at a time, as much as two tons per day (Pinchbeck 253). On inclines, the hurrier got behind the cart and pushed it with her head. This labor explains the baldness of Bet's head, with its "scalp thickened, inflamed, and sometimes so swollen, that it was like a bulb filled with spongy matter" (Reynolds 174), her crooked spine, and her other various internal maladies of the heart and lungs. A woman interviewed by the commission says of her job as a hurrier, "'It is only horse-work and ruins the women; it crushes their haunches, bends their ankles, and makes them old women at forty'" (Great Britain 30). A mining foreman explains that women make better hurriers than men because they will work in places and conditions that men would not tolerate. Her disgust of this debilitation, her indignation at the physical abuse, and her fear of her mother's violence combine to make the Rattlesnake run away from her life in the mines at age twelve. The Rattlesnake's determination and courage to leave are qualities owed more to Reynolds than to fact, however, as the report indicates that most people continued to toil in the coal mines until the work killed them.

In explanation of her initial overwhelming terror of the coal mines, the Rattlesnake reminds the reader that before leaving the mine she was completely uneducated: "I could not read: I had not even been taught my alphabet. I had not heard of such a name as Jesus Christ; and all the mention of God that had ever met my ears, was in . . . curses and execrations" (Reynolds 167). Her ignorance and lack of Biblical knowledge are verified as common by both Engels and the blue book. Engels reports, "All the clergy complain of the shocking ignorance of the miners on religious matters. . . . Only when they swear do the miners show any acquaintance with religion" (284). The commissioners express concern that the lewd conditions the children were exposed to were not tempered by education, even Sunday school, resulting in "a picture of moral and mental darkness which must excite horror and grief in every Christian mind" (Great Britain 34). A youth explains the general reluctance to attend Sunday school: "I work in here in the dark six days, and

I can't shut myself up on Sundays too" (37). Such total ignorance of anything except mining kept many youths in the pits; the Rattlesnake is again an exception, thanks to Reynolds's decision that she be independent.

These and other parallels between Reynolds's story and the blue book reveal that the author carefully read the report and considered its implications. As is evident in the previous passages, Reynolds borrows almost verbatim from the report on occasions, but he disregards complete accuracy in favor of shock value and revelation of the most blatant cruelties. His choice of Staffordshire as the location of the mine is probably based on its abundance of mines; the report states that this district "is remarkable for the extent to which its vast beds are worked" (6). Some aspects of Reynolds's story are accurate based on this location, such as the age children are generally employed, the hours they work, and the meal arrangements. However, according to the report, "female children of tender age and young and adult women" do not work in the pits, but rather at the surface of the mines (24). The districts found generally to employ women and girls in underground work are primarily those in Scotland and Wales. Reynolds's disregard of geographical consistency and accuracy reveals his desire to expose *all* of the most flagrant hardships suffered by female workers in the mining industry.

An important emphasis of Reynolds's story that is less prominent in the blue book is the moral effect of the nudity, foul language, and general squalor rampant in the pits. The commission does report that nudity in the mines is common, and even prints the account of a young boy's observation of the pit girls that work with him: "The girls' breeches are torn as often as ours; they are torn many a time, and when they are going along we can see them all between the legs naked" (25). Other colliers report that "decency is disregarded" (25) and that it is scandalous that often married men and women work in semi- or complete nudity with unrelated members of the opposite sex. However, when the commissioners consider the negative moral effects of mining conditions on women workers, they concentrate primarily on the accounts of the male workers, who complain that mine work makes women unfit domestics. One collier states that work in the pits "unbecomes" women: "there is not one in ten of them that know how to cut a shirt out or make one, and they learn neither to knit nor sew" (31). Another man comments that the mine work prevents women "from learning to manage families. Many could not make a shirt" (32). Even when Lord Ashley addressed Parliament to argue for reform, his emphasis was more on the adverse familial, societal, and national effects of females in the pits than on the individual women (Pinchbeck 267). Reynolds, however, is obviously less concerned about woman's talent with a needle than with her personal moral state. He depicts clearly what is mostly hinted at in the blue book as "debauchery," "sensuality," and "wickedness" (32), and merely dismissed as beastly behavior by Engels, who

lets his reader speculate on "what these half savage creatures are doing when they get below ground" (284). In the first paragraph the Rattlesnake reveals that she is illegitimate, "but this circumstance was neither considered disgraceful to my mother nor to myself, morality being on so low a scale among the mining population generally, as almost to amount to promiscuous intercourse" (Reynolds 164). Bet's sexual relationship with her boss, Phil Blossom, also seems expected in their surroundings of nudity, darkness, and immense immorality. When the twelve-year-old Rattlesnake overhears them discussing Bet's pregnancy, she shows no surprise at their intimate physical relationship.

Reynolds's blunt portrayals of extramarital sex and bastardy are not simply attempts to shock a prudish audience or even to excite a perverse one. Margaret Dalziel emphasizes the honorableness of Reynolds's motives: "he muckrakes only to reform" (43). The vice that surrounds both Bet and the Rattlesnake from their earliest days causes irreparable moral decay in both of them. Bet Flathers becomes a murderess and an abusive parent who eventually dies at the hands of her lover. The Rattlesnake's escape from the mine is followed by her entry into the world of crime; she steals to keep from starving, then learns that prison, with its regular meals, is preferable to the life of the coal mines or of wandering. Even after she has been granted an education and an honest job, she returns to Skilligalee and a life of crime, the result of an abusive childhood that has left her "utterly demoralized" (Neff 73). Reynolds firmly believed that criminals are the products of an "exploitative society," emphasizing this cause and effect with the biographies of his outlaws (James 96). In Bet Flathers and the Rattlesnake, Reynolds skillfully portrays women who turn to mischief because of their overwhelming misery.[2] An underlying message of this story is an advanced one; Reynolds advocates reform of society as a means to eliminate the conditions that force people into crime. Instead of blaming the criminals, Reynolds blames the society that keeps them impoverished, uneducated, and morally destitute. Although a less sympathetic character than the Rattlesnake, Bet Flathers is the character whose ruin is the most complete; her life is totally encompassed by the coal mine, the men who use her body, and her own continually decaying physical and mental health. The Rattlesnake has an opportunity for redemption, but rejects a life of domestic servitude for one of wandering and crime. She is so hardened by the cruelties of her childhood that not even education and benefaction can change the course of her life.

G. W. M. Reynolds's "The Rattlesnake's History" is an indication of the author's awareness of the poor reception of the 1842 legislation preventing women's labor in the pits. Because of the lack of enforcement of the law, abuse of females in the coal-mining industry was still rampant in the late 1840s. The women who remained in the pits were virtually trapped there, largely because the government who tried to rescue them from such slavish labor failed to

provide other options for them. The author's goal in "The Rattlesnake's History" is to enlighten effectively his huge audience of these ongoing problems. Because his readership was so diverse, including people of all classes, Reynolds was able to reach a wider audience than even Lord Ashley with his parliamentary bill. In "The Rattlesnake's History," Reynolds writes an incredibly "sensational" tale with very real facts and conditions, in James's words, a "social melodrama" (100). His concern for the abused women and girls is clear, as is his warning to society: in allowing such corrupt systems of labor to exist, society and government are perpetuating poverty, sickness, vice, immorality, and ultimately the very crime they fear and thus seek to prevent.

NOTES

1. The use of opium to quiet infants was quite common in mining districts, despite the fact that the infant often suffered visibly or even died from the dosages. One woman reports that she has seen many children "made poor creatures by it; they get very thin: the joints and the head enlarge; they become remarkably listless, and they look vacant" (Hellerstein, Hume, and Offen 236). Another confirms that she "has known an infant killed by three drops of laudanum, but nothing was said about it. Knows that many infants die by degrees, and that no inquest or other inquiry is made" (237).

2. Louis James suggests that Reynolds's insight into female character is based largely on his "freedom from many of the moral restraints" imposed on more highbrow Victorian writers (98).

WORKS CONSULTED

Altick, Richard. *The English Common Reader.* Chicago: Univ. of Chicago Press, 1957.

Benson, John. *British Coalminers in the Nineteenth Century: A Social History.* Dublin: Gill and Macmillan, 1980.

Burke, Gill. "The Decline of the Independent Bal Maiden: The Impact of Change in the Cornish Mining Industry." In *Unequal Opportunities: Women's Employment in England, 1880–1918.* Oxford: Blackwell, 1986.

Burt, Daniel S. "A Victorian Gothic: G. W. M. Reynolds's *Mysteries of London.*" *New York Literary Forum* 7 (1980): 141–58.

Chadwick, Edwin. *Report on the Sanitary Condition of the Laboring Population of Great Britain.* 1842. Edinburgh: Edinburgh Univ. Press, 1965.

Dalziel, Margaret. *Popular Fiction 100 Years Ago.* London: Cohen and West, 1957.

Engels, Friedrich. *The Condition of the Working Class in England.* Translated by W. O. Henderson and W. H. Chaloner. Stanford: Stanford Univ. Press, 1958.

Great Britain. House of Commons. *1842 Report of the Children's Employment Commission.* London: Clowes & Sons, 1842.

Hellerstein, Erna Olafson, Leslie Parker Hume, and Karen M. Offen, eds. *Victorian Women: A Documentary Account of Women's Lives in Nineteenth-Century England, France, and the United States.* Stanford: Stanford Univ. Press, 1981.

Helsinger, Elizabeth K., Robin Lauterbach Sheets, and William Veeder. *The Woman Question: Social Issues, 1837–1883.* New York: Garland, 1983.

Humpherys, Anne. "The Geometry of the Modern City: G. W. M. Reynolds and *The Mysteries of London.*" *Browning Institute Studies* 11 (1983): 69–80.

James, Louis. *Fiction for the Working Man, 1830–1850.* London: Oxford Univ. Press, 1963.

———. "The View from Brick Lane: Contrasting Perspectives in Working-Class and Middle-Class Fiction of the Early Victorian Period." *Yearbook of English Studies* 2 (1981): 87–101.

Middleton, Chris. "Women's Labour and the Transition to Pre-Industrial Capitalism." In *Women and Work in Pre-Industrial England,* edited by Lindsay Charles and Lorna Duffin, 181–206. London: Croom Helm, 1985.

Neff, Wanda Fraiken. *Victorian Working Women.* New York: Columbia Univ. Press, 1929.

Pinchbeck, Ivy. *Women Workers and the Industrial Revolution.* London: Virago, 1930.

Reynolds, G. W. M. "The Rattlesnake's History." In *The Slaughter-House of Mammon: An Anthology of Victorian Social Protest Literature,* edited by Sharon A. Winn and Lynn M. Alexander, 163–82. Locust Hill Literary Studies 8. West Cornwall, Conn.: Locust Hill, 1992.

6

Anticommunity and Chaos

THE ROLE OF

FREE INDIRECT

DISCOURSE IN

ZOLA'S *GERMINAL*

Thomas E. Mussio

Although it was not the first novel on coal mining, Emile Zola's *Germinal* (1885) is considered the culmination of nineteenth-century interest in the subject, both for the breadth and accuracy of Zola's depiction of the mines and for the novel's wide, enthusiastic reception.[1] Henri Marel reports that when a delegation of miners was sent to assist at Zola's funeral they mourned and honored the writer with the chant "Germinal! Germinal!"[2] This reaction suggests that not only was *Germinal* Zola's most resonant work but also that it was received as a form of protest on behalf of the miners. The famous closing of the novel in which an avenging army of "germinating" workers promises to rise up and avenge the injustice of the miners' misery is full of revolutionary language and fervor. Indeed, the recurring image of germination within the novel, as well as the novel's title—"Germinal" was the name for the seventh month in the republican calendar—allude to the ideals of republican egalitarianism. Yet the optimism of this language is undercut by the ambiguity of its tone and point of view: does it represent the narrator's shared optimism with Etienne, the main activist in the novel, or is the narrator commenting ironically on Etienne's false hopes? This ambiguity is caused by the passage's inscription within free indirect discourse (*discours indirect libre*), a type of narrative reporting which accommodates the layering or fluid alternation of the narrator's voice with that of a character. A close reading of the passage in relation to the whole novel resolves this uncertainty in favor of the narrator's irony.

The novel sets out to explore the social and political position of the worker, the battle between the working and owner classes, and the European socialist movement,[3] and it exposes the deep, unconscious gaps between the classes that would prohibit progress along the lines suggested by moderate socialists, represented by Rasseneur in the novel. At the same time, it reveals the internal division among the workers and between activists and workers that renders Etienne's dream of progress through revolution improbable. Hence, the narrator ironically exposes anticommunities and chaos where there was thought to be community and order, as in the burgeoning miners' union. Zola's most important instrument of irony is free indirect discourse, or FID; in the novel, it is most often the conveyer of resignation and fear, rumor and gossip, and clichés and political generalities—all of which express or exacerbate the isolation and division among social groups and oppose social progress. Through FID Zola stresses the inveteracy of divisive prejudices and fears between and among the classes and points pessimistically to an existential isolation of individuals from one another.

Although FID existed as a way of representing characters' speech or thought long before the movements of realism and naturalism, recent critics have most often focused on its connection with realism, especially psychological realism. Generally characterized by the absence of quotation marks and the use of an introductory colon, the backshifting in tense, as in traditional indirect discourse, the scarcity of coordinating or subordinate conjunctions, and the indication of characters' idiom or verbal register and tone (usually interrogatory or exclamatory and signaled by the appropriate markers),[4] FID is linked with the narratorial distance and objectivity championed by the realists and naturalists: rather than telling the reader about characters, the narrator lets them reveal themselves (Flavin 152; Niess 125). This apparent reduction of narratorial interference produces the effect of immediacy and greater psychological depth. John Dussinger sees FID's structure as closer to the "rhythm of desire," implying a more accurate representation of the emotional content of FID passages over passages in traditional indirect discourse (Dussinger 101), and Robert J. Niess finds that FID provides "verbal coloring" and a rhythm that corresponds to the "unfinished quality of ordinary speech" (Niess 126–27). Yet despite this interest in FID's mimetic function, most critics recognize FID as a powerful instrument of irony and subtle narratorial commentary (Niess 126, 129–30; Weinberg 3; Oltean 534; Hernadi 37; Flavin 138).[5] Raymond Peitrequin's image of the narrator as "demiurge" summarizes the paradox of FID: although the narrator seems to be less intrusive, the narrator actually controls more strongly the reader's perception of the characters (Peitrequin 31–32). FID passages selectively highlight a character's language, not obtrusively but within a syntactic structure that is fluid and free of the markers typically associated with narratorial control.

In *Germinal* there are about three hundred instances of FID. About 120 of these represent thought, and the majority of the rest represent speech. These figures correspond roughly to the figures Niess recorded in his examination of FID in *L'Assomoir,* the other of Zola's working-class novels (Niess 128). Yet one cannot attribute the extensive use of FID in *Germinal* solely to Zola's interest in capturing the colorful speech of the working class, for the language of both the bourgeoisie and the worker is consistently cast in FID. It is clearly also used for narrative economy, as it serves Zola's ambition for encyclopedic breadth of vision (Zakarian 3–4): through FID the writer can hint at a wide range of general habits and living conditions without diverting from the main plot lines of the novel. Nevertheless, Zola's main thematic interest in FID rests in its capacity to express the fixity, repetitiveness, and idiosyncrasy of thought and speech, which are often hidden from the characters. FID ironizes characters' belief that when they speak or listen they are communicating, when in fact these acts merely trigger the expression of a deep-seated, fixed idea. By eschewing the signs of direct discourse that mark a speaker's rhythm and pauses (when Zola represents direct discourse, he uses ellipses to indicate logical pauses), FID de-emphasizes the communicative aspect of discourse. Hence, in the novel FID marks the futility of discourse in overcoming the gaps between and among classes.

When FID represents thought, the passages are usually short, from one to four lines of text, and they nearly always express a passive, negative emotion: fear, doubt, resignation, despair, indifference, or bitterness. The phrase "a quoi bon?" is a frequent refrain in FID in the novel. In several significant longer passages, FID represents the false hope or fear of a group's strong, general response to a speech or event. When FID is used to indicate speech the passages are longer and are introduced by sentences that mark the speaker's release of pent-up emotion, such as, "Du coup, Etienne s'animait" (179) and "Etienne se soulageait longuement" (247). Yet FID usually unveils the negative facet of the enthusiasm of these outbursts, for it puts into relief the repetitiveness, staticity, or idiosyncracy inherent in the outcry. The FID in *Germinal* points beneath the documentary aspect of the novel toward a deeply pessimistic view of the human community in general.[6]

FID exposes the myths that underlie and perpetuate the apparent injustice of the social order. The deep division between the social classes is epitomized by parallel passages in FID that imagine a radical reversal of the social order. On the miners' side is the passage that describes the miners' spontaneously arising dream of justice and universal happiness, provoked ironically by Etienne's enthusiastic speech in which he criticizes religion's utopian vision and false promises. The miners' vision takes place in the Maheu house, as the village is settling down for the night, amidst the sounds of poor domesticity. In clear relation to this passage is the one that portrays the bourgeoisie's reaction

to the miners' protest march. As several bourgeois characters, hidden in a barn, watch in amazement the stream of protestors, their subconscious fears of a worker revolution arise. Besides the clear thematic parallel around the idea of a radical reversal of the social order, these passages are linked by similar closed-in settings and by the unity and spontaneity of each group's vision. The parallel is furthered by the contrasting images of light in the two scenes. While the redness of the setting sun frames the bourgeoisie's frightening "red vision" of a coming revolution ("la vision rouge de la révolution," 345)[7], the darkness of the miners' night is burst by "une trouée de lumière," which temporarily chases away the misery of their ordinary lives, "comme balayé par un grand coup de soleil" (181) (as if swept away by a great burst of sun). The apocalyptic imagery of both scenes, set next to the narrow confines of the settings of the visions, ironically points out the isolation of these powerful and personal hopes and fears from the outside world.

In the one passage the FID portrays a unified bourgeois consciousness, for because of its syntactic flexibility, it does not convey the vision of revolution through the speech or thought of any one member of the class; rather, the vision seems to rise spontaneously from all of them (with the exception of the innocent Cecile), huddled together. Even Négrel, one of the mine's engineers, who has a more direct contact and real relationship with the miners, is included in this landscape of bourgeois imagination. The idea that the vision springs from a previously inarticulate consciousness is given by the description of Négrel's fear, "une des épouvants qui soufflent de l'inconnu" (345) (one of the fears that blow from the unknown). The way the FID is introduced shows that the source of their fascination with the scene that provokes the collective imaginative vision is unknown to them: "malgré leur désir de détourner les yeux, ne le pouvaient pas, regardaient quand même" (345) (despite their desire to turn their eyes away, they couldn't, they were looking all the same).

This fear of and fascination with the unknown takes the shape of bourgeois prejudices toward the working class. In the bourgeoisie's imagination the miners are savages: "Les femmes hurlerait, les hommes auraient ces mâchoires de loups, ouvertes pour mordre" (346) (the women would howl, the men would have their wolves' jaws, bared to bite). To the bourgeoisie, the revolution would mean an end of society and civility: "on ne laisserait pas debout une pierre des villes, on retournait à la vie sauvage dans les bois" (346) (they would leave no stone left standing in the cities, they would return to the savage life of the forests). The exaggeration of this mythological language, transforming men into beasts, is a summary statement of bourgeois ignorance of the miners. Throughout the novel Zola ironizes the naivete of the bourgeoisie toward the miners. Although many could be adduced, two examples will suffice here to show the pervasiveness of the bourgeois class's ignorance of the

working class. Gregoire, a bourgeois stockholder in the mines, cannot see the connection between the good the mine bestows on him and the misery of the miners who determine its productivity. This naive attitude is expressed in his incredulity at the motives for a strike (214). Hennebeau's reflections on his unhappy marriage also lean heavily on the mine director's limited understanding of the miners' lives. Riding through the mining village during the strike and coming upon several couples "qui se moquaient de la politique et se bourraient de plaisir" (269) (who were mocking politics and giving themselves up to pleasure), Hennebeau remarks to himself: "Jusqu'aux marmots qui déjà s'égayaient à frotter leur misère!" (269–70) (even the little brats who were already taking pleasure in escaping their misery). This observation is conditioned by Hennebeau's weary recognition of his infertile and loveless marriage. The reader knows that the pleasures that Hennebeau idealizes against his own unhappiness are short-lived, mostly disadvantageous to the miners' families, and are discouraged and resisted for as long as possible by conscientious miners. In these, as in most examples, this insensitivity is presented as unconscious. Thus, the FID passage cited above is borne out as truly representative of the bourgeois subconscious.

The exposure of their own dreams to themselves leaves no lasting impression on the bourgeoisie, proving not to be a stimulus to greater understanding but the creation of a drama in which they were the tragic victims. Once safe, after the end of the violent strike and the fatal confrontation of the miners with the military police, they take up their familiar patronizing stance toward the miners and the miners' real tragedy, calling the police action a "leçon nécessaire," but vowing to forgive "leurs braves mineurs" (435) (their deserving miners). Zola gives no indication that the bourgeoisie's perception of the miners has changed.

Just as the bourgeois vision expresses deep-seated and pervasive sentiments among that class, Etienne's speech appeals to the deep feelings of the miners concerning the injustice of their lot. Yet at the same time that it conveys effectively the general consciousness of the miners, FID performs a very different function in Etienne's speech: it reveals the radical isolation of the speaker from his audience. Etienne's speech, meant to turn the miners away from superstitious beliefs that prey on their resignation, becomes the background for a reverie in which the Christian deity is merely replaced in the miners' minds by the deity of "justice." The FID subtly reveals the basic fixity of the miners' way of thinking: "Puisque le bon Dieu était mort, la justice allait assurer le bonheur des hommes, en faisant régner l'égalité et la fraternité" (181) (as the good Lord was dead, justice was going to assure people's happiness, by making equality and brotherhood reign). Etienne's distance from the miners is evident in the introduction to the FID passage. Citing the falseness of the idea of paradise after death, he preaches the possibility of happiness on

earth: "D'une voix ardente, il parlait sans fin" (180) (in an ardent voice he was going on and on). Hence, the reader imagines Etienne speaking throughout the whole of the miners' dream vision, but ironically, his speech produces quite the opposite thoughts from those he sets out to promote.

Set together as parallel visions of the two classes, the two passages of FID reinforce the utopian quality of each. The events in the rest of the novel bear this out. The bourgeoisie show no alteration in their social consciousness, and Etienne quickly loses control of the miners, and the worker movement spirals into chaos. One could argue that no progress at all has been made in the course of the novel toward bridging the gap between the classes. Just as the bourgeoisie's fearful dream of revolution has been repressed and felt as a false threat, Zola suggests, through the parallel, that the miners' dream of reversing the social order and obtaining universal happiness is also illusory.

Even as Zola discloses the major division between the classes, he uses FID to expose the division within the classes that ultimately separates individuals from one another. Because of its smooth, polished syntax, a passage in FID gives the impression that a character's thoughts or speech are ordinary and habitual.

Because of Zola's greater focus on the miners in the novel, there are fewer examples of this type of division within the owner class, but one thinks of the long passages of FID concerning Hennebeau's discovery of his wife's infidelity, his initial angry reflections, and his resignation to carry on with the marriage (340–41) as confirmation of the way Hennebeau's habits of thought preserve his marriage, paradoxically by preserving his distance from his wife.

Far from idealizing the miners, Zola examines the sources of divisiveness within the group from petty gossiping and hypocrisy to selfish nonchalance and rapacious self-interest, and again, it is FID that is the vehicle. FID is suited for representing speech acts that one easily imagines repeated in the course of daily life. For instance, when Maheude vents her frustration to Pierronne concerning her own household at the expense of Levaque, the reader already knows that the peculiarities of the Levaque household are a common subject of discourse in the village. Pierronne's simple comment on the untidiness of Levaque's home is enough to set Maheude off: "Ah! si elle avait eu un logeur comme ce Bouteloup, c'était elle qui aurait voulu faire marcher son ménage! Quand on savait s'y prendre, un logeur devenait une excellente affaire. Seulement, il ne fallait pas coucher avec. Et puis, le mari buvait, battait sa femme, courait les chanteuses des cafés-concerts de Montsou" (120) (Ah! if she had had a lodger like that Bouteloup, she would have been the one who would have managed her house! When you knew how to set it up, a lodger became an excellent piece of business. Only, you shouldn't sleep with him. And then, her husband drank, he beat his wife, he chased the singing-girls in Montsou's bars). The rhythm of the last sentence of this FID passage epitomizes the way FID does not attempt to recreate a character's speech, despite the preservation

of the speaker's tone through the words that are used. Rather, the succession of verbs without any connective tissue and the rather flat, factual tone confirms the feeling that what she has said is unremarkable—that the situation in Levaque's home is generally known. Yet the structure of FID allows the narrator to report a banality among the miners in order to stress the competitive underbelly of life in the village. One finds pleasure and a source of relief from one's misery in the rehearsal of a common criticism of one's neighbors. Zola plays upon this when, in turn, only two pages later, Levaque and Maheude "se soulager sur le compte de la Pierronne" (122) (comfort themselves at Pierronne's expense).

FID is well-suited to portray hypocrisy without giving it exaggerated prominence in the narrative. For instance, when Pierronne's hypocrisy concerning her pretended grief over the death of her mother and stepdaughter is shown, its placement within FID confirms the reader's sense of the inveterateness of Pierronne's falsity: "et elle ne pleurait guère non plus la petite de Pierron, cette gourgandine de Lydie, un vrai débarras" (431) (and she hardly mourned Pierron's little girl, that little hussy Lydie, a true load off). The FID allows the reader to construe the act as simply one more act in a long series of similar acts witnessed throughout the novel. In the same way, the fast, steady stream of FID guides the reader's understanding of Levaque's maternal pose toward Maheude's young children in the scene toward the end of the novel when Levaque is visited by the Gregoires bearing gifts for the unfortunate Maheude: "elle leur vanta Henri et Lénore, qui étaient bien gentils, bien mignons; et si intelligents, répondant comme des anges aux questions qu'on leur posait!" (471). Because Levaque's ruse, like Pierronne's hypocrisy, falls outside the frame of main narrative, it would be uneconomical to treat it fully. In this way FID permits within the narrative an encyclopedic array of actions. The connection between spoken FID and the expression of thoughts that are not important to the plot is clear by the use of FID to represent gossiping, scolding, persuading, and joking.

If the FID passages indicate a pessimistic view of fixed, unchangeable, and flawed relations within the miners, the irony increases when the activists of the novel are incapable of communicating meaningfully with the miners on account of the fixity of their personal concerns. Souvarine, the novel's representative of anarchism and one who, for the sake of progress, cooly sacrifices the lives of tens of miners by flooding one of the mines, is characterized by his silence toward the miners. Toward the end of the novel he becomes increasingly withdrawn, "absorbé peu à peu dans une idée fixe" (413) (absorbed little by little in a fixed idea). Etienne, Pluchart, the priest Ranvier, and Rasseneur all fail to communicate with the miners, as well. The fact that Ranvier's, Pluchart's, and Rasseneur's addresses to the public are reported in indirect discourse or FID points to the generality and self-interested nature of

their speech. These leaders contrast sharply with the simple, most honest spokesman in the novel, Maheu, whose long speech on behalf of the miners before the director of the mine is reported in direct discourse (226–27).

Ranvier's discourse is set in FID primarily to emphasize the banality and fixity of his ideas, as well as his impersonal, predatory relation to his listener. He aggressively repeats his single message when his audience seems to be vulnerable. During the strike he besieges the bourgeoisie and preys on their fear of the threat of their overthrow. Tracing the loss of the Church's power over the poor to the bourgeoisie, he threatens them in God's name: "sûrement Dieu se mettrait du côté des pauvres: il reprendrait leurs fortunes aux jouisseurs incrédules, il les distribuerait aux humbles de la terre, pour le triomphe de sa gloire" (369) (surely God would stand on the side of the poor: he would take the fortunes from the unbelieving idlers, he would distribute them to the poor of the earth, for the triumph of his glory). The narrator makes it quite clear that Ranvier is really interested only in returning power to the church. The narrator notes he exploits the strike ("il exploitait la grève") to bring miners back within his fold, not for their good, but "pour la gloire de sa religion" (383). His promise of power through association with the church is put into FID: "En une semaine, on purgerait le monde des méchants, on chasserait les maîtres indignes, ce serait enfin le vrai règne de Dieu, chacun récompensé selon ses mérites, la loi du travail réglant le bonheur universel" (384) (within a week, one would purge the world of the wicked, one would put to flight the condescending owners, this would be finally the true reign of God, each recompensed according to his merit, the law of work bestowing universal happiness). The reader recognizes this language from the miners' reverie provoked by Etienne's speech earlier in the novel. Thus, the hackneyed quality of the ideas is exposed. The FID, with its pounding rhythm of five successive phrases of the same length, mimics Ranvier's heavy-handedness in relation to the miners and intimates his desperate quest for power.

Pluchart's presence in the novel is mostly as a correspondent of Etienne, and a mysterious figure of hope for the miners. As president of the International, a powerful worker's union across Europe, he passes from town to town giving speeches, as well as corresponding with labor leaders from afar. Yet at his arrival at the mining village, his vanity is immediately exposed. He is described as "vaniteux de ses succès de tribune" and ambitious of spreading his ideas: "Très actif, il servait son ambition, en battant la province sans relâche, pour le placement de ses idées" (250) (very active, he served his ambition, traversing the province without pause in order to get his views accepted). When he speaks, he sets out to trick the miners into joining the International.

FID, along with the narrator's direct commentary, ensures that the reader receives Pluchart's speech in a much more cynical light. The reader is told that Pluchart persuades more by his way of speaking than by his ideas and the

sheer religious enthusiasm of his voice compensates for the vagueness of his ideas. The narrator's control of the movement from the FID of Pluchart's speech back to direct discourse, through indirect discourse, distances the reader from involvement in the rhetorical effect of the speech: "Plus de nationalités, les ouvriers du monde entier réunis dans un besoin commun de justice, balayant la pourriture bourgeoise, fondant enfin la societé libre, où celui qui ne travaillerait pas, ne récolterait pas!" (253) (no more nationalities, the workers of the whole world reunited in a common need for justice, sweeping away the bourgeois decay, founding finally a free society, where those who did not work, did not reap the goods!). The vision described here, which receives a great applause among the miners, is ironically another version of the appeal to universal justice that had earlier been revealed to be so ingrained in worker consciousness. In this, FID is proved again to be a bastion of cliché and generality. Yet here the FID is framed in such a way as to distance the reader further from the supposed communicative setting between Pluchart and the miners: the narrator delays the account of the miners' response with a description of Pluchart: "Il mugissait, son haleine effarait les fleurs de papier peint, sous le plafond enfumé dont l'écrasement rabattait les éclats de sa voix" (253) (he was bellowing, his breath was frightening the painted paper flowers beneath the smoky ceiling from which the bursts of his voice were beating down). This lengthy interruption turns the focus onto Pluchart, and rather than drawing the reader into the miners' enthusiasm for Pluchart's generalities, it reveals the blunt inarticulateness of the speaker: he bellows; his voice is amplified and his words are muddled by the room's echoes. At the same time the reader must recreate the supposed immediate and enthusiastic response of the miners, who are ironically not privy to the same perspective as the reader.

Although Rasseneur's ideological opposition to Etienne seems to set him as the novel's voice of reason because of his moderation, he too is exposed as self-interested. When he is challenged by Etienne to reveal his motives for trying to foil the Pluchart visit, his self-revelation is given in FID. In his speech, Rasseneur tries to show the simplicity of Etienne's approach. The substance of his speech is the following: you can't divide up money the same way you cut up an apple; you can't expect miracles, it is impossible to achieve a reversal of the social order suddenly; you should try to make small improvements when the occasion arises. Despite its inscription within FID the speech retains the rhetorical eloquence of the speaker. Indeed, the introduction to the FID passage indicates the ease with which Rasseneur speaks: "se confessait, en phrases claires, qui coulaient abondantes, sans effort" (244). This ease is in direct contrast with Etienne's following "confession" in which Etienne tries to trace his disorganized course of study. The irony is that while Etienne's confession (245) is full of admissions of illusions corrected and of present ignorance, Rasseneur's speech reads like that of a self-assured veteran. Yet Rasseneur's rea-

sonableness and eloquence come into question when the reader recalls the narrator's early description of him—a former miner turned cabaret owner, who feeds off the miners' daily misery, as they come to his bar to complain to him and to drown their suffering (88). When Etienne organizes the miners into a union and leads them into the strike, Rasseneur's business and his status as labor organizer suffer.

The narrator carefully frames Rasseneur's speeches to the miners with descriptions of the influence of his rhetoric over them rather than his communication with them. At the meeting that follows shortly after the confrontation with Etienne, his speech is introduced: "Ce qui faisait son influence sur les ouvriers des fosses, c'était la facilité de sa parole" (251) (what gave him influence over the mine workers was the facility of his speech). At Plan-des-Dames, the miners' overthrow of his almost priestly influence is accompanied by their rejection of his rhetoric: "Son élocution facile, sa parole coulante et bonne enfant, qui avait si longtemps charmé, était traitée à cette heure de tisane tiède, faite pour endormir les lâches" (287) (his easy way of speaking, his flowing, friendly speech which had charmed for so long, was treated now like warm tea suited to put cowards to sleep).

Like the other activists in the novel, Etienne reveals through his actions the gap of experience that divides him from the miners, even as he addresses the gap between the classes. Yet Zola's portrait of Etienne is more complex, for his division from the miners is traceable to his ambivalent stance toward them and his own internal conflict. When Etienne enters into the lives of the miners, he instinctively feels the injustice of their misery and decides to work for changes. He brings with him the burden of his familial history, which Zola had first treated in L'Assomoir, and he is far from a neutral catalyst. Indeed, Zola's interest in the development of Etienne derives from the writer's broader purpose. Germinal was the thirteenth novel in a series of twenty in which Zola traces the history of one family during the time of the Second Empire. Hence, the themes of Etienne's personality and his "education" and development are woven into the other part of Zola's "socialist" novel.

FIT (free-indirect thought) is a sub-category of FID with all the syntactic indicators of FID that registers the thoughts rather than the speech of characters. Of the approximately 120 cases of FIT spread out among about thirty characters, more than one-third are attributable to Etienne, a far greater percentage than for any other character. This figure attests to Etienne's status as the catalyst and central figure of the novel. Important FID passages from Etienne's speeches to the miners throughout the text serve as signposts of Etienne's education and the communicative distance between Etienne and the miners. The novel marks in broad strokes the development of Etienne as political leader from his vague notion of injustice and his acknowledgment of his ignorance, through his self-education, his preaching to the miners, and the

refinement of his ideas to, finally, his status as labor organizer in the International. Yet this path of development as this labor leader ironically does not lessen the distance between him and his subject, the miners.

Etienne's thought and speech, revealed in FID, shows that his sympathy with the miners is tinged with a sense of superiority that never changes. His thoughts are cast in FID, as he considers leaving the mine after only his first day of work there: "avec son instruction plus large, il ne se sentait point la résignation de ce troupeau, il finirait par étrangler quelque chef" (83) (with his broader education, he would not feel the resignation of this herd, he would end up strangling some boss). The FID of this passage, with its characteristic lack of grammatical conjunctions, does not separate as strongly as direct or indirect discourse would have between the two thoughts of the two main clauses. FID makes it difficult to imagine how Etienne understands the transition of one thought to the other, other than marking a simple contrast in his mind between his active will and passivity of the miners.

This initial distance between Etienne and the miners is further intimated around another passage of FID. In the novel's first scene, the history of the Maheu family's long connection to the mines is recounted in FID by Bonnemort, the grandfather of the Maheus, and it concludes with Bonnemort's ironic observation on the gap between the bourgeois and worker sense of history: "Cent six ans d'abbattage, les mioches après les vieux, pour le même patron: hein? beaucoup de bourgeois n'auraient pas su dire si bien leur histoire!" (37). Besides allowing the further situational irony that arises from the old man's unconscious connection between his pride in his family's history and its long-standing and continual subjugation to the mining company, the framing of the FID gives the impression of Bonnemort's deep resignation concerning the problems associated with the gap between the miners and the owner class which he in many ways represents. A constant, brooding presence in the novel, he carries the marks of forty years of work in the mines. His bad legs and constant coughing and spitting, as well as the question of his pension, keep the novel's focus on the history of injustice and misery in the mines. Yet this is a misery to which Bonnemort has resigned himself. The FID passage is introduced by a phrase that stresses the speaker's withdrawal from the problem of class division and his self-isolation within his memories: "Devant les flammes qui s'effaraient, le vieux continuait plus bas, remâchant des souvenirs" (37). As if in response to the challenges of the world, represented by the flames of the small fire before him, Bonnemort retreats into his reflections, lowering his voice and seeming to forget about Etienne. When at the end of the speech, he seems to stir and expect a response from Etienne, Etienne's preoccupation with his own hunger shows how severely limited the communication is between them. The FID passage points to the fixed ideas of both men and anticipates in a subtle way the communicative gap between miners and Etienne.

Like the other activists, Etienne is prone to vague generalities, mythologies, preaching, and evasive language. It is important that throughout the whole novel, Etienne's speeches of over six lines of text are represented in direct discourse only five times, and only a small number of his speeches are in direct discourse. FID has a way of hiding imprecision and misunderstanding under the cloak of generality. By tracing Etienne's use of the image of the germinating field of avenging miners, one sees clearly that the course of his intellectual development widens the initial gap between the miners and him.

Etienne first sets forth the image of the germinating field that yields an avenging army of unified workers in a speech before a small group of miners in the Maheu household. In this speech, he also notes that the miner was no longer a brute, deaf to the progress in the world, but was now reflecting on his own condition. He then goes on to conjure up the mythological image, which is repeated at the end of the novel. The speech is ironic in two ways. First, the speech's close position in relation to Etienne's self-education intimates a confusion in Etienne between his intellectual progress and that of the miners. In the months leading up to this preaching, Etienne's sense of ignorance about the large questions of social justice is eased: "La honte de son ignorance s'en allait, il lui venait un orgeuil, depuis qu'il se sentait penser" (177) (his shame of his ignorance left him, a pride came to him, ever since he had realized that he was thinking). Hence, when Etienne claims in his speech that the worker was now reflecting on his condition, he is thinking of himself. His enthusiasm for the miner's education is ironically an expression of his enthusiasm for his own education.

That this is a projection of himself onto the miners is confirmed by the other irony of Etienne's speech: throughout the novel there is no evidence of growing worker consciousness. The stimulus to rebellion is exposed as merely another uprising provoked by the miners' vague religious belief that they would overthrow the bourgeoisie as "masters." The miners are depicted throughout as a swelling, chaotic mob whose anger and imagination have been stirred. Etienne's speech itself is not received by the "reflecting" miner as a stimulus to further thought but rather by the hopeful miner in search of a dream. Maheude's reaction to Etienne's rhetoric is typical. Although she initially resists, she gradually gives in to its "charme" (181) and delights in it, not because she believes in it, but because it awakens a vague sense of hope in her and because it affords an escape from the real world: "Elle finissait par sourire, l'imagination éveillé, entrant dans ce monde merveilleux de l'espoir. Il était si doux d'oublier pendant une heure la réalité triste!" (181) (She would end up smiling, her imagination awakened, entering that marvelous world of hope. It was so good to forget harsh reality for an hour). The disjunction between Etienne's exercise of his own intellect and the miners' attraction to a dream is

apparent again in the miners' reception to Etienne's speech at Plan-des-Dames. The miners respond positively to Etienne, not because they understand his "raisonnement techniques et abstraits" (286), but because they are attracted to what most resonates in their hearts, the dream of being masters one day: "Quel rêve! être les maîtres, cesser de souffrir, jouir enfin!" (286–87). Etienne's absorption in his own private education and mythology proves counterproductive to real improvements for the miners.

By the time Etienne evokes the image of the germinating worker the second time, he has gained wide support as leader of the miners. In the central scene of the novel, the miners' meeting at Plan-des-Dames, Bonnemort's displacement by Etienne as the novel's representative voice of miners' consciousness signals not progress but stasis, for Etienne is exposed by his speech as being absorbed in a fixed and highly personal idea. While it seems to the miners that Etienne is helping to bridge the unjust gap between workers and owner, the reader is highly conscious of Etienne's selfish motives and his lack of control over the substance of his vision.

The use of FID highlights Bonnemort's inability to communicate the significance of his experience but also implies his fixation with the past, an attitude which will eventually completely isolate him; by the end of the novel he has withdrawn to a motionless silence. The summarizing effect of FID passages gives the impression that the character is reciting an old, familiar idea which most likely will have little effect on the hearer. For Bonnemort this old idea is that it is counterproductive, dangerous, and truly futile for the miners to challenge the dictates of the mine owners. Later, when he hears that his son, Maheu, will serve as spokesman for the miners before the director of the company, Bonnemort protests that he has seen such negotiations fail: "Dis ce que tu voudras, et ce sera si tu n'avais rien dit. . . . Ah ! j'en ai vu, j'en ai vu de ces affaires!" (224) (Say what you want, and it will seem like you said nothing. . . . Ah! I've seen it, I've seen this kind of thing).

Bonnemort is represented in FID as repeating this claim of experience in his extemporaneous speech at the miners' organizational meeting at Plan-des-Dames. The recasting of the idea in FID anticipates the complete usurpation of Bonnemort's voice by that of Etienne. Already before the FID passage, Bonnemort seems fragile and strangely inarticulate; he is described as having the "pâleur de spectre" in the moonlight and stammers through "longues histoires que personne ne pouvait comprendre" before he comes to rest on the familiar refrain, "il en avait tant vu!" (288). Yet the miners' uneasy and puzzled reception of the speech (289) shows how completely Bonnemort's voice is suspended in this fixed idea. It is here that Bonnemort's failure to communicate reaches its climax; this is the last significant speech of Bonnemort in the novel, and the FID passage anticipates his complete muteness.

Etienne immediately follows Bonnemort with a speech in FID that

recalls and reformulates the family history Bonnemort recounted to him at the beginning of the novel. The introduction to the speech focuses on Etienne's dramatic manner: "Il fut terrible, jamais il n'avait parlé si violemment" (289). Speaking rapidly ("en phrases rapides") and holding Bonnemort up to the miners as a symbol, he reinscribes Bonnemort's family history in terms of exploitation, rising worker consciousness, rebellion, and progress. The miners' enthusiasm for this portrait of things is evident by their applause. Yet, because of the FID, the reader experiences Etienne's eloquence in a much different way from the way the miners experience it. Because of the fluid progression of main clauses in FID, which are easily expressed and do not seem to expect resistance or interruption by an audience and the length and passion of Etienne's speech, the reader loses sight of the communicative setting between Etienne and the miners. As in Pluchart's speech in FID, the movement from FID to indirect discourse in which the speaker is described focuses the reader for a moment solely on Etienne: "Il se tut, mais son bras, toujours tendu dans le vide, désignait l'ennemi, là-bas, il ne savait où, d'un bout à l'autre de la terre" (290) (he was quiet, but his arm, always extended in the darkness, was pointing out the enemy, down there, he didn't know where, from one end of the earth to the other). The sudden transition from the quickly moving FID to this moment of stasis and suspension produces in the reader a sense of the sharp discontinuity between the substance of the speech and its communicative function.

The reader must hear the speech differently because the narrator introduces it in a way that immediately puts it into question. The narratorial commentary of Etienne's self-absorption and egotism surrounding the FID passage is consistent with the narrow focus on Etienne within the FID. Before the reader hears the speech, the narrator has informed the reader of Etienne's ill-digested reading (234), his bourgeois ambition to rise in social prominence, which "il ne s'avouait pas" (234–35), his vanity and desire for popularity (234), and his competition with Chaval for the admiration of Catherine (289). These are the motives behind the speech that are known to the reader but hidden from the miners, that on the one hand condition the reader's understanding of the speech, and on the other help explain the peculiar effect of the FID. Hence, the progress felt by the miners with the usurpation of Bonnemort's caution and resignation is illusory, and the distance between the workers and owners remains.

The gap between Etienne and his hearers is characterized by the transformation of Etienne's self-delusion in his role as progressive leader into a broader and more intense madness among the miners. This is evident in the central scene of the meeting at Plan-des-Dames. In the midst of the meeting, there is a series of enthusiastic speeches that the narrator characterizes as expressions of the "folie de la foi" (291) (madness of faith). This chaotic

fanaticism, which is beyond anything Etienne can control, threatens violence. The transfer of Etienne's limited, intellectual delusion to the intensely emotional delusion of the crowd is traced by the periodic evocation of the moon throughout the scene, which is used to punctuate, first, Etienne's thoughts and then the miners' enthusiastic reception of Etienne's speech. As the meeting begins, the sky promises the "lune pleine," and its rising is tracked from its position behind the forest (283) to when it suddenly rises free and shines on Etienne just as he proclaims in FID, "Le peuple des mineurs n'avait donc qu'à reconquérir son bien" (285) (the miners had only to reconquer their possessions). The presence of the moon stresses the unrealistic, simplistic quality of this thought. Etienne's naivete, however, is amplified by the crowd. Finally, as Etienne's speech has unleashed the miners' hopes, anger, and frustration, the whole crowd is bathed by the moon's light: "Et la lune tranquille baignait cette houle, la forêt profonde ceignait de son grand silence ce cri de massacre" (291) (and the tranquil moon bathed this swell, the deep night girded with its grand silence this murderous cry). The moon, symbol of deceit and mutability, bathes the miners soothingly in their delusion, and the thick, encircling forest defines the Plan-des-Dames as the enchanted forest of the proletariat dream. Yet the end of the scene suggests that their violent enthusiasm may spill over into the real world. When they resolve at the end of the meeting to meet at Jean-Bart the following day—the miners' cries of massacre rise up and are dissolved beneath the moon: "L'ouragan de ces trois mille voix emplit le ciel et s'éteignit dans la clarté pure de la lune" (292) (the hurricane of those three thousand voices filled the sky and died in the pure clarity of the moon). Their cry of "death to the traitors" ironically forecasts their own.

Etienne's fall in popularity exposes his condescending view of the miners: "Quelle brutalité imbécile! quel oubli abominable des services rendus! C'était une force aveugle qui se dévorait constamment elle-même" (433) (What stupid brutishness! what abominable forgetting of his service to them! It was a blind force that constantly devoured itself). The language of brutishness and blindness in the FID contradicts the rhetoric of Etienne's speeches throughout the novel in which he sets forth the image of the new, thinking worker—"l'ouvrier réfléchissait à cette heure" (179)—and thus, the FID passage reveals the disjunction between Etienne's deep-seated sense of superiority toward the miners and his coveted role as their leader. This disjunction, however, is not simply hypocrisy, but a sign of the inveteracy of Etienne's delusion and prejudice that living with the miners has only further deepened, for at the very end of the novel, as Etienne is leaving the village for his new post in Paris and sees workers returning resignedly to the mine, his thoughts are cast again in the same messianic language: "il recommençait le rêve de les changer en héros, de diriger le peuple, cette force de la nature qui se dévorait elle-même" (494) (he

returned to the dream of transforming them into heroes, of leading the people, this force of nature which devoured itself). As he leaves, ironically he feels joy, for he considers his education complete: "Il son éducation était finie" (499). Yet the FID passages have exposed the fact that he has continued to view miners as things, mere instruments for his ambition.

This irony makes it exceedingly difficult to read the end of the novel as hopeful, as it is an expression of Etienne's deluded ideas. By the time he leaves, he has become identical to Pluchart: "Il méditait d'élargir son programme, l'affinement bourgeois qui l'avait haussé au-dessus de sa classe le jetait à une haine plus grande de la bourgeoisie" (499) (he was considering expanding his program, the bourgeois refinement that had raised him above his class threw him into an even greater hatred of the bourgeoisie). His joy as he leaves is ironic, for as he revels in springtime, he forgets about the massacre here only two months earlier. Indeed, his departure intimates his parasitic relation to the miners—like Rasseneur, he has fed off their misery. The contrast with which the novel is framed—between Etienne's arrival at the mines at the novel's opening and his departure at its close—is clear. He had arrived famished, weak, and jobless; when he leaves, he is heading confidently to a new job in Paris, dreaming of utopian societies and leaving chaos behind him.

NOTES

1. Zola's interest in depicting accurately the community of miners in northern France in the 1860s and their lives during a general strike, as well as the size, structure, and condition of the mines themselves has been very well documented. Henri Marel has transcribed and published Zola's *Mes notes sur Anzin,* the writer's detailed observations culled from a brief ten-day visit to the mining town in 1884 (Marel 41–102). A comparison of these notes with *Germinal* reveals that the notes largely supply, as Richard Zakarian points out, the sociological and technological details of the novel (41). The description of the miners' lives—of the topography of the mines and the working conditions within them, the miners' pay, the division of labor, and the hierarchy of power, among many other things—is based in fact, as are the main events of the novel: the miners' strike, their rebellion and rioting, and the tragic collapse of a mine. Zakarian's useful source studies of *Germinal* show Zola's essential faithfulness to the scientific and sociological treatises or documents from which the writer took statistical or otherwise scientific material, usually synthesizing data from two or more sources, to supplement his own observations (41–60). Philip Walker even characterizes Zola's journalistic method of observing and gathering information as a "cult of fact" and cites the writer's own acknowledgment of his obsession for "true detail" (2–3).

2. Marel cites the earlier French works on mines by Guyot and Talmeyr, as well as Malot's *Sans famille* and Verne's *Les Indes noires,* which treat coal mining only tangentially (41).

3. For a detailed discussion of the issue of Zola's conception of the novel, see Zakarian 9–15 or Lejeune 63.

4. For an extensive survey of the linguistic characteristics of FID, see McHale 249ff.

5. Weinburg directly responds to the feeling held by two prominent theorists of FID, Charles Bally and Ann Banfield, that irony and FID are incompatible.

6. Despite Zola's devotion to historical accuracy, Graham Holderness notes that the "emotional intensity" with which the miners are represented "disturbs the balanced externality of documentary statement." This irruption of emotion into the natural text has been explained in various ways. According to Holderness, this emotional intensity is derived paradoxically from Zola's radical unfamiliarity with the miners' lives. This "gap of experience" cannot be bridged with facts, so it becomes the site of the writer's mythologizing (21). Paule Lejeune cites Zola's too close reliance on the traditional trappings of the novel. Thus, she too traces it to Zola's basically bourgeois conception of the world (75–76). Walker's explanation is based on his reading of a wide variety of Zola's writings, letters, and essays as well as novels, in which the writer observes the horrible state of mankind (11–21).

7. All the translations of *Germinal* in this essay are mine.

WORKS CONSULTED

Dussinger, John A. "'The Language of Real Feeling': Internal Speech in the Jane Austen Novel." In *The Idea of the Novel in the Eighteenth Century,* edited by Robert Uphaus. East Lansing: Colleagues, 1988.

Flavin, Louise. "*Mansfield Park:* Free Indirect Discourse and the Psychological Novel." *Studies in the Novel* 19, no. 2 (1987): 137–59.

Hernadi, Paul. "Dual Perspective: Free Indirect Discourse and Related Techniques." *Comparative Literature* 24 (1972): 32–43.

Holderness, Graham. "Miners and the Novel: From Bourgeois to Proletarian Fiction." In *The British Working-Class Novel in the Twentieth Century,* edited by Jeremy Hawthorn, 19–32. London: Arnold, 1984.

Lejeune, Paule. *"Germinal": Un Roman antipeuple.* Paris: A. G. Nizet, 1978.

Marel, Henri. *"Germinal": Une Documentation intégrale.* Glasgow: Univ. of Glasgow Press, 1989.

McHale, Brian. "Free Indirect Discourse: A Survey of Recent Accounts." *PTL: A Journal for Descriptive Poetics and Theory* 3 (1978): 249–87.

Niess, Robert J. "Remarks on the Style Indirect Libre in *L'Assomoir.*" *Nineteenth Century French Studies* 3 (1975): 124–35.

Oltean, Stefan. "Textual Functions of FID in the Novel *Mrs. Dalloway* by Virginia Woolf." *Revue roumaine de linguistique* 26, no. 6 (1981): 533–47.

Peitrequin, Raymond. "De Madame Bovary a Mrs. Dalloway." *Etudes de lettres* 1 (1983): 31–42.

Shaw, Narelle. "Free Indirect Speech and Jane Austen's 1816 Revision of *Northanger Abbey.*" *Studies in English Literature* 30, no. 4 (1990): 591–601.

Walker, Philip. *"Germinal" and Zola's Philosophical and Religious Thought.* Amsterdam: Benjamins, 1984.

Weinberg, Henry H. "Irony and Style Indirect Libre in *Madame Bovary.*" *Canadian Review of Comparative Literature* 8, no. 1 (1981): 1–9.

Zakarian, Richard H. *Zola's "Germinal": A Critical Study of its Primary Sources.* Geneva: Librarie Droz, 1972.

Zola, Emile. *Germinal.* Paris: Flammarion, 1968.

7

Gripped by the Ultimate Master

MINING, MANHOOD, AND MORBIDITY IN D. H. LAWRENCE'S "ODOUR OF CHRYSANTHEMUMS"

Peter Balbert

Bavarian gentians, big and dark, only dark darkening the day-time,
torch-like with the smoking blueness of Pluto's gloom

D. H. Lawrence, "Bavarian Gentians"

There is strong consensus on the precocious excellence of D. H. Lawrence's
early short story "Odour of Chrysanthemums," a work set near the time and
place of his birth late in the nineteenth century in the Eastwood Colliery dis-
trict of England. Commentators on this tale typically stress such central issues
as the two-stage revisions of the story that culminate in the powerful ending
of the last version in 1914, or the rich evocation of the Brinsley mining region
that frames the tragedy of Walter Bates's gruesome death in the pits, or the
revealing reflections of Lawrence's own embattled family that emanate from
the story's drama of grandparents, parents, and children trying to cope with
economic, physical, and emotional exigencies amid the dangerous and thriv-
ing coal industry of the Midlands.[1]

Within this impressive range of criticism accumulated over several
decades, there remains insufficient attention to an integration of these issues

in the interpretations of such a gritty and visionary work. That is, critics have failed to note the provocative interconnections among the impinging themes of family life, biographical relevance, industrial blight, and coal-mining conditions. On the latter issue, the chance of sudden death underground looms as a constant reality of the collier's strenuous and exhausting job. A variety of statistics provides a sobering index to the lack of improvement in the basic state of mining in England over two generations. In 1910, just after Lawrence completed an early version of the tale, there was no reduction *over the previous* forty years in the absolute number of deaths in the mines: 1,000 per year in the 1870s, and 1,000 per year in 1910 (Poplawski 129).[2] In more graphic terms accumulated over a longer time span, the facts appear even more distressing: "A British miner was killed every six hours, perilously injured every two hours, and injured bodily enough to need a week off every two or three months" (Worthen, *D. H. Lawrence* 43). The number of mining accidents dramatically increased during the winter months, with more working hours always required of the men during the season of the highest demand for coal. During the winter interval in which Walter Bates's death occurs in the story, miners worked up to five and a half shifts per week, virtually double the requirement of weekly shifts from April to September.

While "Odour of Chrysanthemums" remains a compelling and finely crafted work of fiction, its intense concern with a collier's family in Eastwood brings us close to Lawrence's biography in many ways. Actual place-names in the vicinity of his birthplace are cited, and a random selection of given and family names forms a reminiscent collection from Lawrence's youth. He also recreates the physical aspects of the neighborhood at the turn of the century with great detail, as he places the Bates cottage "by the railway crossing at Brinsley, a mile north of Eastwood and south of Underwood and Selston Colliery, which are also mentioned in the story. . . . The cottage here is based on Quarry Cottage, Lawrence's grandfather's cottage, later his uncle's at Brinsley; and the death of Walter Bates . . . is based on the death of Lawrence's uncle, James Lawrence (b. 1851) in a fall of coal at Brinsley Colliery on 17 February 1880" (Poplawski 309). John Worthen, the most recent and authoritative chronicler of Lawrence's early years, provides an important summary of the range of the miners' responsibilities and the considerable risks they encountered every day. The following description pertains directly to Lawrence's father, but the short story suggests how these facts carry an ominous importance for the more unfortunate Walter Bates:

> His first job, after going underground at the age of 10, would have been opening and shutting the wind- and fire-proof doors for the passage of ponies and coal tubs. He would probably have progressed to working with the ponies; then, as a "dayman," he would have joined a

team of three or four men working under the direction of two or three "butties." The butties were responsible for the working of a specified section, a "stall," of the coal face; the managers paid them each week (by weight) for the coal the stall produced, which was weighed at the pit-head in tubs marked with their stall number. The daymen—on a fixed daily wage—loaded the coal into the tubs, despatched them to the bottom of the shaft and got rid of waste material; they worked behind the "holers," also on daily wages, who actually cut the coal by digging out the bottom of the seam to create a hole into which the overhanging coal could be broken. The butties themselves worked as supervisors and holers. After the weekly wages of the daymen and holers had been paid, and expenses for blasting powder and candles had been met, the butties would divide up the remaining money. Thus they received the profits after the wages of the others had been paid. If the daymen had been slack, or inefficient or—more likely—one of them had had an accident which slowed down or stopped the filling and movement of coal tubs, then the butties' profit suffered. When he was about 17 or 18, Arthur would perhaps have started as a holer— the most profitable job in the pit below the level of butty or manager, but also the most dangerous. (*D. H. Lawrence* 11)

Given the age of the two children in the story, as well as the circumstances leading to Walter's death (he stayed late to complete his digging assignment), it seems likely that he was a dedicated holer working for a butty team. His wife and mother exhibit an acute awareness of the threat of serious accidents, and the Lawrence family lived for years with the same gloomy realization: "Arthur Lawrence was hurt several times underground: badly in November 1903, when he was left with a limp for the rest of his life by the 'compound fracture of the right leg'; again in 1904, when he 'was struck on the back by a fall of bind, and, falling on a quantity of debris, was badly crushed internally.' He was hurt again in July 1909" (Lawrence, *Letters* 132, qtd. in Worthen, *D. H. Lawrence* 43).

Such appalling statistics about death and injury in the mines do not fully account for the complex tensions that Lawrence experienced in his home as a boy and then recreated in several great works of fiction. Women such as Gertrude Morel in *Sons and Lovers* and Elizabeth Bates in "Odour of Chrysan- themums" resemble Lawrence's mother, Lydia Lawrence, in their reluctant and often embittered membership in the Brinsley mining community; this estrangement reflects an ambition for their children's careers and a class- conscious distaste for the occupation of their husbands. It is noteworthy that the only explicit reference in Lawrence's letters about the emotional texture of this story remains his comment that the work is "full of my childhood's

atmosphere" (*Letters* 471)—an intriguing assertion, no doubt, given the psychological disarray in the Bates family that ultimately results in a wife's stunned insight about the pervasive denial that informs her marriage. Thus it may be helpful here to summarize the embattled context of Lawrence's life in a miner's home when he was approximately the age of young John in the story:

> Home life for the Lawrence children became polarized between loyalty to their mother as she struggled to do her best for them, in scrimping and saving and encouraging them in taking their education seriously, and a rather troubled love for their father, who was increasingly treated by his wife as a drunken ne'er-do-well and who drank to escape the tensions he (as a consequence) experienced at home. Lydia Lawrence consciously alienated the children from their father and told them stories of her early married life . . . which they never forgot or forgave their father for. All the children, apart from the eldest son, George, grew up with an abiding love for their mother and various kinds of dislike for their father. Arthur Lawrence, for his part, unhappy at the lack of respect and love shown him and the way in which his male privilege as head of the household was constantly being breached, reacted by drinking and deliberately irritating and alienating his family. It seems quite likely that, for long periods of their childhood, his drinking and staying out in the evenings, until his tipsy return would lead to a row, effectively dominated the children's experience. His behavior—and his spending of a portion of the family income on drink—caused all the major quarrels between the parents. (Worthen, "Biography" 10)

While the story alludes to earlier occasions of Walter's extended drinking and absence from the home, it is Worthen's comment about Lydia's conscious alienation of the children from their miner-father that interests me in light of Lawrence's subtle characterizations in the tale. The biographer properly understands—before Elizabeth Bates will reach such elusive knowledge—that "as always, the problems with the marriage did not stem from the behavior of only one of the partners. Lydia Lawrence certainly played her part in alienating the children from their father and in setting the agenda for their behavior. They were *not* to look forward to becoming colliers, like their uncles and their fathers and like the vast majority of their contemporaries at school" ("Biography" 11). In this delicate area of an evenhanded consideration of his parents' marriage, Lawrence himself would become more aware in his later years of the extent to which his mother lacked both sympathy for the exhausting aspects of Arthur's job and understanding of his need for a male solidarity and companionability that did not stop at the conclusion of his daily shift underground: "His visits to the pub—the focus of so much anger and bitterness in

the Lawrence marriage—were not to drink. In the words of an Eastwood miner a generation later, 'Got to be a man, to go in the pubs, or you were out of it.' In the pub, Arthur Lawrence was with men whom he understood, and who understood him; 'their interests were his interests,' and in the pub he was 'more sure of himself' than he could be in his own home. For Lydia Lawrence, such visits were a waste of money, self-indulgent and dangerous: the husband who drank and ruined his family was a threat of which she . . . was very conscious" (Worthen, *D. H. Lawrence* 22–23).

What results in the short story from such irreconcilable opposition in the marriage is an atmosphere of resignation about the day's events and the larger pattern of life—as if both the Bates family and Lawrence-as-narrator sense the grip of a deathly influence that informs the present and strangely predicts the future. This determinism has helped to poison the relation between Walter and Elizabeth even as it pervades the colliery environment in which their domestic struggle is enacted. There will be no real escape or solution for them; the husband must define himself as a miner, and his wife must belittle the habits and demands of his self-definition. The mine may offer the Bates family a reasonable living, but it helps to produce its brand of emotional mayhem even before Walter is killed. Although the "master" of this household is never shown alive in this tale, it is hard to avoid intimations of the manhood in her husband that Elizabeth has killed within a colliery region long accustomed to the violent death of men. For instance, she will not permit her children to forget their father's history of alleged excess at the pubs, and—more significantly for his reduced stature at home—she ridicules him in front of John and Annie in ways that recall Lydia's energetic emasculation of Arthur Lawrence.

This syndrome of blame begins with a revealing exchange between daughter and mother as they wait futilely for Walter's return. The mother insists that her worried child get beyond fears for Walter's safety to the likelihood that a deficiency in character explains his absence: "The child became serious. She looked at her mother with large, wistful blue eyes. 'No, mother, I've never seen him. Why? Has he come up and gone past, to Old Brinsley? He hasn't, mother, 'cos I never saw him.' 'He'd watch that,' said the mother bitterly, 'he'd take care as you didn't see him. But you may depend upon it, he's seated in the 'Prince O'Wales.' He wouldn't be this late'" (287). Thus the wife indicts him not only for indulgence, but for subterfuge and cowardice. "You may depend upon it" stands for Elizabeth's distaste for the community, the larger environment, and the habits of her husband, and she remains convinced that all established patterns will continue. Although Elizabeth will not recognize the cyclical quality of cause-and-effect in this marriage, the depressing facts speak for themselves: the more Walter looks for the necessary support and camaraderie of males at the pubs, the more his character is undercut by Elizabeth at home—a condition that sends him more often to the pubs, making

him less of the traditional man-in-charge when he returns to his family, and thus the destructive cycle continues.

This inevitability of domestic tension is framed by a fatefulness in Eastwood about death that extends beyond the home to the surrounding coal-mining region. Lawrence superbly uses the opening page of "Odour of Chrysanthemums" to establish the atmosphere of pervasive pathology so crucial to the tale:

> The small locomotive engine, Number 4, came clanking, stumbling down from Selston with seven full wagons. It appeared round the corner with loud threats of speed, but the colt that it startled from among the gorse, which still flickered indistinctly in the raw afternoon, outdistanced it at a canter. A woman walking up the railway line to Underwood, drew back into the hedge, held her basket aside, and watched the footplate of the engine advancing. The trucks thumped heavily past, one by one, with slow inevitable movement, as she stood insignificantly trapped between the jolting black wagons and the hedge; then they curved away towards the coppice where the withered oak trees dropped noiselessly, while the birds, pulling at the scarlet hips beside the track, made off into the dusk that had already crept into the spinney. In the open, the smoke from the engine sank and cleaved to the rough grass. The fields were dreary and forsaken, and in the marshy strip that led to the whimsey, a reedy pit-pond, the fowls had already abandoned their run among the alders, to roost in the tarred fowl house. The pit-bank loomed up beyond the pond, flames like red sores licking its ashy sides, in the afternoon's stagnant light. Just beyond rose the tapering chimneys and the clumsy black headstocks of Brinsley Colliery. The two wheels were spinning fast up against the sky, and the winding engine rapped out its little spasms. The miners were being turned up.
>
> The engine whistled as it came into the wide bay of railway lines beside the colliery, where rows of trucks stood in harbour. Miners, single, trailing and in groups, passed like shadows diverging home. At the edge of the ribbed level of sidings, squat a low cottage, three steps down from the cinder track. A large bony vine clutched at the house, as if to claw down the tiled roof. Round the bricked yard grew a few wintry primroses. Beyond, the long garden sloped down to a bush-covered brook course. There were some twiggy apple trees, winter-crack trees, and ragged cabbages. Beside the path hung dishevelled pink chrysanthemums, like pink cloths hung on bushes. A woman came stooping out of the felt-covered fowl-house, half-way down the garden. She closed and padlocked the door, then drew herself erect, having brushed some bits from her white apron. (283–84)

The editor and novelist Ford Maddox Hueffer surely was correct to praise the evidence of Lawrence's genius in this passage, but Hueffer's stress on the artist's realism and working-class origins perhaps prevented him from noting the visionary power and anticipatory symbology embodied in the lines.[3] For behind the precise physical details and evocative landscape, there exists (even this early in his career) Lawrence's characteristic ability to create a "dispirit of place" through metaphors and mythologies that—amid the first wave of modernist innovation—properly bend the conventional limits of realistic fiction. As the short story opens, Lawrence's perspective reveals how the Brinsley area is so rife with mechanical dependency and industrial by-product that the domains of the domestic and the pastoral offer no haven from this encroachment. The passage is not only organized by opposition and counterpoint, but also by relative indices of power and effect. The colt, for instance, runs faster than the engine, but the animal only wins when it is startled into a cantering pace that will not be sustained. For the reality is that "the slow inevitable movement" of machines in this industrialized setting in the Midlands already has vanquished much of the flora and fauna, and its influence has affected the natural scenery and workers' homes in the area.

Lawrence does not mince words as he starts the story with this tapestry of degradation. It is more than noise and fire that predominate near the pits; we also feel the omnipresent residue of smut, smoke, ash, and coal dust that blacken the land and lungs of the inhabitants. Indeed, the story avoids Lawrence's usual typology of an enriching and animate darkness, for now the focus remains on a shadowy pall that is shot through with livid flames.[4] Such a darkness enters the respiratory tracts of Brinsley colliers and often permeates their skin, as Lawrence later describes a telltale emblem on Mr. Rigley, a colleague of Walter Bates: "a blue scar, caused by a wound got in the pit, a wound in which the coal-dust remained blue like tattooing" (292). The cumulative effect of living in this environment is not difficult to predict:

> There were regular epidemics: measles, diphtheria, diarrhea, scarlet fever, and whooping cough; in the late nineteenth century, respiratory diseases (tuberculosis and bronchitis) accounted for 17% of deaths in the area. The writer who died of pleurisy and tuberculosis in 1930, at the age of 44, remarked just before he died that "I have had bronchitis since I was a fortnight old." But many families suffered worse than the Lawrences. The Cooper family with their five daughters would be next-door neighbours in Lynn Croft in the 1900's, and Tom Cooper the Lawrence's landlord. The mother, Thirza Cooper, died of "Pulmonary Tuberculosis & cardiac failure" in July 1904 at the age of 55: and all five daughters suffered from Tuberculosis. Ethel died of "Phthisis/Pulmonalis/Exhaustion" early in 1905, when she was 17;

> Mabel Hannah Cooper Marson died of "Pulmonary Tuberculosis" at
> the age of 34, in February 1916; Francis ("Frankie"), died of "Pul-
> monary Tuberculosis and Exhaustion," also at 34, in December 1918;
> Florence Cooper Wilson, died of "Laryngeal Tuberculosis" in July 1924,
> at 43; and Gertrude ("Gertie")—also suffering from tuberculosis, and
> living with Lawrence's sister Ada in nearby Ripley from 1919—had a
> lung removed in 1926, when she was 41. Gertrude was the only one
> of the sisters to live beyond her mid-forties: she died at the age of 57.
> (Worthen, *D. H. Lawrence* 5–6)

In this hellish landscape, oaks have withered, grass has coarsened, ponds are
reedy, alders are abandoned—all part of a toxicity that will exert even more
power in the years to come. Lawrence's use of anthropomorphic imagery sug-
gests the emblematic art of Spenser's *The Faerie Queene,* a work that Lawrence
had studied carefully in school and that he significantly refers to in his per-
sonal correspondence before and during the composition and revision of the
story.[5] The pit banks, with their red sores and ashy sides, also terrify because
of the frightening theme that Dante employs so magnificently throughout *The
Inferno:* morbidity can be animate, eternal, and growing. The beginning of the
third paragraph suggests the extent of this infiltration within the body and
spirit of the miners: they pass as mere shadows as the chiaroscuro reflection
of their soot-covered bodies arrayed against the waning daylight, and also
because of the total enervation that has made them the shadow-replicas of liv-
ing humanity. Note how such pathology even extends, in *literal terms,* to the
Bates house, as skeletal vines, acting as messengers from the heated under-
ground, grip the roof in an effort to pull it down.

Thus the preeminent force in this environment remains the omnipresence
of death and darkness, with the most "alive" elements in the opening tableau
depicted as a woman who "drew herself erect," and as several pink chrysan-
themums, disheveled but very much filled with life. Throughout "Odour of
Chrysanthemums" Lawrence recreates the strong will and conviction of his
mother in the depiction of Elizabeth—a woman who, like Lydia Lawrence,
feels alienated from her community and husband by aspiration, temperament,
and sense of style. Lydia's power may cruelly undercut her husband's author-
ity in the family, but Lawrence will grant in this story—as he will acknowledge
about his mother—that it requires an impressive stability and single-minded-
ness for a woman to pursue her own direction amid the industrial detritus
near Brinsley Colliery. Elizabeth Bates's erect bearing and precisely parted
hair are the signatures of his mother's strength and will. If there is illness and
blight all around her, she will combat them with fastidiousness and
adamance. She is depicted as disillusioned about her husband and his job, yet
amid her resentment and frustration she is described as "calm and set"—the

very attributes that later will hold the family together in the actual wake of Walter's death. She attempts to keep her son from the contaminated brook, and she must sense that the unwieldy fit of the boy's clothes represents a threat that she will guard against: "He was dressed in trousers and waistcoat of cloth that was too thick and hard for the size of the garments. They were evidently cut down from a man's clothes" (284). John wears the pants as a matter of economy, for they have been passed down from collier to son. The Eastwood families, generation after generation, inherit the work in the mines as well as the heavy clothes. Manhood near Brinsley Colliery is unequivocally defined by heavy labor in or near the pits, and Elizabeth realizes that without her intervention (as Lydia demonstrated with Lawrence), John soon will wear the pants of his father too well.

Lawrence continues to chart the formidable aspects of this angry wife who fights against a regional morbidity that—as Elizabeth realizes—also encourages a generalized carelessness about things that live: "As they went slowly towards the house he tore at the ragged wisps of chrysanthemums and dropped the petals in handfuls among the path. 'Don't do that—it does look nasty,' said his mother. He refrained, and she, suddenly pitiful, broke off a twig with three or four wan flowers and held them against her face" (284). It is a small moment, but the lines suggest that a life in opposition to her community has made her into an obsessed woman who will continue her battle at every opportunity. It is important to her that this walkway not be littered with petals—a strange concern amid the more encompassing disarray and decay in the vicinity. Lawrence accommodates some subtle distinctions here in his characterization of the wife-mother. While there may be something admirable in Elizabeth Bates's compulsive efforts to oppose the morbidity of Eastwood, her consequent willfulness and dissatisfaction have the effect of setting the children against the father and of derogating a manhood in Walter that flows from and is required in his job as a miner. Lawrence further demonstrates this dangerous propensity in Elizabeth early in the story by including a scene involving her own father, an engine driver for the mining company in his late years. As a widower, he apparently has been courting a woman whom he wishes to make his second wife. The father senses that Elizabeth disapproves of the timing of this large step in his life, but he wants the blessing of his strong-willed daughter for a proposed engagement. After such approval from Elizabeth is provided with only irony, he still receives a snack of tea and bread from her. Content with her solicitude, he then rewards her with some gossipy incitement about Elizabeth's husband:

> "I hear as Walter's got another bout on," he said.
> "When hasn't he?" said the woman bitterly.
> "I heerd tell of him in the 'Lord Nelson' braggin' as he was going to spend that b——— afore he went: half a sovereign that was."

"When?" asked the woman.

"A' Sat'day night—I know that's true."

"Very likely," she laughed bitterly. "He gives me twenty-three shillings."

"Aye, it's a nice thing, when a man can do nothing with his money but make a beast of himself!" said the grey-whiskered man. (286)

This vignette depicts an unseemly tattling from an elderly and "above-ground" worker about his son-in-law, the collier; his aspersions are offered to a daughter who appears to relish the news (reliable or not) as more fuel for her righteous anger. There is no effort by her father to put the rumor into some perspective—neither about its veracity nor about the framework of a miner's working day.

What added information might we require in consideration of this exchange between father and daughter? It is appropriate to see Walter as a version of Lawrence's father, and the following comments by John Worthen surely have relevance to Lawrence's early fictional work about a miner's family: "Nearly all colliers drank, and Arthur Lawrence apparently drank no more than the rest; mining is a hot, dry, and dusty job, and drinking very little during eight hours or so underground (miners could only drink what they took with them: cold tea was usual) meant that they ended up extremely thirsty. If they could afford it, the pub on the way home or in the evening—with their workmates—was part of the routine. The crucial point was whether they missed work because of their drinking" (*D. H. Lawrence* 21). It is significant that there is no mention by Elizabeth or Walter's coworkers of any history of missed work by him. The influence on the Lawrence children of Lydia's undisguised disapproval of her husband was overwhelming, and this short story contains echoes of the entrenched tensions from Lawrence's childhood. For instance, Elizabeth's father's charge that Walter "can do nothing with his money but make a beast of himself" (285), recalls what "George Neville recorded Lawrence saying after a row with his father around 1906, 'He is a beast, a beast to mother, a beast to all of us'" (Worthen, *D. H. Lawrence* 58). In this regard, Worthen explicitly suggests the extent to which the children are the victims in Lydia's campaign to undercut her husband: "Lydia Lawrence seems not only to have excluded her husband from the everyday life of the home, but as far as possible to have forced the children into making a moral choice against him. The children's polarisation between their loyalties to father and mother led to what Ada called the 'misery in our childhood'" (*D. H. Lawrence* 57).

With the battle lines drawn in the story between the absent husband and angry wife, and with the children caught in the middle of this repeated conflict, the tone now changes to include a coincidental pattern of fatefulness that

adds a mystical texture to the tale. Lawrence employs, in effect, a rhetorical technique of prophetic double entendre as the revelation of the miner's death draws closer. Our attention is first drawn to the children's notice of a random piece of chrysanthemum caught in Elizabeth's apron. The mother responds to her daughter's comment that the flowers "smell beautiful" with an unkind denial of Annie's judgment about the odor; she then ominously explains her negativism about the chrysanthemums by referring to this flower's persistent significance in the history of her connection to Walter. Her comments are neither sentimental nor discursive, but poetic and anticipatory, as if they begin to confirm a fear that she will not state to her children: "It was chrysanthemums when I married him, and chrysanthemums when you were born, and the first time they ever brought him home drunk, he'd got brown chrysanthemums in his button-hole" (289). Just before this lyrical but discomforting rumination by Elizabeth, Lawrence returns to the mood of discontent in the wife through a similar exchange with her son: she minimizes John's praise that "it's beautiful to look in the fire" by ignoring his precocious comment about beauty and gratuitously reminding him that "it'll want mending directly" when the father arrives to typically "carry on" about the warmth in the house (287). In an essay on miners that he wrote late in his life in the context of his own revisionist feelings about his mother's treatment of his father, Lawrence in effect offers a relevant perspective about why Elizabeth Bates might use her children's affirmation of beauty as an occasion to undercut her husband. The following lines recall not only Annie and John's aesthetic pleasure about the flower and the fire, respectively, but also Elizabeth's fear of her children's inheriting their father's instincts and her compulsive need to pick up the petals on the path: "Now the colliers had also an instinct of beauty. The colliers' wives had not. . . . They didn't even care very profoundly about wages. It was the women, naturally, who nagged on this score. . . . With the women it was always: This is broken, now you've got to mend it! . . . Now the love of flowers is a very misleading thing. Most women love flowers as possessions, and as trimmings. They can't look at a flower, and wonder a moment, and pass on" ("Nottingham" 112–13).

Such abrasive comments by Lawrence surely strike us today as reductive sexual politics, but they intriguingly capture an aspect of the short story that he would twice revise until Elizabeth accepts her portion of blame for the state of her marriage. For the fateful comments about chrysanthemums are followed by lines that in a few hours coincidentally will confirm and contradict respective elements of Elizabeth's angry assertion: "Eh, he'll not come till they bring him. There he'll stick! But he needn't come rolling in here in his pit-dirt, for I won't wash him. He can lie on the floor—Eh, what a fool I've been, what a fool!" (289). Elizabeth of course, does not realize the ominous nature of her defiant words. Lawrence can justify such an intrusive pattern of

double meaning because the story—beginning with the tour-de-force first page—offers an uncompromising emphasis on the Brinsley region's saturation with disease and death. As Elizabeth reiterates her contempt for her husband's habits, Lawrence uses the subtext of her words to bring Walter's destiny into closer focus: "'They'll bring him when he does come—like a log.' She means there would be no scene. 'And he may sleep on the floor till he wakes himself. I know he'll not go to work to-morrow after this'" (290). Then Lawrence employs a poignant moment of refracted narration to display Elizabeth's nurturant instincts at war with her tendency to assign absolute blame for the conflict in the Bates home: "The mother looked down at them, at the brown silken bush of intertwining curls in the nape of the girl's neck, at the little black head of the lad, and her heart burst with anger at their father, who caused all three such distress" (290).

At this point in the story, there is no recognition by Elizabeth of the mutuality of blame, and no understanding of how her persistent and unqualified criticism of Walter in front of the children amounts to an attack against his manhood at home and his self-definition as a collier. Significantly, when Mrs. Rigley responds to Elizabeth's queries about Walter's whereabouts, this fair-minded neighbor, who is also a miner's wife, uses a term that long ago lost its meaning in the Bates home; Elizabeth's added comment conveys a graphic precision that she shortly will encounter: "'Jack never said nothink about—about your Master,' she said. 'No!—I expect he's stuck in there!' Elizabeth Bates said this bitterly, and with recklessness" (291). Her conversation with Mrs. Rigley ends with an unkind and thinly disguised impatience about her neighbor's thick Midlands dialect, and with a comment that concludes her pattern of unintentionally fateful pronouncements: "I expect 'e's gone up to th' 'yew tree,' as you say. It's not the first time. I've fretted myself into a fever before now. He'll come home when they carry him" (202).

Yet even before Elizabeth can comprehend her role of "codependency," Lawrence displays her significant strengths when she first learns of her husband's death. Thus a woman who is eager to censor the liberties of her miner-husband, remains an organized and protective woman where her children are concerned. Amid the trauma of Walter's body arriving at the Bates home, she understands the crucial importance of not waking the children. And here, in a kind of stunned slow motion—as her awareness tentatively develops about the prophetic symbol of the flowers—Lawrence focuses on her acute perceptions of what needs to be done, even to the extent of preserving the rug: "There was a cold, deathly smell of chrysanthemums in the room. Elizabeth stood looking at the flowers. She turned away, and calculated whether there would be room to lay him on the floor, between the couch and the chiffonier. She pushed the chairs aside. There would be room to lay him down and to step round him. Then she fetched the old red tablecloth and another old cloth,

spreading them down to save her bit of carpet. She shivered on leaving the parlour; so, from the dresser drawer she took a clean shirt and put it at the fire to air" (296). When the corpse is brought into the room, it enters by way of the nailed pit boots, for Walter's function as a collier defines his death just as it dictated his life. In terms of the bizarre nature of the accident in the pits, the carrier returns to the theme of destiny in this story with his telling comment, "seems as if it was done o' purpose. Clean over him, an' shut 'im in, like a mouse-trap" (297). The carriers know exactly how to behave during the delivery of the bodies of colliers to their families—"none of them spoke till they were far from the wakeful children" (298)—for they have abundant practice in these late-night missions at Brinsley.

When Elizabeth first encounters Walter's body, she sees him "lying in the naive dignity of death" (299), as the solemnity and strangeness of the state brings him a stature and "otherness" that she would never acknowledge during his life. Her education in the power of death to trample her easy assumptions and accusations has begun, as she begins to feel "how utterly inviolable he lay in himself. She had nothing to do with him. She could not accept it" (299). But in one of the most superbly tactile and sensuous moments in Lawrence's fiction, she lays her hand on him, and the connection between what he invested in the job underground and what she denied him at home begins to reach her, as "he was still warm, for the mine was hot where he died" (299). As Walter's mother and his wife wash the dead collier, Elizabeth still selfishly feels his death only as a denial of herself and her womb, and not yet as a revelation of her participatory function in the conflicted marriage. Here she movingly visualizes his warm and extinguished body with the metaphors of his occupation; yet she tries to limit the implications of their estrangement only to the permanence of his passing. "Life with its smoky burning gone from him, had left him apart and utterly alien to her" (300). Slowly the lines move to the larger and more painful recognition that they were strangers even when he was alive: "There had been nothing between them, and yet they had come together" (300). The next stage in her epiphany is crucial, for it finally acknowledges the mutuality of their responsibility for a relationship that was built on isolation: "He had been cruelly injured, this naked man, this other being, and she could make no reparation. There were the children—but the children belonged to life. The dead man had nothing to do with them. He and she were only channels through which life had flowed to issue in the children. She was a mother—but how awful she knew it now to have been a wife. And he, dead now, how awful he must have felt it to be a husband" (301). It is a bittersweet empathy that now must coexist with her practical obligations to a living family.

Death provides Elizabeth with an overriding insight about the distressing facts of her life with her late husband-collier. She understands that both of

them were suffocated, in different ways, by the engrained morbidity of East-
wood, and she realizes how this grip on their souls isolated them from a sym-
pathetic awareness of each other. It is too late for her tears and too untidy in
the room for Elizabeth to ignore her chores; now she must bear the recogni-
tion of a servitude that extends beyond penitence or blame: "A terrible dread
gripped her all the while. . . . At last it was finished. They covered him with a
sheet and left him lying, with his face bound. And she fastened the door of the
little parlour, lest the children should see what was lying there. Then, with
peace sunk heavy on her heart, she went about making tidy the kitchen. She
knew she submitted to life, which was her immediate master. But from death,
her ultimate master, she winced with fear and shame" (302).

NOTES

1. For an excellent summary of the many critical perspectives on this tale as well
as an explanation of the history of revisions by Lawrence, see Harris 32–36.

2. I have adapted my statistics here from an incisive and comprehensive
"Chronology" listing in Poplawski 122–32, which he subtitles, "Coal Mining, the
Labor Movement, and Social Reform in Britain to 1930." I highly recommend this
sequential chart as an invaluable research tool for scholars who want the essential
facts about relevant dates, issues, legislation, and social conditions.

3. See Worthen, *D. H. Lawrence* 215–17, and Harris 33–34, for relevant analyses
of Hueffer's comments and for the interesting circumstances concerning Lawrence's
submission of his manuscript to this editor's journal.

4. I elaborate in considerably more detail on the significance of Lawrencean
metaphors of flame and darkness and their variant representations in his work, in
chapters one and five of *D. H. Lawrence and The Phallic Imagination* and in my articles
on *The Lost Girl* ("Ten Men") and *The Virgin and the Gipsy* ("Scorched Ego").

5. Especially note the relevant references to *The Faerie Queene* and various
themes of death, violence, and eternity, in Lawrence, *Letters* 74, 75, and 210.

WORKS CONSULTED

Balbert, Peter. *D. H. Lawrence and the Phallic Imagination: Essays on Sexual Identity and
Feminist Misreading*. New York: St. Martin's, 1989.
———. "Scorched Ego, the Novel, and the Beast: Patterns of Fourth Dimensionality
in *The Virgin and the Gipsy*." *Papers on Language and Literature* 29 (1993):
395–416.
———. "Ten Men and a Sacred Prostitute: The Psychology of Sex in the Cambridge
Edition of *The Lost Girl*." *Twentieth Century Literature* 36 (1990): 381–402.
Harris, Janice Hubbard. *The Short Fiction of D. H. Lawrence*. New Brunswick, N.J.:
Rutgers Univ. Press, 1984.
Lawrence, D. H. *The Letters of D. H. Lawrence*. Vol. 1. Edited by James T. Boulton.
Cambridge: Cambridge Univ. Press, 1979.

———. "Nottingham and the Mining Countryside." In *Phoenix: The Posthumous Papers of D. H. Lawrence,* edited by Edward D. McDonald, 133–40. New York: Viking, 1972.

———. "Odour of Chrysanthemums." In *The Complete Short Stories,* vol. 2, 283–302. New York: Viking, 1961.

Poplawski, Paul. *D. H. Lawrence: A Reference Companion.* Westport, Conn.: Greenwood Press, 1996.

Worthen, John. "D. H. Lawrence: A Biography." In *D. H. Lawrence: A Reference Companion,* by Paul Poplawski, 3–115. Westport, Conn.: Greenwood Press, 1996.

———. *D. H. Lawrence: The Early Years, 1885–1912.* Cambridge: Cambridge Univ. Press, 1991.

8

W. H. Auden and the Homoerotics of the 1930s Documentary

Marsha Bryant

Since the appearance of Laura Mulvey's influential essay on the heterosexual male gaze in classical Hollywood cinema, fictional film and literature have remained central sites for exploring issues of gender and sexuality. By contrast, nonfictional forms have tended to figure mainly in discussions of social class. Recent work such as Joseph A. Boone's analysis of travel literature has begun to challenge this alignment, not only by bringing gender and class to bear on nonfiction, but also by invoking the homoerotic to unsettle "assumptions about male sexual desire, masculinity, and heterosexuality that are specific to Western culture" (90).

A nonfictional genre that proves crucial to understanding intersections of gender, sexuality, and class is the documentary—the twentieth century's primary means of representing social reality. In British literature and film of the 1930s, we can see how a male-on-male gaze shaped the documentary tradition during this decade of social and representational crisis. Because most of the documentarists were bourgeois men who scrutinized working-class men in their texts, British documentary practice provides a veritable nexus of what Eve Kosofsky Sedgwick has termed "homosocial desire." Significantly, a major focal point for these documentaries was industrial Britain and its miners, and it was in representing these muscular men that the 1930s documentary most reinforced and undermined dominant constructions of masculinity.

In this essay I wish to explore how coal miners functioned as objects of bourgeois male identification and desire in W. H. Auden's industrial poems, two key documentary books (J. B. Priestley's *English Journey* and George Orwell's *The Road to Wigan Pier*), and two documentary films (*Industrial Britain* and *Coal Face*). Documentary contexts enable us to see the cultural dynamics that underpin Auden's signature industrial landscapes, while the

poet's homosexuality prompts us to acknowledge the sexual dynamics that inform documentary's male-on-male gaze. To reassemble the necessary cultural contexts, I will first discuss the male environment of the British documentary film movement. I will then consider the economic and gender codings of the industrial north that appeared in both Auden's poetry and documentary texts. Finally, I will read Auden and documentary through one another to show how 1930s representations of coal miners unsettled boundaries between cross-class scrutiny and homoerotic looking.

Filmmaker John Grierson both introduced the word "documentary" to the English language and founded what would become Britain's largest center of documentary production in the thirties. Rejecting the studio system of commercial cinema, which was "driven by economics into artifice," he set out to establish a socially responsible, reality-based cinema (201). Grierson sought government sponsorship from the Empire Marketing Board (EMB), which was considering the use of film to promote Empire products to British consumers. In 1927 Grierson organized the EMB Film Unit. When the EMB was abolished in 1933, Grierson's growing network of documentary filmmakers and trainees was transferred to the General Post Office (GPO) to publicize government communications. The work of the EMB and GPO Film Units, along with that of Grierson's associates at other film agencies, would become known as the British documentary film movement. In his study of Grierson, Ian Aitken has noted the thematic parallels that these documentarists shared with Auden's literary circle: a preference for "industrial subject matter," a sense that the depression revealed capitalism's failures, and a belief in artistic commitment (179). Auden worked for six months at the GPO Film Unit, where he collaborated on five documentaries.

Grierson's mostly male film units at the Empire Marketing Board and General Post Office were perhaps the most cohesive homosocial group in which documentary practice developed in the 1930s. Although men also headed the Mass-Observation documentary movement (which assessed public—or "mass"—identity through human observers who recorded their own and others' behavior), its cross-class scrutiny of the industrial north extended more fully to working-class women; moreover, many volunteer observers were women—especially during the war years. By contrast, the working environment at the EMB Film Unit was, as Erik Barnouw recounts, "strangely monastic" despite its three women employees: "Working hours were limitless. Staff members got the impression that marriage was taboo, and the existence of girl-friends was kept from Grierson. Grierson himself fell for Margaret Taylor, sister of staff member John Taylor, and they got married, but Grierson did not mention it for eighteen months. She went to work at the unit, but they never arrived or left together. . . . Grierson and his staff spent hours at the pub together, drinking and talking" (90). Several members of this network went

on to shape other documentary groups such as GB-Instructional and Strand Films. A quick glance at the all-male portrait gallery of filmmakers in Paul Rotha's *Documentary Diary* reinforces the importance of *institutional* male-male bonds to the British documentary film movement, a "crucially important" homosocial category that Sedgwick points to in *Between Men* (19).

The documentary film movement brought together communities of public school and university men to observe working-class men, a dynamic with Victorian precedents in the men's settlement movement that Seth Koven has discussed. Despite some fundamental differences—the settlers established long-term residence in London's slums and devoted their attention to instructing boys—the civic-minded nature of both groups' public activities facilitated the expression of homoerotic desire. Koven's speculation about the homosexually inclined settlers might well apply to some of the documentarists: "While ostensibly these men came to heal the wounds of a class-divided nation, it seems probable that many were also driven by the need to come to terms with their own sexualities" (373). In the case of the British documentary film movement, homosexual *and* heterosexual men who scrutinized muscular coal miners also confronted their own masculinities.

Male writers, filmmakers and photographers traveled north to Britain's industrial regions during the 1930s, a cultural convergence that attested not only to the prominence of industrial Britain in literary and visual media, but also to documentary's growing influence. Like London's male urban explorers of the late-Victorian period, documentary observers of the 1930s transgressed class lines to establish contact with the working classes. Both kinds of bourgeois scrutiny mixed class voyeurism and social reformism, a vexed dynamic that Judith R. Walkowitz has assessed in Victorian accounts of London's other city, the impoverished East End. Yet the greater physical distance involved in traveling to the north country—as opposed to merely nightwalking in London's slums—reflects the decade's Marxist metaphor of "going over" to the working classes. Documentarists of the 1930s departed from their Victorian predecessors by ostensibly seeking to learn from—rather than instruct—the people they observed. Despite documentary's extensive travels into working-class terrain, their representations were shaped as much by the growing repertoire of public images as by actual encounters with the industrial north. For example, filmmaker Rotha and photographer Bill Brandt both acknowledged the influence of Priestley's *English Journey* on their respective texts, *The Face of Britain* (1935) and *The English at Home* (1936). This intersection of actual and textual territory riddled documentary's map of 1930s industrial Britain.

Geographically, the industrial north includes Lancashire (the district of Orwell's *Wigan Pier*), the West and East Ridings of Yorkshire (Priestley grew up in the former), Wearside, and Tyneside. Yet Philip Dodd explains that this region "is less a number of particular places with specific histories" than it is

a "place with an agreed iconography" (17). Thus the industrial Britain of the 1930s included not only the mining districts of the Midlands (the region of Birmingham—Auden's hometown—and the Black Country), but also those of South Wales. Rather than indicating a particular geographical direction, then, "north" designates an economic margin to London's center. This figurative existence of industrial Britain explains why the publishers of *The Road to Wigan Pier* could include photographs of squalor far from the mining community Orwell visited—such as collieries in South Wales, miners' shacks in Newcastle, and even slums within London itself. In the visual text of *Wigan Pier,* also indebted to *English Journey,* the grimy slag heaps and decrepit buildings spill over the northern border to threaten the center, a textual proliferation illustrating Peter Stallybrass and Allon White's general contention that "what is *socially* peripheral is so frequently *symbolically* central" (5). We might think of 1930s industrial Britain as a metaphoric black country that animates and unsettles documentary representation.

Just as not all of industrial Britain appeared due north of London, neither did all of it suffer economic decline. John Stevenson points out that while the 1930s was "a period of prolonged depression in the old staple industries" such as coal production, the decade also marked "the time when a new industrial structure" based on electric power "provided the real basis for the export boom and the rising prosperity of the second half of the twentieth century" (92). Because of this shift in industrial production, the economic gap between classes widened considerably. Mass consumption of electrical home appliances attested to the middle class's growing economic prosperity, but as Noreen Branson and Margot Heinemann assert, "There can be no doubt at all that employed miners, even at the end of the thirties, were living worse than they had done before the First World War" (99). Drawn to such areas of industrial decline, documentary discourse defined the "real" industrial Britain as the poverty-stricken regions suffering from the depression. This discrepancy between economic and iconographic power hinges on the same cultural dynamics that Stallybrass and White have noted, in which "the low-Other is despised and denied at the level of political organization and social being" yet proves "instrumentally constitutive of the shared imaginary repertoires of the dominant culture" (5–6). For bourgeois male documentarists, the economically marginalized black countries became a rugged testing ground for the "real men" who labored in mines.

Documentary practice in the 1930s gendered industrial Britain as almost exclusively male—despite the fact that, as Stevenson points out, the number of female workers actually rose in light industries (94). Documentary framings of the north conventionally render women invisible or relegate them to domestic space; Robert Colls and Philip Dodd correctly note that "working-class women are simply read out of the picture or 'left' at home" (25). The

EMB film *Industrial Britain* goes so far as to expel women from its frame. While its opening sequence contains brief shots of two working women (one at a spinning wheel, the other at a loom), the male voice-over labels them "scenes of yesterday"; in other words, women's labor belongs to the preindustrial order—the shot of the second woman, who faces away from the camera, reinforces this expulsion. Even the GPO film *Coal Face* (1935), with its innovative women's chorus written by Auden, shows them only metonymically—in a brief shot of a laundry-laden clothesline marking the miners' return home. Generally speaking, then, "woman" did not figure into documentary images of industrial labor.

This male gendering of the industrial north marked another departure from cross-class spectatorship in Victorian London where, as Walkowitz states, "the [female] prostitute was a central spectacle in a set of urban encounters and fantasies" (21). It also departs from the Victorian diaries and photographs of Arthur Joseph Munby, whose fascination with women laborers—including miners—hinges on gender as well as class difference. While Paula Rabinowitz finds Munby's project central to documentary's "slippage between class power and sexual knowledge," we must note the male-male dynamic that shaped documentary images of industrial workers in the 1930s.

With its sexual iconography of erected chimneys and penetrating mines, industrial Britain was masculine terrain. Moreover, documentary's central figure of the worker was a "real" man and thus a point of identification for the male documentarist and his male readers and viewers. Documentarists who entered Britain's metaphoric black country were therefore forced to confront their own status as physically inferior men. Traditionally, the cultural configuration of Britain's industrial north combines a body/mind dualism with bifurcations along gender as well as class lines; Dodd explains that "the North is masculine, working class and physical; the South, feminine, middle-class and spiritual" (20). Orwell confronts this dividing line in the self-examination that follows his accounts of coal miners in *The Road to Wigan Pier*. Faced with the "accusation" that "because I have been to a public school I am a eunuch," he writes, "I can produce medical evidence to the contrary, but what good will that do?" (168). So the bourgeois male documentarist faced a dilemma—how could he represent industrial workers without calling into question his own masculinity?

Documentarists employed various strategies for erasing the north/south divide that threatened to un-man them. One strategy for closing the distance between their own manhood and the miners' was to use their sustained contact with industrial Britain to call attention to the documentarist's position as a man among real men. In the documentary section of *Wigan Pier*, for example, Orwell shows his grit by shifting to second-person pronouns in his account of descending into coal mines: "When you crawl out at the bottom you are perhaps four hundred yards under ground. That is to say you have a

tolerable-sized mountain on top of you" (24). Orwell also wants his male reader to know that he is no mine tourist, but an initiate who merits admiration. Listen to the tough swagger of this assertion: "When you have been down two or three pits you begin to get some grasp of the processes that are going on underground" (30). Assuming that his readers have *not* descended mines, Orwell displaces the "pang of envy" that he feels for miners' "toughness" onto his male readers; they are to envy Orwell's toughness by association (22). In other words, the uninitiated man replaces the documentarist's former position on the "eunuch" side of the line.

Another documentary strategy pushed further this transfer of masculinity by gendering the genre itself. Rotha, who collaborated with Grierson at the EMB and GPO Film Units, claimed that "the documentary method" is "the most *virile* of all kinds of film." His account of the new genre, *Documentary Film* (1936), renders strategic camera angles into "weapons with which the director fights to put across his theme" (118, 193). Grierson also invoked an aggressive masculinity in his defenses of the British documentary film movement, casting his group of filmmakers as commandos of a new aesthetic. For example, in 1937 he boasted of "the documentary men . . . fighting synthetic nonsense," and in 1939 he hailed them "taking command" in a "Battle for Authenticity." By contrast, Grierson characterized commercial cinema as "impotent and self-conscious art" (217, 208, 181). Thus documentary practice became a male enterprise, and a commitment to portraying the real men of Britain's industrial north became an assertion of masculinity. We can still see the effects of this male gendering in postmodern American films as diverse as Michael Moore's *Roger and Me* (which maintains documentary's traditional focus on workers), and Ross McElwee's *Sherman's March* (which departs from it). As Bill Nichols asserts, the documentarists' goals in these contemporary documentary films—"to save the community, to find a mate"—replicate the "classic goals for male fiction heroes" (*Representing* 72). Examining 1930s representations of male workers helps us to reassess the role of gender in documentary history.

The hypermasculine coding of industrial Britain was so deep that Auden did not need to write a first-person account of mine shafts to activate its conferral of manliness, although growing up in Birmingham gave him a northern aura. In the same year that *Wigan Pier* was published, both detractors and defenders contributing to the Auden issue of *New Verse* agreed on two things: they linked his writing to the industrial north and the working classes, and they gendered it as strongly male. For example, George Barker cites Auden's "cocksureness" as a technical "danger" (24), while Bernard Spencer pronounces with approval, "Auden doesn't go soft" (27). By the time these comments appeared in 1937, Auden had been incorporating industrial Britain into his writing for ten years.

Auden's representations of the industrial north mark the beginning of his socially conscious poetry. "The Watershed," first published in 1928, offers an appropriate place to begin reading Auden and documentary practice through one another. The poem participates in documentary's sustained act of looking across class lines, yet it also questions the documentary observer's presence in mining country. Auden's poem surveys this industrial landscape through a double act of looking; we perceive the scene through a stranger who enters unfamiliar territory, and through the poem's disembodied speaker who observes this stranger's activity.

At first glance, the setting appears decayed and depopulated, an appropriate space for expressing modernist alienation:

> Who stands, the crux left of the watershed,
> On the wet road between the chafing grass
> Below him sees dismantled washing-floors,
> Snatches of tramline running to the wood,
> An industry already comatose,
> Yet sparsely living. A ramshackle engine
> At Cashwell raises water; for ten years
> It lay in flooded workings until this,
> Its latter office, grudgingly performed. (*English Auden* 22)

But we should also note that despite Auden's emphasis on decay, some of this machinery still operates (the "ramshackle engine"). Similarly, the landscape's "comatose" industry is still "sparsely living"; the phrase means not only "barely alive," the usual gloss, but also the struggle of living frugally in the developing depression. This socioeconomic marker shows that the poem's terrain is more than the psychological projection that Edward Mendelson and others have seen. Auden's industrial landscapes reflect his culture's documentary excursions into the working-class communities of Britain's north.

When we return "The Watershed" to its documentary contexts, what becomes immediately significant is the way that miners occupy the center of this poem:

> . . . two there were
> Cleaned out a damaged shaft by hand, clutching
> The winch the gale would tear them from; one died
> During a storm, the fells impassable,
> Not at his village, but in wooden shape
> Through long abandoned levels nosed his way
> And in his final valley went to ground. (*English Auden* 22)

All three of the workers that Auden describes died in the mines. The "wooden shape" in "long abandoned levels" not only means a coffin—the gloss Katherine Bucknell offers in *Juvenilia*—but also the support beams that once held the tunnel ceilings in place. Auden's death scenes do more than enhance the poem's ominous tone; they also point to the dangers that miners faced at work. As Branson and Heinemann note, "Standards of roof support and safety suffered in the drive for low-cost output," and the noise of mechanical cutters "made it harder to hear cracks in the timber" (102).

The documentary observers who traveled through mining country in the 1930s were also struck by perilous working conditions. Priestley's *English Journey* (1934), the GPO Film Unit's *Coal Face* (1935), and Orwell's *The Road to Wigan Pier* (1937) all cite alarming statistics of the number of coal miners killed on the job. According to Priestley, for example, "during the five years ending with 1931 [the period during which Auden composed "The Watershed"] more than 5,000 people were killed in the coal-mining industry, and more than 800,000 people injured" (261). Priestley's account of how these miners die is especially horrific: "Every man or boy who goes underground knows only too well that he risks one of several peculiarly horrible deaths, from being roasted to being imprisoned in the rock and slowly suffocated" (261). Mirroring documentary's discrepancies between economic and iconographic power, those who bear the brunt of Britain's labor struggles are also those who energize Auden's poem.

Auden's modernist predecessors D. H. Lawrence and Wilfred Owen provide additional contexts for "The Watershed's" images of mining accidents. Auden's juvenilia about the industrial north—especially "The Miner's Wife"—reveal a heavy debt to Lawrence. But documentary representations of miners departed from these earlier literary influences by employing the statistical language of fact, by emphasizing physical contact with the black country and by focusing more closely on miner's bodies. While traditional literary contexts are important for understanding the cultural dynamics of Auden's poem, documentary contexts are crucial.

The central position of miners marks only one of "The Watershed's" documentary aspects; the poem's addressee who enters industrial Britain bears striking similarities to documentary observers in texts of the 1930s. His intrusive gaze prompts the poem's opening query, as well as its dramatic imperatives that appear just after the scenes of mining accidents: "Go home, now, stranger, proud of your young stock, / Stranger, turn back again, frustrate and vexed: / This land, cut off, will not communicate." Auden's repeated word "stranger" marks the socioeconomic divide that separates the middle-class observer (and reader) from the landscape's working-class inhabitants. Embarking on "an adventure of observation"—Grierson's phrase for the documentary enterprise (205)—Auden's stranger has traveled to a culturally

coded terrain, but one that is unfamiliar to him personally. Priestley spoke for many documentary observers when he began his account of the Black Country's industrial terrain with these words: "This *notorious* region was *strange* to me. *Now I have seen it,* but of course it is still *strange* to me" (80; emphasis mine). Similarly, Orwell writes that "when you go to the industrial North you are conscious, quite apart from the unfamiliar scenery, of entering *a strange country*" (109; emphasis mine). In all three cases, industrial Britain's notoriety as Britain's other country not only draws the observers' scrutiny but also directs their vision, so that firsthand accounts mirror cultural expectations of "strangeness."

Connoting a dark inscrutability as well as grime and soot, the industrial north was England's own heart of darkness—a remote interior where the working-class rituals of work and home were performed. Grierson, in fact, would link documentary film's explorations of this terrain to earlier British explorations of Africa: "Our gentlemen explore the native haunts and investigate the native customs of Tanganyika and Timbuctoo, but do not travel dangerously into the jungles of Middlesbrough and the Clyde." This imperialist construction of outlying working-class communities as colonial territories has precedents in the Victorian urban exploration narratives that Walkowitz discusses, in which London's affluent West End and impoverished East End "imaginatively doubled for England and its Empire" (26).

Of course, industrial Britain did not appear exotic or strange to those who lived and labored there; as Stan Smith notes in his comments on "The Watershed," bourgeois social construction can cause one to see "through a class darkly" (74). Addressing this very issue of appropriation, Auden's line "This land, cut off, will not communicate" does not signify an *inability* to communicate, but a *refusal* to serve as "accessory content" to bourgeois representations, such as the documentary text or the "tourist's inventory of places seen" (Mendelson 34). The poem's taunting speaker becomes the voice of industrial Britain wresting interpretive control from the voice-over narration that usually accompanies documentary images of mines and miners. As William Stott writes of American documentary practice, the genre aimed to "giv[e] the inarticulate a voice" (56)—an enterprise blind to the representational inequality that positions one class as mute and the other as articulate, one class before the camera and one behind it.

In "The Watershed," inarticulateness becomes a deliberate strategy for thwarting easy access to Britain's industrial north; the poem's intruding stranger—and the reader—must struggle with these notoriously cryptic passages to render them legible. Turning what John Tagg calls "the axis of representation" back on the middle classes, Auden's speaker leaves the miners' bodies hidden and exposes the stranger's lingering presence. Moreover, the poem's imperatives ("Go home," "turn back") expel this observer from the

scene; he is denied the visual authority upon which conventional documentaries depend. The alternative dynamics of "The Watershed" allow space for critiquing representation—a feature that runs across the spectrum of Auden's documentary work.

Auden set some of his most explicitly homosexual love poems in Britain's industrial north, documentary's primary site of male identification and desire. For example, the homoeroticism in "I chose this lean country" adds an erotic dimension to the industrial terrain of "The Watershed." Consider what Gregory Woods calls the poem's "wet dream" section:

> Last night, sucked giddy down
> The funnel of my dream,
> I saw myself within
> A buried engine-room.
> Dynamos, boilers, lay
> In tickling silence, I
> Gripping an oily rail,
> Talked feverishly to one
> Who puckered mouth and brow
> In ecstasy of pain,
> "I know, I know, I know"
> And reached his hand for mine. (*English Auden* 440)

Industrial technology facilitates tactile experience in this scene; the machinery heightens the effect of the "tickling" atmosphere, while the "oily rail" heightens the speaker's awareness of his grip. Also significant is the speaker's underground male companion with his sensual "puckered mouth." Before joining this man in the "buried engine-room," the speaker traversed "this lean country" alone, examining a deserted mine and climbing "a crooked valley"— Mendelson has noted Auden's use of the word *crooked* to signify homosexuality (225–26). In "The chimneys are smoking," published in the 1933 anthology *New Country* and in Auden's 1936 volume *Look Stranger!* mines become a trope for the buried, "crooked" love that must "hide underground"; Auden's speaker links himself and his male lover with "the colliers" in a world of "double-shadow" (*English Auden* 117–18). From these industrial, underground enclosures (the engine room, mines), Auden creates erotic spaces safely removed from hostile eyes. The shared industrial terrain of Auden's love poems and documentarists' homoerotic observations of miners provides an important context for British documentary practice in the 1930s.

When we place alongside one another images from the documentary film *The Mine* (G-B Instructional, 1935), Orwell's *Wigan Pier,* and Auden's industrial love poems, the boundary between cross-class scrutiny and homoerotic

FIGURE 1 Torso, left arm, and bulging muscles of a miner's body in a still from *The Mine* (G-B Instructional, Ltd., 1935), an educational documentary filmed by Frank Bundy, directed by J. B. Holmes. *Courtesy of Carlton International Media Limited and the British Film Institute.*

looking begins to break down. No physique proved more intriguing to the male documentarist's gaze than the coal miner's. Whereas Lawrence had filtered his erotic descriptions of miners' bodies through the women characters who watch them bathe—in *Women in Love,* for example, Gudrun gazes at Beldover miners bathing in their backyards—documentary observers of the 1930s preferred to bypass domestic space and watch miners in their all-male work environments. Consider the still from *The Mine* (fig. 1), an educational documentary filmed by Frank Bundy and directed by J. B. Holmes. Fracturing the miner's body into torso and left arm, the frame's erotic dismemberment centers on his bulging muscles. Stark frontal lighting also contributes to this sexualized display of a man at work; the absence of fill and back lighting shrouds the miner's head in darkness and positions the viewer as a voyeur.

In *Wigan Pier,* Orwell frames working miners with a similar gaze that gravitates toward the torso before moving down: "It is only when you see miners down the mine and naked that you realise what splendid men they are.... Nearly all of them have the most noble bodies; wide shoulders tapering to slender supple waists, and small pronounced buttocks and sinewy thighs, with not an ounce of waste flesh anywhere" (23). Orwell's verbal equivalent of the film image employs heavy sibilance to highlight the miners' individual body parts. Sharing a homoerotic as well as a cross-class gaze, *The Mine* and *Wigan Pier* illustrate the figurative dismemberments that Woods finds central to homoerotic poetry. According to Woods, male-male "sexual appraisal and

activity" are analogous because "the focus of desire . . . operates obsessively in close-up"—a dynamic we also see in these documentary images of miners' bodies (30, 31).

Orwell's specifically *economic* appraisal in *Wigan Pier* also makes explicit the role of class difference in shaping documentary's homoeroticism. As his detailed account of substandard wages, household budgets and widespread malnourishment makes clear, it was economic deprivation that sculpted the miners' "slender" waists and lack of "waste flesh," just as strenuous manual labor sculpted their "wide shoulders" and prominent musculature. Measuring in ounces the miners' indentations and curvatures, Orwell's homoerotic economy intersects culturally not only with documentary cross-class scrutiny, but also with homosexual cross-class encounters. Bourgeois gay men's attraction to working-class men—especially younger ones—often freighted the metaphor of "going over" with homosexual meanings.

Jeffrey Weeks has noted that affluent British mens' "fascination with crossing the class divide"—a "clearly observable" trend by the late nineteenth century—reveals "a direct continuity between male heterosexual *mores* and homosexual" (112). More generally, Sedgwick posits "the potential unbro-kenness of a continuum between homosocial and homosexual" by revealing the erotic dynamics of both nonsexual and sexual male bonds in *Between Men,* which draws examples from eighteenth- and nineteenth-century English novels (1). The homoerotics of documentary practice in the 1930s also unset-tle distinctions between heterosexual and homosexual. I have used the term *homoerotic* to characterize documentary images of miners because, as Woods contends, homoeroticism constitutes "a major, self-referential part of male sexuality as a whole" (1). This term also suits my purposes because, like the term *documentary,* it is inclusive in theory but male-centered in practice. For example, Allen Ellenzweig defines the homoerotic as "feelings of desire, inti-macy, admiration, or affection between members of the same sex," yet he includes only images of men in *The Homoerotic Photograph* (2). Similarly, 1930s documentary film positions itself as championing "real" people but privileges "real men" for visual attention. If we return homoeroticism to the center of documentary practice, we can see that gender and sexuality—as well as class—proved crucial to shaping our century's principal discourse of reality.

Two gay men—Auden and the composer Benjamin Britten—played a key role in the British documentary film movement. Collaborating for the first time on the chorus and music to *Coal Face* (1935), Auden's first film produc-tion, these artists drew wide acclaim for their innovative integration of verse commentary and music in the most famous GPO film, *Night Mail* (1936). Auden and Britten also collaborated with J. B. Holmes, the director of *The Mine,* on a production for Strand Films. The fact that homoerotic images of coal miners predate Auden and Britten's employment with the film movement—

along with the collaborative nature of film production—renders problematic accounts of the decade that segregate gay men from their peer artists, such as Valentine Cunningham's *British Writers of the Thirties*. He pronounces that "much of the period's writing about the proletariat is vitiated by the bourgeois bugger's *specialist* regard" (150; emphasis mine). Yet Cunningham ignores not only Orwell's frank appraisal of miners' physiques, but also the documentary film movement's homoerotic voyeurism.

Documentary's most sustained homoerotic looking at coal miners occurred within the British documentary film movement. Two productions provide especially good examples of how documentary filmmakers sexualized these men whose labor required great muscular strength and dexterity—the EMB Film Unit's *Industrial Britain,* begun in 1931 and released in 1933, and the GPO Film Unit's *Coal Face,* produced and released in 1935. The latter film grants more screen time to underground work scenes, attesting to the coal miner's increasing iconographic power. Although they had different directors, *Industrial Britain* and *Coal Face* employ remarkably similar depictions of miners' bodies; the films even share bits of the same footage. Yet while some critics have pointed out the male-centeredness of both films—Colls and Dodd even note that *Coal Face*'s "only sustained close-ups are of semi-naked miners"—they have largely ignored the homoerotic dynamics of their male-on-male gaze.

In each film, an abrupt cut from shadowed groups of miners entering the shaft to a single miner removing his shirt marks a transition to more homoerotic images (fig. 2). Because of the mine's heat and darkness, such representations might draw little comment were it not for the distinct cinematic style with which the filmmakers frame these workers. Three distinctive characteristics in these transitional shots play out in subsequent images of the miner's half-naked, bent body: brighter lighting makes the exposed torso flesh glisten, closer framing effects a figurative dismemberment of the miner's body, and camera angles position the viewer as a voyeur. In *Industrial Britain,* for example, the miners' muscular torsos are brightly lit while faces and heads are usually shadowed—a radical departure from the film's framing of other industrial workers. The camera moves closer to miners in *Coal Face,* allowing the light to sculpt flesh contours and render sweat and body hair visible. This camera position also enables the further fragmentation of miners' bodies; while torso shots appear in both films, *Coal Face* also includes shots of miners' legs. Such fractured framing reflects not only what Miles and Smith call the film's "aggressively modernist" form (191), but also its homoerotic display of the *miner's* form. As Beatrix Campbell observes in *Wigan Pier Revisited,* "the miner's body is loved in the literature of men because of its work and because it works" (qtd. in Colls and Dodd 25). In other words, the miner's body performs both physical and cultural work as the focal point of documentary's male-on-male gaze.

FIGURE 2 Coal miner at work in a still from *Industrial Britain* (EMB Film Unit, 1933).
Courtesy of Kino Video International Corporation, New York.

Industrial Britain and *Coal Face* also create homoerotic images by positioning their viewers as voyeurs. Lighting contributes to this effect, but camera angle is most crucial here—often miners' backs are to the viewer, or their heads are turned away in profile shots. In an unusual framing from *Coal Face*, for example, the camera looks over a miner's shoulder (medium close-up) as he lifts his bottle toward his mouth and toward the viewer. This miner appears in the lower left portion of the frame, so that the surrounding darkness adds to the image's voyeuristic effect. Documentary's supposedly unobtrusive camera style takes on new meaning in such images; while it seemingly allows the miners to appear working and eating "naturally," it also frames them with a homoerotic gaze. Moreover, the miners almost seem conscious of their erotic objectification in the scene from *Coal Face* which features two seated men eating sandwiches (fig. 3). Unlike other shots in which the glistening torsos and body hair of miners are visible, these men face the camera *and* they have draped their shirts over their left shoulders. Acknowledging the cameraman's and viewer's gaze, these miners momentarily disrupt the film's dominant framing of workers as objects of desire. The mining sequences of *Coal Face* and *Industrial Britain* close with shots of a miner pushing a tub of coal into a dark tunnel, away from the viewer (fig. 4). His body's bent position displays shoulder and back muscles, and the rear angle reaffirms the cameraman's—and viewer's—voyeuristic activity.

How did such frankly homoerotic images come to circulate in government-sponsored films, and how have critics come to ignore them? The answer

FIGURE 3 Coal miners eating their lunches and at rest in a still from *Coal Face* (GPO Film Unit, 1935).
Courtesy of the Post Office Film and Video Unit.

FIGURE 4 Coal miner at work in a still from *Industrial Britain* (EMB Film Unit, 1933).
Courtesy of Kino Video International Corporation, New York, N.Y.

lies largely in our viewing habits. Conditioned to anchor photographic images with their accompanying verbal texts, and conditioned to read films like *Industrial Britain* and *Coal Face* as rhetorical cinema, we usually grant primacy to the voice-over narrator's exposition. For example, Nichols maintains that "direct-address commentary in the British documentary of the 1930s" derives from classical rhetoric, so that "each sequence sets in place a block of argumentation that the image track illustrates" (*Ideology* 196, 197). The tendency to read EMB and GPO films as articulating Grierson's social agenda in tandem with his essays also prompts commentary-centered readings. As a consequence of such conventions, we have learned to view the miners in these films only as socioeconomic information. *Industrial Britain* especially invites such readings because its voice-over often beckons our attention away from the homoeroticism of the images—emphasizing instead the miners' "narrow and confined" work spaces, their "primitive method of hewing coal," the number of miners in Britain, and "the human factor" that remains in "this machine age."

In *Coal Face,* however, the commentary itself sometimes ventures close to acknowledging the homoerotic spectacle of miners at work. For example, when the miner who removed his shirt bends over and hews out a coal seam, the male commentator points out that the temperature in the mine can reach 80 degrees; and when we return to this shirtless miner a few shots later, the commentator explains that "a miner can work with a *naked* flame" (emphasis mine). These references to heat and "nakedness" heighten attention to the displayed body, momentarily diverting our attention away from the film's ongoing commentary on working conditions. In fact, the innovative, polyvocal sound track of *Coal Face* offers us a good opportunity to break some of our documentary viewing habits.

Featuring a sound track as fractured as many of its images, *Coal Face* interrupts the dominant voice-over narration through its use of a men's spoken chorus and a women's sung chorus (the latter a poem by Auden), as well as its use of Britten's discordant music. The first chorus "speaks for" the workers in the mining sequence with a litany of job titles (such as "barrowman" and "hewer"), while the lyrics of the second chorus constitute a love poem by Auden. Of these two choruses, it is actually the *women's* that most serves my purpose of reading *Coal Face* as a homoerotic text—a dynamic that becomes clearer if we return to Sedgwick's *Between Men.* Her assessment of women's status in male homosocial exchange borrows from René Girard's study of how "erotic triangles" shape "the male-centered novelistic tradition of European high culture." Of particular interest to Sedgwick is the bond between rival males who form "the two active members of an erotic triangle," the passive member being a woman (21). This schema also proves useful in assessing the status of the women's chorus in a male-centered documentary film, although there are some key differences. In both cases the "woman" facilitates

negotiations between men, and the relationships between her and each male serve to shape the text to a much lesser degree than does the relationship of the men to one another. In the case of Auden's lyrics for the *Coal Face* chorus, however, woman figures only as a voice through which a male observer expresses homoerotic desire for a coal miner; the miner is active because of his vigorous labor, but passive because the documentary observer controls his image on the screen. We can also read this ventriloquism as a drag performance in which a gay man publicly expresses—and masks—his homosexual desires.

Neither film nor literary critics have addressed the significance of Auden's lyrics to *Coal Face,* much less their subversion of male gender roles. While Colls and Dodd, as well as Miles and Smith, ignore Auden's love poem in their analyses of the film, Mendelson and Lucy McDiarmid comment chiefly on its formal properties. Yet the poem becomes richer when we return it to the contexts of the film for which it was written, and when we take into account the homosocial environment in which it was produced. Unlike the men's chorus which appears intermittently in the second sequence of *Coal Face,* Auden's poem dominates the verbal sound track in the third sequence—even though women's bodies do not appear in this film. The women's chorus begins as the miners leave the pit head, so that the men remain objects of desire after their work is performed:

> O lurcher loving collier black as night,
> Follow your love across the smokeless hill.
> Your lamp is out and all your cages still.
> Course for her heart and do not miss
> And Kate fly not so fast,
> For Sunday soon is past,
> And Monday comes when none may kiss.
> Be marble to his soot and to his black be white. (*Plays* 421)

Initially, Auden's poem would seem to close off a homoerotic reading with its strict gender and color oppositions of collier/Kate, his/her, and black/white—a dichotomy that Lawrence used to heighten sexual tension between miners and women. For example, the young wife in "A Sick Collier" is "startled" when her husband returns from the pit "with a face indescribably *black* and streaked," a stark contrast to her "*white* blouse," "*white* apron" and "*fair*" complexion (268; emphasis mine). Yet Auden's use of such oppositions—and other formal patterns—actually points to the poem's homosocial dynamics.

When we consider the work of gender in its "elegant chiasmus and subtle rhyme scheme," this love poem hardly proves "distanced from ideological significance," as McDiarmid claims (143). The male/female opposition, for example, prefigures a command Auden issues in his 1955 poem "The Truest

Poetry Is the Most Feigning": to "Re-sex the pronouns" of love poems. Alan Sinfield sees this strategic alteration as "a closeted gay aesthetic" (60). Note also how in *Coal Face,* the poem's irregular rhyme scheme (ABBCDDCA) links the male figures of lines one and eight. More telling, the poem's series of imperatives *directs* the collier and "Kate" toward one another, suggesting that this pairing is not "natural" behavior (Kate's impulse is to "fly"). These cues for the collier's and Kate's gestures anticipate Judith Butler's performative theory of gender, in which any "gender identity . . . is performatively constituted by the very 'expressions' that are said to be its results" (25). If the poem's imperative heterosexual coupling is, in effect, no more than a set of stage directions, then the true site of desire in *Coal Face* is the underground enclosures where male documentary observers watch half-naked miners.

While Auden's poem for *Coal Face* positions the film's male viewers within documentary's homosocial network, its performance by a women's chorus also creates a network of gay male viewers who could interpret "O lurcher loving collier" as a drag performance. A related chorus that Auden also wrote for women's voices—"Rhondda Moon," from the Auden-Isherwood play *The Dog beneath the Skin* (1936)—provides fuller access to this gay coding; like the *Coal Face* poem, it expresses desire for a miner. Significantly, this play debuted one month before Auden left the GPO Film Unit. "Rhondda Moon," a campy love song, parodies the extent to which documentary representation eroticized male workers' bodies; the Rhondda is a Welsh mining district. At the same time, Auden's chorus appropriates documentary's socially acceptable form of homoeroticism to represent homosexuality. The song occurs when a chorus joins Madam Bubbi—"an immense woman in sequin dress"—on the Nineveh Hotel's cabaret stage:

On the Rhondda
My time I squander
Watching for my miner boy:
He may be rough and tough
But he surely is hot stuff
And he's slender, to-me-tender,
He's my only joy:
Lovers' meeting,
Lovers' greeting,
O his arms will be around me soon!
For I am growing fonder
Out yonder as I wander
And I ponder 'neath a Rhondda moon! (*Plays* 261–62)

This over-the-top performance, culminating in an avalanche of feminine internal and end rhymes, intersects with documentary's discrepancies between

economic and iconographic power. Auden locates the singers' object of desire in a district hit especially hard by the depression; the Rhondda was also the site of the Parc and Dare miners' stay-down strike. Unlike his desiring observers, the song's struggling miner has no "time" to "squander" but possesses the riches of a "rough and tough" yet "slender" body. This latter adjective recalls Orwell's economic appraisal of "slender supple waists" in *Wigan Pier:* the erotics behind both texts hinge on class difference.

Another network of key words points to "Rhondda Moon's" explicitly homosexual meanings that depend on class and *age* difference. As Koven notes, late-Victorian and Edwardian culture's definitions of the word "rough" referred generally to lads (that is, boys), especially to those of the working classes. Yet "rough" also acquired sexual connotations in gay circles; for example, "rough trade" meant "working-class, usually youthful male prostitution" (373). When we add to this cultural meaning the inside joke behind the lead singer's name—Isherwood had a young, working-class boyfriend nicknamed "Bubi"—we can see that "Rhondda Moon" performs the double act of sending up documentary's homoeroticism while representing homosexual liaisons. Humphrey Carpenter's biography recounts Auden's introducing Isherwood to "Bubi" and other boys that frequented Berlin's Cosy Corner, a working-class bar (90, 96). Because documentary's public images of miners shared a male-male gaze across class lines, they provide a partial screen for Auden's private network of gay references. The female singers give "Rhondda Moon" additional cover, just as they do for the song in *Coal Face;* both women's choruses about miners are, in effect, drag performances—Madame Bubbi's size and costume certainly suggest a drag queen. In the homosocial environment that shaped the coal miner's image, Auden's dubbing in of women's voices intersects with documentary's socioeconomic framing to facilitate the expression of homoerotic desire. Thus documentary practice proves to be another way of knowing that was, in Sedgwick's words, "structured—indeed fractured" by our century's "endemic crisis of homo/heterosexual definition" (*Epistemology* 1).

As we have seen, homoeroticism cut across documentary practice in 1930s Britain, linking Auden's industrial love poems, documentary films, and Orwell's *Wigan Pier.* This intersection of masculinities was most pronounced in the British documentary film movement's collaborative productions about coal miners. For male documentarists and viewers, the homoerotic display of miners' bodies functioned as a point of identification that celebrated masculine virility. For gay men who collaborated on and viewed these documentary films, it constructed industrial Britain's "real men" as objects of sexual desire. These homosocial dynamics complicate Paul Willemen's characterization of the documentary film movement as simply the tool of "a particularly reactionary state apparatus" (2). While documentary's conquest metaphors and

invisible women certainly reinforced the dominant culture's heterosexism, Grierson's government-sponsored film units also produced homoerotic images in a state that criminalized homosexuality.

In most examinations of the 1930s, critics focus on class alone as the driving force behind the decade's social instability—and thus as the driving force behind both Auden's poetry and documentary representation. But another factor proved equally important in negotiating the decade's uncertainties—the social act of "being a man." Documentary texts of the 1930s mark a crisis of masculinity in their sometimes contradictory assertions about "manliness" in the face of industrial Britain. Just as the rise of mass production triggered bourgeois anxieties about losing "individuality," it also triggered anxieties about losing masculinity. Auden's "How to Be Masters of the Machine," an essay that appeared in the *Daily Herald* the same year that *Industrial Britain* was released, articulates a generation's fears: "Most of the operations in a mass production plant are of such slight importance in themselves that no one could possibly feel that doing them *made him a man*" (*English Auden* 316; emphasis mine). Thus documentary's cross-class scrutiny of industrial labor was inextricably bound with its investment in masculinity. While documentary anxieties yielded texts that subscribed to dominant constructions of masculinity—most notably the documentarist as swaggering explorer of working-class terrain—these same anxieties also generated texts that challenged traditional masculinity.

Like its brother-genre the travel book—which Paul Fussell sees as "projecting, implicitly, various models of the post-war young man" (77)—documentary constructed images of men at a cultural watershed of masculinity. Too young to have "proven" their manhood in the Great War and as yet untested by the Spanish Civil War and World War II, the documentary men of the 1930s found being a man a less scripted performance than did their fathers and older brothers. As Isherwood expressed it in *Lions and Shadows,* the culture's determining "Test" of masculinity was absent: "Like most of my generation, I was obsessed by a complex of terrors and longings connected with the idea of 'War.' 'War,' in this purely neurotic sense, meant The Test. The test of your courage, of your maturity, of your sexual prowess: 'Are you really a Man?' Subconsciously, I believe, I longed to be subjected to this test; but I also dreaded failure" (75–76). Yet for the Auden generation, one group of men did not need a war to prove their masculinity for they were, as Priestley put it, "continually and severely tested" in the Black Country's coal mines (261). The buried sites of coal mining *and* of homoerotic desire are exposed in Auden's poems, Orwell's *Wigan Pier,* and in such documentary films as *Industrial Britain* and *Coal Face.* British documentary movements of the 1930s relocated high modernism's site of male desire, leaving the urban, heterosexual brothel (Picasso's "Demoiselles D'Avignon," Joyce's "Circe" chapter of *Ulysses,* Eliot's

early poems) for an industrial, homoerotic landscape. If we are to understand fully the decade that still provides us with models of socially engaged art, we must restore gender and sexuality to the documentary frame.

WORKS CONSULTED

Auden, W. H. *The English Auden: Poems, Essays and Dramatic Writings 1927–1939.* Edited by Edward Mendelson. New York: Random, 1977.

———. *Juvenilia: Poems 1922–1928.* Edited by Katherine Bucknell. Princeton: Princeton Univ. Press, 1994.

———. *The Dog beneath the Skin. Plays, and Other Dramatic Writings by W. H. Auden, 1928–1938.* Vol. 1 of *The Complete Works of W. H. Auden,* edited by Edward Mendelson, 189–292. Princeton: Princeton Univ. Press, 1988.

Barker, George, et al. "Sixteen Comments on Auden." *New Verse* 26–27 (1937): 23–30.

Barnouw, Erik. *Documentary: A History of the Non-Fiction Film.* London: Oxford Univ. Press, 1974.

Boone, Joseph A. "Vacation Cruises; or, the Homoerotics of Orientalism." *PMLA* 110 (1995): 89–107.

Branson, Noreen, and Margot Heinemann. *Britain in the 1930s.* New York: Praeger, 1971.

Butler, Judith. *Gender Trouble: Feminism and the Subversion of Identity.* New York: Routledge, 1990.

Carpenter, Humphrey. *W. H. Auden: A Biography.* Boston: Houghton, 1981.

Coal Face. Dir. Alberto Cavalcanti. GPO Film Unit, 1935.

Colls, Robert, and Philip Dodd. "Representing the Nation: British Documentary Film, 1930–45." *Screen* 26 (1985): 21–33.

Cunningham, Valentine. *British Writers of the Thirties.* Oxford: Oxford Univ. Press, 1989.

Dodd, Philip. "Lowryscapes: Recent Writings about the 'North.'" *Critical Quarterly* 32.2 (1990): 17–28.

Ellenzweig, Allen. *The Homoerotic Photograph.* New York: Columbia Univ. Press, 1992.

The Face of Britain. Dir. Paul Rotha. G-B Instructional, 1935.

Fussell, Paul. *Abroad: British Literary Traveling between the Wars.* Oxford: Oxford Univ. Press, 1980.

Grierson, John. *Grierson on Documentary.* Rev. ed., edited by Forsyth Hardy. Berkeley: Univ. of California Press, 1966.

Hynes, Samuel. *The Auden Generation: Literature and Politics in England in the 1930s.* Princeton: Princeton Univ. Press, 1976.

Industrial Britain. Dir. Robert Flaherty-John Grierson. EMB Film Unit, 1933.

Isherwood, Christopher. *Lions and Shadows.* 1938. New York: Pegasus, 1969.

Koven, Seth. "From Rough Lads to Hooligans: Boy Life, National Culture and Social Reform." In *Nationalisms and Sexualities,* edited by Andrew Parker et al., 365–92. New York: Routledge, 1992.

Lawrence, D. H. *Poems*. Rev. ed., edited by Keith Sagar, 35–37. London: Penguin, 1986.

———. "A Sick Collier." In *The Complete Short Stories*, vol. 1, 267–73. Harmondsworth, Eng.: Penguin, 1976.

———. *Women in Love*. New York: Cambridge Univ. Press, 1987.

McDiarmid, Lucy. "Liberating the Pseudoese." *Yale Review* 79, no. 1 (1989): 136–46.

Mendelson, Edward. *Early Auden*. Cambridge: Harvard Univ. Press, 1983.

Miles, Peter, and Malcolm Smith. *Cinema, Literature and Society: Elite and Mass Culture in Interwar Britain*. London: Croom Helm, 1987.

The Mine. Dir. J. B. Holmes. G-B Instructional, 1935.

Mulvey, Laura. "Visual Pleasure in Narrative Cinema." *Screen* 16, no. 3 (1975): 6–18.

Nichols, Bill. *Ideology and the Image*. Bloomington: Indiana Univ. Press, 1981.

———. *Representing Reality: Issues and Concepts in Documentary*. Bloomington: Indiana Univ. Press, 1991.

Orwell, George. *The Road to Wigan Pier*. 1937. New York: Harcourt, 1958.

Priestley, J. B. *English Journey*. New York: Harper, 1934.

Rabinowitz, Paula. *They Must Be Represented: The Politics of Documentary*. London: Verso, 1994.

Rotha, Paul. *Documentary Diary: An Informal History of the British Documentary Film, 1928–1939*. New York: Hill and Wang, 1973.

———. *Documentary Film*. London: Faber, 1936.

Sedgwick, Eve Kosofsky. *Between Men: English Literature and Male Homosocial Desire*. New York: Columbia Univ. Press, 1985.

———. *Epistemology of the Closet*. Berkeley: Univ. of California Press, 1990.

Sinfield, Alan. *Cultural Politics—Queer Reading*. Philadelphia: Univ. of Pennsylvania Press, 1994.

Smith, Stan. *W. H. Auden*. New York: Blackwell, 1985.

Stallybrass, Peter, and Allon White. *The Politics and Poetics of Transgression*. Ithaca, N.Y.: Cornell Univ. Press, 1986.

Stevenson, John. "Myth and Reality: Britain in the 1930s." In *Crisis and Controversy: Essays in Honour of A. J. P. Taylor*, edited by Alan Sked and Chris Cook, 90–109. New York: St. Martin's, 1976.

Stott, William. *Documentary Expression and Thirties America*. London: Oxford Univ. Press, 1973.

Walkowitz, Judith R. *City of Dreadful Delight: Narratives of Sexual Danger in Late-Victorian London*. Chicago: Univ. of Chicago Press, 1992.

Weeks, Jeffrey. *Sex, Politics and Society: The Regulation of Sexuality since 1800*. 2d ed. London: Longman, 1989.

Willemen, Paul. "Presentation." In *British Cinema: Traditions of Independence*, edited by Don Macpherson in collaboration with Paul Willemen, 1–5. London: BFI, 1980.

Woods, Gregory. *Articulate Flesh: Male Homo-eroticism and Modern Poetry*. New Haven: Yale Univ. Press, 1987.

9

The Language of This Graveyard

POLITICIZING

THE POETIC IN

TONY HARRISON'S *V.*

Ed Madden

Wherever hardship held its tongue the job's breaking the silence
of the worked-out gob.

Tony Harrison, "Working"

In 1984, the poet Tony Harrison visited the graves of his parents at Beeston Cemetery. This neighborhood cemetery was situated over a worked-out coal mine in Leeds, a working-class city in economically depressed northern England. What he found saddened him: desecration by graffiti, litter, and vandalism. Many of the gravestones, including those of his parents, were spray-painted with obscenities and slogans of support for the local football team, Leeds United. At the time of his visit, England was torn by one of the longest, most controversial, and most critical labor strikes of this century, a year-long strike by coal miners facing job loss and the closure of pits. The 1984–1985 miners' strike would turn out to be one of the most damaging incidents in the history of Britain's labor movement, and one of Prime Minister Margaret Thatcher's political triumphs. In response to the desecration of the cemetery, and in response to the class conflict dividing the nation, represented so clearly and emblematically for Harrison in the 1984–1985 miners' strike, Harrison wrote a poem of economic disaster and social decline, the long poem *v.*[1]

Central to the poem is an analysis of language as power—an analysis that informs the poem's thematicization of political and social division, class resentment, and poetic transformations. One focus of this paper, then, will be "the language of this graveyard," the language—rather, languages—through which Harrison figures the discursive, cultural, and political tensions in Margaret Thatcher's Britain. Harrison attempts to ground poetry in the material conditions of history by stressing the vulgar vernacular of those outside official history, and by using materialist and indecorous representations of social conditions—the muck of daily life, the *"shit they're dumped in"* (9), and the coal that signifies, for Harrison in 1984, Britain's economic histories. Harrison foregrounds the issue of language as power in the epigraph to the poem: "My father still reads the dictionary every day. He says your life depends on your power to master words" (3), a quotation that echoes Harrison's own thematic linkage of economic power, linguistic power, and the educated poet's alienation from his own father and family. But the attribution of the quotation, "Arthur Scargill, *The Sunday Times,* 10 Jan 1982," foregrounds the historical context central to the poem. Scargill was the president of the National Union of Mineworkers (NUM), and the stubborn leader of the 1984–1985 miners' strike. Yet the power of verbal mastery is, throughout the poem, realized not in labor movement polemics but the crude resistance of a young skinhead defacing the gravestones of the Leeds cemetery.

When the poem was included in a television broadcast in 1987, the popular press called Harrison's poem a "tribute to Scargill" (Harrison, v. *New Edition* 42). The popular press seemed to perceive and affirm the poet's intended alliance with the politics of the strikers—and the poet-speaker's alliance with the skinhead. Terry Eagleton insists, however, that "the actual Miners' Strike impinges on v. hardly at all, other than in [the] moving epigraph" (350). And Ken Worpole has criticized Harrison for substituting a mob of skinhead football supporters for the complex "social groundswell" of the miners' strike, which "produced a new sense of 'community' that . . . integrated whole new constituencies of the peace and ecology movements, some of the churches and civic bodies, feminism, black and gay politics, too" (73).[2] I would insist, however, that the strike plays an important, if at times indirect, role in the poem's formulation of political and poetic meaning, not simply indicating a political climate within which to read the poem's portrayal of class division and Harrison's thematic concerns about class, history, and poetry, but also indicating the importance of coal as a synecdochical figure for the material history of the working class. More important, the strikes provide a significant political context within which to stage the poet's desire for political alliance with the working class, and the skinhead's consistent destabilization of any such alliance—an alliance formulated as poetic transcendence of the political and resisted through a polemic and crude emphasis on the materiality of the social,

an alliance further indicated and indicted in a number of key puns, such as "gob," "flying visits," and "enemies within." Harrison connects the miners' strikes to the themes that animate much of his poetry: class division, history's materiality, the troubled relation of poetry to history, the tension between poetic transcendence and political alliance, and the desperate albeit inadequate commitment to Labour politics.

Marked and threatened by the coal mine that rests beneath the cemetery and by the mine closings that form the poem's political contexts, the multiple "languages of this graveyard" trace a tension between the political and the poetic, a tension Harrison examines but doesn't resolve. Instead, tying the traditional poetic theme of human mortality to the social death of unemployment, Harrison imagines a skinhead double, whose voice consistently resists the poet-speaker's attempts to poeticize social conflict. His language of cultural vandalism, class resentment, and sexual aggression refuses poetic transcendence, mocks nostalgic or spiritual palliatives, foregrounds internal division within the poem and the speaker, and resists any easy alliance of poetic project and political purpose. Moreover, as the cemetery threatens to settle into the exhausted mine below, the voice of the skinhead threatens to become the emblematic voice of economic exhaustion: the "gob" or mouth of the skinhead, to use a vernacular pun Harrison employs effectively, replicates the "gob" of the worked-out mine, which itself suggests the worked-out history of economic exploitation. The "language of this graveyard," then, comes from the "gob" of a "yob" without a "job"—to use three rhymes that appear in Harrison's work ("yob" is derogatory slang for a young man).

Some critics have noted the importance of the word "gob" in Harrison's work, the word that means both "mouth" and "worked-out mine." Rarely noticed, however, is the fact that to tell someone to shut his "gob," as the poet-speaker tells the skinhead in the poem, is ironically to echo one of the major reasons for the strikes, the threat of closed mines. Furthermore, the "flying visits" Harrison makes back to Leeds to see his parents' graves echo the "flying pickets" for which Scargill's NUM became known during the 1984–1985 strikes. However, they simultaneously mark the social differences education has installed between him and his working-class background. These are perfunctory visits, not political commitments.

Set in a graveyard and ending with the poet's own epitaph, the poem echoes in both form and theme Thomas Gray's "Elegy Written in a Country Churchyard." The poem refuses the traditional elegiac consolations of an afterlife, or of artistic transformation, and its vision of a future is not especially hopeful: man can only be "resigned / to hope from his future what his past never found" (5). The poem resolutely insists on the ambiguities of the present, and the differences—class, race, gender, sexuality, employment, language,

culture, nation, religion—that fracture contemporary England. Yet the "unending violence of US versus THEM," writes Harrison, is "personified in 1984 / in Coal Board MacGregor and the N.U.M." (5); that is, all those social and political differences are exemplified for Harrison by the 1984–1985 miners' strike, "personified" in the text by the NUM and Ian MacGregor, chair of the government's National Coal Board (NCB), and also alluded to in the poem's epigraph, the citation from Scargill, president of the NUM.

Those social differences are also textualized in the obscenity-laced voice of a skinhead in the graveyard, a ghostly double of the poet who voices the hopelessness and resentments of the unemployed and (non)working poor. The language of the skinhead is a language of shit and coal and filth: language of the dirt we return to, the "shit" we're dumped in, the ashes of exhausted lives, and the vulgar vernaculars of the working class—a language connected, metonymically and metaphorically, to the great worked-out coal pit that lies beneath the cemetery. The skinhead in the poem is a representative of the unemployed and of larger cultural decline in regions dependent on the coal industry, yet he is also a representation of internal conflict of the poet, of the educational difference that has separated the poet from his own culture of origin. That is, the skinhead figures both who the poet might have become, given fewer educational opportunities, and what might or has become of so many in this region, unemployed, resentful, and on the dole. In fact, Harrison uses the phrase "the enemies within" to describe the potential skinhead within himself, the possibility of what he might have become without an education. The phrase repeats Margaret Thatcher's characterization of the striking miners as "the enemies within" Great Britain, thus inextricably linking the skinhead, within the context of the poem, to the striking miners as a figure of social division and class resentment.

Although much has been written of the autobiographical contexts and themes in Harrison's work, particularly his relation to his parents, I would like to focus here on the public contexts of this poem—literary, historical, and rhetorical. John Lucas has called v. a poem "very much of its moment" (360), and it seems worthwhile to return to the contexts of that historical and cultural moment. These include not simply the poem's writing and publication during the 1984–1985 miners' strike, which Harrison explicitly foregrounds within the poem, but also the revision of Thomas Gray's well-known literary model.[3] Through his use of poetic tradition, historical context, and the languages of profanity and polemic, Harrison politicizes the poetic. After a brief discussion of the miners' strike, I will examine Harrison's resistance of traditional elegiac or poetic consolations (by comparing the poem to Gray's elegy and to contemporary work of Philip Larkin), his representation of the troubling failure of political alliances, and the emphasis he places on the skinhead's voice as a working-class voice of opposition.

THE 1984–1985 MINERS' STRIKE

Harrison's poem has been called "one of the major literary products of the Thatcher years" (Burton 16), and it takes as its context the 1984–1985 miners' strike, characterized by historians from the right and the left as "the seminal domestic event of Mrs. Thatcher's years in office" and "the key conflict during the Thatcher era" (Taylor 292, Thomsen 175). The longest national domestic labor dispute in postwar Britain—and the longest strike in the coal industry since 1926—the 1984–1985 strike began March 12, 1984, and ended with the defeat of the miners on March 5, 1985. Just as the victory in the Falklands was seen as the symbolic triumph of Margaret Thatcher's first term in office, so the defeat of the NUM was characterized by conservative writers as "the central political event of the second Thatcher Administration" (Lawson 161).

Indeed, the event is often portrayed as Thatcher's quite personal triumph over organized labor, particularly in light of her government's capitulation to union demands in 1981 (over salary issues and the closure of twenty-three pits) and her party's submission to NUM wage demands in 1972 and 1974.[4] More important, the end of the strike was seen as a crucial political and symbolic blow against the labor movement as a whole (Thomsen 174); Robert Taylor calls it "the last, almost primeval scream of a dying proletariat," "a national tragedy of often heroic proportions" (298). The strikes were marked by massive picketing, by violence between strikers and police, and by poor strategy on the part of NUM leaders.[5] At stake in the 1984 NCB plans was the closure of twenty pits—and the concurrent loss of 20,000 jobs (Derbyshire and Derbyshire 113, Taylor 293). The effects were profound: the strike polarized the nation, and damaged relations between police and public in the mine towns; the Labour Party was divided, the national unity of mine workers was destroyed, and a second union formed (the Union of Democratic Mineworkers); the trade union movement was cowed, and it became "unthinkable" that a national union would ever again take such action in the foreseeable future (Derbyshire and Derbyshire 115–16). The end of the strike marked "the declining power of organized labour" (Taylor 292). As Thatcher minister Nigel Lawson says, superciliously, "the eventual defeat of the NUM etched in the public mind the end of the militant trade unionism" (161).[6]

Two previous strikes during Edward Heath's Conservative Party administration reflected both the increased radicalization of NUM during the previous decades and the rising anger of mine workers over pit closures, manpower cuts, and the government's attempts to regulate trade union activity. In 1972, a six-week long miners' strike forced the government to make "humiliating" concessions to salary and benefit demands (Taylor 199). The 1974 strikes are widely assumed to have contributed both to the demise of

the Heath government in 1974 and to Thatcher's defeat of Heath as party leader in early 1975.[7]

In Harrison's poem, "all the versuses of life" are "personified in 1984 / by Coal Board MacGregor and the N.U.M." (5). In many representations of the conflict, it was, in fact, *personified,* dramatized as an almost Manichaean struggle between the personalities of the taciturn MacGregor and charismatic Scargill. The event is sometimes referred to in contemporary histories as a "drama" (Taylor 298, Derbyshire and Derbyshire 113), with "two principal actors" (Derbyshire and Derbyshire 113). Ian MacGregor was an expatriate Scottish businessman, seasoned in American business operations, effectual in carrying out Thatcher's policies in the steel industry, and appointed chair of the NCB in 1983. Arthur Scargill, head of the NUM, was an evangelical labor union leader from Yorkshire, characterized variously as "an uncompromisingly militant Socialist," a "class warrior," an "avowed Marxist," and "a self-confessed class-war revolutionary" (Taylor 358, 296; Derbyshire and Derbyshire 113; Lawson 146).[8] Scargill had made a name for himself as the charismatic leader of "flying pickets" during the 1972 strikes—particularly in leading 15,000 workers to force the closing of the Saltley coal depot in Birmingham, the final showdown of the strike. He was elected president of NUM in 1981 and led the union through both the 1981 and 1984–1985 strikes. In his memoirs, Lawson—who as Thatcher's energy minister in 1981 began precautionary plans in preparation for a coal strike and who insisted that the problems of the coal industry necessitated "the decisive defeat of the militant arm of the NUM" (142)—personalized the conflict with Scargill, saying it was "essential that the government spent whatever necessary to defeat Arthur Scargill" (160–61). The emblematic personification Harrison uses actually replicates the personification at work in the larger cultural arena. It makes sense, then, that he would further personify class conflict in the arguments between an unemployed skinhead and the politically anxious poet-speaker.

POLITICS AND POETRY

Let the class now give, in their own language, the substance of this and the preceding stanzas. Are lack of educational privileges and poverty insuperable obstacles to success? Is the argument good? . . . Do you believe in this "mute, inglorious Milton" theory?

Instructions to students studying Gray's "Elegy" in 1886 (Harbrook)

In December 1969, after watching a television documentary on the mining industry in Britain, Philip Larkin was inspired to write a poem about a mining disaster, "The Explosion" (Motion 394–95). Although Larkin himself had

little sympathy for the working classes and miners of his own era—"Fuck the non-working classes" he wrote sarcastically in a letter in 1971 (Motion 409)—this poem is one of the most beautiful in his oeuvre, transforming coal mining into poetry, tragedy into beauty. The poem, in fact, performs a kind of alchemy, making coal into gold; the blackened, coughing, and smoking men of the coal mines are transformed, in the vision of the poet, into something "Gold as on a coin." The poet remakes loss through apotheosis: the dead miners are "Larger than in life they managed." Their "oath-edged talk" is replaced by the decorous "lettering in the chapels" and the language of religious consolation. They no longer live in working-class housing: "they / Are sitting in God's house in comfort." Although there is an emotional pathos to the poem, there is, for their widows, the spiritual promise of union in the afterlife, and the poem offers an elegiac vision that transcends the loss of the explosion, an image of natural renewal: a man holding a bird's nest, "showing the eggs unbroken." In this elegy, the poet offers the traditional—albeit perhaps contingent—consolations of religion, art, imagination. These are precisely the consolations Harrison will resist in his own version of the coal mine poem, primarily through the interior voice of the skinhead.

"The Explosion" concludes Larkin's 1974 collection, *High Windows,* echoing themes informing his work: the need for community and continuity, the role of ritual in maintaining continuity. A decade after the publication of *High Windows,* England was in a state of crisis because of the miners' strike. No longer romanticized peasants from a pastoral national past, miners were subject to a number of competing interpretations in the public imagination—class revolutionaries, victims of economic hardship, united (or divided) workers, and, according to Thatcher herself, the "enemies within"—a phrase which Harrison repeats in v. to describe the skinhead (13). Larkin was, presumably, uninterested and unsympathetic.[9]

Although Harrison's formalism might, in only the most general way, remind one of Larkin's poetics, Harrison's poetic impulse and his politics are clearly quite the opposite of Larkin's, especially if we compare v. to "The Explosion."[10] In the cemetery of dead miners and laborers that Harrison's speaker visits, the decorous "lettering" of chapels and tombstones has been replaced by obscene graffitti, and the miners' "oath-edged talk" finds its inheritance in the profanity of an unemployed skinhead. Harrison transforms tragedy into poetry, but not beauty. Dunn has argued of both Larkin and Harrison that their poetry absorbs "the materials of ordinary life" rather than transcends them ("Importantly Live" 254), but where Larkin in "The Explosion" seems to offer some kind of transcending consolation, Harrison is explicitly antitranscendent, denying resolution and disavowing religious consolations—"I don't believe in afterlife at all" (7). Even the trajectory of the work's publication history suggests a kind of opposition: Larkin moved from

being inspired by a television documentary to write a poem about a mining disaster while Harrison wrote about economic disaster in a poem that would end up on television in 1987, in a program splicing a reading of the poem with images documenting the deterioration of the inner cities of the north. Unlike Larkin's elegy for his romanticized and pastoral miners, Harrison's social elegy[11] for the loss of community is emphatically antitranscendent and materialist. Or, as the self-appointed guardians of moral decency insisted when the poem was broadcast on television in 1987, the poem is a kind of "filth."[12]

Not only was the state in trouble in 1984, but the official state of poetry in England was also at a critical moment. Poet Laureate John Betjeman died in May. Larkin, then seen as a popular formalist poet of nostalgia and restraint—and quite conservative politics—turned down the laureate position, and it was subsequently accepted by Ted Hughes, a poet who combined raw mythographies of nature with a savage, Darwinian naturalism. Outside the official centers of the laureate and London, a second generation of postwar poets was in the process of, as David Lloyd says, "politicizing" and "energizing" British poetry by writing from the margins against the powerful center of the Empire, by accurately recognizing rather than lamenting the decline of centralized power and cultural fragmentation, and by returning to class, regional, and ethnic allegiances (21–26).

Harrison is one of those poets, popularly and critically recognized as a poet whose work addresses the languages and experiences of the Leeds working class. Blake Morrison, in fact, argues that Harrison is the first genuine working-class poet of England this century (216–17). Born into a working-class family in Leeds, Harrison was educated at Leeds Grammar and took a degree in Classics at Leeds University. Although educated and alienated by that education from his class and family roots, Harrison attempts to recover in his multivocal and political poetry the voices and histories of his region. His poetry attempts to give voice to the voiceless.

Now a renowned poet, dramatist, and translator of classical drama, Harrison was a "scholarship boy," one of the bright working-class students who profited from the 1944 Butler Education Act, which provided secondary and tertiary education for working-class children (in the past economically and socially barred from education). Indeed, that act, according to Neil Corcoran, brought a new range of themes and allegiances into British poetry after the 1960s, particularly class issues and the "besetting preoccupation" with the "cultural (and usually economic) difference between the educated child and his (and it is usually 'his') parents" (153). As Harrison's autobiographical poems demonstrate, acculturation and language acquisition come at a cost: self-exploration and cultural achievement require self-division and exile from background and community.[13]

Harrison's work has been called a "scholarship boy's revenge" (Dunn, "Formal Strategies" 130) because he juxtaposes educated and formal style, vernacular language, and subversive or political subjects. His texts are filled with quotation, self-referentiality, allusion, intertextual citations, puns, word-play, polyphonic shifts in linguistic registers; and throughout, Harrison has "a strong sense of the social ground of language, especially its silences and occlusions, and of the suppression of variations across an apparently homogenous language community by the dominant discourse" (Rylance 115). Indeed, most of the criticism of Harrison's work focuses on his use of language—not simply as recovering history or voicing the voiceless, but as a strategy by which to foreground discursive and cultural heterogeneity. Such a representation of linguistic diversity as cultural diversity may resist or subvert dominant culture or dominant versions of history, while also representing in language the disjunctures of both culture and social class. Indeed, Harrison's use of puns such as "gob" suggests that his poetic style must be tied to his class politics—and to his use of such emblematic contexts as the strikes. As Eagleton writes, "no modern English poet has shown more finely how the sign is a terrain of struggle where opposing accents intersect, how in a class-divided society language is cultural warfare and every nuance a political valuation" (349).[14]

Describing the tombstones of the Leeds cemetery covered with both official and unofficial languages, Harrison writes, "The language of this graveyard ranges" from "a bit of Latin," religious language, and poetry to euphemism ("fell asleep in the Good Lord"), and finally to the obscenities of "CUNT, PISS, SHIT and (mostly) FUCK!" (4). As if to emphasize the range of discourse in the cemetery, Harrison rhymes "the good book" with "FUCK!" To foreground the materialism that outweighs religious consolation, he rhymes "Good Lord" with what "they could afford." This range of language, from the cultured Latin of the poet's classical education to the obscene graffiti of the skinhead, reflects the educational and social inequalities of class (Peach 127)—inscribed in the registers of available language. The skinhead has asserted his identity in the only public writing available to him, graffiti. Concluding his catalogue of the "language of this graveyard," Harrison adds, "more expansively, there's LEEDS v. / the opponent of last week, this week, or next" (5).

The "v" of the poem is itself a "wholly indeterminate sign" (Huk, "Poetry" 207), ever displaced throughout the poem. Yet it is also the preeminent sign the speaker locates as he describes the writing that surrounds him, tombstones covered with both official and unofficial languages. The "v" of the title seems to mean the "v." of "versus" in sports lingo, as the skinheads and football fans have written "LEEDS v." whatever team has currently "vexed" them (another "v"). Harrison opens that "versus" up "more expansively" to include all the differences that fracture society: "These Vs are all the versuses of life / from LEEDS v. DERBY, Black/White, and (as I've known to my cost) man v.

wife," writes Harrison, moving on to include Communist v. Fascist, Left v. Right, class v. class, us v. them, Hindu v. Sikh, East v. West, and male v. female, *all* "personifed" at this historical moment in MacGregor v. the NUM. Imagining the skinhead with spray paint running through the cemetery, Harrison further ties the "v" of versus, visually, to the checkmark which teachers "never marked his work much with at school," suggesting the educational and class differences that lie between the speaker-poet and the skinhead. But the "v" of "versus" soon becomes the nostalgic "v" of "victory," as the speaker remembers the large "v" he whitewashed on a wall at the end of the Second World War, an echo of the vandalism (another "v") performed by the skinheads wielding spray paint, but one with the sanction of the dominant culture.

This memory sets in play another trajectory of displaced meaning, that of the word "UNITED" sprayed on his parents' tomb. Though literally shorthand for the Leeds United team, the speaker wants to "redeem" the "desecration" by imagining that the word means that his parents are "UNITED . . . 'in Heaven' for their sake" (7). This attempt to "redeem" or transcend the intent of the defacement enacts the connection between language and power and the disconnection between poetry (cultural power) and class that inform Harrison's work. Furthermore, he would make the word "apply to higher things, and to the nation"—"nation" rhyming with "desecration," foregrounding the disjuncture-yet-rhyme in meaning that the poet would force. In doing so, according to Huk, "he robs his class of the 'hearing' . . . he originally set out to give them" ("Poetry" 208). Yet the poet's attempt to transcend the "thoughtless spraying" is itself only an "accident of meaning" (7). Although, mid-poem, the poet repeats his attempt to force "UNITED" upward to transcendence, to give the "scrawl" some "higher meaning" (10), the poem falls back to "v," which points downward toward the leveling vortex of mortality and the dividing vortices of class division, represented by the worked-out and worn-out mine of coal that lies beneath the cemetery.

By the end of the poem, where the difference of class (skinhead/poet) has been displaced onto the difference of gender (man/wife), the speaker imagines his marriage "UNITED" here, not in the hereafter. The "v" graphically represents sexuality in the vulva, when the skinhead "added a middle slit to one daubed V" (12). Love, sex, and marriage may seem to promise an idea(l) of union at the end, but the language of sexuality throughout the poem has been a language of possession and aggression. The hope that word "UNITED" offers is "worn" on a tombstone—in a pun it is ascribed to a metaphysical realm, inscribed only in an ideal realm (past community or spiritual hereafter), proscribed by mortality and class division, and "worn out" by use. The poet reimagines "victory" not as the united country of the past, but as a triumph of the "vast" forces that create coal, the epochal sense of time against which the human individual loses his or her meaning (18). The only meaning

left, then, at the end, is what lasts on stone, and the speaker ends the poem as Gray did his elegy, imagining his own epitaph. So "versus" becomes "verses" (19), or poetry, and "v" becomes all the voices of history and division that structure this poem.

Gray's "Elegy Written in a Country Churchyard" is, as noted, a thematic and formal model for v. Harrison uses Gray's elegiac stanza, the iambic pentameter quatrain, rhymed abab, as well as the added epitaph. Some of the echoes of Gray's poem border on the parodic. A "hoary-headed Swain" points out the epitaph on the tombstone in Gray; a skinhead scrawls graffiti on tombstones in Harrison. Harrison's speaker, like Gray's, wishes to be "mindful of the unhonoured dead" and "in these lines their artless tale to relate." In this urban churchyard, littered with Harp beer cans and obscenities rather than "with uncouth rhymes and shapeless sculpture decked," Harrison, like Gray, would put into language the unknown and unarticulated history of the working poor, "the rude forefathers of the hamlet." As Young says, Harrison "sees his role as spokesman for the inarticulate, for the mass of people who have been exploited throughout history without being able to protest even or to cry out in rage" (171).

It is Gray's evocation of a "mute inglorious Milton" that most significantly figures this theme of the inarticulated history in Harrison's poetry. A symbol of unrealized promise, this rural Milton never had the money or education to become a poet: "But Knowledge to [his] eyes her ample page / Rich with the spoils of time did ne'er unroll." Similarly, Harrison finds in the cemetery Wordsworth the organ-builder and Byron the tanner. In "On Not Being Milton," one of Harrison's most frequently cited poems, he imagines a return to his class roots through racial politics, industrial history, and Gray's "mute inglorious Milton." In this sixteen-line Meredithian (and in some ways Miltonic) sonnet, Harrison links race and class, rethinking working-class culture through the cultural politics of negritude and the history of coal mining, and suggesting that he is "growing black enough" through coal-dust or recovered history "to fit my boots." He represents the stutter of working-class language as a kind of class resistance by linking it to the Luddite rebellion against industrialization: "the looms of owned language smashed apart!" Alluding to Gray, he adds, "Three cheers for mute ingloriousness!" (Selected Poems 112).

If Gray's poem offers the modern reader a "thematic constellation of poverty, anonymity, alienation, and unfulfilled potential" (Weinfield xi), and if the tragedy of this unfulfilled potential can only be understood today through the history of social class (62), then Harrison must reimagine Gray's "mute inglorious Milton" fractured into the alienated poet of working-class roots and the ghostly presence in the cemetery of the skinhead he might have become, given different economic and social opportunities—an "alter ego" with an "aerosol vocab" (18). The skinhead appears as a different language within the

language of the poet. His slogans are written in all caps, defacing the page of poetry like graffiti across the rhymes on the tombstones; his own language is printed in italics throughout the poem, like the quotations from foreign languages. The skinhead is both a familiar, then, and a foreigner. Social class divides the speaker's society, but it also causes internal division, from the speaker's past and in the speaker's sense of self. Yet this split self only mirrors the divided nation (Grant 110–11). The skinhead himself is a figure of cultural identity crisis, harking back to an idealized community of masculine solidarity (Peach 125, Hebdige 55) and substituting sports communities for class solidarity.

Gray looks beyond the inequities of class and the leveling of death to the consolation of union with Father and God in heaven; Harrison rejects the false consolations of union and heaven to focus on the inequities of class and station that remain even after death. Harrison has taken Gray's almost archetypal graveyard poem and politicized it, highlighting the class disjunctures that Gray seems to transcend. In doing so he has resisted the tropes and strategies of the traditional transcendental elegy, neither accepting the traditional religious consolations, nor figuring the artistic transformations so clearly at work in Larkin's poem. In v. for example, the "poet" tries to "redeem" the skin's language by universalizing it—wresting class (or team) solidarity into ideal unities—a strategy that some critics say proves poetry to be an aggressive act of ideological domination (Huk, "Poetry" 208–9). For writers from marginalized groups, the traditional elegy is problematic in its erasure of the conditions of death and the communities of the dead. Elegies by women, ethnic minorities, and gays and lesbians demonstrate a resistance to transcendentalizing or universalizing poetic strategies, as well as an emphasis on the particularities of death and of the community. Such "invocational elegies," as Margot Backus calls them, invoke the dead to reclaim both their relation to the community and the communal lives lost or destroyed by social death and marginalization.[15] Harrison's threnody is, in fact, an elegy for the social deaths enacted by acculturation and social class—and more particularly in the social deaths rendered by unemployment and the economic inequalities so readily registered in the contemporary miners' strike.

For the skinhead, surveying the tombstones that state the occupations of the dead, unemployment has enacted a kind of social death, so that his own mortality seems to offer erasure, not commemoration or consolation. Gray's theme of unfulfilled potential is situated not among the dead in Harrison's revision, but among the living, or rather in the realm of social death that unemployment enacts. Because the skinhead will have nothing to show or name for his life's work, he says that he does not want to meet his mother after death, rejecting the postmortem reunions of both the poet's "UNITED 'in Heaven'" and Gray's final union with father and God. In fact, he transforms the afterlife into a threat: "*Ah'll boot yer fucking balls to Kingdom Come*" (11).

The only thing the mason may carve on his tombstone is "*The cunts who lieth 'ere wor unemployed,*" or nothing. Harrison, then, resists the tendency to poeticize the "rude forefathers" who are dead and gone in the past by inserting the voice of the unemployed living dead, the ghostly and "rude" skinhead. He may be an "inglorious" Milton, but he is not "mute."

The skinhead will tell "*St fucking Peter / ah've been on t'dole all mi life in fucking Leeds!*" Faced with this erasure, this social and economic loss, the skin rails at the poet-speaker: "*They'll chisel fucking poet when they do you / and that, yer cunt, 's a crude four-letter word*" (10). To the skinhead, the occupation of poetry is ineffective. When the poet tells the skin he hopes to give him a "hearing" in a book, the skin replies, "*A book, yer stupid cunt, 's worth a fuck!*" (10). His internal rhyme repeats the poet's previous stanza rhyme of "good book" and "fuck," suggesting that the internal division of class alienation puts into question the usefulness of poetry just as the external social and economic divisions undermine the consolations of religion. The skin insists, "*it's not poetry we need in this class war*" (12). Even near the end of the poem, as the poet attempts to claim resolution in the idea of love, he is haunted by the skinhead's cry, "*Wanker!*" which reduces poetry to masturbatory and useless labor.

It is the skin's refusal of poetry that most completely destabilizes and interrogates the traditional power of poetry to transcend, and disturbs the place of the poet in the discursive field of the graveyard. Throughout most of the poem, the "language of this graveyard" remains a site of contestation: "*Who needs / yer fucking poufy words,*" the skin tells the poet. "*Ah write mi own. / Ah've got mi work on show all over Leeds / like this UNITED 'ere on some sod's stone*" (12). The ubiquity of his work may suggest that Harrison ignores the complexities of working-class culture and reduces the young into "a mob or undifferentiated mass," as Ken Worpole complains (72–73), but Harrison seems self-conscious of this reduction, especially when the poet asks the skin to sign his name to his work. On the tomb of Harrison's parents, "He aerosoled his name and it was mine" (13). Although one might be tempted, as most critics are, simply to read this as yet another marker of the internal division of class in the presence of a double, or the correlation of poet and skin in an act of discursive vandalism,[16] I think the signature foregrounds the issue of the poet's ventriloquism, another "v" and another kind of cultural vandalism. Harrison self-consciously recognizes that it is only through the voice and interpretation of the poet—even when resisting the traditional universalizing strategies of poetry—that the voice of the skin is heard.

WORKING-CLASS VOICES AND *V.*

Harrison's citation of Scargill in the epigraph suggests that the theme of discursive power as cultural power links the poet/skinhead conflict to that

between Scargill and MacGregor. And word power did play a role in the strike negotiations. The fluent and charismatic Scargill could fill auditoriums, but MacGregor was "surprisingly inept" and unable to articulate the NCB case (Taylor 296). In fact, writes one historian, "for many months he seemed to have convinced himself that a mere form of words could be agreed with Scargill that would satisfy all sides on the issue of pit closures. Well-thumbed copies of *Roget's Thesaurus* were used to find the magic formula that would end the strike" (296). Words and books function similarly in Harrison's work. "The pen's all I have of magic wand," claims the poet in *v.*, and with that he attempts to reclaim the skinhead's scrawls (7), hoping they can agree on the magic formula of "UNITED." When the skinhead, though, resists the poet's poetizations, language may become a weapon, as well as a magic wand, and the poem enacts a battle of words. In an earlier poem, "Wordlists II," Harrison describes his own Uncle Harry, "the most eloquent deaf-mute," who jabbed at a dictionary "when there were Tory errors to confute," turning the dictionary into a "paper bomb" (*Selected Poems* 118).

However, despite the Scargill epigraph, the correlation of linguistic and political conflicts is an unstable one in *v.*, and the political allegiance of poet and skinhead uneasy. Perhaps that is most clearly marked by the poet's infrequent visits, both to Leeds and to the grave of his parents. He is a native and yet a visitor, allied by political impulse, but without the solidarity of class or the allegiance of residence. The cemetery, like Leeds, has been abandoned by those, like the poet, who "have gone away / for work or fuller lives" (6), who only return for "flying visits," that ironic echo of traveling picketers Scargill organized and sent to strike sites around the nation. Scargill's own inability to unite all the mine workers—or to enlist support from other trade unions—finds its poetic echo in the poet-speaker's inability to enlist the skinhead in an alliance.

It is on a question of language that the skinhead enters the poem, and questions the allegiance of the poet's own flying pickets. Although right-wing critics would find it easy during the 1987 television controversy to label the politics of the poem—Tory MP Gerald Howarth called Harrison "another Bolshie poet" (qtd. in Harrison, *v. New Edition* 41)—Harrison problematizes the issue of political alliances through the thematic of language as cultural power. The poet asks, attempting to understand the working-class scrawls of anger and resentment: "What is it that these crude words are revealing? / What is it that this aggro act implies?" While he recognizes words as acts of aggression, he interprets them merely as an attribution of the skin's own racism to the dead (as if there is a solidarity of prejudice, the "unending violence of US v. THEM"), or as an inexplicable "*cri-de-coeur*" in the face of mortality. Entering the poem on the question of articulation, the skin interrupts the poet's melancholy reverie: "*So what's a* cri-de-coeur, *cunt? Can't yer speak*

/ *the language that yer mam spoke? Think of 'er! / Can yer only get yer tongue round fucking Greek?"* (9).

Scargill invokes the political power of the father's language, but the skin-head invokes the emotional power of the mother's language and Harrison's own mother, who thought his first book "obscene." Although the skin uses words Harrison's mother would not have used, the implication is that he speaks the mother tongue that the poet has rejected. When the skinhead refers to the poet's educated and cultured discourse as Greek, he underlines the rifts of acculturation and class, "Greek epitomising not only the educational level of attainment that Harrison has reached, but signifying education—a classical education—as cultural capital" (Peach 129). And if education itself is a kind of capital, then the poet is a capitalist, or at least someone who has profited at the expense of others, and his allegiances must be questioned.

The poet indicts himself as part of the problem, answering the question "who's to blame" with "It isn't all his fault, though. Much is ours" (6)—the his/ours opposition implying that the skinhead is one of "THEM," and the poet's "US" is his own cultured audience. *"Don't treat me like I'm dumb,"* the skinhead shouts at the poet, the pun on "dumb" suggesting their educational differences, but also the skin's possession of a voice, which he thinks the poet fails to acknowledge. The poet writes to give the skin a hearing, but he also writes to force the skin's language into (his own) higher meanings. Poetry then contains, uses—perhaps exploits—the language/labor of others. Harrison knows, as Dunn states, that "he is supposed to be on the side of the skins and punks, the defacers and disfigurers of England, or the defaced and disfigured, all those struggling to articulate themselves in a culture that disinherits as many of those as its democracy manages to educate" ("Abrasive Encounters" 347). But because the skinhead speaks for those excluded from educated cul-ture, of which the poet is inevitably a part, Harrison distrusts his own craft and occupation.

Harrison's skinhead is not a miner, so the actual strikes appear in his poem only—and perhaps fittingly (recalling the comparison to Larkin)—through television: "As the coal with reddish dust cools in the grate," writes Harrison, "on the late-night national news we see / police v. pickets at a coke plant gate, / old violence and old disunity." The news also shows the Gulf War, a war tied to issues of fuel consumption (and thus indirectly to the coal strike),[17] and "the map that's colour-coded Ulster/Eire" (17). In October 1984, the IRA bombed the Grand Hotel in Brighton during the Conservative Party Conference, so the invocation of Irish politics provides another important his-torical context, but Harrison simultaneously indicates the literary context. He writes, "Behind a tiny coffin with two bearers / men in masks with arms show off their might," reimagining through a politicized Irish funeral the two-line funeral march that ends Gray's "Elegy." That the dead victim is apparently a

child (the "tiny coffin") only reemphasizes Gray's theme of unfulfilled poten-
tial—in this case unfulfilled because of nationalist and masculinist power
rather than economic powerlessness.

The television news begins and concludes with images of play—the earth
small as a "taw" (a shooting marble) or spinning like a soccer ball. Television
thus frames the news, including the strike, though the sensibility of the skin-
head football supporter, for whom football divisions mimic social divisions,
displacing energy from political activism into "play" (see Rutter 148). But the
news also begins and ends with coal, the "glow" to which the television fades,
echoing the cooling coal that precedes the news, and the ashes, flames,
embers, and smoke that form a motif throughout the poem. This motif
undoubtedly repeats Gray's image of unfulfilled desires and aspirations sur-
viving death, "Even in our ashes live their wonted fires," but adds the social
and historical importance of the coal industry to this tale of unrealized poten-
tial and unrecorded lives.

Coal seems to underlie the poem both literally and figuratively. As the
poet listens to opera and watches television after his visit to the cemetery, he
repeatedly notes how the hearth and home are warmed by coal (16–17). The
miners' strike provides the historical context for the poem, and coal provides
a symbol that allows Harrison to focus on both the immediate history and the
longer perspective. As noted above, the blackness of coal in the sonnet "On
Not Being Milton" is aligned with the politics of negritude, the proud recla-
mation of a disempowered (black) culture.[18] In v. he represents the interaction
of race and class through a theft of language. When skinheads steal the "N"
and "F" from a sign over Yorkshire mines, "PRINCE OF WALES" suddenly
becomes "PRI CE O WALES" (8). The "price" of Wales (its mines or its lan-
guage) is linked through an act of vandalism (against the Empire?) to the
racist politics of the National Front (NF). Class resentment feeds xenophobia
and racism; one division perpetuates another.

The Beeston cemetery itself rests over an abandoned coal mine, a "great
worked-out black hollow" (14) that threatens to swallow eventually the ceme-
tery and its dead; tombstones are already starting to list from the "subsidence"
of the "worked-out pit," a much slower kind of vandalism than the skin's
spray-painted graffiti. The "pit" is not only the Old Testament *sheol* that
prefigures Christian belief in an afterlife, nor is it only the leveling (hence
the threat of "subsidence" and settling) effect of death attested to in Gray's
"Elegy." It is the void against which individual lives take their meaning, and it
is also the image of "worked-out" class exhaustion and exploitation. "*When
dole-wallahs fuck off to the void,*" asks the skin, what will the mason carve on
their tombs (10)?

Huk reads the state of the cemetery and its position over the pit as "fig-
ures for its inarticulate souls' eclipse by the industry that consumed them"

("Poetry" 207). The skinhead himself uses coal to represent the limitations of his own socioeconomic situation: *Folk on t'fucking dole / 'ave got about as much scope to aspire / above the shit they're dumped in, cunt, as coal / aspires to be chucked on t'fucking fire"* (9). This symbolization of the poor as lumps of coal—equating the working class with one of its primary industries—makes the poet's comfort at the end of the poem seem especially troublesome. As he turns from the skinhead to his wife, leaving the graveyard of social differences for the private home of the privatized family, his hearth reduces primeval "perished vegetation" to a "brief flame" and smoke "escaping insubstantial up the flue" (16). The "vast" forces of history and the social industry it took to create the coal disappear in the creation of the poet's material comfort.

In earlier poems, Harrison uses a colloquial pun to link metaphorically work, language, and worker, as in the sonnet "Working," which concludes, "Wherever hardship held its tongue the job / 's breaking the silence of the worked-out gob" (*Selected Poems* 124); Harrison notes that "gob" is a northern word for a worked-out coal mine, and also a word for the mouth and for speech. In "Cremation" (*Selected Poems* 125) a retired miner "keeps back death the way he keeps back phlegm / in company, curled on his tongue." The miner is himself worked out, exhausted; the connection of choking phlegm to death echoes the coal mine beneath the cemetery, a worked-out gob. When the man is left alone, with "the last coal fire in the smokeless zone," "he hawks his cold gobful at the brightest flame, / too practised, too contemptuous to miss." The gob of phlegm and class resentment, held decorously "in company," must either be swallowed, or hawked up and spit out—specifically into one of the last coal fires left in an industrialized nation. As both Peach and Morrison accurately point out, Harrison's poems are full of mouths: references to being inarticulate; the stammerers and the dumb; images of stuttering, hawking, spitting, and chewing (Peach 116, Morrison 57). The chain of associations multiplies through metaphor and metonymy—gob, pit, mine; mouth, coal dust, phlegm, tongue, speech; labor, hearth, material conditions (and material comfort), history; resentment, exhaustion, death—until the "gob" (which so often rhymes with "job" or "yob") synecdochically represents the exhaustion, silence, and unrecorded history of the working class.

As if to emphasize the failure of poetic and religious consolations, in *v.* it is the angels in heaven who have choked gobs. The skin says that when he tells St. Peter that he has been on the dole all his life, *"Then t'Alleluias stick in t'angels' gobs"* (10). Like the phlegm that the miner needs to hawk up and spit out, the angels need to clear their throats of the hymns they have been offering. That angels should have "gobs" should not be surprising, considering that the "HARP" of inspiration in the poem is neither poetic nor angelic, but alcoholic, the "tins" littering the cemetery. More important, this moment implies that even when the skin alludes to religious consolation in his use of religious

language, his economic status destroys his spiritual hopes. The facts of economic history stick in the craw of religious consolation. That also should not be surprising, since in the Leeds the poet describes, neighborhood churches have turned into shops (religion supplanted by commerce); their "pews are filled with cut-price toilet rolls" (16).

The only time the poet in v. uses the word "gob" is when he tells the skin to "shut yer gob awhile" (11), lapsing into the skin's language (he even leaves off his aspirant "h" with "Ah'll tell yer 'ow") to tell the skin about his own act of teenage vandalism in an attempt to find a common ground. But the phrase he uses resists his own intent. Telling the skin to "shut" his gob can only recall the National Coal Board's agenda. Worked-out pits and unproductive mines were precisely what Thatcher's government sought to close in 1984, and the voices and actions of the miners had little effect in Thatcher's England. So in the act of seeking the skin's sympathy he inadvertently foregrounds the context of the miners' strike, and the problems and silencing of the working class.

Despite the poet-speaker's command "shut yer gob," silenced voices, disempowered and inarticulate, are precisely the ones Harrison wants to recover. In "National Trust" (*Selected Poems* 121), for example, history, articulation, class, ethnicity, and property come together in the tale of "Bottomless pits." Harrison tells the story of "stout upholders of our law and order" who wagered on the depth of a bottomless pit. They winched a convict down on a rope, brought him back "flayed, grey, mad, dumb. // Not even a good flogging made him holler!" Harrison suggests a better way to "plumb / the depths of Britain" is to dangle a scholar in a working tin mine in Cornwall, where "those gentlemen who silenced the men's oath" also "killed the language that they swore it in." The loss of the Cornish language replicates the loss of working-class history, which is itself figured as a "bottomless pit" that has yet to be accurately measured. "The dumb go down in history and disappear," writes Harrison, "and not one gentleman's been brought to book"—"those gentleman" who exploited the working poor or disenfranchised and silenced the Cornish language have never been charged for their crimes, nor have the poor themselves had their histories accurately recorded.

This impulse is repeated in v. when the poet tells the skinhead that he wants to put him in a book to give him "a hearing" (10). The skin resists his alliance and refuses to collaborate in the poeticization of working-class anger, yet at the end of the poem the poet says that the skin's language "underwrites" his (18): it is the guarantor that insures that his language and his art will exist. Just as the coal on the hearth creates the comfort of the domestic and privatized family, just as the history of class division has resulted in a poet divided from his past, and just as the worked-out pit lies beneath the discursive struggles of this graveyard and this poem, the skinhead's language—vulgar, material, working class, regional—lies beneath and within the poet's art. It is

"carved below": language from below, history from below, coal from below, resistance from below. An expression of worked-out anger, exhaustion, or class resentment, it constantly questions the poetry that appropriates its voice.

From the skinhead in the graveyard the poet turns to his wife, "home to my woman." From the television news of conflict (framed by the image of the world as a soccer ball), the poet turns to the privacy of his bedroom. There is a parallel—whether self-conscious and intended or not—between these acts of privatization and displacement in the poem and the real privatization and displacement of 1984, a time when Margaret Thatcher was attempting to privatize national industries, especially the mining industry, destroying jobs in the process, and a time when (as in the U.S.) "moral" or "family" values and the primacy of the nuclear family unit over any other form of social organization were being used to disable or destroy progressive politics.[19]

But, luckily, that's not how the poem ends. The poet turns from addressing skin and wife, to addressing the reader, and "you" are given the choice of how to interpret "UNITED" and "v." and whether or not to leave them on the tombstones, as he has left "UNITED" on his parents' tomb. (With whom will the reader collaborate?) The reader is asked to turn his or her back on Leeds (site of the poet's education) and "read" the tombstone—"read" repeated twice in the penultimate stanza, perhaps echoing Gray's "Approach and read (for thou can'st read)." Like Gray's "Elegy Written in a Country Churchyard," Harrison's elegy written about an urban cemetery ends with the speaker's own epitaph:

Beneath your feet's a poet, then a pit.
Poetry supporter, if you're here to find
how poems can grow from (beat you to it!) SHIT
find the beef, the beer, the bread, then look behind. (19)

Peach, one of those critics seeking resolution at the end, says v. "closes with beef, beer, bread, the three necessities which his ancestors provided, to which Harrison now feels 'poetry' can be added." Harrison has, he says, "resolved" the tensions and "settled" the conflicts (131). "Settled" is a perhaps unfortunate word, considering that we are not allowed to forget that the cemetery may some day settle into the "worked-out gob" below.

Nor does the epitaph resolve the poem. The skinhead's presence and language remain. Poetry supporter hints at athletic supporter and the soccer-cheering skinhead of "UNITED," a word the poet would wrest away from the skin, but leaves to the reader at the end. "SHIT" is also the skin's word, *the shit they're dumped in.* Poetry, Harrison wants to insist, is grounded in the material conditions and hardships of history. Gray tells his readers not to seek the antinomies of "merits" or "frailties," yet we are told to find the three

essentials of beef, beer, and bread, and look "behind" for poetry and/or shit. (Behind us or behind the tombs?)[20] Furthermore, Harrison's ancestors were bakers and butchers (his father and his grandfather, whose names appear on the tomb at Beeston, along with their occupations), but brewers? The skinhead is no brewer, but it is he who brings the "HARP" (beer or inspiration) to the cemetery. Throughout the poem, the voice of the skinhead, like the ever threatening coal mine, always underlies and undermines the project of the poet.

NOTES

1. Harrison's poem *v.* (which has been called his "longest and most ambitious poem to date" [Grant 108] and "one of the great public poems of our times" [Barker 52]) has been published in a number of places, both alone and in collections; in this essay I will quote from the 1990 edition of *"v." and Other Poems*, since this text is probably the most easily available to American readers. The poem was first published in the *London Review of Books* in 1984, and reprinted in the *Independent* in 1987. It was published in hardback by Bloodaxe Books in 1985, with fourteen photographs by Graham Sykes, and included in the second edition of the 1987 *Selected Poems*. Bloodaxe released a second edition of *v.* in 1989, with seven photographs by Sykes, and thirty-five press items related to the television broadcast controversy.

2. John Lucas notes that even Harrison's parents may be reduced to "emblems" of class resentment and underprivilege rather than appearing as full characters (360).

3. The "Elegy" (published in 1751) may seem a more esoteric than public context, but Gray's poem is recognized as one of the most popular and well-known poems in the English language (Weinfield 1), suggesting a quite public context for many general readers.

4. Lawson describes the conclusion of the 1981 strike as "the first time the Thatcher Government had been defeated by militant trade union power" (141).

5. Leaders were unaware that, in fact, the Conservative government had been expecting and preparing for a strike for some time (see Derbyshire and Derbyshire 113; Lawson; Thomsen 173–74). Moreover, Scargill and NUM leaders failed to seek a national strike ballot from the union constituency, alienating many members; as a result, they were not only unable to enlist support from other unions, but also unable to receive full support from miners. Many writers also point out the poor scheduling: beginning a coal strike in March, just as demands for coal fuel are starting to dwindle. Scargill also failed to condemn violence, and he refused to budge on the issue of closing "uneconomic" pits (Derbyshire and Derbyshire 115).

6. See Derbyshire and Derbyshire 113–16, Lawson 142–61, Taylor 292–302, Thomsen 172–75. For more extended and systematic historical and social analyses of the strike, see also Gibbon, Howell, Richards. For a succinct history of the NUM, see Francis. On the immediately preceding strikes see Taylor 196–99, 208–17.

7. Of course, the miners' strikes were not the only factors contributing to Heath's downfall. Mounting economic and social unrest in England and continued violence in Northern Ireland also played a part (Derbyshire and Derbyshire 35).

8. See Taylor 198, 358–59.

9. In a letter to a friend in September 1984, Larkin said of labor union leaders that they "can't lose: either they get what they are asking for, or they reduce the country to chaos, at which point their friends the Russkis come marching in." Trade unions were a frequent target in Larkin's letters to friends; in 1970 he wrote of a dock strike, "the idle Commie layabouts want '50 a week basic pay instead of a kick up the arse WHICH IS WHAT I'D GIVE 'EM." Larkin was, according to his biographer, "proud of his right-wing isolation" and filled with a "horrible fascination" by the national politics of the 1980s (Motion 402–3, 410–11, 511).

10. Morrison links Harrison's formal and textual difficulty to his class politics: "To call Harrison's poetry 'laboured' is not to damn it but to describe it precisely: it is written with labour, and on behalf of labour, and out of the labouring class" ("Labouring" 219)—"and on behalf of Labour Party aspirations" ("Filial Art" 57). In 1971 Harrison himself described his use of "the most difficult traditional verse forms" in terms of a need for labor: "It had to be hard work, and it was, and it is" ("Inkwell" 33).

11. "Social elegy" is the term Helmut Haberkamm uses to denote the poem's combination of social criticism with elegiac mode. As Carol Rutter notes, "the elegy in Harrison's hands has a hard political edge to it" (19).

12. Interestingly enough, Larkin's *High Windows* was the book in which he famously used the word "fuck" (in "This Be the Verse" 30). When some reviewers noted the "foul" language, Larkin responded that the language might be meant to shock, or it might be the most accurate word, or it might be funny in a "traditional" way (Motion 444).

13. See Rutter 19, Eagleton 349, and Rylance 126. On the importance of this issue as a general theme in Harrison's work, see Worpole, Rylance, and Corcoran.

14. Rylance's "On Not Being Milton" and Grant's "Poetry *versus* History" seem the most useful examinations of Harrison's use of language. Peach and Rylance find Harrison's work an unusual combination of the poststructuralist and the poignant (see Peach 121), and Rylance describes the work as both postmodern "bricolage" (126) and, in Raymond Williams's terms, an "interaction of dominant, residual, and emergent cultures" (124). Huk, Eagleton, Geyer-Ryan, and Garofalakis all read Harrison in relation to Bakhtin, Geyer-Ryan insisting that social and linguistic polyphony is "the central principle upon which all his poetry is based" (207). Huk cites v. in particular as an example of a poem of dramatic and dialogic modes, "with its explosion of monologic form by means of inner debate [between the nostalgic poet-speaker and the disruptive skinhead], decentring of positions, and analysis of his own stance as poet" ("Tony Harrison" 79). For more general introductions to the use of language in Harrison's work, see Rutter, Burton, and Lamb.

15. Backus develops these ideas insightfully and convincingly in her study of the lesbian elegy.

16. See, for example, Peach, who insists that the poet's goal is to "understand" the vandalism and thus unite his occupation as poet to both class and family ancestry, and that the poet and the skin are united in the poet's memories of his own juvenile acts of vandalism (127–29).

17. The Gulf War provoked another poem by Harrison that gives voice to the voiceless and revises the themes of a canonical poem: "A Cold Coming," which echoes the language, themes, and East/West encounter of Eliot's journey of the Magi," and gives voice to a dead Iraqi soldier.

18. Rylance develops this correlation in relation to Anglo-Caribbean poets (123–25).

19. The poetic appropriation of the skin's voice of obscenity and anger found its fullest expression and irony in 1987, when *v.* became a television film. Director Richard Eyre and Channel Four television created a film version of the poem, combining images of inner city deterioration, graveyards, and war with the poet reading the poem. The film version of *v.* won the Royal Television Society's Best Original Programme Award. Despite the critical acclaim, however, the tabloid press and politicians attacked the film viciously. The poetic text of *v.* had been available—in the limited way poetry is available—for almost three years, but the broadcast of *v.* caused an uproar: "the tabloid press frothed at the mouth, Tory MPs fulminated, and—the ultimate accolade—questions were asked in the House" (Grant 113). A motion on the floor of the House of Commons, sponsored by Tory MP Gerald Howarth, condemned the broadcast and the poem. (Howarth, who had sponsored an Obscene Publications Bill in April 1987, also bothered to count the expletives in the 448–line poem.) Much of the press material related to the controversy, including the House motion, has been collected by Neil Astley, the editor of Bloodaxe Books, and included with a second edition of the poem, published in 1989.

The film version was originally to have been broadcast on October 29, 1987, immediately after the Booker Prize awards ceremony, a time slot that would have assigned a stamp of cultural worth and cultural approval to the poem, but because of public protests the broadcast was moved to a later date and later time slot, November 4, 1987, at 11:30 p.m. Ironically, as a result of the publicity, the broadcast "was experienced by more people than possibly any single poem before or since" (Barker 52), "the poem reached an audience of several million" (Astley 36), and, as Richard Eyre says, Tony Harrison became "the uncrowned poet laureate—a truly public poet" (37). The viewer call-in log on the night of the transmission includes the following item: "Tom S, who is still in school, and doesn't take much interest in poetry to say this was really good. Gave details of the book" (Harrison, *v. New Edition* 71). This kind of school-boy testimonial keeps popping up in accounts of the controversy—with particular attention paid to Harrison's appeal to working-class students. It is no wonder that Tory MPs and conservative parents were soon trying to have Harrison's poetry removed from school curriculums—more often than not using moral offense to effect political censorship.

The broadcast of the poem was, in Lucas's words, an "important intervention" (353), since throughout the 1980s the British government had been policing and censoring television, and the Tory party was determined "to sanitise our screens, to wipe them clean of the filth of opposition" (351–53). One cannot help comparing this to the silencing of working-class voices effected by the crush of the miners' strikes in the middle of the decade. Furthermore, among those protesting most loudly was Mary Whitehouse, president of the National Viewers' and Listeners' Association. Whitehouse

was Britain's version of Rev. Donald Wildmon in the U.S., chair of the National Federation for Decency and later the American Family Association, known for his attacks on the "obscene" art of Robert Mapplethorpe and David Wojnarowicz. In the 1980s, at the same time Whitehouse was seeking standards of "good taste and decency" in British broadcasting, Wildmon was creating the Coalition for Better Television with Jerry Falwell. On Wildmon, see, for example, Bolton 8–12, 27. A substantive comparison needs to be drawn between the religious conservative cultural agendas in 1980s Britain and America, both galvanized around issues of sexuality, and both antagonistic to publically funded art.

20. One might be reminded of the traditional bawdy limerick that is the epigraph of Harrison's first book, *The Loiners:*

There was a young man of Leeds
Who swallowed a packet of seeds.
A pure white rose
Grew out of his nose
And his arse was covered with weeds. (qtd. in Young 169)

If dominant culture is the "pure white rose" growing out of a (presumably turned up) nose, then the culture of resistance is the "arse . . . covered with weeds." Even the church benches in the Leeds of v. now covered with discount toilet paper suggest an excremental aesthetic and the need to address the "shit" of this world and not the promise of another.

WORKS CONSULTED

Astley, Neil. "The Riff-Raff Takes Over." In v., 2d ed., by Tony Harrison, 35–36. Newcastle upon Tyne: Bloodaxe Books, 1989.
———, ed. *Tony Harrison.* Newcastle upon Tyne: Bloodaxe Books, 1991.
Backus, Margot Gayle. "Judy Grahn and the Lesbian Invocational Elegy: Testimonial and Prophetic Responses to Social Death in 'A Woman Is Talking to Death.'" *Signs* 18, no. 4 (Summer 1993): 815–37.
Barfoot, C. C., ed. *In Black and Gold: Contiguous Traditions in Post-War British and Irish Poetry.* Atlanta: Rodopi, 1994.
Barker, Jonathan. "Peru, Leeds, Florida, and Keats." In *Tony Harrison,* edited by Neil Astley, 46–53. Newcastle upon Tyne: Bloodaxe Books, 1991.
Bolton, Richard, ed. *Culture Wars: Documents from the Recent Controversies in the Arts.* New York: New Press, 1992.
Burton, Rosemary. "Tony Harrison: An Introduction." In *Tony Harrison,* edited by Neil Astley, 14–31. Newcastle upon Tyne: Bloodaxe Books, 1991.
Corcoran, Neil. *English Poetry since 1940.* London and New York: Longman, 1993.
Derbyshire, J. Denis, and Ian Derbyshire. *Politics in Britain: From Callaghan to Thatcher.* 1986. Cambridge, Eng.: W. & R. Chambers, 1988.
Dunn, Douglas. "Abrasive Encounters." Review of v. In *Tony Harrison,* edited by Neil Astley, 346–47. Newcastle upon Tyne: Bloodaxe Books, 1991.

————. "Acute Accent." In *Tony Harrison,* edited by Neil Astley, 212–15. Newcastle upon Tyne: Bloodaxe Books, 1991.

————. "Formal Strategies in Tony Harrisons Poetry. In *Tony Harrison,* edited by Neil Astley, 129–32. Newcastle upon Tyne: Bloodaxe Books, 1991.

————. "'Importantly Live': Tony Harrison's Lyricism." In *Tony Harrison,* edited by Neil Astley, 254–57. Newcastle upon Tyne: Bloodaxe Books, 1991.

Eagleton, Terry. "Antagonisms: Tony Harrison's 'v.'" In *Tony Harrison,* edited by Neil Astley, 348–50. Newcastle upon Tyne: Bloodaxe Books, 1991.

Eyre, Richard. "Such Men Are Dangerous." In *v.,* 2d ed., by Tony Harrison, 37–38. Newcastle upon Tyne: Bloodaxe Books, 1989.

Francis, Hywel. "Learning from Bitter Experience: The Making of the NUM." In *Miners, Unions and Politics, 1910–1947,* edited by Alan Campbell, Nina Fishman, and David Howell, 253–71. Brookfield, Vt.: Scolar Press/Ashgate, 1996.

Forbes, Peter. "The Bald Eagles of Canaveral." In *Tony Harrison,* edited by Neil Astley, 486–95. Newcastle upon Tyne: Bloodaxe Books, 1991.

Garofalakis, Mary. "One Continuous Us." In *Tony Harrison,* edited by Neil Astley, 202–9. Newcastle upon Tyne: Bloodaxe Books, 1991.

Geyer-Ryan, Helga. "Heteroglossia in the Poetry of Bertolt Brecht and Tony Harrison." In *The Taming of the Text: Explorations in Language, Literature and Culture,* edited by Willie van Peer, 193–221. London: Routledge, 1991.

Gibbon, Peter. "Analysing the British Miners' Strike of 1984–5." *Economy and Society* 17, no. 2 (May 1988): 139–94.

Grant, Damien. "Poetry *versus* History: Voices Off in the Poetry of Tony Harrison." In *Tony Harrison,* edited by Neil Astley, 104–13. Newcastle upon Tyne: Bloodaxe Books, 1991.

Gray, Thomas. *The Complete Poems of Thomas Gray.* Edited by H. W. Starr and J. R. Hendrickson. Oxford: Clarendon Press, 1972.

Haberkamm, Helmut. "'These Vs Are All the Versuses of Life': A Reading of Tony Harrison's Social Elegy *v.*" In *In Black and Gold: Contiguous Traditions in Post-War British and Irish Poetry,* edited by C. C. Barfoot, 79–94. Atlanta: Rodopi, 1994.

Harbrook, R. Heber. *Gray's Elegy, with Literary and Grammatical Explanations and Comments, and Suggestions As to How It Should Be Taught.* 1886. Lebanon, Ohio: C. K. Hamilton, University Publishers, 1889.

Hargreaves, Raymond. "Tony Harrison and the Poetry of Leeds." In *Poetry in the British Isles: Non-Metropolitan Perspectives,* edited by Hans-Werner Ludwig and Lothar Fietz, 231–51. Cardiff: Univ. of Wales Press, 1995.

Harrison, Tony. *A Cold Coming: Gulf War Poems.* Newcastle upon Tyne: Bloodaxe Books, 1991.

————. "The Inkwell of Dr. Agrippa." In *Tony Harrison,* edited by Neil Astley, 32–35. Newcastle upon Tyne: Bloodaxe Books, 1991.

————. *Selected Poems.* Harmondsworth, Eng.: Penguin, 1984.

————. *v.* Newcastle upon Tyne: Bloodaxe Books, 1985.

————. *v.* 2d ed. Newcastle upon Tyne: Bloodaxe Books, 1989.

————. *"v." and Other Poems.* New York: Farrar Straus Giroux, 1990; Noonday Press, 1991.

Hebdige, Dick. *Subculture: The Meaning of Style.* London: Methuen, 1979.

Hooker, Jeremy. "'The centre cannot hold': Place in Modern English Poetry." In *Poetry in the British Isles: Non-Metropolitan Perspectives,* edited by Hans-Werner Ludwig and Lothar Fietz, 73–96. Cardiff: Univ. of Wales Press, 1995.

Howell, David. *The Politics of the NUM: A Lancashire View.* Manchester, Eng.: Manchester Univ. Press, 1989.

Huk, Romana. "Poetry of the Committed Individual: Jon Silkin, Tony Harrison, Geoffrey Hill, and the Poets of Postwar Leeds." In *Contemporary British Poetry: Essays in Theory and Criticism,* edited by James Acheson and Romana Huk, 175–219. New York: State Univ. of New York Press, 1996.

———. "Tony Harrison, *The Loiners,* and the 'Leeds Renaissance.'" In *Tony Harrison,* edited by Neil Astley, 75–83. Newcastle upon Tyne: Bloodaxe Books, 1991.

Lamb, C. E. "Tony Harrison." In *Poets of Great Britain and Ireland since 1960,* edited by Vincent B. Sherry, vol. 40 of *Dictionary of Literary Biography,* 157–66. Detroit: Gale Research, 1985.

Larkin, Philip. *High Windows.* New York: Farrar Straus Giroux, 1974.

Lawson, Nigel. *The View from No. 11: Britain's Longest-Serving Cabinet Member Recalls the Triumphs and Disappointments of the Thatcher Era.* New York and London: Doubleday, 1993.

Lloyd, David. "Poetry in Post-War Britain: The Two Generations." In *In Black and Gold: Contiguous Traditions in Post-War British and Irish Poetry,* edited by C. C. Barfoot, 11–26. Atlanta: Rodopi, 1994.

Lucas, John. "Speaking for England?" In *Tony Harrison,* edited by Neil Astley, 351–61. Newcastle upon Tyne: Bloodaxe Books, 1991.

Ludwig, Hans-Werner, and Lothar Fietz, eds. *Poetry in the British Isles: Non-Metropolitan Perspectives.* Cardiff: Univ. of Wales Press, 1995.

Morrison, Blake. "The Filial Art." In *Tony Harrison,* edited by Neil Astley, 54–60. Newcastle upon Tyne: Bloodaxe Books, 1991.

———. "Labouring: *Continuous.*" In *Tony Harrison,* edited by Neil Astley, 216–20. Newcastle upon Tyne: Bloodaxe Books, 1991.

Motion, Andrew. *Philip Larkin: A Writer's Life.* New York: Farrar Straus Giroux, 1993.

Peach, Linden. *Ancestral Lines: Culture and Identity in the Work of Six Contemporary Poets.* Bridgend: Seren Books/Poetry Wales Press, 1993.

Richards, Andrew J. *Miners on Strike: Class Solidarity and Division in Britain.* Oxford: Berg, 1996.

Rutter, Carol. Introduction to *Permanently Bard: Selected Poetry,* by Tony Harrison, edited by Carol Rutter. Newcastle upon Tyne: Bloodaxe Books, 1995.

Rylance, Rick. "'On Not Being Milton.'" In *Tony Harrison,* edited by Neil Astley, 114–28. Newcastle upon Tyne: Bloodaxe Books, 1991. Rev. version of "Tony Harrison's Languages." In *Contemporary Poetry Meets Modern Theory,* edited by Antony Easthope and John Thompson, 53–67. Toronto: Univ. of Toronto Press, 1991.

Taylor, Robert. *The Trade Union Question in British Politics: Government and Unions since 1945.* Oxford: Blackwell, 1993.

Thomsen, Jens Peter Frølund. *British Politics and Trade Unions in the 1980s: Governing against Pressure*. Brookfield, Vt.: Dartmouth Publishing, 1996.

Wainwright, Jeffrey. "Something to Believe In." In *Tony Harrison*, edited by Neil Astley, 407–15. Newcastle upon Tyne: Bloodaxe Books, 1991.

Weinfield, Henry. *The Poet without a Name: Gray's "Elegy" and the Problem of History*. Carbondale and Edwardsville: Southern Illinois Univ. Press, 1991.

Worpole, Ken. "Scholarship Boy: The Poetry of Tony Harrison." In *Tony Harrison*, edited by Neil Astley, 61–74. Newcastle upon Tyne: Bloodaxe Books, 1991.

Young, Alan. "Weeds and White Roses: The Poetry of Tony Harrison." In *Tony Harrison*, edited by Neil Astley, 167–73. Newcastle upon Tyne: Bloodaxe Books, 1991.

Part II
The American Scene in Appalachia and the South

PENNSYLVANIA,

WEST VIRGINIA,

KENTUCKY,

AND ALABAMA

10

The Molly Maguires in the Valley of Fear

Robert E. Morsberger

From the Civil War to the beginning of World War II, there was another civil war, an unofficial one between capitalist management and labor. In literary chronology this war runs from *Life in the Iron Mills* (1861) to *The Grapes of Wrath* (1939). Among the bloodiest battlefields were the coal mines. In the 1870s, intensified by the depression of 1873, the war turned violent between the anthracite coal miners of southeastern Pennsylvania and the Philadelphia and Reading Railway, which owned most of the mines as the Philadelphia Coal and Iron Companies and could use its monopoly on shipping to set freight rates that kept the independent mine operators in line. Most of the miners, Irish Catholic immigrants, belonged to the Ancient Order of Hibernians (AOH), a secret society condemned by the Church, though its members claimed their sole purpose was fellowship. Most of the AOH members also belonged to the union, the Workingmen's Benevolent Association (WBA), but despite the fact that there were Protestant miners from England, Wales, Germany, and Northern Ireland in the WBA, the two organizations were generally considered synonymous. Franklin B. Gowen, the ambitious and ruthless president of the Philadelphia and Reading Railway and Coal and Iron Companies, was determined to crush the union; cutting wages to the near starvation level, he refused to negotiate with the miners; his operators set the terms unilaterally and told the miners they could take them or leave them. During the "Long Strike" from January to June 1875, Gowen succeeded in breaking the union, but he was not yet done with the Schuylkill AOH, for within that secret society may have been another yet more secret, a terrorist group engaged in sabotage and murder, called the Molly Maguires. Its story became one of the

most notorious and dramatic in the nineteenth-century labor wars. The sensational element lay in the fact that Gowen had hired a Pinkerton detective, James McParlan(d) (he first spelled his name McParlan but later added a *d*), who infiltrated the Mollies under the false name of James McKenna, was an active member for two and a half years, and then informed on them, sending twenty to their deaths by hanging.

The year after the trials, Allan Pinkerton wrote a partially fictionalized account of this episode, *The Mollie [sic] Maguires and the Detectives,* because, he wrote, "the detective's adventures . . . are sufficiently romantic and attractive, if properly related, to satisfy the most exacting reader, without the author having recourse to the smallest amount of extraneous matter, employing any of the powers of the imagination, or the tricks of the professional novel-writer in enchaining attention" (Pinkerton 27). In fact, Pinkerton did embellish his narrative with fictional details and presented it as a tale of daring adventure, which subsequent dime novels embellished further. Early in the twentieth century, Sir Arthur Conan Doyle met Allan Pinkerton's son William during an Atlantic voyage, became fascinated by Pinkerton's account of the detective infiltrating the terrorist Mollies, and used it for the plot of the final Sherlock Holmes novel, *The Valley of Fear* (1915). As one would expect, Pinkerton makes his detective and the agency wholly heroic and portrays the Mollies as a criminal conspiracy, and Doyle follows suit.

Like the first Sherlock Holmes novel, *A Study in Scarlet,* The Valley of Fear begins with a revenge murder in England, which Holmes solves; the second half is a flashback to the United States that dramatizes the events motivating the revenge. Thus, in The Valley of Fear, Holmes becomes involved in a mysterious murder at the moated grange of Birlstone Manor, where the owner John Douglas has had his face blown off. After seven chapters of subtle sleuthing, Holmes solves the mystery. It turns out that Douglas was not killed at all; instead, in self-defense, he killed an assassin from a secret society they had both belonged to. Taking advantage of the fact that the dead man was faceless but had the same symbol of the secret society branded on his arm, Douglas had passed off the assassin as himself, to ward off further assassination attempts, and had gone into hiding. The second half of the novel, seven more chapters and an epilogue, flashes back to the coal and iron mines of 1875 America; it is not clear what state contains the mountain-ringed valley of fear, for Doyle has changed all the names. Schuylkill County is now Vermissa Valley, the Ancient Order of Hibernians has become the Eminent Order of Freemen, the Coal and Iron Police are now the Mine Police, and the Molly Maguires are now the Scowrers, an ancient Scottish word for "scarers" (Higham 246). Doyle keeps secret from the reader the fact that John McMurdo, a new arrival to the valley, is in fact a Pinkerton detective; not until the end do the readers discover his true mission and identity, when McMurdo,

learning that the Scowrers have detected the existence among them of a spy named Birdy Edwards, persuades the Scowrers that he can lure Edwards to them, gathers the leaders together and announces that in fact he is Birdy Edwards, a Pinkerton. Before the Scowrers can kill him, they find themselves surrounded by a force from the Mine Police. Edwards's testimony gets most of the leaders hanged, but the survivors pursue him for ten years. Marrying his landlord's daughter Ettie, Edwards flees, adopting a series of disguises, the last of them as Mr. Douglas of Birlstone Manor. With the death of the assassin, it seems that Douglas is finally safe, but an epilogue tells that he is killed by the machinations of the arch criminal Professor Moriarty, whom the Scowrers have hired to help them.

Interested chiefly in mystery and suspense, Doyle shows practically no awareness of the complex political, economic, and social issues of the Molly Maguire episode. Deriving that portion of his plot from Allan Pinkerton's self-serving book, which suggests that his detective ran the risk of assassination, Doyle sides entirely with management capital and shows almost no interest in or insight into the working conditions of the miners. At first, Doyle paints a sufficiently forboding picture of the iron and coal valleys: "It was not a cheering prospect. Through the growing gloom there pulsed the red glow of the furnaces on the sides of the hills. Great heaps of slag and dumps of cinders loomed up on each side, with the high shafts of the collieries towering above them" (Doyle 959). Doyle does show the ugly squalor of the town, with its "huddled groups of mean, wooden houses," and comments that "the iron and coal valleys of the Vermissa district were no resorts for the leisured or the cultured. Everywhere there were stern signs of the crudest battle of life, the rude work to be done, and the rude, strong workers who did it" (959). But he never takes us down into a mine or shows the dangerous, unhealthy working conditions—foul air, gas that was poisonous and inflammable, dripping water, cave-ins, explosions, coal dust blearing the eyes and blackening the lungs, torn and herniated muscles—the miserable wages, the oppression of the miners by the operators and their private army. Instead, Doyle speaks of "generous wages." Apparently the squalor is of the miners' own making rather than the result of wage slavery. Doyle calls the Scowrers a "vile association" (981); they are not embattled workingmen trying to fight oppressive conditions but simply a "murder society" (967). Gowen and some newspapers had compared the Mollies to the Thugs, and Doyle follows suit. His Scowrers, whom Doyle also compares to Robespierre (997), have created a reign of terror, and Doyle succeeds very well in creating the atmosphere of that terror, in which everyone is afraid to cross the murderers. The Scowrers' victims are not tyrannical cutthroat capitalists but model employers (1000).

In 1935, Gaumont-British filmed The Valley of Fear under the title *The Triumph of Sherlock Holmes,* starring Arthur Wontner as Holmes and Ian

Fleming as Dr. Watson. Until the end, when Professor Moriarty is thwarted and McMurdo/Douglas escapes, the film is quite faithful to the book, with the significant exception that it is done in modern dress and thus lacks any historical framework and significance whatsoever. In this adaptation by H. Fowler Mear and Cyril Twyford, Mrs. Douglas, formerly Ettie Shafter, narrates the flashback before her husband's survival is established. Putting the flashback in the middle keeps the focus more on Holmes, but it also speeds up and streamlines the episodes in the Valley of Fear. McMurdo, renamed Murdock, is not American but British, though he says he spent most of his life in the United States. Ettie's father, the landlord, denounces the Scowrers as a society of blackmailers and murderers. Not only are there no scenes in the mines, but there is not even a mention that the Scowrers are miners nor any explanation of why they exist except to commit crimes.

Though exciting and suspenseful, The Valley of Fear misses historical ambiguities, for there were two reigns of terror. If the Molly Maguires resorted to terror, so did the railroad and mining companies. Workers were often made to live in substandard housing in company towns and buy inferior but overpriced goods at the company store; otherwise, they would lose their jobs or never be hired in the first place. Wages were usually a dollar a day or less for a twelve- to sixteen-hour day of dangerous and unhealthy work, and in the company towns, workers were paid not in cash but in scrip redeemable only at the company store. Mine workers were charged for equipment they used, such as explosives, so that it sometimes happened that workers got a bobtail check, meaning that after rent and company store and equipment charges were deducted, they got nothing or even less than nothing—they could end up owing money after a week's work. Boys who worked in the mines, sorting out slate from coal in the breakers, were charged for transportation and sometimes ended up working for less than nothing. There were seldom health or safety precautions, which the operators did not want to pay for; an average of ten miners a week died in mine accidents. If someone was invalided or killed, he became part of the human slag heap; there were no benefits to the injured person or the dead man's family. Instead, one boy, Andrew Chippie, was made to work for years at no salary to pay off his dead father's debts at the company store. This was slavery pure and simple. Yet, George Baer, one of Gowen's successors as president of the Reading Railroad and the mines it owned, who believed in the "divine right of stockholders," said, "The rights and interests of the laboring man will be protected and cared for, not by the labor agitators, but by Christian men to whom God in His infinite wisdom has given the control of the property interests of this country" (Dulles 191). During the railroad strike of 1877, when federal troops were used as strikebreakers, the courts defined a labor union as a "malicious conspiracy" (Bimba 37). Miners who struck or were active in the union were given punishing jobs or blacklisted.

Order was maintained by a private army of Coal and Iron Police, who searched people's homes without any clear jurisdiction and maintained martial law. The editor of the operators' *Miners Journal* advocated lynching miners (Broehl 119), and Pinkerton, who bragged of the murder of members of the AOH (Pinkerton 259–60), wrote that he wanted vigilantes to kill Mollies (Broehl 247–48). McParlan argued against this, afraid uninformed vigilantes would turn on him.

A far better historical and dramatic treatment than either the novel or the film version of The Valley of Fear is the 1970 film *The Molly Maguires,* written by Walter Bernstein and directed by Martin Ritt. Both had been blacklisted for their proletariat politics; as revenge against the blacklist, they teamed up to make *The Front* (1976), and Ritt later dealt with labor relations in *Norma Rae* (1979). Bernstein did considerable research on the history of the Molly Maguires. As Maurice Collins observes in the next essay in this collection, Anthony Bimba argues that the Mollies might never have existed, that they were probably a fiction invented by oppressive management to destroy union agitators, but all other historians attest to the organization's existence. Bimba, a Communist writer in 1932, had his own agenda to promote, but Walter Bernstein, who had also been a Communist from 1946 until the Soviet invasion of Hungary (Bernstein 134, 254–55), shares Bimba's criticism of cutthroat capitalism yet acknowledges the existence of the Mollies. Unlike Doyle's fictional treatment, *The Molly Maguires* features the actual historical characters and uses the real names of most of them. The detective, played by Richard Harris, is James McParlan, who goes undercover as James McKenna. Heading the Mollies is John Kehoe (Sean Connery). Kehoe, who had been nicknamed "the King of the Mollies," was in actuality a tavern keeper, like his counterpart, Boss McGinty, in The Valley of Fear, and it was "Muff" Lawler, not Kehoe, as in the film, who inducted McParlan into the Mollies. The Kehoe of the film is a composite character. Bernstein's script makes him a miner, which he had been before acquiring his tavern, thus making him more sympathetic and allowing the film to show us many scenes in the mines. For unlike the book and film of The Valley of Fear, with their one-sided politics and their settings entirely above ground, *The Molly Maguires* is closer to Zola's *Germinal* and reveals mining in all its grim, oppressive detail.

It opens with a wordless sequence twelve minutes long, brilliantly photographed by James Wong Howe. To a folklike tune played on Irish pipes (Henry Mancini's score makes effective use of Irish and nineteenth-century songs and dances), the camera moves from a sooty sun to the mine buildings and ore cars coming up and descending. Miners with shovels climb up the tracks. As two more miners push a heavy car down, the camera follows it into the depths, like a descent into hell. We see mine boys with ponies, men with candles on their hats like pinpoints of light in the darkness. In this grim

episode, the men, all coughing, all covered with soot, are raising timbers against cave-ins, working with picks and spikes, sloshing through water, while water drips on them. The impression is of overwhelming misery and oppression. Then three men quickly set up explosives and light the fuse. The last car goes up, the men walk away, their tin lunch pails clanking, and as Kehoe strides into the camera, there is an explosion behind him; superimposed on the flames is "Pennsylvania 1876," followed by the film credits.

Next, we see the night train arrive. The streets are empty except for armed guards. One man gets off, John McParlan, who goes to the local tavern, which looks like a Van Gogh painting of the Borinage. To the tune of "Molly Malone," there is a brawl between McParlan and two miners who accuse him of cheating at cards. It is broken up by Captain Davies of the Coal and Iron Police, who clubs McParlan and arrests him. We then learn that the clubbing and arrest were a device to establish cover for McParlan, a spy who passes himself off as James McKenna, a man with a shady past who wants to hide by working in the mines. The sadistic Davies, a Welshman (played by Frank Finlay) seems to be based on Robert J. Linden, a Pinkerton detective who became a captain in the Coal and Iron Police in 1875, after the real McParlan had already infiltrated the Molly Maguires two years earlier, in the fall of 1873. Bernstein's filmscript compresses five years of actual history into a few months and takes some liberties with chronology. From time to time in the film, McParlan and Davies meet on the sly to compare notes and plan strategies. Davies wants to get the leaders, whereas McParlan is working purely for the money. Angry at always being looked down upon at the bottom of the barrel, he tells Davies, "I'm tired of looking up; I want to look down."

After his interview with Davies, McParlan finds lodging at the boarding house of an invalided former miner, and romance begins to develop between him and the landlord's daughter Mary Raines (Samantha Eggar). In actuality, McParlan "sparked" Mary Ann Higgins, but not until two years after he went undercover. Both The Valley of Fear and The Molly Maguires dramatize a love story between the detective and his landlady; Doyle has them marry, but at the end of The Molly Maguires, Mary Raines, though she was clearly in love with McParlan, rejects him as an informer, saying that though she once thought she would go anywhere with anyone she did not find repellent, in order to get out of the valley, she now finds that she has to draw the line. Thus, the film's McParlan, while winning promotion to head of the Denver office, loses the woman he loves as the price of his betrayal. The real McParlan, more callous, said at the trials that he courted Mary Ann Higgins solely to throw off suspicion.

The real McParlan worked only a day or two in the mines and then got invalided out through a minor self-imposed injury, after which he passed himself off as a counterfeiter, though using real money provided by the

THE MOLLY MAGUIRES IN THE VALLEY OF FEAR

Pinkertons. But in the film, McParlan starts to work at five a.m. We see the whole town trudging off to the mines, their candles descending into the dark. Below, in another long wordless sequence, we see more backbreaking, muscle-straining work. The film shows exhausted boys sleeping during a brief break. On payday, McParlan, charged for equipment used or damaged, receives twenty-four cents for a week's work.

Conan Doyle omits the religious element altogether, but Bernstein's screen-play includes a sensitive treatment of the Catholic church's ambiguous attitude toward the AOH, along with its condemnation of the Mollies. The local priest sympathizes with those scorned and oppressed but preaches against violence. He knows the sufferings of his parishioners but condemns as sinners those who commit sabotage or beat foremen or operators. As he threatens to excommunicate the Molly Maguires, the camera focuses in turn on the faces of each member of the secret society. On May 29, 1875, the *Pilot*, a Boston Catholic periodical, called strikes and unions necessary to combat the tyranny of ruthless employers (Broehl 203), but on December 15, 1875, Archbishop Wood of Philadelphia did in fact excommunicate the Mollies, whom he called "otherwise the Ancient Order of Hibernians" (Broehl 271).

Back in the mine, two suspicious Mollies open a coal cart to bury McParlan beneath an avalanche, but Kehoe has second thoughts and saves him. Posing as a counterfeiter ("passing the queer"), McParlan claims he had killed a man in Buffalo. Kehoe finds him bold, with a way about him, but Mary warns him not to be too trusting.

During a brutal soccer match, the film brings out the hostility between Irish and Welsh miners. When the match deteriorates into a brawl, with gunfire, Kehoe breaks it up. The Iron and Coal Police then fire over the heads of the crowd but beat Daniel Dougherty severely with their guns. The "Peelers" want the men to fight each other. But the Mollies retaliate, and as a test of his loyalty, McParlan breaks a policeman's jaw. When Davies tells McParlan he wants him to be a provocateur, the spy says he would kill somebody if he couldn't get out of the mine. "Don't get confused what side you're on," warns Davies.

McParlan is tempted to do so, for the more he works in the rat-infested pits, the more he empathizes with the miners, and he and Kehoe find them-selves drawn toward each other as friends. Persuaded of McParlan's trustworthiness, Kehoe inducts him into the AOH, whose members show him their signs and passwords. But later, when McParlan protests a plan for the AOH to commit violence, Kehoe tells him in a sinister voice that the group he is in is *not* the Ancient Order of Hibernians. Shortly thereafter, in a debate over whether to bash or kill a new superintendent, the majority vote for bashing, but McParlan urges them to "kill the bastard." A major issue during the trials was whether in fact McParlan acted as a provocateur. According to a history of the AOH, Gowen wanted the Pinkerton to be so, to start the miners on a

murderous "crusade of crime" and then inform on them (Broehl 131–12). During the Long Strike, Gowen wanted violence so that he could connect the union with the Mollies and destroy it, so it is quite possible that McParlan's job was not to prevent crime but to permit and even incite it in order to get evidence for convictions (Broehl 194).

In the film, McParlan assists Kehoe in blowing up a coal train, but later, when the Mollies go after the new superintendent, someone (McParlan, of course) has tipped off the police, who are waiting for them. In the ensuing gunfight, the superintendent is killed. After McParlan goes back to rescue a wounded Mollie, the Mollies get away, but the police make wholesale arrests, including McParlan to protect his cover. Davies tells the informer that he wants to break the union. "Decency is not for the poor," he sneers; "you pay for what you get."

Shortly thereafter, masked Coal and Iron Police break into the home of a mining family at Wiggans Patch, where they kill the tavern keeper and his wife. At the trials, the defense charged the railroad and coal company with vigilante murders at Wiggans Patch, but the court ignored the episode.

Attempting a retaliatory act of sabotage, the Mollies run into an ambush set up by McParlan; Dougherty is caught, but Kehoe escapes. Telling Kehoe that the archbishop will not intervene to save Dougherty, the priest warns Kehoe of an informer. When Mary Raines's father dies (presumably of black lung), Kehoe rages that the mining company has not even left him with a decent suit of clothes to be buried in. After he breaks into the company store to steal a suit for the corpse, Kehoe throws out the rest of the clothes, whereupon McParlan, apparently in real revulsion against his employers, starts smashing everything on the shelves. Kehoe joins this contagious act of rebellion, and after demolishing the goods, the two men torch the store. Afterwards, McParlan tries to dissuade Kehoe from further violence, but Kehoe, having passed the point of no return, walks into a trap that McParlan has laid, and he and his accomplice join Dougherty in prison.

At the trial, for the murder of the superintendent of the Shenandoah mine, McParlan appears as a witness, giving his true name and his job as detective. Since the main focus of the film is on McParlan's struggles between his divided loyalties, the film cuts the trials from the point where McParlan identifies himself and goes straight to the verdict of guilty and the sentence of death by hanging. McParlan feels self-revulsion but says, "I only have to get high enough" to get over it. But he may not get over being rejected by Mary Raines, who cannot accept him as an informer. Feeling remorseful, McParlan goes to Kehoe's cell to express sympathy for the miners he has betrayed. "You made your sound, Jack. You've no regrets," he tells the condemned man, who answers that the informer came for absolution, for punishment to set him free, but "You'll never be free. There's no punishment this side of hell to free you

for what you did." "See you in hell," replies McParlan. As he leaves, we see the executioner dropping sandbags through the traps of the three gallows.

The history of the Molly Maguires is so complex that Bernstein's script, like Shakespeare's history plays, necessarily simplifies it. Many of the historical characters and events are omitted. Gowen has no dialogue and appears only as a silent spectator for a St. Patrick's Day parade. In fact, twenty Mollies were hanged for various murders, but the film deals with only three, Kehoe, Daniel Dougherty (Anthony Zerbe), and McAndrew. Also omitted are many of the murders attributed to the Mollies, thus making the Mollies less criminal and more sympathetic. All we see are a few acts of sabotage, the beating of a Coal and Iron policeman in retaliation for an atrocity by the police, and one killing, which seems to happen at random. When the Mollies consider committing an assassination, Kehoe votes against it, and it is McParlan, acting as a provocateur, who urges them to "Kill the bastard." While the parish priest several times preaches against violence and the film's terrorist tactics are challenged, there is no question that the film sides with the miners. The most significant omission is the trials, which went on for three years. The film assumes there was only one trial, of Kehoe and his two accomplices, and after introducing the detective as a witness, cuts to the verdict of guilty and the sentence of death. In fact, Kehoe was not hanged until December 18, 1878, the last of the Mollies to go to the gallows. Nor was he hanged for any of the events portrayed in the film but on charges dredged up for a mob stoning to death of a mine foreman in 1862, for which there was only flimsy evidence against Kehoe. Many of the witnesses on both sides in the trial were perjured, and many people were hanged on the basis of evidence that would not stand up in a modern court of law. One was hanged on identification by a witness who admitted he never saw his face but who claimed that his curious posture in court was the same as that he observed in a gunman three city blocks away. Several Mollies saved their own lives by turning informer, and one of them, James Kerrigan, was probably guilty of the murder for which he sent his comrades to the gallows. The trial procedures and sentence reviewing were manifestly unfair; Gowen, the railroad president and mine owner, anything but impartial, doubled as district attorney and not only prosecuted the accused but tried to identify the entire Ancient Order of Hibernians as Mollies and indict them all as accessories before the fact. Gowen argued that mere membership in the AOH was enough "to convict of murder in the first degree every member of that organization in this county, for every murder that has been committed in it," and that all members should be hanged (Broehl 304).

In The Valley of Fear, Doyle makes his Pinkerton detective entirely heroic, a brave man risking his life to get the goods on a band of murderers. The Molly Maguires makes the detective a far more complex character because the group he is infiltrating is not just a criminal society but is fighting against

brutal working conditions, starvation wages, a repressive tyranny of employers and their private police. Though McParlan ultimately betrays them, he cannot help identifying with their suffering and rage, and as he insinuates himself into their friendship, he comes to like and respect some of them, to the point where he actually tries to stop them from committing acts of sabotage that he will have to inform on, in order to save them from walking into a trap that he will make. But when Jack Kehoe replies, "They won't stop, so we can't stop," McParlan does set the fatal trap, and at the trial that condemns them to death, he testifies against his friends. The film makes us, up to a point, like and root for both McParlan and Kehoe, while at the same time making us criticize Kehoe's resort to violence and condemn McParlan's act of betrayal. He is, after all, not just a detective but an informer, and anyone who has seen John Ford's film *The Informer* knows that for the Irish, informing is one of the most despicable acts.

Consequently, *The Molly Maguires* has complex characters and moral ambiguity. Neither of the antagonists is entirely a hero or a villain. The one clear villain is the captain of the Coal and Iron Police, a brutal sadist, and by implication Gowen, his employer, though we get only a brief glimpse of Gowen at a distance, when the wife of one of the miners identifies him and calls him a handsome man. After one interview with McParlan, the captain tells him he can't leave yet, he'll have to be marked; and he clubs him savagely on the head. "It's a pleasure to be associated with a man who enjoys his work," says McParlan ruefully, as blood pours from the wound near his temple.

Unlike *The Triumph of Sherlock Holmes*, which not only shows no sympathy for the miners but does not even make it clear that the terrorists *are* miners, *The Molly Maguires,* like John Steinbeck's strike novel *In Dubious Battle,* is clearly on the side of the oppressed workers, even though it challenges the methods that they resort to in their desperation. Both the miners and Steinbeck's striking migratory farm workers have genuine grievances, while there is nothing good to say about the powers that oppress them. After the destruction of the Mollies and the WBA, subsequent unions were attacked for Molly Maguireism, and it became customary for the next half century for ruthless employers to employ a private police force, use detectives for union surveillance, and generally exhibit contempt for civil liberties, as Ina Rae Hark shows in her essay in this collection on John Sayles's film *Matewan,* which dramatizes the West Virginia mine wars of 1920–1921.

Despite somewhat streamlining the events, *The Molly Maguires* is impressive for the amount of historical detail it manages to fit in. Bernstein's screenplay is admirable for the richness of its characterization, its involving drama, and the detailed texture of its picture of the Molly Maguire episode. Filmed on location in Pennsylvania at the then sizeable budget of eleven million dollars, *The Molly Maguires* flopped at the box office, recovering less than two million

dollars of its cost (Lukas 143). Since it is artistically and dramatically compelling, its financial failure is probably due to the fact that the title was meaningless to the public of 1970, who knew little or nothing about the Molly Maguires. Their history and the film deserve to be better known.

WORKS CONSULTED

Bernstein, Walter. *Inside Out: A Memoir of the Blacklist.* New York: Knopf, 1996.

Bimba, Anthony. *The Molly Maguires.* New York: International Publishers, 1932.

Broehl, Wayne G., Jr. *The Molly Maguires.* Cambridge: Harvard Univ. Press, 1965.

Dewees, Francis P. *The Molly Maguires: The Origin, Growth, and Character of the Organization.* Philadelphia: J. B. Lippincott, 1877. Reprint, American Classics of History and Social Science Series, no. 5. New York: Burt Franklin, n.d.

Doyle, Arthur Conan. *The Complete Sherlock Holmes.* Garden City, N.Y.: Garden City Publishing, 1938.

Dulles, Rhea Foster. *Labor in America.* New York: Thomas Y. Crowell, 1949.

Higham, Charles. *The Adventures of Conan Doyle.* New York: Norton, 1976.

Lukas, J. Anthony. "The Molly Maguires." In *Past Imperfect: History according to the Movies,* edited by Mark C. Carnes et al. New York: Henry Holt, 1995.

The Molly Maguires. Screenplay by Walter Bernstein. Paramount, 1970.

O'Neill, James. *The Molly Maguires.* Novel based on the screenplay by Walter Bernstein. Greenwich, Conn.: Fawcett, 1969.

Pinkerton, Allan. *The Mollie Maguires and the Detectives.* New York: G. W. Dillingham, 1877.

The Triumph of Sherlock Holmes. Dir. Leslie S. Hiscott. Screenplay by H. Fowler Mear and Cyril Twyford, based on the novel The Valley of Fear, by Sir Arthur Conan Doyle. Gaumont-British, 1935.

11

The Molly Maguires and the Continued Influence of Nineteenth-Century Labor Fiction

Maurice Collins

Martin Ritt's film *The Molly Maguires* and its reception illustrate the degree to which, as Lucy Maddox has said, we have not yet "turned a fully suspicious eye on . . . our own reinventions of the American past" (178). In light of the recent attention given (by such ethnohistorians as Takaki, Roediger, and Ignatiev) to the Irish racial formation in the nineteenth-century United States, it is important that attention be given to the pervasive and persistent effects of the fiction of that period. Ritt's 1970 film, while attempting to create sympathy for the Molly Maguires, adheres far more closely to the rubric set by Allan Pinkerton in *The Mollie [sic] Maguires and the Detectives* (1877), than it does to more reliable historical estimations and reduces one of the most crucial intersections of race and class in American history to a failed attempt at workers' self-activity through sabotage.

Ritt's film attempts to view sympathetically the conditions that would motivate a secret terrorist society but in doing so he reinforces the assertion that the Molly Maguires existed and committed the crimes with which they were charged. Historians such as Anthony Bimba, however, present compelling cases that the Mollies might never have existed and those hanged for murder may have simply been pawns in a conspiracy against labor. Aurand and Gudelnas maintain that only three statements of fact can be corroborated when it comes to the Molly Maguire period: "1. Numerous murders were perpetrated in Schuylkill County between 1861 and 1875; 2. The Philadelphia and Reading Railway and Coal and Iron Companies financed a private investigation into a reputed secret criminal society; 3. As a result of that investigation twenty men were executed for allegedly committing some of those murders" (Denning 119).

In fact, even Pinkerton's re-creation of the court records shows that these twenty men were hanged almost entirely upon the testimony of a company-paid detective and several characters of ill repute (even by Pinkerton's own admission) who were looking for a plea bargain. To understand Ritt's choices, it is necessary first to understand Pinkerton's. This necessarily involves an exploration of the special racial status of the Irish in late-nineteenth-century America.

While it may seem odd to be discussing the Irish in racial terms, recent scholarship has shown that Irish Catholics were in fact viewed, in both England and America, as nonwhite peoples. Noel Ignatiev maintains that "while the white skin made the Irish eligible for membership in the white race, it did not guarantee their admission; they had to earn it" (59). It is not sufficient to dismiss the situation faced by the Catholic Famine Irish as simply the same kind of oppression faced by any immigrant group upon its arrival in America. The situation facing the Irish was quite specific (which is not to say any more or less oppressive) and fueled by a distinctly racist ideology. In his study *Apes and Angels,* L. Perry Curtis contends that "English comic artists, in fact, saved their best simianizing efforts for Irish rebels; and not even the stereotypical African 'savage,' with his grotesquely enlarged lips and mouth, came close in terms of monstrousness to the Irish and Irish American gorillas of the Fenian era" (121). This English tendency was brought to the U.S. and practiced by American illustrators, such as the influential Thomas Nast, "and became as closely identified with corruption, clericalism, and organized violence in America as in the British Isles" (64).

David Roediger's *The Wages of Whiteness* and Ignatiev's *How the Irish Became White* have recently argued the instability of Irish "whiteness," and the work has found its way into more mainstream ethnohistories such as Ronald Takaki's *A Different Mirror.* Roediger and Ignatiev focus primarily on comparisons between the Irish and free blacks in antebellum America. They argue this comparison on several levels. The huge influx of Famine Irish beginning in the 1840s created, in the United States, an Irish immigrant population not unlike the population of freed slaves. Both were relatively unskilled, unpropertied, desperate, in direct competition for jobs, and both had been the victims of racial oppression.

Both Roedgier and Ignatiev show how the Irish were able to read the racial climate in America and manipulate it to succeed—often at the expense of the black populations. Ignatiev marvels at how quickly the Irish were able to understand the racial climate and align themselves in whiteness with the dominant culture. But the Irish did not have to invent this understanding from whole cloth upon arrival because they had learned the rubric in Ireland and simply had to insert American values for the variables. The understanding with which the Irish arrived points to a racialist ideology separate from Roediger's and Ignatiev's formulations. It is also more useful to understanding the

effects of the postwar Molly Maguire episode in general and Pinkerton's account in particular—that is, the centuries-old rubric that casts the Catholic Irish as savages and compares them directly to Native Americans.

In *The Invasion of America,* Francis Jennings traces the origins of this rubric to Ireland and discusses its later application to the peoples the conquerors of Ireland later found in the New World—the American Indians: "Some part of the ideas of Elizabethan English colonizers were brought to America from their previous experience in England. . . . These adventurers had gone to Ireland . . . with 'a preconceived idea of a barbaric society and they merely tailored the Irishman to fit this ideological strait jacket.' They and their successors carried the same preconceptions to America to fit onto Indians, "using the same pretexts for the extermination of the Indians as their counterparts had used in the 1560s and 1570s for the slaughter of numbers of the Irish" (45–46). Jennings argues that the rubric was developed by these conquerors as an attempt to satisfy the "just war" ideology (earlier used to justify the Crusades), clearing the way for justifiable conquest of Ireland and the New World. The rubric operated in this way: the peoples of these lands were savages, so defined by their lack of proper religion, their ferocity, their indolence, and an intemperance that rendered them incapable of self-government. It is then not only the privilege but the duty of more civilized peoples to govern these savages and their resources. Thus the origins of "Manifest Destiny" are in fact to be found in the English conquest of Ireland.

Using considerable evidence from the colonial period to demonstrate the admirable industry of the American Indian cultures, Jennings shows how the American manifestation of the rubric was developed in utter contradiction to fact. He explodes myths such as those that maintain that Indians gathered but did not cultivate, that Indians roamed aimlessly about the land, and that Indians did not engage in industry and trade on the European model. An entire chapter is devoted to a study of the fur trade, which he calls "a giant social organization that stands in manifest refutation of the . . . myths in this capsule of ideology" (85). Therefore, "the civilized-uncivilized distinction is a moral sanction rather than any given combination of social traits susceptible to objective definition." Not only were these models conceived for a Machiavellian ulterior purpose, they were conceived in absolute contradiction to the observable data. "How, then, did the observed data of the Indian peasant turn into the myth of the roaming savage?" Jennings asks: "Part of the answer is found in the deliberate intent of propagandists to create opinion in England favorable to aggressive policies in America, but another part is contained in the development of connotations that became incorporated in the term and acquired a life of their own" (73).

Curtis identifies a similar rhetorical rubric at work in England, applied specifically to the Irish: "The newer forms of evolutionary thought . . . tended

to polarize Englishmen and Irishmen by providing a scientific basis for assuming that such characteristics as violence, poverty, improvidence, political volatility, and drunkenness were inherently Irish and Irish alone" (95).

Jennings further shows the tenacious survival of similar models into nineteenth-century America, citing the formulations of two important figures: Francis Parkman and John Marshall. According to Jennings, "Francis Parkman, who has often been called the greatest of American historians, wrote in the nineteenth century that 'the Indians melted away, not because civilization destroyed them, but because their own ferocity and intractable indolence made it impossible that they should exist in its presence'" (85). Jennings discusses Chief Justice John Marshall's statement of "one reason for inventing savagery," when the justice "argued with impeccable logic from a false assumption to a conclusion that he admitted would be criminal if not for the assumption. 'The tribes of Indians inhabiting this country were fierce savages,' wrote Marshall in a landmark decision in 1823, 'Whose occupation was war and whose subsistence was drawn chiefly from the forest. . . . That law which regulates, and ought to regulate in general, the relations between the conqueror and the conquered was incapable of application to a people under such circumstances'" (60). Jennings believes that "for Justice Marshall the fundamental criteria were two: subsistence 'from the forest' and the 'occupation' of war. Since it could hardly be argued that civilized societies eschewed war or withheld honor from professional soldiers, the critical factor in being savage reduced to a mode of subsistence" (60).

But Jennings has underestimated the Euro-Americans' ability to differentiate the type of violence they perpetrate from that perpetrated by savages—thus allowing them to keep savage violence as a part of the model. Slotkin maintains that this differentiation was formulated in the following way: "Racialist historians would argue that what sets Anglo-Saxons apart from the Greeks of antiquity and other enlightened and imperial races is their extraordinary capacity for violence, both personal and collective. . . . Among more primitive classes of the population (or in primitive conditions), this capacity takes the form of vigilantism or crime; but at its most advanced level, it is the supreme expression of the race's capacity for organizing society and projecting its will upon nature and the lesser races" (230). This leads Slotkin to his theory that a type of paternalism ruled racialist ideology in the nineteenth century. Slotkin further maintains that this ideology was then applied to class and to workers in particular. He has difficulty explaining how that move was made so seamlessly: "[In 1877] the working-class 'hostiles' were predominantly white, and largely American born. . . . If the ideological task of antilabor journalists was to enforce the association between strikers and Indian savages, then the project faced formidable difficulties, and required the making of some powerful new fictions and the revaluation of old ones" (480). The key is that

169

he works from the assumption that when commentators were talking about the Irish, those commentators believed they were talking about class. In fact, this may not have been the case. The Irish bridged, for these racialist thinkers, the gulf between nonwhite peoples and workers. When the Famine Irish arrived on the continent, dormant elements of the ideology applied to the American savage were activated and readily applied back onto them. And, as the Irish became white—to borrow Ignatiev's formulation—they offered a segue to white workers in general. The Molly Maguires incident may well have been the crucial moment in the intersection of these ideologies.

Many critics and historians identify crucial shifts in ideology in the late nineteenth century and many identify the focus of these shifts to be concurrent with the Molly Maguires incidents (1861–1876). Roediger maintains that the first sixty-five years of the century were "the formative period of working class 'whiteness'" (Roediger 14) but some of his own examples illustrate that for some time thereafter "whiteness" remained unstable as regards the Irish. Curtis maintains that "the process of simianizing Paddy's features took place roughly between 1840 and 1890 with the 1860s serving as a pivotal point in this alteration of the stereotype. . . . More revealing in some respects than the overall change in Paddy's physiognomy was the rate of that change . . ." (29). Slotkin identifies "the crucial four-year period from the Panic of 1873 to the Great Railroad Strike of 1877" as "the best case for studying the interaction of western realities and Metropolitan ideologies during this crisis of industrialization" (325).

It is during this period that Slotkin demonstrates most dramatically the association by major newspapers of the Indians in general with the Irish in general and of Sitting Bull, Crazy Horse, and Chief Joseph in particular to the Molly Maguires in particular. Slotkin maintains that this is a result of the growing tendency of the Irish to organize and halt the steady flow of progress, becoming, like the Indians, an impediment to Manifest Destiny.

Of the Indian, the *New York World* wrote, "The Indian is economically dispensable. . . . He may be allowed to starve to death or to suffer violent extermination without substantial loss to white society" (qtd. in Slotkin 359). The Irish were, like the Indians, increasingly dispensable and increasingly in the way. Ignatiev demonstrates by various pieces of evidence that the Famine Irish were seen from their arrival as highly dispensable, often being used in the South on projects slaveholders deemed too dangerous on which to risk slaves since they viewed the loss of a slave as a loss of a property asset (Ignatiev 109). Further, Ignatiev maintains that they lacked any sort of intercessor: "In the course of my research I learned that no one gave a damn for the poor Irish. Even the downtrodden black people had Quakers and abolitionists to bring their plight to public attention (as well as the ability to tell their own stories effectively)" (178).

Curtis attributes the shift in Paddy's image "from a drunken and rela-
tively harmless peasant into a dangerous ape-man or simianized agitator"
(xxxi) and its rate of change to the rate of politicization of the Irish public
and the rise of Fenianism. He maintains that "the timing of [Paddy's] trans-
mogrification into a gorilla suggests that the coincidence of Fenianism with
the debate over *The Origin of Species* and the increase in social and political
tensions arising out of economic expansion of the mid-Victorian era lay at the
root of the simianizing process" and that this racism was "the price paid by
Irishmen for increasing political activity and agrarian protest" (101, 21).
Thus, in the late nineteenth century, the dispensable Irish were becoming
politicized and organized, perhaps making it time for capital to dispense with
their services.

Interestingly, one newspaper, the *Irish World*, saw the ideological connec-
tion but from a viewpoint sympathetic to the Indians and the Mollies. Slotkin
discusses the *Irish World*'s stance opposing Custer's behavior in the Black Hills
and defending Sitting Bull's defense of his home: "The *Irish World* of New York
. . . was ideologically bound to identify itself against the principle of extend-
ing Anglo-Saxon rule by dominating other and weaker races or nations. . . .
The *Irish World*'s . . . editorials . . . condemn the belief that 'The Indian can-
not be civilized' and that we 'must have a policy of extermination' and answer
that the Indian was eminently suited for civilization, if only treated fairly[:]
. . . 'if SITTING BULL is a savage JOHN BULL is a hundred times a greater sav-
age'" (Slotkin 475). That the Irish World defaults to John Bull as the real sav-
age shows a deliberate awareness that the model was being applied to both
Indians and Irish in the same way and that the origins of both plights were
also the same. Significantly, the *Irish World* is the only newspaper Pinkerton
addressed directly in his book: "As the editor possibly had to do something to
earn his proportion of the $30,000 received for the defense of the Mollies . . .
I have not the heart to devote space to an answer" (551). The very presence
of this ad hominem attack indicates that the Irish World presented some sort
of threat to Pinkerton's program.[1]

It is the less positive Indian/Irish association, the older rhetorical model
from which it had come, and the current climate of anti-Irishism on which
Pinkerton's account plays most heavily. His Mollies in particular and Irish in
general exhibit regularly qualities of indolence, intemperance, savage vio-
lence, and, a popular addition in the nineteenth century which contemporary
Irish Americans might find surprising or laughable, promiscuity.

McParland is able to win over the Irish population of the region and thus
gain entrance to the Mollies largely through his activities as an accomplished
idler: "his jolly, devil-may-care manner, his habit—not really a habit but an
assumption of one—of being nearly always intoxicated, ready and willing to
shoot, dance, fight, gamble, face a man in a knockdown or a jig, stay out all

night, sleep all day, tell a story, rob a hen roost or a traveler—just suited all those with whom he daily came in contact" (147). He works in the mines only temporarily; his chief occupation, to all appearances, is that of counterfeiter— a parasitic calling that would earn the enmity only of practitioners of the Puritan work ethic but seems to win the admiration of his contemporaries. McParland's very entrance into the world of the coal-mining Irish is accomplished by bursting into a pub in a seemingly drunken frenzy, performing a frenetic jig upon a table and fighting another inebriated patron. The primary activities of leisure (read indolence) for the Irish are the violent sports of cock- and dogfighting.

A planned but averted massacre illustrates not only the degree but also the type of violence the audience is meant to associate with the rank-and-file Mollies: "one of the most sickening wholesale assassinations that the heart of savage ever conceived[:] . . . that there were men in [McParland's] division who, to secure revenge, or when under the excitement of enmity or drink, would perform deeds that might make angels weep, and throw the acts of the Indians in the shade" (235). The particulars of this account are clearly designed to create an association, conscious or unconscious, with the popular accounts of Indian massacre.

McParland's primary form of disguise is feigned drunkenness, offering him a regular excuse from his failures to perform certain Mollies duties and one that is readily accepted by the other Mollies. Further, the illustration of the raffle and dance attended by McParland, shows a host of passed-out-drunk attendees, including one pig. This fondness for drink offers one commentator a direct link to Indians: "the magic spell of wiskinky [sic], so savage was it, could convert the sons of Erin into Aborigines of the American wilds" (qtd. in Ignatiev 76). The "partly dressed" Mrs. Casey's willingness to serve and/or drink beer from the bedpan demonstrates not only just how comfortable she is with unsanitary conditions but also how avidly she and McParland's Molly compatriots crave drink (268).

This sort of intemperance, which plays neatly into the argument against capacity for self-government, is linked also to promiscuity since both are failures through a lack of moderation (or self-government) to achieve the Aristotelian mean. The promiscuity may seem hidden but would have been obvious to the reading public. From the brazen hussy who kisses McParland at the wedding, to the home of Bridget Monaghan, Pinkerton reports the scandalous behavior of the libertine Irish women, and sets it in contrast to the relatively chaste Polish women. Bridget Monagahn's "subterranean abode[, which] was . . . the habitation of geese, ducks, chickens, goats, and pigs, among which Mrs. Bridget walked, 'monarch of all she surveyed,'" offers a particularly illustrative view of the various racialist strategies Pinkerton employs:

An inventory of other things found in the apartment would read as
 follows:
1 Widow Bridget Monaghan—very angry and flushed as to face and
 scantily clad
1 maiden lady of uncertain age, ditto as to raiment, and badly scared
5 goats, scattered about the floor very promiscuously
37 chickens—including one plucky game-cock
1 collection of new-washed female raiment, hanging damp on the line
5 ducks and a drake
1 goose and a gander (371–72)

Mrs. Monaghan's attire and that of her maiden friend, in which they appear to
be comfortable in the presence of male callers, and the random display of their
unmentionables about the room, play obviously into the idea of promiscuity.
How the goat displays its promiscuity is less clear, although it seems probable
that it is an allusion to a literary tradition of stipulating the lustfulness of
goats, to classical satyrs and even to Satanism (with which Catholicism was
sometimes conflated). Whether the writer meant to draw in some or all of
these implications, the association of these characters with all of the animals
in the room is a more immediate nod to the standard nineteenth-century strat-
egy of associating various "lower" races with animals. In nearly every illustra-
tion of the Mollies in the text, at least one animal is present inside the house.
Apparently Pinkerton's ghostwriter's hyperbole provided, in the case of Widow
Monaghan's home, even more animals than the illustrator could fit in the
space since the latter depicted only six chickens. Also, he does not depict the
unmentionables, substituting shirts and pants for them. Perhaps the audience
would be far more shocked at seeing them (though the Irish are not) than sim-
ply to hear that they had been seen.
 Pinkerton and his illustrator also attempt one of the favorite techniques
of Victorian literature—phrenology. Perhaps most instructive is the descrip-
tion and illustration of Mickey Cuff:

 Good old Mickey Cuff, as he heard himself ironically called by his
 neighbors, was not generally looked upon as either good or handsome.
 . . . His face was broad and retreating at the base and narrow and pro-
 jecting at the top, preceded, when he walked, by a pug nose. . . . Cuff's
 mouth was the crater of a miniature volcano, continually bursting
 forth with loud oaths, running streams of tobacco juice and bursts of
 fetid breath. . . . To make the thing still more hideous, there were four
 tusks in the front of the upper and lower jaw, jutting out slantingly,
 causing either lip to protrude and assume a grin. When Cuff laughed,
 which was constantly—and never more diabolically than when

incensed to the pitch of working violence on something—his little,
round, black eyes retreated into their socket, the nose wriggled felici-
tously, like the stump of a dog's tail when begging for meat, and his
four broad tusks clattered together. . . . In fact, the big fellow's face was
open, like that of an alligator. . . . His temper was as peculiar as his *per-
sonnel*. (242–44)

This description is reinforced by an illustration of a clearly simianized Cuff,
starkly contrasting McParland's "forehead high, full, and well rounded for-
ward; florid complexion, regular features[:] . . . there was no mistaking McPar-
land's place of nativity, even had not his slight accent betrayed his Celtic
origin. He was in fact a fine specimen of the better class of immigrants to this
country" (24). The illustration of Flynn's attack (166), recalls *Punch's* O'Con-
nellite Irish Frankenstein—discussed and reproduced by Curtis (32)—and
prefigures even more nearly the later Parnellite Irish Frankenstein (43)—even
to posture and facial expression. It is significant that both illustrations from
Punch are related directly to specific Irish political movements.

Apart from the way they figured into the conducive racialist climate, the
Molly Maguires offered Pinkerton several other attractive advantages to what
is, no matter what anyone says about the intentional fallacy, a piece of pure
propaganda and product placement for the Pinkerton Detective Agency. The
Catholicism of the new immigrants separated them, not only from the major-
ity population (especially those in the nativist movement) but also from most
of the Irish already in America. Pinkerton makes several explicit statements
that he is not anti-Irish as does Gowen, the president of the Philadelphia and
Reading Railway and Coal and Iron Companies, a character who figures heav-
ily into the beginning and end of Pinkerton's narrative. But the crucial dis-
tinction is that Gowen is Protestant and as such would never have been
included in the race formulation thrust upon the Catholics from the west of
Ireland. Gowen makes this clear in his remarks to the court, identifying him-
self as a Protestant. Ignatiev discusses the lengths to which many of these
Protestant Anglo-Irish went to dissociate themselves from Catholic "Celts"
(36–39).

Further, for every one of Pinkerton's few explicit statements of historical
fact (of which most of his public would have been aware) that the Catholic
church condemned the activity of secret societies, there exists at least one
other inference that the church was actively or silently complicit. Added to
the standard fears operational in any religious prejudice, are two other fac-
tors. First, Irish Catholics militated for school reform, insisting on bilingual
education (since contrary to popular rumor, many Irish immigrants spoke
only Irish) (Callahan 23), vouchers for parochial schools, even refusing to
read from the King James version of the Bible in the classroom. Second, the

Catholic church was a favorite target of conspiracy theorists. Pinkerton worked this angle as well insisting, "Many good Catholics were remaining in the organization and . . . the priesthood, if not tacitly countenancing the society said little against it" (20). McParland receives on good authority assurance from a Molly of "the clergy being with them very cordially, if not inside the ring" (103). Slotkin shows that, in at least one instance, the *New York Herald* was prepared to accuse the Jesuits of conspiratorially fomenting rebellion of Indians (460).

The Mollies also satisfied a more secular version of rampant international conspiracy fears. Newspapers had begun to report alleged misdeeds of the Mollies concurrent with reports of the Paris Commune and antirent strikers in New York's Tompkins Square. While this may not have been the origin of the red scare, it was certainly one of its earliest and most prolific manifestations. Gowen says of the Hibernians, which he freely conflates with the Mollies: "As far as we can learn, the society is of foreign birth, a noxious weed which has been transplanted from its native soil—that of Ireland—to the United States. . . . It lived and prospered in the old country" (Pinkerton 14). In his address to the courts, Gowen reiterates and expands upon this conflation: "Whether this society, as it is known as the Ancient Order of Hibernians, is beyond the limits of this county good or not I cannot tell . . . and I am willing to be satisfied of that fact now, if there is any evidence of it . . . up to this time we have not furnished to us any evidence that in any place its objects were laudable or commendable" (Pinkerton 519). Pinkerton corroborates Gowen's claims: "Having for the public eye a motto to all appearances as elevated in tone as that of any secret order in the land, and professing the noblest moral principles its [the order's] members were, with some exceptions, assassins, murderers, incendiaries, thieves, midnight marauders, gamblers, and men who did not scruple to perform almost any act of violence or cowardice that a depraved nature or abnormal animal instinct might conceive . . . brutally manufacturing widows and orphans—not caring for and cherishing them" (146). He continues, "It was maintained by some that the Mollies of the coal regions were not supported or recognized by the Hibernians throughout the US, but there is abundant evidence of this being utterly false, the Sleepers, or Mollie Maguires, being substantially part and portion of the society. That this entire organization, from root to branch, was rotten and corrupt, has been unmistakably shown to the people of the country" (251). To make the international secret society angle still more titillating, Pinkerton relates in great detail, as does Gowen, that "the 'goods' . . . were given out in Ireland, the transatlantic headquarters of the society and thence transmitted to this country" (163).

The Irish had come to be the standard for political corruption in America. Since at least half of the Mollies with whom McParland came in contact

were political operatives, sheriffs, or publicans, they allowed Pinkerton to work that angle as well. In Jack Kehoe, sheriff and publican and purportedly "King of the Mollies," Pinkerton had a symbol to play upon every stereotype of political corruption.

The Irish had also become the enemies of two major political movements. The antidraft riots and antiabolition initiatives by some Irish had caused abolitionists to sour considerably upon the Irish as a whole. Ignatiev cites Garrison himself who, despite early hopes of an alliance with the Irish, had come to have nothing but scorn for them. O'Connell's petition in favor of abolition failed miserably in America. O'Connell's "you did not learn this cruelty in Ireland" speech was met with responses that the Irish in America were Americans now and loyal to it as such. O'Connell believed that this had to do with something peculiar in the atmosphere of America: "To become white they had to learn to subordinate county, religious, or national animosities, not to mention any natural sympathies they may have felt for their fellow creatures, to a new solidarity based on color—a bond which, it must be remembered, was contradicted by their experience in Ireland" (Ignatiev 96).

The temperance movement began with no such hope for the Irish and found little encouragement otherwise. This too had apparently to do with the peculiar atmosphere of America since the temperance movement, like the antislavery movement, was alive and well in Ireland. Roediger maintains that "when Irish-American Catholics flouted Protestant and industrial capitalist standards regarding alcohol consumption and sexuality they often did so guiltily, knowing that their own standards were also being violated. . . . Though drinking was a central part of social life for males in Ireland, per capita alcohol consumption there in the early nineteenth century trailed that of the United States" (152). Ignatiev cites one publican who expressed gladness that he was away from the repressive temperance advocated in Ireland by Fr. Mathew. However the enmity began, the continual drunkenness of not only McParland but of his cronies as well, is calculated to gain the alliance of the temperance advocates. Pinkerton would have been well aware of the uneasy alliance of nativists, antiabolitionists, and temperance advocates that comprised the Know-Nothing Party and which nominated Millard Fillmore (fresh from an audience with the Pope) for president of the United States. The Irish were fair game for any number of "Americans" and could therefore be scapegoated with relative impunity.

Pinkerton's novel resembles nothing so much as it does James Fenimore Cooper's *The Last of the Mohicans.* Slotkin finds in *Mohicans* a complex representation of the racialist ideologies of the nineteenth century. Pinkerton's novel is perhaps less complex but clearly written in the same vein as Cooper's. Pinkerton's own preface implies the connection he expected readers to make with Romantic fiction: "The author . . . is aware that, in many places, the

relation reads much like fiction, and that it will be accepted as romance by very many who are unacquainted with the country and the people attempted to be described" (ix). This is not far removed from Cooper's own protestation in the first line of his preface to the 1826 edition: "The reader who takes up these volumes, in expectation of finding an imaginary and romantic picture of things which never had an existence, will probably lay them aside, disappointed" (Cooper 1).

The Mollie Maguires and the Detectives resembles *The Last of the Mohicans* not only in claims to accuracy, but also in form, ideology, and cast of characters. Cooper's Indians, like Pinkerton's Irish, are creatures of appetite, admirable in accordance with their "gifts" but ultimately unable to achieve a mean. All are therefore mercurial and incapacitated for self-government. They can be divided cleanly into "good" Indians and "bad" Indians. Their passing, like that of Pinkerton's Irish, is inevitable and, unlike that of Pinkerton's Irish, it is lamentable.

Like the critical work surrounding the racial status of the Irish, Cooper's novels have recently experienced a serious reconsideration in the academy. Pinkerton's novel, like Cooper's, relies for effect upon the trope of the interrupted idyll—the serene pastoral environment shattered suddenly by savage violence and creating a psychic wound to the body politic. Michael Denning has discussed the operation of this trope in connection with dime novels surrounding the Mollies. Pinkerton employed this trope as well and to great effect. The Mollies have "converted the richest section of one of the most wealthy and refined of all the sisterhood of States into a very golgotha" (16). On the one hand, Tamaqua is a frontier town "filled with excited men and exciting whiskey"; on the other hand, it is described over several pages as "a handsome place" (360) immediately preceding the murder of policeman B. F. Yost. Just before it is interrupted by our introduction to Mickey Cuff, described above, Shenandoah is described as "a handsome little inland town, the center of a productive coal country and the place of residence of many excellent people" (239).

Many critics see in the character of Natty Bumppo a prototype of the detective who was to become one of the dominant literary types of the nineteenth century. As Slotkin sees it, "Leatherstocking is a man frozen in stasis between the opposed worlds of savagery and civilization. This stasis is his protection from renegadery on the one hand, and social climbing on the other" (Slotkin 105). Like Hawkeye, McParland serves as a guide to the society of savages, his liminal status qualifying him to lead the respectable and civilized safely through such a world. And like Hawkeye, McParland continually protests to that civilized audience his true allegiance to it and not to the world of savages he also knows. Hawkeye's repetitive assurance that he is "a man without a cross" is replicated in Pinkerton's repeated assurances (there

are at least seventeen in the text) that McParland was on the side of the company. For example, he argues, "this endeavor to have it seem that McParland fomented discord and caused crimes to be perpetrated which led to the arrest and punishment of his companions and intimates, is so absurd, that only those who desired to do so, put any faith in it, and for such persons and their wretched opinions I have supreme contempt. McParland was constantly instructed to avoid prompting outrages. . . . He could not stop them. . . . I shall show some of the troubles he did succeed in preventing" (149). Clearly it is important that Pinkerton demonstrate that McParland was protective of life and, possibly of equal or greater importance for prospective clients, property. An operative who destroys the resources of the client would not be terribly attractive to corporations looking to solve their security problems. But Pinkerton's treatment of drunkenness implies that this strategy is not merely an assurance of protection of property. Every time Pinkerton is compelled to relate a story involving the operative's drunkenness he hastily assures the reader that the operative was only feigning such to fool and win the confidence of his profligate enemies. Thus the operative, while being Irish, is one of the good Irish, capable of some degree of self-governance and thereby more "like" the audience. A second device through which Pinkerton illustrates this "likeness" is McParland's accent. When he speaks to the Mollies, McParland utilizes a stage brogue; when talking to the other operative or even to himself, he uses only King's English. Unlike Hawkeye, however, McParland *is* a social climber and joins the dominant and civilized culture at the novel's conclusion.

Slotkin reads in Cooper's novel a profound tension between the demands for subservience in the older order and the egalitarian ideals of a democratic society: "The mythology of race, and the linkage of this myth to a larger myth of progressive history, provided Cooper with a resolution to the contradiction between democratic or egalitarian ideals and the perceived need for subordinating one social class (or race) to another" (98). He contends that Cooper's solution to this is that Hawkeye naturally recognizes the superiority of his better, allowing a natural order to take place without infringing on Hawkeye's rights or ability to rise in the society. But Slotkin also maintains that toward the end of the century, many "progressives" were making peace with the idea that for progress to continue, there would have to be a relatively permanent underclass. Pinkerton's novel offers a perhaps less complex questioning but his own resolute Chartism would certainly have impinged upon his conceptions of natural order as Cooper's egalitarianism impinged upon his own. It is necessary then for Pinkerton to differentiate between the "good" and "bad" Irish, just as Cooper differentiated between "good" and "bad" Indians. The "good" Irish (and they are few), like "good" Indians, know their place, respect their betters, and thank these latter for the privilege of working in their

industries. Similarly, McParland is rewarded for being a good Irishman by pro-motion, but only to a certain level, within the company. But the hero with whom we are left is Gowen, whom Denning reads as one of the two heroes of the piece and to whom Pinkerton surrenders control of the narrative—displaying Pinkerton's own sense of place in the natural order.

Jane Tompkins reads *The Last of the Mohicans* as a serious "meditation on kinds, and more specifically an attempt to calculate exactly how much viola-tion or mixing of its fundamental categories a society can bear" (106). While Pinkerton's account is once again less complex it retains the basic strategy. As Slotkin says, "we do not perceive what the difference between Indian and white cultures and characters is unless we see what happens to those who try to cross the line between them." (91). Tompkins maintains that, in Cooper, the result of "crossing a cultural boundary . . . is disorientation and loss of identity on an awesome scale" (104). The results for the Pinkerton's Irish are far more serious.

Ignatiev argues that many of the events termed riots by the newspapers were really unorganized labor actions and civil disobediences—attempts by an inferior kind to become more like the dominant kind. In *The Mollie Maguires and the Detectives,* Pinkerton exhibits a people clearly incapable of self-governance attempting to take that governance by force. It too is then a meditation on kinds, showing the disastrous consequences for the urban sav-ages who cross cultural boundaries.

This fits with Slotkin's reading of the utility of the ideology of the Indian War. Pinkerton's novel is clearly crafted to garner more business for his detec-tive agency. But it is also crafted so as to fit within the trends of apocalyptic fiction gaining prominence toward the end of the century. Slotkin identifies in this trend the Indian War mentality—that a showdown was coming between progress and regressive savages and that the only solution would be a war of extermination of the latter. Slotkin has also argued that many of the inflam-matory reports from the Plains Wars were followed immediately by pleas for an increase in the army so as to deal with the threats posed by Indians. This mutated into a similar argument for more military to quell civil rebellion. Slotkin argues that "Grant['s] triumph over the savages of the plains would not only end the Indian wars, it would point a stern lesson to other forces within the Metropolis—disorderly 'tramps,' immigrant laborers, recalcitrant blacks—about the will and capacity of the republic to punish its enemies and vindicate its moral and political authority" (8). These wars, he maintains, "serve as a warning to all classes of the consequences that must follow when a racially defined underclass rejects the tutelage of its natural rulers" (478). Pinkerton suggests a more private solution—a private army—his private army, and one that would be no less exterminationist in its goals and objectives. Pinkerton's formulation offers a plea for the use of force, deadly force, on the

unruly Irish and from there, on unruly labor as a whole. Pinkerton relates that his "plans were formed for unrelenting and unending warfare upon [the Mollies]" (455). Gowen assures the court, "There is not a place on the habitable globe where these men can find refuge and in which they will not be tracked down" (Pinkerton 517). The consequences for the Irish, and for labor in general, became potentially as dire as for the Native American.

Denning maintains that Pinkerton's account remains the most influential of the mass of Mollies literature produced since the events transpired. Clearly Ritt, while molding much of the story to suit labor sympathy, has worked more or less directly from Pinkerton's account, incorporating also a few of Arthur Conan Doyle's innovations on it. Among the most significant of the film's innovations are its portrayal of Kehoe, its claims of McParland's complicity in the Mollies' crimes, and the separation of the Mollies from both the Catholic church and the Ancient Order of Hibernians.

The decision to make Jack Kehoe a miner instead of a sheriff and publican creates sympathy for the Mollies in several ways. First, it allows Ritt to demonstrate the harshness of mine conditions and create sympathy for Kehoe directly as he is every bit as dispossessed as every other worker. Were he portrayed as the relatively wealthy, petty bourgeois businessman, that sympathy would be far more difficult to draw. However, this change also removes at least one site for discussing how the effects of upward mobility by the Irish may have been received by the general public, thereby sidestepping a part of the class dynamic of the original. Second, it allows Ritt to avoid playing into the stereotype connecting the Irish to political corruption. Pinkerton dwells somewhat on Kehoe's power as sheriff and political boss. Ritt does not avoid this altogether, however, as, during the Hibernians meeting, Kehoe recommends that the Hibernians get the vote out for a gubernatorial candidate since they might need a pardon from him someday.

Ritt's handling of the McParland character is even more instructive. McParland's affair with Mary Raines offers several advantages. First, it offers the always attractive option of a love story, expanding upon the Pinkerton account that McParland only "sparked" one particular woman and that only briefly and only to ingratiate himself. Conan Doyle expanded upon this portion of the story but his detective, who was English and only feigning Irishness, fell for a woman Conan Doyle hastily assures us is of a "German type." Ritt's McParland seems to fall genuinely for Mary Raines, who is Irish like himself and who speaks to the dreams of many Irish immigrants to escape their conditions and rise to a level of middle-class white respectability. Furthermore, McParland seems genuinely hurt and disappointed when she informs him that he went too far to achieve that escape. This is one of several ways Ritt's McParland shows his sympathy, even solidarity with the other Irish in the story.

He sometimes defends the Mollies to Guard Captain Davies, on one occasion (shot in a mine shaft) discussing what the working conditions might drive a man to do. Even Davies is made slightly sympathetic, explaining that he had also worked the mines but had found his way out. Despite this, Davies is sufficiently concerned with McParland's sympathies that he warns him not to forget which side he is on—a far cry from Pinkerton's McParland who never needed such a reminder. The sympathy shown by Ritt's McParland then validates and encourages audience sympathy.

Ritt goes further still, showing McParland in direct complicity with, encouraging, and committing Mollies' crimes. In the torching of the general store, following Mr. Raines's wake (which Ritt also remade from Pinkerton's original), it is McParland who encourages violence to property. Kehoe's original intention is to take by force the suit he believes Raines has earned but been unfairly denied. Kehoe then turns to looting useful goods and distributing them hurriedly to the crowd gathered outside, beginning with clothing and moving to food. It is McParland who begins rampantly smashing the shelves, destroying the property Kehoe means to distribute. It is McParland who lights the match and touches it to the kerosene, setting the store ablaze. In the discussion preceding the attack on the mine superintendent in Shenandoah, it is McParland's vote that decides the question of whether to murder or simply beat the target. A hung vote would have caused their chapter to pass the job to other Mollies but McParland votes to murder the man. During their final conversation, Kehoe recounts these and other acts of McParland's as evidence that he believes the latter to have been, in his heart, on the Mollies' side. In these scenes, Ritt directly contradicts Pinkerton's assurances and creates the impression that the Mollies were goaded to violence by McParland so he could build a better case.

Ritt's dissociation of the Church and the Hibernians indicates that he may have been aware of and sensitive to at least a part of the debate over the accuracy of Pinkerton's assertions and indicates some sensitivity to the concerns of modern Catholics and Irish-Americans. Ritt dwells significantly upon the priest's sermon castigating the terrorism of the Mollies. The priest offers his understanding of the harshness of the congregation's lives and shares their frustrations but states categorically that the Mollies are in the wrong and have cut themselves off from the church. This is softer still on the Mollies than the historical Archbishop Wood's threat of excommunication but still absolves the church of the complicity Pinkerton implied. Ritt's pastor shows sympathy on several other occasions as well but never relents in his criticism.

Ritt is no less clear on his dissociation of the Ancient Order of Hibernians from the Mollies. A meeting of the Hibernians immediately precedes the meeting on the Shenandoah matter. Frazier and Dougherty persuade McParland to stay as the other Hibernians are leaving, and as Kehoe begins to discuss the

job, McParland protests that he has joined only the Hibernians, "all things lawful and not otherwise." Kehoe responds sharply and categorically, "This is not the Hibernians." When Davies instructs McParland to infiltrate the Hibernians, McParland says, "Nothing wrong with them. Just Irish looking after their own." When Davies wants a list of names, McParland again defends the legality of the Hibernians. During the making of the film, the Pottsville local of the Hibernians contacted Paramount, voicing concerns over the depiction they might receive, and they were invited to observe filming. Whether this motivated Ritt's choices here, these choices stake a clear claim that the Hibernians were not involved.[2]

Most important among the ways Ritt does not diverge from Pinkerton's account are the violence ascribed to the Irish in general by the racialist ideology of the time and to the Mollies in particular by the mine operators, the role that violence plays in interrupting the idyll, and the existence of a conspiratorial secret society.

Robert Morsberger argues in his essay in this collection that many of the murders attributed to the Mollies are omitted, making them "less criminal and more sympathetic." It is true that this makes them less criminal and more sympathetic than in Pinkerton's account. But depicting them involved with violent acts at all makes them more criminal and less sympathetic than in the accounts given by any of the alleged Mollies themselves. Violent acts (of one person against another, violence done to workers by the workplace) occur in 13 of 26 total scenes in the film, or 50 percent of all scenes. Violence is discussed, planned, or implied as an offstage action in at least 3 more, bringing the percentage to 61 percent. Clearly, Ritt is attempting to show the mines as the violent environment Slotkin maintains they were, but most of that violence is perpetrated by the Irish, and some of it is just for fun. The only leisure activity in which the whole community participates, the rugby game against the Welsh from Tamaqua, is shot over the course of four full minutes and its violence is enjoyed by women and priest alike. Combined with the fight that follows (precipitated by a drunken Dougherty and including gunshots), the scene lasts for nine minutes, making it one of the longest single scenes in the film. While thrice the violence of the Coal and Iron Police is shown—in Dougherty's arrest, McKenna's arrest, and the massacre of Frazier and his wife—the violence of the Mollies is shown ten times. The Mollies make one short reference to trying other more peaceful means (the Long Strike), but none of these attempts are actually shown. McParland was already underground at the time of the Long Strike, so it might have been within the purview of the film to discuss it. Instead, violence appears to the film audience as the Mollies' only strategy for bettering their working conditions.

Ritt's opening tracking shot begins with an idyllic sunrise over the mountains uninterrupted (as it uses no cuts) as it follows a coal car back down into

the mine. Then the first cut occurs, revealing the harsh conditions within the mine. Thus, part of the idyll's interruption is the mine itself, but the scene unfolds to show the Mollies setting charges to blow the mine. The background noises become progressively quieter as Kehoe, having set his last charge emerges and walks from the mine in silence with several other miners. As they reach a more wooded area, the chirping of birds fades in, restoring the idyll so it can once again be interrupted as the mine blows—erupting in flame and roar. The score sweeps up and emblazoned across the fiery explosion is the name "The Molly Maguires" as if it were a signature of the work on which it is printed. Later, Kehoe and Frazier sneak out of the mine to blow the tracks down which a train is steaming idyllically along a riverbank, only to topple in the explosion and interrupt the pristine flow of the river by dumping tons of coal into it. The assassination attempt occurs at the mine superintendent's stable as he peacefully combs his horse.

McParland's opening sequence begins somewhat differently in the film than in Pinkerton as he enters the pub quietly, not dancing some furious jig. But Ritt retains at least one element from the Pinkerton account as McParland squares off against Frazier (McParland wins). Were it not already obvious that we are to read this as typical Irish behavior, Ritt makes it crystalline. Davies identifies the Irish origin of the secret societies on which the Mollies are modeled and informs McParland that the "crazy" Mollies "think they can get what they lost with the gunpowder." McParland replies, "That's not crazy, it's only Irish." Thus a representative from the culture confirms and gives license to this portion of the stereotype.

Ritt's decision to show the Mollies in commission of violent acts—even before McParland's arrival—and his replication of such secret society favorites as the "recognition sign" and the "answering sign" stake a claim that, however justifiable their reasons, the men hanged for murder in Pennsylvania were guilty; they did belong to an international, or at least national, secret society with aims to violently overthrow capital. The stark violence and formulaic but titillating inclusion of such intrigue make *The Molly Maguires* a drastically different film from that labor film for which Ritt is far better known—*Norma Rae*. Norma Rae and Reuben Warshawsky work entirely within the letter and spirit of the law. It is useful to ask whether the same ethic, applied, for example, to the struggles of workers involved in the Long Strike might not have produced a film more helpful in the long run to labor and to the memory of the oppressed Irish hanged in Pennsylvania than the blazing and romantic failures he depicted.

While Ritt seemed to be attempting to create some sympathy for the Molly Maguires, he both reinforced stereotypes of these people who still have not gotten the advocate Ignatiev believed was lacking in the nineteenth century and reinvented the American past without the critical eye for which

Maddox calls. Slotkin warns, "It is not simply that the making of legends alters or misrepresents the facts of historical cases. . . . What is lost when history is translated into myth is the essential premise of history—the distinction of past and present itself. . . . Both past and present are reduced to instances displaying a single 'law' or principle of nature, which is seen as timeless in its relevance, and as transcending all historical contingencies" (24). Like some recent remakers of *The Last of the Mohicans,* Ritt has attempted to be more politically sensitive to the oppressed characters in question but like those other films, Ritt's *Molly Maguires* evokes the romantic appeal of a valiant failure without reference to the complex racial and class-dominated environment in which it occurred, thus reducing the story to one that could be told about any number of workers at any number of historical moments.

Even though Ritt attempts to explain the root causes of the violent activities of a secret society like the Mollies—and perhaps even to justify those behaviors—one must question whether he would not have done greater service to question whether they existed at all and whether (as some like Bimba contend) belief in the existence of the Mollies and the subsequent hanging of nineteen alleged members was not simply an elaborate fiction designed to reignite both nativist and antilabor passions. Many of these histories were available to Ritt but the earlier fictions proved too attractive, compounding the irony that the Eckley Miner's Village was established as a Pennsylvania State Museum only after the film used the site as a set and bequeathed several of the most interesting buildings (the Breaker, the Company Store, the Mule Barn) built for the set and now a part of the museum. Despite the protestations of innocence of the condemned men themselves, Ritt has helped ensure that the legend that includes the alleged violence of the alleged Molly Maguires is read into the historical record as surely as the replicated buildings are a part of Eckley's historical site.

NOTES

1. In "Blackfaced Rednecks" in this collection, Ina Rae Hark quotes Frank Keeney's equation of capital's strategy toward labor with its strategy toward the American Indian. Hark argues convincingly that class and race are often linked to but are not the same as one another. Keeney's statement shows that, like the *Irish World* but over forty years later, workers recognized capital's attempt to conflate the two.

2. From a conversation with Leo Haley, president, Pottsville Local Chapter of AOH, June 1992.

WORKS CONSULTED

Callahan, Joseph. "The Irish Language in Pennsylvania." In *The Irish Language in America,* edited by Roslyn Blyn, 18–25. Philadelphia: Univ. of Pennsylvania Press, 1987.

Cooper, James Fenimore. *The Last of the Mohicans*. New York: Penguin, 1986.

Curtis, L. Perry, Jr. *Apes and Angels: The Irishman in Victorian Caricature*. Rev. ed. Washington, D.C.: Smithsonian Institution, 1997.

Denning, Michael. *Mechanic Accents: Dime Novels and Working Class Culture in America*. London: Verso, 1987.

Ignatiev, Noel. *How the Irish Became White*. New York: Routledge, 1995.

Jennings, Francis. *The Invasion of America: Indians, Colonialism and the Cant of Conquest*. New York: Norton, 1975.

Maddox, Lucy. *Removals: Nineteenth-Century American Literature and the Politics of Indian Affairs*. London: Oxford Univ. Press, 1991.

Pinkerton, Allan. *The Mollie Maguires and the Detectives*. New York: G. W. Carleton, 1877.

Roediger, David R. *The Wages of Whiteness: Race and the Making of the American Working Class*. London, Verso, 1991.

Slotkin, Richard. *The Fatal Environment: The Myth of the Frontier in the Age of Industrialization, 1800–1890*. New York: Harper Perennial, 1994.

Tompkins, Jane. *Sensational Designs*. New York: Oxford Univ. Press, 1985.

12

Openness to Experience in Stephen Crane's "In the Depths of a Coal Mine"

Patrick K. Dooley

In early January 1894 Hamlin Garland dispatched Stephen Crane to S. S. McClure with a bundle of manuscripts and a note, "If you have work for Mr. Crane talk things over with him and for Mercy Sake! Don't keep him *standing* for an hour; as he did before, out in your pen for culprits" (*Log* 95–96). The publication of *The Red Badge of Courage,* that would make Crane an overnight international celebrity, was almost two years away.[1] Crane's first novel, *Maggie,* had appeared a year earlier. Virtually no one bought it; nonetheless it gained him important support from critics William Dean Howells and Hamlin Garland and syndicate owners S. S. McClure and Irving Bacheller.

In April 1894, Crane offered the manuscript of *The Red Badge of Courage* to McClure. He and his syndicate, suffering through a brief recession, were overextended. So McClure neither accepted nor rejected Crane's war novel; instead he kept Crane's manuscript for six months. (Incidentally, McClure held the only copy of Crane's masterpiece, and it was misplaced for several weeks. Eventually, it was found in the pressroom; some of *McClure's* compositors had been reading it!) One supposes, then, that McClure felt some responsibility and remorse for delaying the career of a young writer whose work he very much admired, and so he sent reporter Crane to do a story on the anthracite coal mines of Pennsylvania's Wyoming County.

En route to the northeast corner of Pennsylvania, Crane (and his friend Corwin Linson) spent the night at Crane's sometime hometown of Port Jervis, New Jersey. The next day, the *Port Jervis Union* puffed Crane's fame and success and reported his next assignment: "Mr. Stephen Crane, of New York city, whose novel 'Maggie' has given its author considerable literary celebrity, and whose magazine articles have many readers in this village, was in town over night, as the guest of his brother, Mr. W. H. Crane. He started for Scranton this

noon, where he goes to obtain material for an article in McClure's magazine on the coal fields of that region. He was accompanied by Mr. C. K. Linson, the well known artist, who will furnish the illustrations for the article" (*Log* 108).

On May 18–19 Crane and Linson made two descents into the Dunmore mines—the first shaft was 750–feet deep, the second, 1000 feet. Crane and Linson boarded at the Valley House in Scranton: the journalist worked on his first draft, and the illustrator, his drawings. In late July, "In the Depths of A Coal Mine" was syndicated in five newspapers. The abbreviated newspaper version contained up to three of Linson's drawings. Shortly thereafter the full version, with fourteen illustrations by Linson, was the feature article in the August *McClure's*.

Fortunately, we have most of Crane's first draft to compare with the final *McClure's* version. A comparison of these drafts reveals Crane's sure-handed self-editing as he held himself to his maxim, "preaching is fatal to art in literature" (*Correspondence* 230). Before we look at Crane's revisions, we will examine how Crane's extraordinary openness led him to a sophisticated metaphysical position on the nature of human experience. Hence, "In the Depths of a Coal Mine" offers both social commentary and philosophical insight.

"NEW EYES": CRANE'S METAPHYSICS OF EXPERIENCE

Crane's philosophical contemporaries, the pragmatists William James, C. S. Pierce, and John Dewey, sought to transcend the dualisms of subject/object, knower/known and person/thing. The subject matter for philosophical (and literary) inspection, they argued, was *experience*. Dewey proposed using neutral and interactive language. For example, he referred to experience as "a transaction" or "a negotiation" between experiencers and their experiences. (Note that both terms are plural.)

For his part James took aim at two of the "Idols of the Tribe": Truth and Reality. We "naturally" suppose that experience puts us into contact with a static, given Reality and we "naturally" assume that a detached spectator's objective report is capable of capturing the Truth about what is "out there." But truths and realities are all that human experiencers can manage. Accordingly reliable, practically useful accounts of multiple realities constituted by a variety of experiencers and realized across a spectrum of contexts form the basis of James's modest and realistic pragmatic epistemology.

For the American pragmatists (and for Crane) the first step in the philosophical reconstruction of our habitual views of Truth and Reality is a realization that all facts (as well as values, ideas, and beliefs) are theory-laden and context-dependent. Alert to the constitutive nature of contexts and consciousnesses, Crane maneuvers his readers into experiential contact with richness, novelty, and surprise as he has us confront a variety of incompatible

versions of the "same" event. On precisely this point, Crane's writings are replete with observers and participants who discover that experiences grant them "new eyes."

In the second paragraph of "In the Depths of a Coal Mine," the narrator notes how Crane and Linson reacted to a group of second-shift miners walking by them (fig. 1): "They went stolidly along, some swinging lunch-pails carelessly, but the marks upon them of their forbidding and mystic calling fascinated *our new eyes* until they passed from sight" (591; emphasis added). As capable witnesses, Crane and Linson already had "new eyes": they are neither too aloof nor too engrossed, neither too clinical nor too sympathetic. As attentive and balanced onlookers, they are not without biases and preconceived views. As epistemologically competent experiencers with prior, even firm and well-considered opinions, they remain, crucially, open, tractable, and sensitive enough to permit, even encourage revisions of their beliefs.

A comparison of Crane's opening and second to last paragraph (both of which describe the mine, the breakers, and the area around the mine) dramatizes how Crane's subterranean tour radically reconstituted the "same" scene (fig. 2). The sketch begins with a graphic description of the land around the mine—nature ruined and degraded: "The breakers squatted upon the hillsides and in the valley like enormous preying monsters eating of the sunshine, the grass, the green leaves. The smoke from their nostrils had ravaged the air of coolness and fragrance. All that remained of the vegetation looked dark, miserable, half-strangled. Along the summit-line of the mountain, a few unhappy trees were etched upon the clouds. Overhead stretched a sky of imperial blue, incredibly far away from the sombre land" (590). At the end of the piece, as Crane rides the elevator up to the surface, he wonders about "the new world that I was to behold in a moment" (599–600). Reborn, the ravaged and ugly land around the mine has become Edenic—beautiful, wholesome and natural: "Of a sudden the fleeting walls became flecked with light. It increased to a downpour of sunbeams. The high sun was afloat in a splendor of spotless blue. The distant hills were arrayed in purple and stood like monarchs. A glory of gold was upon the nearby-by earth. The cool fresh air was wine" (600). Of course, neither the "ravaged" land nor the "glory of gold" earth is the total, final Truth. Indeed, for Crane (and the pragmatists) experience forces us to confront a pluri-verse of multiple realities that tolerate a wide variety of opinions and adaptive strategies.

But not every opinion, however contextualized and thereby understandable, is equally valid; not every tactic, however long endorsed by habit and tradition, is equally fruitful. The arbiters of our beliefs and actions are pragmatic: success or failure, pleasure or pain, safety or danger, profit or loss, stability or precariousness. The second terms in each pair loom large in Crane's account of coal mines and miners.

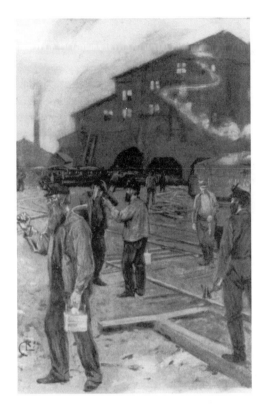

FIGURE 1. Miners going to and from work, illustrated in *McClure's Magazine* Aug. 1894: 197.
Courtesy of Thomas Cooper Library, University of South Carolina.

FIGURE 2. "Breaker," from *McClure's Magazine* Aug. 1894: 201.
Courtesy of Thomas Cooper Library, University of South Carolina.

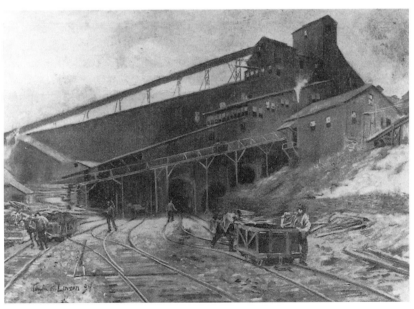

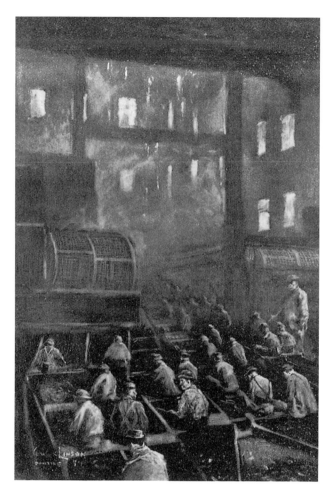

FIGURE 3 "In a large room sat the little slate-pickers," from *McClure's Magazine* Aug. 1894: 201.
Courtesy of Thomas Cooper Library, University of South Carolina.

A coal mine is not a safe place; mining is not a healthy job. No news here! Crane's genius, however, turns these obvious and commonplace observations into emotionally charged, empathetic encounters. A number of Crane's stories and journalistic pieces skillfully exploit the irony of participants unable to understand themselves and their situations. Such is also the case with the Scranton miners.

The situation of the miners is complex; Crane is careful to preserve nuance and ambiguity. On one hand, miners "choose" to become miners. He explains how badly the slate boys want to become real miners, deep down inside the earth (fig. 3). On the other hand, these "tiny black urchins" have

had a difficult apprenticeship in the breakers: "breathing this atmosphere until their lungs grow heavy and having this clamor in their ears until they grow deaf as bats. Poor little ambitious lads, it is no wonder that to become miners, is the height of their desires" (602). Perhaps, suggests Crane, a boy growing up in a mining town has little choice about his future.

But when it comes to a description of the mine as a place of work, Crane is neither restrained nor cautious. It is an unfair contest. Since the miners are thieves and intruders, it is only a matter of time until nature retaliates. Though the miners are able to probe and blast and tear away at the mine walls and ceilings, Crane (and Linson) cannot bring themselves to touch the walls or ceiling that bear the seams of coal: "The sense of an abiding danger in the roof was always upon our foreheads. It expressed to us all the unmeasured, deadly tons above us. It was a superlative might that regarded with supreme calmness of almighty power the little men at its mercy. Sometimes we were obliged to bend low to avoid it. Always our hands rebelled vaguely from touching it, refusing to affront this gigantic mass" (594). The miners surely understand that in the long run the odds are against them. Still, they "willingly" gamble their lives. Crane, however, sees the situation differently: "It is war. It is the most savage part of all in this endless battle between man and nature. These miners are grimly in the van. They have carried war into places where nature has the strength of a million giants. Sometimes their enemy becomes exasperated and snuffs out ten, twenty, thirty lives. Usually she remains calm, and takes one at a time with method and precision. She need not hurry. She possesses eternity" (596–97; fig. 4). Though not as unabashedly and aggressively

FIGURE 4 "He who worked at the drill engaged in conversation with our guide," from *McClure's Magazine* Aug. 1894: 205.
Courtesy of Thomas Cooper Library, University of South Carolina.

reformist as B. O. Flower's *The Arena* (which also published a number of Crane's pieces) *McClure's* magazine was a muckraker. Clearly then, Crane had to make decisions about the extent and explicitness of his social commentary about mines and miners. As we shall now see, Crane used art not propaganda to lay out his case. A collation of the first draft with the *McClure's* article reveals substantial shifts in tone, content, and rhetorical style.

SELF-EDITING, INDIRECTION, AND SOCIAL COMMENTARY

There are many minor alterations of the first draft.[3] Some emendations are purely stylistic; others, seemingly minor, are rhetorically telling and philosophically significant. Crane was careful about the uncertain situation of the miners—did they have a real choice in becoming miners or were their lives environmentally determined? Crane's account of miners' health problems uses precisely parallel language. The magazine version has it "there *usually* comes to him an attack of '*miner's* asthma,'" while the draft version is subtly different: "there comes an *inevitable* disease, the '*mine* asthma'" (599, 606; emphasis added).

Overall, the magazine version is cooler and less strident. More significantly, all editorial commentary has been excised from the published version. What remains appears to be the simple reporting of the dirt, din, and danger of coal mining. There is no overt indictment of the mining industry, but by powerful indirection and effective understatement, Crane deftly leads the reader to make a social and moral assessment.

Linson recalled that Crane composed the first draft in their Scranton hotel room. In the initial version, Crane's simmering outrage and indignation leaked onto his pages; however, upon his return to New York City, his artistic sense reasserted itself. For example, the phrase comparing the mine to "a penitentiary for bandits, murderers, and cannibals" (606) was removed because it undercut the moral message that most miners did not view themselves trapped by the mine. Crane did not need to point up the coal industry's inhumanity to miners; the treatment of the mine mules made his moral point for him. (More on the mules shortly.)

Crane's most extensive and important deletions reflect a reporter's commitment to neutrality. He wondered why the miners did not organize a strong union: "When I studied mines and the miner's life underground and above ground, I wondered at many things but I could not induce myself to wonder why miners strike and otherwise object to their lot" (605). That sentence and his sardonic comment that a coal miner's retirement bonus is "mine asthma" were deleted.

Crane eliminated four paragraphs near the end of the piece that denounced the mining industry and its place in American society. These

sections discussed the fact that miners' hardship provides comfort for coal-burning homeowners, the fact that miners' grime gives livelihood to "virtuous and immaculate coal-brokers" (607), and the fact that miners' diseases bring financial health to "the impersonal and hence conscienceless thing, the company" (607). Finally, Crane refrained from saying the obvious, "one cannot go down in the mines often before he finds himself wondering why it is that the coal-barons get so much and these miners, swallowed by the grim black mouths of the earth day after day get proportionately so little" (606).

As noted above, Crane held that preaching and literary art are incompatible. His letter to the editor of *Demorest's Family Magazine* continues, "I try to give readers a slice out of life; and if there is any moral or lesson in it I do not point it out. I let the reader find it for himself. As Emerson said, 'There should be a long logic beneath the story, but it should be kept carefully out of sight'" (*Correspondence* 230).

Crane's most potent incrimination utilizes the signature characteristic of his style: irony. He skillfully contrasts the reluctant mine mules with the youngest boys, the slate pickers who are eager to be promoted deeper into the mine to become door boys, then mule boys, then laborers and helpers and, finally, in the depths of a coal mine, "real miners" who make the blasts. The mules (fig. 5), which "resembled enormous rats" in their "stable [that] was like a dungeon" (597), become the vehicle of Crane's ethical point. Aghast at the condition of the miners, Crane dramatically reserves his moral condemnation, "the tragedy of it," for the lot of the animals:

> One had to wait to see the tragedy of it. . . . It is a common affair for mules to be imprisoned for years in the limitless night of the mines. . . . When brought to the surface, these animals tremble at the earth, radiant in the sunshine. Later, they go almost mad with fantastic joy. The full splendor of the heavens, the grass, the trees, the breezes breaks upon them suddenly. They caper and career with extravagant mulish glee. . . . To those who have known the sun-light there may come the fragrant dream. Perhaps this is what they brood over when they stand solemnly in rows with slowly flapping ears. A recollection may appear to them, a recollection of pastures of a lost paradise. Perhaps they despair and thirst for this bloom that lies in an unknown direction and at impossible distances. (597–99)

Crane's ethical case reverses the standard a fortiori argument: if the stronger case holds, surely the weaker case presents no problem.[4] From the opposite direction Crane asks, if the weaker case, animal welfare, raises moral issues, how much more ought the mining industry's treatment of humans be questioned?

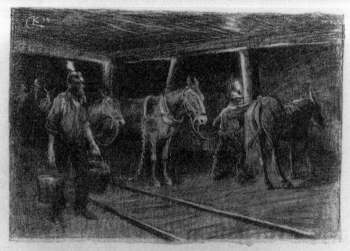

MULE STABLES. PUTTING IN A TEAM.

dor of snows had changed again and again to the glories of green springs. Four times had the earth been ablaze with the decorations of brilliant autumns. But "China" and his friends had remained in these dungeons from which daylight, if one could get a view up a shaft, would appear a tiny circle, a silver star aglow in a sable sky.

Usually when brought to the surface, the mules tremble at the earth radiant in the sunshine. Later, they go almost mad with fantastic joy. The full splendor of the heavens, the grass, the trees, the breezes, breaks

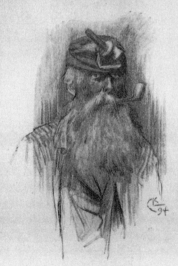

upon them suddenly. They caper and career with extravagant mulish glee. A miner told me of a mule that had spent some delirious months upon the surface after years of labor in the mines. Finally the time came when he was to be taken back. But the memory of a black existence was upon him; he knew that gaping mouth that threatened to swallow him. No cudgellings could induce him. The men held conventions and discussed plans to budge that mule. The celebrated quality of obstinacy in him won him liberty to gambol clumsily about on the surface.

FIGURE 5 Mule stables, putting in a team, illustrated in *McClure's Magazine* Aug. 1894: 207. *Courtesy of Thomas Cooper Library, University of South Carolina.*

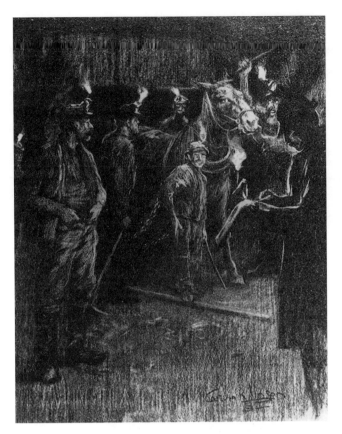

FIGURE 6 "Whoa, Molly," from *McClure's Magazine* Aug. 1894: 194.
Courtesy of Thomas Cooper Library, University of South Carolina.

Crane continues his oblique critique in another pairing of the human and nonhuman. Darkness and silence are the natural state underground. Here "there frequently grows a moss-like fungus, white as druid's beard, that thrives in these deep dens but shrivels and dies in contact with the sun-light" (599). The unnatural inhabitants of the mine—the men and the mules—are phototropic so they yearn for "the glorious summer-time earth" (594). Not in every case, suggests Crane. Apparently many miners have adjusted to "the stretches of great darkness, [and] majestic silences" (597). But not the mules. Some of them "seem . . . somehow, like little children. We met a boy once who said that sometimes the only way he could get his resolute team to move was to run ahead of them with the light. Afraid of the darkness, they would trot hurriedly after him and so take the train of heavy cars to a desired place" (598; fig. 6). For the mules, every return to the surface means salvation and liberation. However, inured to the mine's debilitating dangers and accustomed to

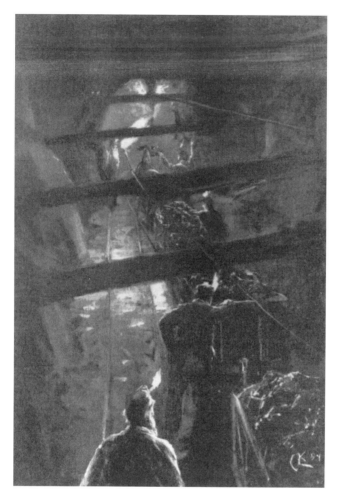

FIGURE 7 The main gangway in a coal mine, illustrated in *McClure's Magazine* Aug. 1894: 194.
Courtesy of Thomas Cooper Library, University of South Carolina.

silence and darkness, a coal miner's daily return to and thereafter his retirement on the surface are not always happy or healthful: "If a man may escape the gas, the floods, the 'squeezes' of falling rock, the cars shooting through little tunnels, the precarious elevators, the hundred perils, there usually comes to him an attack of 'miner's asthma' that slowly racks and shakes him into the grave. Meanwhile he gets three dollars per day, and his laborer one dollar and a quarter" (599). Many miners, like the moss-like fungus, shrivel and die when they come into prolonged contact with the fresh air and the sunlight.

In conclusion, as the elevator ascends the mine shaft Crane reflects about the "new world" he will reenter. "In the Depths of a Coal Mine" has made us privy to new worlds of mines, mules, and miners. However, Crane's most important insight about these several new worlds deals with discerning the role of coal mining in turn-of-the-century American society.

Whereas his first draft explicitly commented upon how miners are exploited by coal-burning consumers, coal brokers, and coal companies, the *McClure's* version ends with an abstract, symbolic summary. Crane began his article by likening miners' work to the feeding of a monster: "with terrible appetite this huge and hideous monster sat imperturbably munching coal, grinding its mammoth jaws with unearthly and monotonous uproar" (591). Crane concludes by returning to the breakers now refashioned and recast as machines, the embodiment of American business; note his penultimate and ultimate phrases: "Of that sinister struggle far below there came no sound, no suggestion save the loaded cars [fig. 7] that emerged one after another in eternal procession and were sent creaking up the incline that their contents might be fed into the mouth of the breaker, imperturbably cruel and insatiate, black emblem of greed, and of the gods of this labor" (600).

NOTES

1. The standard resource for study of Stephen Crane is *The Works of Stephen Crane* (10 vols.). Both versions of "In the Depths of a Coal Mine" are contained in volume 8, and page citations for this and other volumes have been included in the text. (Most of the Virginia critical edition has been conveniently collected in a single volume, *Stephen Crane: Prose and Poetry*.)

The standard biographical and bibliographical resources are *The Correspondence of Stephen Crane* (cited as *Correspondence*), *The Crane Log: A Documentary Life of Stephen Crane, 1871–1900* (cited as *Log*), and Patrick K. Dooley, *Stephen Crane: An Annotated Bibliography of Secondary Scholarship* (cited as *Bibliography*). For those wanting to investigate philosophical themes in Crane, see Dooley, *The Pluralistic Philosophy of Stephen Crane* (cited as *Pluralistic Philosophy*).

2. Corwin Knapp Linson (1864–1959), painter, illustrator, and photographer, was introduced to Crane during the winter of 1892–1893, and they remained friends until 1897. Both lived in the old Art Students League Building on East Twenty-third Street in New York City; it was in Linson's studio that Crane read the accounts by veterans in *Century Magazine's* series "Battles and Leaders of the Civil War." Crane resolved to write about how it felt to be in combat: the result was *The Red Badge of Courage*.

In addition to illustrations for *McClure's*, Linson's work appeared in *Century* and *Cosmopolitan*. *Scribner's Magazine* sent him to Athens to provide sketches of the revived Olympic Games in 1896, and he won a bronze medal for his drawings. For reliable information on Linson's life and work, see Stanley Wertheim's entry on him in *A Stephen Crane Encyclopedia*. The captions of the Linson illustrations that appear

in the text are from the original published version. Note that in the fourth and sixth illustrations Crane can be seen taking notes.

3. Whether Crane initiated the editing of his manuscript or whether it was *McClure's* censorship is a matter of scholarly dispute. The matter is further complicated by differences between the syndicated newspaper and magazine versions of the piece. It is my view that because *McClure's* printed a number of preachy social commentary articles (including some by Crane's friend and mentor, Hamlin Garland), Crane's self-editing best explains the differences between the first draft and the complete magazine version. See my *Pluralistic Philosophy* 10–14 and 153–54, nn. 22 and 23, for more on this issue. For secondary comment on Crane's journalism see chapter nine of my *Bibliography*, "Journalism, Tales and Reports" 213–32.

4. For a clear example (its plausibility and decency aside) of the a fortiori ethical argument strategy, see Thomas Tooley's article. Tooley argues that if the stronger case, infanticide, could be made morally innocuous, then objections to the weaker case, killing fetuses, would be obviated. As noted, Crane reverses this strategy by making vivid the weaker case—animal welfare—letting his readers extend his argument to the stronger case—the use and abuse of humans.

WORKS CONSULTED

Crane, Stephen. *The Correspondence of Stephen Crane*. Edited by Stanley Wertheim and Paul Sorrentino. 2 vols. New York: Columbia Univ. Press, 1988.

———. *Stephen Crane: Prose and Poetry*. Edited by J. C. Levinson. New York: Library of America, 1984.

———. *The Works of Stephen Crane*. Edited by Fredson Bowers. 10 vols. Charlottesville: Univ. Press of Virginia, 1969–1976.

Dooley, Patrick K. *Stephen Crane: An Annotated Bibliography of Secondary Scholarship*. New York: G. K. Hall, 1992.

———. *The Pluralistic Philosophy of Stephen Crane*. Urbana: Univ. of Illinois Press, 1993.

Tooley, Thomas. "In Defense of Abortion and Infanticide." In *The Problem of Abortion*, edited by Joel Feinberg, 120–34. Belmont, Calif.: Wadsworth, 1984.

Wertheim, Stanley. *A Stephen Crane Encyclopedia*. Westport, Conn.: Greenwood Press, 1997.

13

Coal Mining, Literature, and the Naturalistic Motif

AN OVERVIEW

Tom Frazier

And far below, beneath his feet, the stubborn tapping of the picks continued. His comrades were all down there, and he could hear them.

Emile Zola, *Germinal*

In the too often trendy world of literature, the careful reader soon becomes cognizant of the artistic certainty that writers will search high and low for suitable and unique motifs to carry the weight of their creative efforts. At times the motifs appear to be contrived while at others the motifs arise naturally and vitalize the precept that writing is generated by the writers' and readers' backgrounds, which is central to the observations of the new historical critics.

Almost every social ingredient, whether life in the London slums or life in agricultural America, has been brought into service in the "naturalistic" literary canon. However, if one needs just one naturalistic metaphor to carry the symbolic weight of a work, coal mining more than satisfactorily fills the bill. The stark world of coal mining and the lives of those who dig the coal clearly create the verisimilitude so important to naturalistic literature. The naturalistic works that depict the real world of coal miners and coal mining show the miners trapped underground by economic forces and digging tons of coal, one shovelful at a time, to meet the day's quota while their families starve on the surface in run-down shacks or in tightly controlled company towns.

But why does coal mining stand out above other economic structures as a viable naturalistic motif? It is most likely because of the very nature of the industry. Mining seems to be the most unnatural means of attaining a

livelihood from the land because in order to enjoy the economic cornucopia promised by the enterprise, individuals must dig and claw their way into the deep recesses of the earth. Today, the methods of mining are enhanced by technology, but the process remains the same. Getting to and then removing the coal dictates that the vast inner structure of a mountain or range of mountains be removed. To compensate for this removal, miners have designed man-made replacements for the extracted natural supports, first with pillars of wood and more recently with large roof bolts driven deep into the top of each mine shaft. However, natural forces beyond even the most diligent miner's control show how futile these efforts at propping up the world really are when scores of miners are killed annually as the result of mine explosions and roof falls.

A less abstract metaphorical argument is the magnitude of coal's importance to the newly emerging industrial economies in the nineteenth and early twentieth centuries. As Harry Caudill writes in *Night Comes to the Cumberlands* (1962), following the Industrial Revolution, "ships, locomotives, factories and newly built electric power plants were driven by coal and millions of people warmed by its sooty flame" (71). For this reason, "in the late nineteenth and early twentieth centuries, coal was king of the industrial world" (Eller 128). The new, heavy industries required coal for power, and coal gained economic and social clout from this industrial dependence. Although coal miners often participated in work stoppages, they soon found that the omnipotent companies and company owners, in most cases, were able to push the miners' concerns aside and force the men to continue digging the coal.

The significance of coal mining as a naturalistic literary motif is even more apparent because of the breadth of its use. The coal-mining metaphor has crossed national boundaries. Wherever coal is mined as an essential segment of an area's economy, writers find the process to be a suitable vehicle for their aesthetic and philosophical biases. In fact, in *Germinal* (1885), his thirteenth Rougon-Macquart novel, Emile Zola focuses his narrative upon the inhabitants of Montsou in coal-rich northern France and the inhumane conditions under which the miners must live lives filled with "chilling resignation and despair" (Lethbridge viii).

In many instances, the lives of coal miners and the literature written about them have been governed by what Richard Taylor characterizes as "logical determinism or fatalism" (360) or to some extent group "social engineering" (Hunt 269), which was so popular with the followers of B. F. Skinner in the 1940s and 1950s. The same resignation perceived in Zola's works is just as prominent in such American coal novels as James Still's *River of Earth* (1940). At one point, Still allows one of his characters, Kell Haddix, to voice the fatalism that had been engineered in him and his fellow miners, real and fictional: "I'll kill my young'uns off before I'll let them crawl inside a mine hole. . . . Oh,

they'll be miners I reckon. My chaps and yours'll be miners. Brought up in the camps they got no chance. No chance earthy" (200–201).

Following the failed strike that he has instigated, Zola's protagonist, Etienne Lantier, like Kell Haddix, finds similar controlling forces at work and poses the disturbing question, "Was Darwin right, was the world nothing but a battlefield where the strong ate the weak for the beauty and survival of the species?" (521). The laudable rationale for his friends' actions proves little. True, the miners felt that their indignation and rebellion were justified, but in the end might does not mean right. The economic and social forces against which they take a stand prove to be the "fittest" and remain in control, and the miners are again forced underground.

The fatalism of Kell Haddix and the epiphanic reality of Etienne Lantier clearly illuminate the coal miners' forced acceptance of lives that are beyond their control to alter. Even when miners eventually are able to gain concessions from some coal companies, they most often still find themselves at the beck and call of another outside force, a workers' organization, which continues controlling the lives of its individual members. This poststrike, defeated life is found in Richard Llewellyn's *How Green Was My Valley* (1940). Like Zola in *Germinal* in France, Llewellyn finds in coal mining in his native Wales a suitable literary vehicle because the miners' plight about which he writes is to him and to many of his readers a reality. In *How Green Was My Valley*, Llewellyn presents a graphic, naturalistic portrait of life in a Welsh mining town replete with hardships and danger. On the surface, the narrative is the story of the lives of the villagers, particularly the Morgan Family, but on a deeper, more significant level it is another chapter in the history of coal mining.

Nonetheless, Huw, one of the Morgan sons, dreams of escaping the shadows of the coal mining in his hometown through an education and a resulting better life. However, he is constantly drawn home, each time witnessing the futility of the life his family lives. For instance, Llewellyn's miners, as do those of Zola, go on a twenty-two week strike for better working conditions but are forced to return to the coal pits for even more meager wages because, regardless of their good intentions, reality dictates that they care for their families. A close reading reveals that like their mining brothers in other countries, Llewellyn's workers exist in a world against which they are powerless to act. Their lives are regulated by economic determinants that grow into deeply engineered social practices that corral generations of such miners by the fatalistic attitudes that have been fashioned for them.

The plight of the characters in *How Green Was My Valley* gained an even wider audience with the multiple Academy Award–winning 1941 John Ford film version. In fact, the set for the film *How Green Was My Valley* was so realistic and carried such an emotional import that it was used for other movies which Twentieth-Century Fox set in such countries as Norway, Scotland, and

France, indicating a universality of situation and attitude of the working class depicted in the film (Halliwell 387).

English writers also wrote about the unrelenting entrapment of miners. In his Croydon-based narratives, D. H. Lawrence gives insight into the lives of those miners who stand up for their rights against the mining companies but who find their powerlessness reinforced by their failures. Lawrence adopts his life as the son of a Nottinghamshire miner as the impetus for several pieces of fiction, of special interest being the stories "Odour of Chrysanthemums" (1911), "The Miner at Home" (1912), "A Sick Collier" (1912), and "Strike Pay" (1912). Even though Lawrence's miners band together in unions in several instances, as individuals they live the same basic lives that they lived prior to their organization. Nothing changes even though they want it to. Instead of their economic well-being coming from the coal they dig, they now rely upon handouts that can be withheld at any time or for any reason by the groups which they, themselves, have created.

"A Sick Collier" tells the story of Willy and Lucy Horsepool. In the beginning, theirs is a happy story. They are newly married and have set up house-keeping in "Scargill Street, in a highly respectable six-roomed house which they had furnished between them" (75). Although Willy regularly comes home a tired, "short sturdy figure, with a face indescribably black and streaked" (76), they are able to have a relatively good life free from want. However, the workers are eventually forced into a strike that lasts for some fifteen weeks, and we are told, "They had been back just over a year when Willy had an accident in the mine, tearing his bladder" (78). While Willy is home recuperating, the miners go out on a more intense, nationwide strike. Willy can only watch the goings-on from his window.

As his pain increases, Willy's emotional and mental stability diminishes. After one extremely agonizing episode, Lucy expresses her fear: "Oh, I hope they haven't heard anything! If it gets about he's out of his mind, they'll stop his compensation" (82), indicating that even though his condition is the result of a work-related injury, both the company and the union will consider him expendable and will withdraw all support. Again, the survival of a miner is out of his own hands, a reality to which both Willy and Lucy have been conditioned by their witnessing past treatment of other miners.

More than just the physical realities of living in the coal town become apparent when Lucy notices early in the story that Willy brings a "faint indescribable odor of the pit in[to] the room, an odor of damp, exhausted air" (77), as if his body and soul exude a reminder of the control mining has over him, something that cannot be escaped or washed away. Lawrence uses this same technique of olfactory imaging in "Odour of Chrysanthemums" when he employs the clinging aroma of the title plant as a naturalistic "omen," which, like the aroma accompanying Willy, "exudes a cold, deathly smell" (Amon 99).

Authors of all ilks and inclinations find significant places for coal mining in their works. George Orwell, best known for his "Big Brother" portrait in *1984* (1949), centered his *The Road to Wigan Pier* (1937) upon coal mining. In this book Orwell is clearly moving from social observation to direct political writing. The "condition of England" is that many coal miners in the north are desperately unemployed. The unemployed miners are the most depressed of the working classes. Richard Hoggart in his introduction to an edition of the book talks about the paradoxes of Orwell's descriptions. He sometimes finds the English working classes to be physically repulsive, but he also feels great compassion for them. Hoggart writes, "He constantly drove himself into extreme and unpleasant situations and could describe them with exactness. One of the best passages in *Wigan Pier* is the description of the nature of work down in the mine. It is terribly hard and grimy work, and Orwell wanted his readers to know this. In the course of his description he says that he suddenly put his hand on 'a dreadful slimy thing among the coal dust.' . . . It is in fact a quid of chewed tobacco spat out of a miner's mouth" (Hoggart 6).

Although the idea of coal mining as a literary motif occurs often in European fiction, there seems to be a direct affinity between the coal-mining motif and American naturalistic fiction. This symbiosis comes perhaps from the conquer-the-land attitude held by many adventurous Americans. As mentioned earlier, mining is the most drastic means of garnering wealth from the earth because the resources are forced or raped away with nothing being returned, unlike in farming. So American naturalistic literature is fraught with works revolving around coal mining or with works that make more than mere obtuse references to this industry. In most cases, this mention involves the miner's hopeless, powerless existence.

Often the purpose of these works proves to be as much social as literary. For instance, the primary literary raison d'etre for Upton Sinclair was to bring industrial wrongs and worker maltreatment to public attention. Sinclair attacked almost every American industry, his best known being his exposé of the meatpacking industry in *The Jungle* (1906). In *The Jungle*, Sinclair shows that workers often are willing to put up with almost anything as long as some form of employment is available, placing their lives in the hands of those who control the jobs. Sinclair utilizes this same attitude in his attack upon the coal-mining industry in *King Coal* (1917). Here, too, the company owners play upon the economic necessities of the miners in order to keep a firm reign upon the workers. The novel was inspired by the 1913 Colorado mine workers' strike in which fourteen women and children were killed. His interesting postscript to the book discusses the intersections of artistic "truth" and politics in his writing. Clearly, his vision transcends the facts of one Colorado coal camp. The life portrayed in the novel is "the life that is lived to-day by hundreds of thousands of men, women and children in this 'land of the free'"

(417). Furthermore, the "poisonous" industrial power is "a deep, far-spreading root" that affects negatively industrial workers in West Virginia, Alabama, Illinois, Pennsylvania, and many other states (429).

Other American writers concerned with the existence in the American coalfields focus upon the debilitating lives the miners and their families lead and show that the economy is the clear tool for keeping the workers enslaved, harkening back to the question Etienne Lantier asks at the conclusion of *Germinal*. The coal companies are in the position to control all aspects of miners' lives from providing the only medical care to forcing the workers to shop at the company commissary. As James Goode writes in the preface to *Up from the Mines* (1993), "the very life of the camp depended upon the work schedules of the mining company, we heard the 'work whistle' blow every evening to signal whether the miners would report to work at six o'clock a.m. the next morning" (11). American country music also commented upon this situation when Tennessee Ernie Ford recorded the Merle Travis song "Sixteen Tons" in 1955 (Stambler and Landon 99; Green 294–317). In this song, Travis and Ford chronicle the complete economic indenture created by the company store.

As insidious as this economic stranglehold proves to be, many miners find hope in the mere idea of the company store and the coal camps. For instance, in James Still's *River of Earth,* Brack Baldridge voices the undying hope springing eternal in the minds of the miners. At one point he says, "Going to be good times in Blackjack. . . . I hear they're to pay nigh fifty cents an hour for coal loading. And they're building some new company homes. I got my word in for one" (175). Even earlier he discloses, "They put my name on the books, and I drawed these victuals out of the storehouse on credit" (70). In reality, the houses are just one step beyond the shacks recently vacated by the Baldridges, and the family can never get out of debt with the company store. There is no escape or hope for betterment. The miners are forced to meet the demands of the owners, now strengthened by the workers' having hocked their souls for food.

Just as there is no hope of escape, the miner has no hope of settling down in one place to raise his family. The coal quotas must be met. If the company for which the miner works decides to close up shop or if a particular miner is no longer needed, the miner must fend for himself, the only recourse being to move to another coal camp. In *River of Earth,* mother Alpha Baldridge bemoans the moving about that her family constantly suffers: "Forever moving yon and back, setting down nowhere for good, searching for God knows what. . . . So many places we've lived—the far side of one mine camp and next to the slag pile of another" (51–52). James Still further portrays this condition in his short story "The Moving" (1940) in which the young narrator laments yet another move but is "yearning to stay in this place where [he] was born" (98). Again the miners' survival is commensurate with the whims of the company.

Drastic measures such as blatantly and violently standing up against the companies and making demands for better lives were often necessities to change the miners' living conditions. In Pennsylvania's anthracite coal fields, a group calling itself the Mollie Maguires emerged. Ostensibly, the Mollies were formed to terrorize the mining companies into meeting the miners' demands and to frighten all miners into joining their cause. The Mollies came to the reading public in 1915 with the appearance of Arthur Conan Doyle's short novel The Valley of Fear in which he portrays the Mollies as merely a gang of thugs and which indicates that the crime under investigation finds its source in American labor (Cox 126–32). The group again rose to the artistic surface in the 1970 film *The Molly Maguires,* starring Sean Connery and Richard Harris and directed by Martin Ritt, but here much of the strength of the film rests upon its depiction of the untenable conditions of the lives of the miners and their families. An attempted infiltration of the group adds intrigue as demanded by the viewing audience.

In a like manner, the miners of the eastern Kentucky coalfields eventually found themselves forced to deal with a body with as strong a hold on their lives as the companies had when they banded together in their own versions of the Mollies, the miners' union, especially the United Mine Workers of America (UMWA). From the time these organizing efforts began in the coal fields, miners were caught up in a tug-of-war between the company and the union. If miners sided with the union, they would be thrown out of company housing and lose their jobs at best or killed by mine thugs at worst, much as in the 1920 massacre in neighboring Matewan, West Virginia, later chronicled in the 1986 John Sayles film *Matewan.* Just as surely, if the miner sided with the company, his fellow miners would take revenge against him. Again, the old damned-if-I-do-and-damned-if-I-don't fatalism reared its ugly head.

In the 1920s, the coalfields of Harlan County, Kentucky, were embroiled in a similar labor war between the miners who wanted union representation and the companies who did not want their miners to become a large, cohesive, independent-minded body. Gun battles raged and miners were killed. At one point, American author Theodore Dreiser came into the mountains, hoping to quicken the organization efforts. This area-wide unionization bid found its central place in mining lore and literature, and movement leaders assumed positions of high visibility. In *The Scapegoat* (1980), Mary Lee Settle tells the story of one such union proponent, Mother Jones, and the struggles she and her followers faced trying to organize the workers. Mother Jones appears again in Denise Giardina's *Storming Heaven* (1987), if only in passing.

Coal miners have often attempted to better their lots through organization, negotiation, and strike. However, when one looks at the coal-mining fiction, the unchanging conditions of the miners' lives are laid bare; they are caught up in a cyclical, predetermined life. Just as Zola and Llewellyn do,

other mining writers show that the individual usually returns to the scene of his hard life or at least hints that there is no escape from the drudgery of the mining life.

The closing scene of James Still's *River of Earth* leads the reader to view the lives of the Baldridges as one generation replacing another with few definite changes in their lives. Still's young narrator says, "I ran outside, and there were only wagon tracks to mark where death had come into our house and gone again. They were shriveled and dim under melting frost. I turned suddenly toward the house, listening. A baby was crying in the far room" (245). We are given no indication that life will change for this new Baldridge. In a like voice, James Goode says in "Piecing the Coal Quilt," "From darkness they come into the world / To toil in darkness / And to darkness will return" (10–12).

Writers of American literature were the most receptive to incursions into and inclusion of the subterranean, subhuman world of the coal fields. Vicki Covington, a writer from Birmingham, Alabama, builds upon that area's coal-mining industry in *Night Ride Home* (1992). Her work is usefully related to the ideas of the cultural critic Raymond Williams in the essay by Mary Roche Annas in this collection.

James Lee Burke, who has gained literary fame for his Cajun detective–bait-shop owner Dave Robicheaux, uses the bombing at a Kentucky coal mine for the narrative impetus in *To the Bright and Shining Sun* (1970) and makes reference to labor unrest in Texas in *Cimarron Rose* (1997). Robert E. Lee Pre-witt, from Harlan County, Kentucky, in James Jones's *From Here to Eternity* (1951), and Youngblood Hawke, in Herman Wouk's *Youngblood Hawke* (1962), must deal with their coalfield backgrounds as they look for escape in the military and in publishing respectively.

The two coal-mining novels of Denise Giardina—*Storming Heaven* and its companion *The Unquiet Earth* (1992)—go beyond the confines of their immediate geographical setting and speak out about the human condition as they tell the story of one of the most devastating periods in the history of Giardina's native West Virginia coalfields. But these novels do more than "reproduce scene and character accurately and objectively" (Ensor 2:630). In these works, Giardina attempts an explanation of the underlying events of the novels, both real and fictional, in light of their cause-effect nexus, moving the works from the sphere of realism into the sphere of naturalism.

Economic determinism holds sway over every other aspect of the lives of the characters in each novel. From the opening scenes of *Storming Heaven* to the closing moments of *The Unquiet Earth,* characters are thrown into battle against superior economic forces for their lives and their livelihoods. But in no instance are the individuals able to overcome the attitudes that pilot their every action and that grow from the world in which the individuals are forced to work.

The closing lines of "Night in the Coal Camps," by Kentucky novelist and poet James Still, could easily be adopted as a coda for any study of the significance of coal mining in literature because it speaks loudly for the situations described by writers such as Zola and Giardina and those in between:

Drawn Faces on pillows, mouths hollowed in breathing
The unquiet air; and the million-tongued night tremulous
With crickets' rasping thighs, with sharp cluckings
Of fowls under drafty floors. In the caverns deep
The picks strike into coal and slate. They do not sleep. (6–10)

Here, as in the works of others writing about coal mining, the miners must continue their lives deep in the dark mine shafts and in despair because they are controlled by outside forces. This reason, if no other, makes coal mining more than suitable to be called into service as a literary motif for the predestined lives that many writers envision for their characters and attempt to bring to the readers' notice in their fiction.

WORKS CONSULTED

Amon, Frank. "D. H. Lawrence and the Short Story." In *The Achievement of D. H. Lawrence*, edited by Frederick J. Hoffman and Harry T. Moore, 222–34. Norman: Univ. of Oklahoma Press, 1953. Rpt. in *Short Story Criticism: Excerpts from Criticism of Works of Short Fiction Writers*, vol. 4, edited by Thomas Votteler, 198–201. Detroit: Gale, 1990.
Burke, James Lee. *The Bright and Shining Sun*. New York: Scribner's, 1970.
———. *Cimarron Rose*. New York: Hyperion, 1997.
Caudill, Harry M. *Night Comes to the Cumberlands: A Biography of a Depressed Area*. Foreword by Stewart L. Udall. Boston: Atlantic-Little, Brown, 1962.
Covington, Vicki. *Night Ride Home*. New York: Simon and Schuster, 1992.
Cox, Don Richard. *Arthur Conan Doyle*. New York: Ungar, 1985.
Doyle, Arthur Conan. The Valley of Fear. New York: Doran, 1915.
Eller, Ronald. *Miners, Millhands, and Mountaineers: Industrialization of the Appalachian South, 1880–1930*. Knoxville: Univ. of Tennessee Press, 1982.
Ensor, Allison. "American Realism and the Case for Appalachian Literature." In *Appalachia Inside Out: A Sequel to "Voices from the Hills,"* edited by Robert J. Higgs, Ambrose Manning, and Jim Wayne Miller, vol. 2, 630–40. Knoxville: Univ. of Tennessee Press, 1985.
Ford, Tennessee Ernie. "Sixteen Tons." Capitol, EAP-693, 1955.
Giardina, Denise. *Storming Heaven*. 1987. New York: Ivy Books, 1994.
———. *The Unquiet Earth*. 1992. New York: Ivy Books, 1994.
Goode, James B. "Piecing the Coal Quilt." In *Up from the Mines*. Photographs by Malcolm Wilson. Ashland, Ky.: Jesse Stuart Foundation, 1993.

———. *Up from the Mines*. Photographs by Malcolm Wilson. Ashland, Ky.: Jesse Stuart Foundation, 1993.

Green, Archie. *Only a Miner: Studies in Recorded Coal-Mining Songs*. Urbana: Univ. of Illinois Press, 1972.

Halliwell, Leslie. *The Filmgoer's Companion*. 4th ed. New York: Hill and Wang, 1974.

Hoggart, Richard. Introduction to *The Road to Wigan Pier,* by George Orwell, 1–12. London: Heinemann, 1965.

How Green Was My Valley. Dir. John Ford. Twentieth-Century Fox, 1941.

Hunt, Morton. *The Story of Psychology*. New York: Doubleday, 1993.

Jones, James. *From Here to Eternity*. New York: Scribner's, 1951.

Lawrence, D. H. "A Sick Collier." In *Short Stories: An Anthology of the Shortest Stories,* edited by Irving Howe and Ilana Wiener Howe, 75–82. New York: Bantam, 1983.

Lethbridge, Richard. Introduction to *Germinal,* by Emile Zola, translated by Peter Collier, vii–xxvii. Oxford: Oxford Univ. Press, 1993.

Llewellyn, Richard. *How Green Was My Valley*. 1940. New York: Macmillan, 1979.

Matewan. Dir. John Sayles. Hallmark, 1986.

Molly Maguires. Dir. Martin Ritt. Paramount, 1970.

Orwell, George. *1984*. New York: Harcourt, 1949.

———. *The Road to Wigan Pier*. 1937. New York: Harbrace, 1972.

Settle, Mary Lee. *The Scapegoat*. 1980. Columbia: Univ. of South Carolina Press, 1996.

Sinclair, Upton. *The Jungle*. 1906. Afterword by Robert B. Downes. New York: New American Library, 1980.

———. *King Coal*. 1917. New York: Bantam, 1994.

Stambler, Irwin, and Grelun Landon. *Encyclopedia of Folk, Country, and Western Music*. New York: St. Martin's, 1969.

Still, James. "The Moving." *North Georgia Review* 5 (Winter 1940–1941): 18–20. Rpt. in *The Run for the Elbertas,* by James Still, foreword by Cleanth Brooks, 97–101. Lexington: Univ. Press of Kentucky, 1980.

———. "Night in the Coal Camps." In *The Wolfpen Poems,* by James Still, introduction by Jim Wayne Miller, 41. Berea: Berea College Press, 1986.

———. *River of Earth*. 1940. Foreword by Dean Cadle. Lexington: Univ. Press of Kentucky, 1978.

Taylor, Richard. "Determinism." *The Encyclopedia of Philosophy,* edited by Paul Edwards, vol. 2, 357–73. New York: MacMillan, 1967.

Wouk, Herman. *Youngblood Hawke*. 1962. New York: Signet, 1963.

Zola, Emile. *Germinal*. 1885. Translated by Peter Collier. Introduction by Robert Lethbridge. Oxford: Oxford Univ. Press, 1993.

14

Men Are That Way

THE SHORT STORIES

OF E. S. JOHNSON

Daiva Markelis

As the daughter of Lithuanian immigrants, as well as a researcher studying the literacy practices and oral traditions of turn-of-the-century immigrants, I have for some time been interested in representations of Eastern European immigrants, both as they are constructed in literature and expressed in the popular media. While reading a passage on the symbolic importance of clothes to immigrant women in a 1910 work called *Our Slavic Fellow Citizens,* by Emily Balch, I was intrigued by the following footnote: "This story ['The Wife from Vienna'] which appeared in the *Atlantic* of January, 1906, is one of several delightful sketches which Miss Johnson, of Pittston, has given us. Though they generally deal with Lithuanians, they reflect quite closely the atmosphere of Slavic life in a mining town. 'The Ticket for Ona,' 'Landless Men,' and 'Wocel's Daughter' appeared in the *Atlantic* of January, 1908, March, 1907, and June, 1906, respectively. 'The Younger Generation' appeared in the *American Magazine* for September 1906" (371).

I read E. S. Johnson's stories with interest. While they sometimes suffer from an excess of coincidences and an emphasis on what might be termed the romantic "trappings" of love, they are worth examining because of the portrait they present of everyday life in the turn-of-the-century coal-mining towns of northeastern Pennsylvania, a region that has played an important but relatively unrecognized role in United States history. With their strong sense of place, attention to detail, and "exotic" subject matter, Johnson's stories clearly belong to the tradition of regionalist or local-color writing, of which the *Atlantic Monthly* of the time was a major proponent.

The stories are worth unearthing for another, perhaps more important, reason: they focus on women, the wives and daughters of the immigrant

miners. Coal mining has been conceived of as a male enterprise in the public imagination, its heroes manly workers or equally manly reformers. This perception is to some extent an understandable one, since men were the primary victims of mining accidents and risked losing their jobs in labor uprisings. In the wake of the dramatic hardships that the miners experienced, it is easy to ignore the women, who "thanked God and the saints" ("Wocel" 804) when the ambulances passed by their homes.

Johnson's depictions of women caught between "Old World" conceptions of women's domestic roles and a growing awareness of expanding possibilities provide a counterpoint to the stereotypical images of Eastern and Central European immigrant women of the time as helpless, drab, and unenlightened.[1] The purpose of this essay is to introduce readers to E. S. Johnson by outlining the themes that were important to her: the physical and emotional strength of immigrant women in the small coal-mining towns of Pennsylvania, their reliance on clothing as both a means of Americanization and as a source of pleasure, and their ambivalent attitudes toward men and marriage.

In my search for information on E. S. Johnson, I explored several databases and consulted various anthologies of women writers of this period. I found nothing. As far as I know, these five stories constitute Johnson's complete literary output. Had I come upon them without having read Emily Balch's footnote, I would not have known, though I might have suspected, that Johnson was a woman. I ventured to guess what E. S. stood for. Esther Susan? Ellen Sara? Elena Stase?

Like her name, Johnson's ethnic background also remains a mystery. While Johnson isn't a Lithuanian or Slavic surname, the altering of immigrant names to more pronounceable "American" ones was so common as to achieve proverbial status.[2] Many a Lithuanian Jonaitis was transformed into a Johnson. In *That Man Donelaitis*, Margaret Seebach's novel about Lithuanian coal miners published in 1909, the last name of the hero, Andro Donelaitis, is changed by his Irish coworkers to the more ethnically acceptable Donnelly.

Whatever Johnson's heritage, it is clear that she was familiar with the details of the Lithuanian and Slavic coal miners' lives in the anthracite regions of Pennsylvania. This new wave of immigrants, settling in less populated areas such as Pittston, Shamokin, Luzerne County, and Mahanoy City, as well as in the larger cities of Scranton and Wilkes-Barre, was poorly equipped for life as miners. The great majority had been peasants who came to the United States when the disintegration of feudalism in the mid-nineteenth century resulted in high levels of unemployment throughout the Russian empire. The intense development of the Pennsylvania coal industry provided many job opportunities although the work itself was often of a sporadic nature. There was heavy recruitment of immigrant laborers, who often agreed to work for lower than standard wages (Fainhauz 49).

Johnson understood the troubled relationships that existed between the new immigrants and the region's more established residents, especially the Irish, who in previous generations had experienced much profound discrimination themselves and now looked down with belligerence upon "them for'ners" ("Wocel" 804). While this hostility was primarily economically motivated, it was exacerbated by cultural misunderstandings. We see a clear example of this in "Wocel's Daughter" when two Irish ambulance drivers deliver the body of Stefan Zatorski, whom they mistakenly believe to have died in a mining accident, to the Wocel residence where he had boarded. The drivers tell the landlord that the man is merely injured. Experience has shown them that the Lithuanian immigrants in the region, in contrast to other nationalities, will not allow a corpse to be waked in their homes. One driver tells the other, "They're scairt of a dead body. . . . It's the way with them ignern't people" (804).

What the Irishmen don't realize is that it is more a matter of economic necessity than superstition that dissuades the "for'ners" from taking in a dead countryman until burial. Eastern European immigrants often kept boarders, more so than other immigrant groups, with sometimes as many as ten men to a room (Fainhuaz 63). A corpse in such cramped quarters would have occasioned an exodus of tenants to other boarding houses, resulting in the loss of badly needed income to the family.

This incident illustrates more than just the antagonisms existing between two different ethnic groups; it reveals the clever and often effective ways that Eastern European immigrant women coped with the many hardships and disappointments that came with being the wives and daughters of miners. The cunning of the Irish drivers is turned against them when they confront Wocel's wife, Eliska, the boardinghouse mistress. At first she feigns ignorance of English, which the drivers suspect "she'd understand all right if she wanted to" (805). She then instructs a child standing nearby to tell the Irishmen that if Zatorski is merely injured, he should be taken to the hospital instead (804), a logical response but one that the frustrated drivers hadn't anticipated.

In addition to understanding the details and complexities of the lives of small-town Pennsylvania miners, Johnson was knowledgeable about the more obscure facets of European political history, such as the blurring of linguistic and cultural boundaries that typified the Eastern Europe of the time. In "The Ticket for Ona," Poul receives a letter from his sister Ona stating that she is not coming to the United States from Lithuania as planned but is instead marrying a German Pole who speaks Lithuanian. Ona writes that her fiancé "used to come smuggling" (113), a reference to the illegal carriage of books across the border from East Germany to Russian-occupied Lithuania, where literature written in the Latinate alphabet had been banned by Czar Nicholas II, who replaced it with Cyrillic as a means of Russification. We also

discover that Ona's previous letters had been scribed by a Lithuanian Jew. The Jews of this region, more highly literate than other ethnic groups, often helped to write letters for neighboring Poles, Lithuanians, and Russians (Greenbaum 46).

The majority of historical works dealing with coal mining in the United States focus mainly on working conditions or labor relations; the mundane, "feminine" realities of life get short shrift. We don't often hear, for example, that immigrant women in the Pennsylvania coal-mining towns maintained small gardens, growing vegetables and occasionally flowers, especially those native to their homelands. Among Lithuanians the rue was popular (Kucas 60). The gardens not only helped supplement the diet of miners and their families, they provided emotional sustenance as well, the soft, pliable soil a marked contrast to the hard earth of the mines. Women baked their own bread, suspicious of the white bread of the Americans (60). Fashionable clothes were a source of pleasure, an antidote to the ubiquitous black and grey "uniforms" of the women's husbands, brothers, and fathers. One of the women I interviewed for my literacy project talked about how her mother, a cleaning lady in a large coal-mining city, loved "fine things," especially nice hats. "She loved beautiful clothes when she could afford them," according to Irene McLeod. "They helped her forget the dreary reality of her life."

A major theme running through Johnson's stories is the importance of clothing to coal miners' wives and daughters. When Stefan Zatorski attempts to woo Annunziata Wocel, he leads her not to a secluded spot in the nearby forest, as was the custom with young *American* men (at least according to the narrator of the story), but to the principal fabric store in town. When Ketta Goroby, the "wife from Vienna," decides to leave her husband and return to her homeland, her American hat is the one object that she takes along—"a splendid creation, having lace, ostrich tips, flowers of several colors, and a moderate allowance of velvet ribbon" (21). Although she claims to miss the sophistication of life in Vienna and scorns all things American, including the measly vegetables ("Where is the kohlrabi?" she asks indignantly), and even leaves behind her American dresses, she cannot forgo her beloved chapeau.

A "love of soft fabrics and gay raiment" ("Ona" 109) can be read as a mark of superficiality, a concern for outward appearances at the expense of more "substantial" matters. Virginia Woolf's observation in *A Room of One's Own* of the dominant mind-set of her time comes to mind: "football and sport are 'important': the worship of fashion, and the buying of clothes 'trivial'" (77). When placed in the context of the traditionally male ethos of coal mining, this preoccupation with appearance may seem especially trivial; the harsh material world of the miners contrasts sharply with the soft fabric that makes up the lives of their daughters, wives, and girlfriends. In Johnson's stories, however, clothes are important not only because they bring such pleasure to the

MEN ARE THAT WAY

women, but also because of what they reveal to us about the cultural and social concerns of the time.

For Eastern and Central European women immigrants, clothing, especially the hat, symbolized something very different from what it represented for American women. Louise Montgomery, in her 1913 treatise on immigrant working women in the Stockyards of Chicago, describes the "exaggerated importance [placed] upon the possession of a fashionable hat" (59), which "brings girls of all classes and all nations to one level" (60). Indeed, for Ketta Goroby, who ultimately decides that life in the unfashionable United States is preferable to an existence as a Slovakian innkeeper's daughter in Vienna, the hat represents the blurring of European class distinctions. In Pittston there would have been no contradiction in the most fashionably dressed woman at church on Sunday washing cabbages on the front steps of her father's boardinghouse during the week, a situation we see in "Wocel's Daughter." In contrast, a working woman in Eastern or Central Europe wearing a fancy hat, indeed *any* hat, would have incurred the collective ridicule of the community. Balch quotes an aristocratic Slovakian woman referring to her former servant: "It can't be true, can it? She writes that she wears a hat. Of course even in America that is impossible" (97).

The hat is thus a particular sign of Americanization and, at least partly, of the loosening of both sexual and religious mores, especially when contrasted with the scarf that Catholic women wore to church in Europe, which, in Lithuania and parts of Poland, indicated that a woman was married and, therefore, no longer sexually available. The clergy exerted greater control in Eastern Europe than in the United States; the covering of the head at mass with a black scarf signified modesty and obedience and guaranteed that the priest, in his highly colorful, decorative vestments, remained the focus of attention. When Maria, the foolish young wife in *That Man Donelaitis*, has her hat pulled off her head by an angry crowd aware of her status as the wife of a scab, her greatest fear is that she will have to wear a babushka to church, as her mother-in-law has suggested she do. Maria responds angrily, "You do not wear one yourself no more, and you will not have me shame the family by coming like that!" (187). The hat is most clearly a sign of sexual sophistication and allure in the story "The Younger Generation." When Gracie Naktis accuses her older, more worldly husband, Casimir, or Cass as he is now called in Pennsylvania, of being unfaithful, it is the proprietress of the local milliner shop whom she suspects as his lover. Cass, who is unable to understand what he sees as his wife's unreasonable suspicion, asks:

> "Why wouldn't I go in a milliner store if I wanted to?" he demanded, visibly ruffled. "I ain't sayin' I did. But why wouldn't I take an interest in the styles, if I like?"

"A married man ain't got no business runnin' after—"
"Say it!" shouted the accused one. "Say it, I tell you. Say what you mean if you talk to me!"
"—Hats," concluded Gracie lamely. (468)

The word "hat," of course, is a symbolic replacement for the more familiar "skirt," with its overtly sexual connotations. As we read the story, it becomes clear that Cass is chasing neither skirts nor hats, that the alleged infidelity exists only in Gracie's imagination. We also understand, however, why she might feel threatened by and perhaps envious of the millineress. At the start of the story, we are presented with the image of Gracie frying up (and burning) a herring for breakfast. The remnants of a dress she is sewing for a customer lay unfinished at the sewing machine. The hat shop girl, in contrast, is an independent woman with her own business. She is described as thin, long-necked, and black-eyed (468). Her stylish appearance and "exotic" good looks (clearly non-Lithuanian) pose a threat to the short, blond, inexperienced Gracie.

While clothes in these stories represent pleasure and modernity, they also serve to symbolize custom and convention. The pull of the old—the persistent need for tradition—reveals itself in the importance of ritual; things are to be done the "proper" way. We see this, or rather hear this, in the chorus of female disapproval that greets Poul Zellak when it is discovered that he has no money to buy his intended the traditional wedding outfit—dress, wrappers, veil, shoes, and "nice white gloves" (109). The matrons of Carson's Hollow collectively dissuade Veronika from marrying Poul until he can provide her with the necessary wedding array.

Despite their concern for what might be considered surfaces, the Slavic and Lithuanian immigrant women in these stories are more practical and less romantic than the men, possessing a common sense borne out of necessity and hard experience. In "Landless Men," when Mrs. Mauditis tells her husband, Jonas Mauditis, "farmer by birth and huckster by his American profession" (335), that the police had paid a visit earlier in the day and adds, sarcastically, that *two* officers had shown up because it is two months' rent they are remiss in paying, he is unperturbed, remarking that in America the police "are of no account, harmless as rabbits" (336). He brings up a law which he believes guarantees that once his furniture is out of one house and in another, it belongs to him once again. "So you say," his wife answers, with a more realistic perception of the way things work in the New Country, as she continues to placidly prepare supper.

There is a general consensus among the women in these stories that trying to change men is not only fruitless, but unnatural as well, a tampering with the gendered nature of the universe. "Men are that way," Mrs. Mauditis

tells her daughter, implying that they will wait for a woman to make up her mind about marriage for only so long before moving on, in spite of the greater abundance of men ("Landless Men" 337).

When Poul attempts to convince Veronika that he will be a good husband with no vices, she replies that "a man has to do *something* that is wrong and wastes his money. . . . It is necessary. They all do. Else, see, they would be like women!" ("Ticket" 109). Poul himself agrees with Veronika's perception of who is the more practical one: "I suppose you can save my pay better than I can." "I have learned the American money, of course," answers Veronika, in the United States only seven months (108).

The immigrant men in these stories *do* change, however, though sometimes this is achieved through brute force on the part of the women, as we see in "Landless Men" when Jonas Mauditis' daughter, Antanina, no longer willing to accept her father's compulsive moving of the family from one location to another in order to avoid angry landlords, challenges the patriarchal order of the household by holding a gun up to her father, who immediately yields to her wishes. "Women with guns are so uncertain," he says forlornly (345).

More significant changes on the part of the men are brought about by less dramatic means than physical violence or its threat. The growing awareness of new social mores, *American* mores, including those concerning behavior toward women, works as a civilizing influence. In "The Wife from Vienna," when Ketta, frightened by her own bold move toward independence, suggests that she be punished by her husband, he answers, in a measured voice, that "it is not the American fashion" (23), a reply that Ketta is only somewhat relieved to hear. In "The Younger Generation," Gracie's husband, like Ketta's, acknowledges the temptation to discipline his wife but realizes that things are different in this new country; he is, in multiple and complex ways, a different person, a transformation reflected in his new name: "A Casimir Naktis of the old style—say his uncle or his grandfather, Russian born and bred—would have closed the incident with boots, the poker, and the broom-stick. But Cass Knight, who had grown up in America, passed a mine-foreman's examination, and voted for Roosevelt, was distinctly at a stand-still" (468).

In Lithuanian, the word "naktis" means "night," not "knight." Whether this is deliberate phonetic playfulness on Johnson's part or an oversight is difficult to determine. The word "knight" may well represent the ambivalent feelings that Gracie has toward her husband—he is both her champion and her tormentor. Her husband's self-control is viewed by Gracie in decidedly ambivalent terms. The explicitly stated desire for physical punishment on Gracie's part is intertwined with a sexual longing that Cass is unable or unwilling to fulfill. An undercurrent of sexual rage flows through Gracie, inciting her, at the end of the story, to hit her husband when he doesn't respond to her tentative sexual advances.

It is perhaps not surprising that two of the women in these five stories have such conflicted feelings toward the restrained behavior of their husbands. This period in history was one of immense cultural anxieties concerning women's expanding roles and opportunities, anxieties reflected in the local-color writing of the time, as Ammons and Rohy point out (xviii). For many immigrant women, the new choices and ways of life available to them must have been exhilarating, though they must have also engendered considerable fears of personal and cultural displacement.

As for Johnson's immigrant coal miners, although they are enlightened through repeated exposure to American mores, their knightly behavior has other sources as well. The relative scarcity of women in most immigrant groups of the period resulted in a greater choice of available partners, conferring on these immigrant women a status that white Protestant American women, for all of their societal and economic privileges, lacked (Weatherford 208). Immigrant men realized the nature of this marital supply-and-demand economics—their women could afford to be selective. The men in Johnson's stories generally act in a courtly manner, attending to the material needs and emotional concerns of the women, who often ignore their advances or take on deliberately cool, nonchalant personas. In "The Ticket for Ona," when Poul Zellak asks Veronika Boslas whether she is interested in marriage, she answers, "Oh, I suppose so. It would come sometime, and one day is much like another" (108). Her response when Poul inquires whether she likes him better than two previous suitors reflects a similar lack of enthusiasm: "Just as those two,—I like you just about as well!" (109).

Such ambivalent attitudes toward marriage were by no means rare. As Weatherford has shown, while most immigrant women of the time did marry, many did so reluctantly, fearing the loss of their newly found independence. Antimarriage views were rampant. Married women advised their single counterparts to avoid matrimony (46), and immigrant widows were more than content with their newly single status (45). Some women, of course, managed to maintain their independent spirits after marriage. One such woman was Anna Klikunas, the mother of Sister Cyrill Krasauskas, whom I interviewed for this project. She had been in charge of the workers on her family's farm in Lithuania when she was eleven years old and made the trip to the United States by herself at sixteen. According to her daughter, "When my mother married, she wore the pants in the family. My father said to her, 'Here's all the money, here's everything. You do everything. You buy everything.'"

The stories of E. S. Johnson belong to the growing body of literature by immigrant women, much of it previously neglected, such as Mary Antin's *The Promised Land*, which was excerpted in the *Atlantic Monthly* beginning in 1913, and the short stories of Anzia Yezierska. Both authors are currently enjoying a wider readership and continuing scholarly attention. These and

other recovered and newly popularized works, such as Hilda Satt Polacheck's *I Came a Stranger: Story of a Hull-House Girl*, deal with the *urban* immigrant experience. Literature about the experiences of immigrant women in rural and coal-mining regions is far less numerous, much of it waiting to be unearthed. In his work on Lithuanian coal miners in Pennsylvania, for example, David Fainhauz mentions in passing two works by immigrant women: Miliauskas's *Early America: Memories of a Coal Miner's Daughter* and Elisabeth Lankovskas-Polubinskas's *Experience and Life Story*. Some of this literature is written in languages other than English. Polish, Russian, and Slovakian newspapers flourished in the coal-mining regions of the East. Approximately fifty Lithuanian newspapers and periodicals were published in Pennsylvania between 1886 and 1955, most of them in cities and towns where mining was the major industry (Fainhauz 149). It is in one of these newspapers, *Vienybe Lietuvninku* (*Lithuanian Unity*), that the first Lithuanian woman writer was published, Liudvika Malinauskaite-Sliupiene, whose short stories, essays, and vignettes are not yet translated into English (Daugirdaite-Sruogiene 13). How many other unknown women, of all nationalities, have provided us with enlightening portraits of American immigrant life?

The work of uncovering women's writing, undertaken with much vigor by feminist scholars in the past three decades, is far from finished. By reading and critiquing previously unpublished or little-known diaries, letters, novels, stories, and autobiographies by women, especially working-class women, women of color, and immigrant women, we can expand our understanding of the rich diversity of women's experience in the United States and add to an inclusive, still-growing canon of women's literature.

NOTES

1. One example is found in Upton Sinclair's *The Jungle,* published in 1906, the same year as three of Johnson's stories. Ona Lukosaityte, the wife of the heroic Jurgis Rudkus, is presented as a weak, pale, and delicate being, "one of God's gentlest creatures" (6), unfit for work in this new country.

2. There traditionally has been some confusion concerning the term "Slavic." It refers not to a specific group of people residing in a particular geographical area, but to a number of languages belonging to the Indo-European family, including Polish, Czech, Serbo-Croatian, Bulgarian, Ukrainian, and Russian. In the United States during the years of peak immigration, speakers of Slavic languages were often collectively termed "Slavs." Lithuanian, often mistaken for a Slavic language, is a Baltic one.

WORKS CONSULTED

Ammons, Elizabeth, and Valerie Rohy, eds. *American Local Color Writing, 1880–1920.* New York: Penguin, 1998.

Balch, Emily Greene. *Our Slavic Fellow Citizens*. New York: Charities Publication Committee, 1910.

Daugirdaite-Sruogiene, Vanda. *Ausros Gadynes Dukra Egle*. Lithuanian Historical Review Series, vol. 8, bk. 2. Chicago: Lithuanian Research and Studies Center, 1985.

Fainhauz, David. *Lithuanians in the USA: Aspects of Ethnic Identity*. Translated by Algirdas Dumcius. Chicago: Lithuanian Library, 1991.

Greenbaum, Masha. *The Jews of Lithuania: A History of a Remarkable Community, 1316–1945*. Jerusalem: Gefen, 1995.

Johnson, E. S. "Landless Men." *Atlantic Monthly*, Mar. 1907, 335–45.

———. "The Ticket for Ona." *Atlantic Monthly*, Jan. 1908, 106–13.

———. "The Wife from Vienna." *Atlantic Monthly*, Jan. 1906, 17–25.

———. "Wocel's Daughter." *Atlantic Monthly*, June 1906, 797–808.

———. "The Younger Generation." *American Magazine*, Sept. 1906, 468–77.

Krasauskas, Sister Mary Cyrill. Personal Interview. 29 Apr. 1996.

Kucas, Antanas. *Amerikos Lietuviu istorija* (Lithuanians in the United States: A History). Boston: Lietuviu Enciklopedijos Leidykla, 1971.

McLeod, Irene. Personal Interview. 12 Jan. 1997.

Montgomery, Louise. *A Study of Chicago's Stockyards Community: The American Girl in the Stockyards District*. Chicago: Univ. of Chicago Press, 1913.

Seebach, Margaret R. *That Man Donelaitis: A Story of the Coal Regions*. Philadelphia: Lutheran Publication Society, 1909.

Sinclair, Upton. *The Jungle*. 1906. New York: Penguin, 1985.

Weatherford, Doris. *Foreign and Female: Immigrant Women in America, 1840–1930*. New York: Schocken Books, 1986.

Woolf, Virginia. *A Room of One's Own*. San Diego: Harcourt Brace Jovanovich, 1957.

15

Proletarian Disaster and Social Change

REPRESENTATIONS OF

RAYMOND WILLIAMS IN

VICKI COVINGTON'S

NIGHT RIDE HOME

Mary Roche Annas

It would be difficult to find a more valid authority to describe the relationship between power and cultural expression than Raymond Williams. Williams grew up in Abergavenny, a small town in Wales, where mining as existence was crucial to the whole community—an ever present sign of the fragile balance between landscape and livelihood. In his early essays, Williams describes the border between mining and learning as more fluid than fixed, since the working-class community of Wales respected formal education and guided its children firmly in that direction. In Williams's youth the two principal industries of Abergavenny were mines and railways, the first involving work that is fixed underground, and the second suggesting motion and escape.

In his autobiographical novel *Border Country*, Williams describes the edge where the land in Abergavenny gives way to a mountain "called Holy Mountain because of its history which included a burial ground and a chapel" as memorable for its "honey strong tang of bracken" (279). Fred Inglis writes that in his other life as an English academic, Williams claimed never to have dreamed of any landscape save this heavy, swampy, seeping Holy Mountain (16). Terry Eagleton, combining the images of mind and earth, describes Williams as "a countryman [who] labored at the centre of his intellectual plot of land" (qtd. in Inglis 306). Many critical and biographical texts on and by Williams skip quickly over description of his early days, not because these

scenes are inconsequential, but because the thread of original community and its relationship to social ideals continues so harmoniously throughout all Williams's prose and fiction. In his eclectic but thorough treatment of Williams's fiction, Tony Pickney goes so far as to attribute the idea of a "post-modern geography"—a reassessment of the interconnections between space and intellectual activity—to Williams (140). In his own writings on literature and culture, Williams consistently returned to socioeconomic class as a true marker of the relevance of art to culture. He harshly critiqued theorists who separated "high" and "low" art and relied on Marx's reassessment of ownership and property to describe working-class representation within art, which Williams claimed was often then appropriated by the capitalist hegemony for its own purposes.

Williams began his discussion of how culture and revolutionary activity relate in *Culture and Society* (1958). Here he articulated an argument for the integration and organic energy of a whole culture recognizing the contribution of each part. In *The Long Revolution* (1961), Williams critiqued the liberal response to equality in education and employment and continued his analysis of just how self-defeating a class-driven society can be in its attempt to offer a limited and restricted education to some of its citizens. It is only in *Culture* (1981), however, that Williams suggests that working-class culture develops self-protectively in response to repressive forces. He posits that, at a time of political repression, the subaltern culture goes underground and begins a protective period of energetic communication and teaching, which is unrecognized by the hegemonic power. Williams labels this cultivation and protection of energy the "informing spirit" of a civilization and goes on to say that when this energy is released in artistic expression it also represents true revolutionary activity.

A crucial connection exists between Williams's concept of explosive cultural expression and political activity. In a community that is oppressed economically and politically, a disaster that primarily affects the proletariat presents an opportunity for the members of that community to harness the energy that is released during cultural expression, and to use that energy to influence political change.

In *Night Ride Home,* Vicki Covington describes Bessemer, a small Alabama mining town, against this political backdrop. The individual neighborhood boundaries in this town suggest options of fight or flight: Sweetgum Flat, Warrior Road, and Uptown Camp, which encloses the mine superintendent's home. The novel spans the year 1939, the year World War II began. The story is centered on the collapse of a mine shaft, which has trapped several middle-aged men, in much the same way that the war is about to engulf the lives of the younger men. Superimposed upon the political polarization of the mine workers and the company bosses, are three love triangles, which threaten the

power balance as genuinely as do the war and the mine disaster. The shift of power in the novel occurs at the time of the mine collapse—the collapse of a coal shaft and consequently of a support wall—and represents a blending of cultural strength and political awareness in this community. The specific artistic and cultural activities of the townspeople reflect revolutionary activity in resistance to the company, which owns and mines the town. At first the reader is distracted by the three love triangles which cross class lines, but resolve along loyalty to a class consciousness transcending individual needs and privileging community needs. Nonetheless, these relationships serve to intensify the other changes in this society and to detail the class conflicts, which play out as the story develops.

Whenever there is a crisis of control between the economically powerful class and the working class in Bessemer, the struggle always resolves by displacement onto death or loss. In this way the whole town, including the company and its bosses, seems to grieve when it is actually the workers who sustain all the losses, both economic and personal. While death represents an intense moment of passion in the story, it replaces and defers emotion, which later reappears as direct political action. As a town, Bessemer has replayed the drama of a mine disaster over and over.

At these times of crisis, the townspeople seem to focus almost obsessively on cultural and artistic detail. In this way they embody Williams's idea of informing spirit and transmit a nurturing energy to each other. As Williams writes in *Culture*, the informing spirit "is manifest over the whole range of social activities, but is most evident in 'specifically cultural' activities [such as] styles of art, [and] intellectual work" (11). In the story, Tess Hayes is a Bible singer and the mother of the protagonist, Keller Hayes. Color and sound surround and follow Tess. Her voice is euphonic and spiritual as she sings. She gives an orange apron to the town "whore," Bolivia Ivey, who is pregnant with her son's child. Tess paints antique toys, which pastors and choir directors give her as payment for singing. These preachers cross religious and racial lines, so Tess, by virtue of her art, seems to be able to go with them where some other characters cannot. This mingling is seen as Tess follows them to a Catholic church to sing on Christmas Eve. Tess wears colorful clasps made from scraps of material in her hair, material that is left over from a quilt she is piecing together on her son's bed as he prepares to leave her home and marry. To her society Tess represents what Williams describes as part of a "system of generation and nurture," which holds a culture together (*Long Revolution* 136). Williams recognized the influence and importance of a proletarian contribution to national culture through material representation of what was sometimes patronizingly described as folk art—the art that Tess expresses. But in *Night Ride Home* the characters that are vehicles of cultural expression are not always positive or pleasant. Scotty Sandifer, Keller's father-in-law to be,

represents an unlikely political manifestation of this same informing spirit. When the mine shaft collapses, Scotty comes out of his haze of alcohol to help rescue the workers who are trapped, to patch up his damaged relationship with his daughter Laura, and to support Tess as she waits to hear if her husband, Ben Ray, is alive.

This moment of destruction gathers the working-class community together and necessitates its confrontation with the mine superintendent in his office. While the crossing of class lines during this emergency is short-lived, the realization by the workers that they have actually swung the power balance to themselves is evident: "Ranger Avery's office was now public property, it seemed. People were eating on the floor studying the maps on the wall as if touring a museum, idly browsing among various documents that lay next to the oak desk in a filing drawer" (177).

They also support each other by sharing an exotic array of food. They bring pecan, buttermilk, and chocolate pies, casseroles with hot red pepper, and tiny rolls stuffed with ham and sage. Covington's description of both the panoramic detail of the landscape and the specific and focused detail of the cuisine implies that both reflect enormous cultural power in the town and that artistic and political expression are profoundly linked. Her landscapes interweave industry and nature. Note how Covington achieves this mingling in the description of one of her characters: "She'd picked blackberries that day, and her fingers were stained purple. She was sitting on the porch with her cats underfoot, waiting for sunset to come before making a cobbler. The sulphur stench from where the scrap hill was burning in spontaneous combustion carried itself all over the hollow, seeping into her very being" (32). Each of these images intrudes on the previous one, and it is difficult to tell where one ends and the next begins. The unspoken certainty throughout this disaster, that some of the workers will be sacrificed to the mine comes, not out of atavistic resignation, but out of generations of experience with incidents of this type, which impose their own set of rules on the families. Scotty observes that he "didn't know protocol, but he knew that miners were supposed to lie in the face of disaster" (176).

Lying about love relationships does not protect the characters any better than lying about signs of morbidity and mortality during a disaster. Although the love triangles represent a secondary loop of the plot, they serve to show that social life in Bessemer is no easier than political life, since a society that is so rigidly class-divided cannot be stable for long. The first two love triangles—Keller, Laura, and Bolivia, and Keller, Bolivia, and Charles—are dependent on the characters' maturing and committing to their likely partners, but the third triangle—Tess, Scotty, and Ben Ray—presents the most subtle and complex interrelational shift of power. The energy generated here is not primarily erotic, although Tess has a sexual relationship with her husband

and is intrigued by Scotty's attention when Scotty befriends Tess as Ben Ray is trapped in the mine. When Ben Ray rises out of the ground alive, the fact that his right leg has been severed is almost forgotten in his family's joy to see him. The mine owners have not killed him outright, as they did Bolivia's and Scotty's fathers, just denied him participation in the only work that this society offers to a man.

As these characters enter the superintendent's office they bring political and erotic power with them as they confront the imminent threat of death and the possibility of yet another collapse. It is in this room that difference seems so insignificant, yet at the same time so circumscribed and intense. The people of the town are trapped here at the mercy of the mine owners, who have directly caused the collapse by not monitoring safety conditions. As Scotty and Charles go through old newspaper clippings that are kept as an archive of death in the office, they find reports of previous disasters: "In twenty-five, fifty-three killed. Fireboss had found gas in four places on Six right that morning, and these places were supposed to have been cleared before the men entered" (178). It is important to note that this town is not without knowledge of union organization and political pressure to insure safety concerns, and as the vigil continues and the workers wait, one miner reads aloud, "Convention in Detroit . . . John Lewis had called off the big strike last month" (30). In this way they reflect the political climate at the eve of World War II. Lewis had taken this action because the war was about to begin, and realizing that power always shifts to the proletariat during a time of war, had weighed the benefits and drawbacks and concluded that a strike at this time would harm national and local interests as well. Lewis was criticized for this action, and some saw the vote itself as privileging bourgeois interests over working-class ones. As they sit in the office and wait, the workers in this small town are aware of the complex nature of this issue. The imminent war distracts people from daily safety concerns in the mine, but when the collapse happens, the certainty of immediate death shifts attention away from the war. The people are distracted by their own local threat: "The neighborhood was particularly quiet, and Keller realized that everybody was either trapped in the mine, or praying" (118). The immediate proletarian disaster of the mine collapse is metonymic for the looming national disaster of war. The mine collapse postpones the war in a cultural sense because it forces the neighborhood of Sweetgum Flat to remain in the immediacy of its own life until the collapse is resolved. Some measure of political change becomes necessary before the ordinary lives of these people can resume. The people will ultimately demand safety changes, to which the company will concede, recognizing its own monetary loss when working-class lives are sacrificed. In a sense death, culture, and art, all unite the working class and separate it from the mining company, and the people flaunt their artistic expression to remind the company bosses of this separation.

The threat of death suspends time and the threat of war is deferred. When Keller arrives at the mine, desperate for news of his father, he "parked Charles' truck by the cemetery that lay just south of the mine area" (122). Thus the proximity of cemetery and mine becomes both a reality for burying bodies, and a trope for burying the safety violations which cause these deaths. Bolivia's baby is born, but dies because a doctor is not available. This particular death allows Laura and Keller to begin their life together relatively undisturbed. So the characters polarize around their families and the energy of political change is diffused again. Yet change as an uncontrollable construct of power still remains outside the story's focus. The sense of political power, which was realized in the mine collapse, dissipates as Keller leaves for New Orleans where he will join his army unit. In this way he distances himself from Laura and the proletarian culture he has left behind. He pictures himself one day as a "steel mill executive or a scientist or an engineer" (254). Nevertheless, in his imagination he sees himself returning to these cultural roots: "On Saturday nights, they'd ride home to Sweetgum Flat to see their parents" (254). Keller also sees himself as moving beyond this culture in a singular independent force, yet he adheres to what Williams describes as "the inextricable interrelationship between politics, art, economics, and family organization" (Garnham 124). While Keller is too young and unsophisticated to appreciate the worth of his own culture and class, he internalizes the strength that he takes from it. At a religious service before the soldiers leave for war, he "thought of his school buddies somewhere behind him, taking communion. Would they fire a weapon, sink a ship, love war, come home? He wasn't going to forget them. Or the miners, or the accident, or the baby" (243). *Night Ride Home* fractures and reestablishes circles within working-class culture, but recognizes the energy, which continues unbroken between culture and politics during a proletarian disaster.

It would, of course, be reductionistic to insist that all disasters are proletarian disasters. However, to suggest that the working class is usually more vulnerable to these disasters is reasonable, even from a conservative standpoint. There is an obvious tendency to fall back on oversimplified Marxist ideals when critiquing a novel with such strong working-class voices as the ones presented here. However, the act of separating dominant elements of class (such as economic power, exploitation of natural resources for profit, and perpetuation of oppressive social constructs) from residual elements of cultural consciousness in the art, history, music and craft of this particular society helps to point out the different emphases that Raymond Williams advocated. Williams recognized the value of working-class culture and its contribution to a national culture; he went so far as to say that the recognition of this value is essential to affecting social change. The foreshadowing of social change in *Night Ride Home* is as evident when Tess sings her Bible songs and

Bolivia gathers chokeberries and mint to mix medicine as it is when the families of the miners demand accountability for safety violations.

WORKS CONSULTED

Covington, Vicki. *Night Ride Home.* New York: Simon and Schuster, 1992.

Eagleton, Terry. *Raymond Williams.* Boston: Northeastern Univ. Press, 1989.

Garnham, Nicholas. "Raymond Williams, 1921–1988: A Cultural Analyst, a Distinctive Tradition." *Journal of Communication* (Autumn 1988): 123–31.

Inglis, Fred. *Raymond Williams.* London: Routledge, 1995.

Pinkney, Tony. *Raymond Williams.* Bridgend, Wales: Seren, 1991.

Williams, Raymond. *Border Country.* London: Hogarth, 1987.

———. *Culture.* London: Fontana, 1981.

———. *Culture and Society.* New York: Columbia Univ. Press, 1958.

———. *The Long Revolution.* Harmondsworth, Eng.: Penguin, 1965.

16

Out of the Dark
and into the Light

VIOLENCE AND VISION

IN JAMES LEE BURKE

Theresa R. Mooney

Self-discovery attained by rising above foolish, near fatal mistakes, redemption won after enduring a gauntlet of trials, and escape from a violent and limiting past to a potentially constructive future are the thematic hooks that propel James Lee Burke's 1970 coal-mining novel, *To the Bright and Shining Sun*. Burke's protagonist, sixteen-year-old Perry Woodson Hatfield James, initiates his journey toward self-discovery after helping a trio of locked-out, fellow miners (who are also his kinsmen) explode the tipple of a supposedly unoccupied mineshaft operated by scabs. Standing loyal to his relatives, Perry intends merely to fight back against the union-breaking callousness of the mine operators. With his kin, he plans to damage property—to hurt the mine owners financially in retaliation against their efforts to deprive the miners of union and of livelihood. However, the explosion inadvertently causes the death of a man in the shaft. By helping his kinsmen set the charge, Perry becomes caught up in the class warfare pitting union against owners, United Mine Workers (UMW) against coal-mine operators. Mirrored in this class conflict is Perry's struggle with himself. His own violent impulses, his fierce family loyalties, and his stubborn determination to do things his way, all conspire to trap him in a bleak existence that is as much a dead end as the exploded and sealed-off mineshaft.

Recognizing his need to pull free of these traps, Perry makes a preliminary escape to a Job Corps site in the Blue Ridge Mountains of North Carolina. There, he learns the skills of a heavy-equipment operator. Affirming his identity as a union man, he gets himself tattooed with a Confederate flag bearing

the words "United Mine Workers." Shortly before earning certification as an operator, however, he chooses to leave. Violence draws him back to eastern Kentucky when his father (a lung-damaged "happy pappy" long unable to work in the mines but still attending union meetings) gets injured in a retaliatory bombing against the UMW. Determined to find and punish the three strangers who set the bomb, Perry endures the death of his father and the "welfaring" of his family, as he searches. Then, when he finally locates the bomb setters, he stands, in an ironic partnering, alongside a circle of avengers that includes the trio of kin with whom he wired the tipple in the novel's opening scene. He is too late to prevent his kinsmen from chain-whipping the three bomb setters, but he does halt the vengeance before anyone gets killed. Perry's intervention marks his redemption; recognizing his father's death as a kind of expiation for the unintended death of the scab buried in the bombed mineshaft, he turns a gun on his own kin, so that the three bombers can run off safely. Freed of his own violent impulses and of his obligation to "avenge" his father's death, Perry escapes to his future. Stopping just long enough to let the town sheriff know where the three strangers are, he hops a freight train toward Cincinnati. With his newfound redemption and his job skills, he breaks free of the dark entrapment of the mining life.

As the protagonist of James Lee Burke's second novel, Perry James is a third-generation coal miner and a product of his environment. Primarily through Perry, whose thoughts and actions are conveyed sometimes in first person and sometimes in third, Burke brings to life the Cumberland Mountain area of Kentucky and the people who subsist there. Shifting between first and third person enables him to alternate action and reflection, and to vivify the mind-set of the region. Secondarily, in the pivotal sixth chapter, through the morphine-induced dreams of Perry's fatally injured father, Burke reaches back through the history of the region to replay the role of the UMW in the lives of the James family and the area workers. Through his primary and secondary focuses, Burke evinces a quiet respect for the common man, a love of the land, and a wary understanding of the high personal price of violence. Acknowledging the influence of naturalists such as Stephen Crane, William Faulkner, and John Steinbeck, Burke has avowed that a character is "an extension of his environment" (Ott 711) and that "environment is character" (*People* 4). However, because Burke's vision in this novel is redemptive, the character of young Perry James is far more than environmental product; fed by hopes and dreams greater than what the coal-mining life can support, he becomes what one reviewer has called "his own man in an unjust world" (Levin 33). In a complex technique that complements his shifting between first and third person, Burke sketches out Perry's independence and capacity for redemption in a series of dreams that punctuate the narrative at strategic points. In this novel, James Lee Burke's vision of the coal-mining life is naturalistic but not fatalistic.

Perry is not only a third-generation coal-miner but also a descendent of the Hatfields and the Jameses (a branch that included brothers Frank and Jesse). Two of the men he stands with as the novel begins, Big J. W. and Little J. W. Sudduth, are his cousins and are offspring of "a North Carolina moonshiner who was killed at the age of seventy-six in the dirt streets of Harlan while giving whiskey free to the miners when John L. Lewis first organized" there (Burke 1).[1] The third, Bee Hatfield, is Perry's uncle; in the forties, Bee "did two years in the Kentucky penitentiary for shooting a company deputy, and because he had refused to name [those] who shot three more company men in the same battle, he was made a business agent for the United Mine Workers when he was paroled" (Burke 3).[2] For these three, for the rest of Perry's family, and for most of the Cumberland Mountain folk who populate Burke's book, violence and the union are inextricably yoked. But Perry feels uncertain toward the act they are committing and also about his identity as a union man. Although he has been born to a world of violence, as he stands with his three kinsmen to set the charge that will blow the mine's tipple, he is "too afraid to care whether he worked union or not" (Burke 4). Even though he knows that "no James or Hatfield in his family had ever been afraid of operators, company thugs, strikebreakers with their axe handles, or even the National Guard" (Burke 4), Perry thinks to himself, "It ain't too late. . . . Run on down the road as far as you can get and it ain't a part of you any longer" (Burke 8). Despite his doubts, however, Perry helps ignite the fatal explosion. By acting in concert with his three kinsmen, he chains himself to the cycle of violence so long in motion for generations of miners; hobbled by his environment, he becomes a prisoner of his own deed as well.

Jobless, denied credit at the company store, and fearful of having his part in the mine explosion detected, Perry makes an effort to free himself by signing on with the Job Corps. Sent to the mountains of North Carolina to train with the Forest Service,[3] away from home for the first time, Perry muses in third person, "he was very far from the J. W.'s, the county sheriff, the man on the coal tipple, and the company men who would be around his father's cabin—and there was no way they could touch him now" (Burke 30). Mistakenly thinking he has extricated himself from his troubles, Perry fails to realize how his own potential for violence will trip him up and threaten to imprison him further. While in the Job Corps, he learns skills guaranteed to free him from the coal-mining life: how to operate heavy equipment, how to follow someone else's rules, how to read and write, how to practice patience, and how not to drink to excess. These skills are hard-earned; Perry acquires them partly by error rather than intent. He breaks some work rules, accepts the consequences of doing so, and eventually gets promoted to assistant leader of his crew. He gets drunk and tattooed, nearly going AWOL and risking expulsion from the corps. In a confrontation with Birl, another youth on his

crew, he maintains his patience and thereby avoids violence. Later that same day however he unwisely allows Birl to goad him into a fight; working himself into righteous indignation, Perry forgets that violence breeds violence. He readies himself for redress but gets blindsided by Birl, who strikes him over the head with a cue stick and injures him so severely he is hospitalized.

In the hospital, the first in the sequence of dreams through which novelist Burke projects his redemptive vision occurs. Perry dreams "of the man on the coal tipple, but this time he felt no guilt. The man looked like Birl, and the rage welled up inside Perry again. *They taken our jobs and credit away. . . . There wouldn't be no trouble if they let us alone. We didn't ask for nothing more than that. . . . He deserved what he got up there on the tipple. He'd a done it to us unless we got him first*" (65–66).

The dream enables Perry to begin to understand why he is so often violent; anger and retaliation are part of his response to injustice. His connection between the unjust accusations and unwarranted hostility of his fellow corpsman and the supposed behavior of the man killed in the mine explosion may seem like mere rationalization, a handy excuse for his enraged behavior. However, this dream is the first of several; taken together, they illustrate Perry's turning away from violence, away from darkness, and toward a more promising future. They show him growing away from the fatalistic, unthinking fury of the J. W.'s and his uncle Bee, and into an awareness of how to stand for justice rather than to retaliate against injustice. He is beginning to understand the cost of violence, to know that both "perpetrator and victim are dehumanized by it" (qtd. in Ross 2).

At this point, just when he is starting to understand the nature of violence and when he is about to be certified as a heavy-equipment operator, Perry leaves the Job Corps. Learning that his father has been severely injured by an explosion, he returns home. Family loyalty and the need to redress another injustice lure him back to mining country. As he prepares to leave the mountains of North Carolina, his mentor counsels him, "When this thing passes, give yourself a break and get out of those coal fields" (Burke 71), and a fellow corpsman suggests, "Don't go back to that mine bit. . . . Get that heavy equipment job in Cincinnati, and I'll meet you at the ball game one Sunday, and we'll crawl home on our elbows" (Burke 73). Perry foregoes these potential redemptions—escaping the mining life, obtaining a financially rewarding job, having the time and money for recreation—by allowing the violence instigated against his father to draw him back to Kentucky.

In the explosion that injures Perry's father, Woodson, some people are killed immediately, and the building in which the UMW meets is burned to the ground. Ten years earlier, Woodson had been buried in and then rescued from a collapsed shaft after gas accidentally exploded (Burke 16). This time, the explosion is intentional. This time, Woodson is again pinned underneath

exploded debris; rescued and hospitalized, he survives semicomatose for a week, with snippets of his past life unfurling in morphine-induced dreams that thread together Burke's pivotal chapter six. The devastating personal cost of violence is subtly but insistently underscored in Woodson's dying reveries.

Dreaming of his days as a young married man capable of earning a good livelihood with his farming and carpentering skills, his days of only occasionally doing mine work to supplement his income, his days before the Great Depression, Woodson recalls what life was like without violence (Burke 78). But then he dreams of the day he "killed two soldiers in a battle outside a shaft" (Burke 79). Initially exhilarated by his violent actions, after shooting down the soldiers, Woodson looks at his fellow miners and wonders "if his face looked as horrible as theirs" (Burke 80). Regretting his furious deed, he feels guilt and remorse, even though he thinks, "We didn't have no choice about what we done. . . . They gunned our men down on the picket and we give it back to them" (Burke 81). He understands at that moment how violence, especially as retaliation, demeans a man and makes him "horrible." Dreaming on, Woodson recalls the two days he was trapped "under a pile of rock in a Virginia coal mine" (Burke 85). On that second day, he had recognized the toll that violence exacts: "I figure I made a bargain for punishment when I dropped them two soldiers, and now the bargain's complete, and you got to let me walk out of here or let the rest of the shaft come down on me" (Burke 86–87). He understands that retaliation does not really repay injustice but actually deprives the avenger of far more.

Rallying from his semicoma and his dreams, Woodson urges Perry to extricate himself from the futile and expensive cycle of violence: "My daddy fought against them [mine owners], and I did, too, and it didn't do neither one of us any good. They ruined the land, they taken our homes, and they made good men take up guns to get back just part of what was theirs to begin with. I don't want no more of it for my children" (Burke 90). Certain that he is dying and unconvinced of Perry's feeble assurances that he can go back to the work camp any time he chooses, Woodson again warns Perry against revenge: "We never gunned down no man unless they pushed it on us, and we never shot no man out of revenge. There's been people shot all over these coal fields, and there ain't nobody that was ever better off for it" (Burke 91). This redemptive knowledge, illustrated in Woodson's fevered hospital dreams and voiced in his urgings to his son, boosts the nascent awareness that Perry obtains for himself in his own earlier dream.

However, despite this knowledge and awareness, young Perry James is unable to disengage himself from violence. The very day after Woodson dies, Perry's grief and anger temporarily obliterate his many hard-earned lessons. Set on revenge, he buys a gun; then, hoping to uncover information about the bombers he holds responsible for his father's death, he sits drinking with some

locked-out men just off the picket line. Drunk by midafternoon, he faces off against his own kin, the J. W.'s, thinking that they plan to take vengeance against the bombers before he can. Later that day, even drunker, Perry thinks, "His father had been wrong when he said that fighting the operator had never helped the miner. Violence in kind was the only thing the association understood" (Burke 111). By nightfall, his drunkenness leads him to vandalize the pawnshop where he bought his gun; arrested and jailed, he dreams in a nightmare about the explosion that killed Woodson, picturing the three bombers with "hideous, laughing faces" (Burke 117). This stuporous scenario is a bit briefer than Perry's earlier hospital dream and much shorter than Woodson's dying reveries. Although Perry's faculties are too dulled for him to register the lesson of this dream, it, too, underscores the futility of vengeance, the horror of how violence taunts and demeans.

Seeking to provide for his family, unable to get work in the mines, and unwilling to leave home until he has avenged Woodson's death, Perry runs a local moonshiner's whiskey up to Ohio. Armed with his new gun, he encounters a number of risks: aerial detection while transporting the whiskey by mule from still to car, speed traps on the blacktopped highway, an unmarked police vehicle tailgating him. However, he relies upon his wits—rather than the power of a gun—to overcome these threats. And, briefly, he considers something other than revenge. As he reaches the outskirts of Cincinnati, he contemplates potential redemption: "Someday he would live here, after he had taken care of everything back home. . . . He would get out of the coal fields, find a job that paid a living wage. . . . It would just take time" (Burke 141). After safely delivering the whiskey, while waiting at the bus station to ride home, Perry ponders staying on, getting work, and sending money to his family. If he did, "there would be no J. W.'s to worry about, no long evenings in the cabin while his mother stared blankly at the fire, and no more quiet hatred or that anticipation of sudden violence when he stood next to a scab or a company man on a street corner" (Burke 144). Presented with another opportunity to escape the mining life, Perry again foregoes his chance. He is not yet ready for escape and redemption; revenge calls him back again to Kentucky.

Unrested and exhausted as he walks the seven miles from his local bus depot to his home, Perry falls asleep on the roadside, dreaming once more of the man on the tipple. This time, he connects the man's terrifying death with the obscenely grinning faces of the three bombers who killed his father. In the dream, he repeatedly shoots the three with his pistol, but his bullets cannot stop their laughter (Burke 149). With greater emphasis than the dreams earlier in Burke's novel, this one highlights for Perry the absolute futility of violence. Not even expending every bullet in his gun has an effect on the three. Startled from this dream, he wakes and walks home, where he discovers that

his two younger brothers and sister are being taken away from his mother and into the welfare system. Despite his efforts on their behalf and despite his assurances to the welfare workers, he is unable to keep the family together. He watches helplessly as his siblings are carted off. Later that day, he buys a pint of whiskey, consumes it rapidly, expends all his gun shells in a drunken and impotent round of target practice that mimics the futility of his roadside dream, and passes out overnight in the mud.

A few weeks after this hopeless night, Perry's family is dispersed. His spirits seem to rise when the mine lockout finally ends. A National Labor Relations Board order opens the mines, and Perry and his kin are allowed to return to work. Pending elections, both union and nonunion workers are hired. The very first day the mines reopen, this volatile mix of former picketers and line breakers generates several confrontations. In one, when Big J. W. accuses a nonunion worker from Tennessee, "You been crossing picket lines three months getting strikebreaker wages," the man retorts, "We ain't no strikebreakers. I got people to support back home, and if I don't work they don't get nothing to eat" (Burke 166). Blinded by his violent nature and his distorted loyalty to the union, Big J. W. cannot see his common bond with this fellow worker. Hostility and anger also fuel another altercation; both of the J.W.'s continue to badger the nonunion men on the crew, and then the brothers face off against Perry in retaliation for his having stood up to them in the bar weeks earlier. Fortunately, the tension falls short of outright violence but at the end of that first day, Perry declares to his foreman, "You better fire me now . . . because I ain't taking no more from the likes of them. . . . The job don't pay enough to put up with them two all day" (Burke 172). In asserting that he is not willing to "put up" with the destructive fury of his kinsmen, Perry deliberately starts to separate himself from the cycle of violence that traps him. He reveals a clearer understanding of the nature of violence, the kind of awareness toward which his dreams have been pointing him.

However, Perry once again risks his hard-earned gains, when he gets drunk alongside his uncle Bee Hatfield as they celebrate the union's election victory. So drunken that he becomes hallucinatory, Perry imagines that the faces of the three Caudill brothers (men who work in the same mine as he does) are actually the brutal, grinning visages of the men who killed his father. Uncharacteristically, Bee acts wisely rather than violently; he protects Perry from the offended Caudills when they realize that he is bad-mouthing them: "I'm a-taking him out. His daddy got killed and it don't ever get off his mind. He just got too much of that bad Rachel whiskey tonight" (Burke 178). Bee's rescue of Perry foreshadows the boy's impending redemption of himself. However, the rescue and the celebration of the union's victory are short-lived. Two weeks after the union gets voted in, the seemingly defeated owners mechanize the mines by bringing in augur drills; as a result, the union itself ends

up discharging the workers from their newly resumed jobs and suspending their membership. In this ironic twist, the union victory becomes a defeat for the workers.

Set back yet another time, Perry is at his lowest when Bee Hatfield arrives one evening at the James cabin, to tell him that the three bombers have been found and are locked away in Big J. W.'s car trunk. Armed once again with his pistol, Perry rides with Bee out to the end of the holler; there in the darkness, encircled by the J. W.'s and some local men known to belong to the Klan, the three captives lie prone on the ground. They are so cruelly bloodied and chain whipped that "Perry wanted to turn his head aside after he had looked at them" (Burke 197). Standing in the brutish circle of avengers, listening to the J. W.'s issue threats and to the tormented men beg for mercy, Perry reaches a decision. Connecting the lessons taught him by his father, by his Job Corps experiences, by his own efforts, and by his dreams, he determines, "*Not like this*" (Burke 199). Realizing that his kinsmen expect him to kill the three men or, failing that, to murder them themselves, Perry takes a stand against the senseless violence. Instead of reacting unthinkingly against injustice as he has so many times before, he acts for justice. Understanding that his father's death was a kind of atonement for earlier vengeance, and recognizing that he can break the cycle of violence, he pulls his gun on the avengers and orders, "Let them go. . . . We ain't going to kill them. . . . I ain't going to do it. Nobody is" (Burke 200–201). When both J. W.'s refuse to back down, Perry cocks his pistol directly into their faces; even after they threaten and disown him, he stands firm in his purpose. He allows the captives to run off into the woods, gives them time to put distance between themselves and their tormentors, throws his kinsman's car keys too far to be recovered, and drives off in Bee Hatfield's vehicle, escaping the circle of avengers and the cycle of violence they represent. Leaving Bee's car by the courthouse, Perry stops to tell the sheriff where the three bombers are and to turn his pistol over; then he heads toward the railroad tracks and hops a freight toward Cincinnati. Rising thus from his lowest point, Perry reaches toward a brighter future: "He'd find a job somewhere, and on Sunday afternoons he would go to the ball games and drink beer and eat sausage at Crosley Field" (Burke 206–7). Paying, through his own trials, for the unintentional murder of the man on the tipple, Perry earns his escape.

Having learned that violence exacts too high a cost, he redeems himself from its vicious cycle; he acts, not in retaliation, not in response to injustice, but on behalf of those who cannot act to save themselves. His hard-won redemption "depends solely upon his own capacity for heroic action" (Clark and Clark 63). By the novel's end, Perry James recognizes a truth expressed elsewhere by author James Lee Burke: "violence is always a mark of fear and moral cowardice. All violence degrades, demeans, and dehumanizes. It makes a victim of the perpetrator as well. . . . Violence is the ultimate failure" (qtd.

in Schultz 3). Perry eventually manages to avoid this failure, to break free of the traps that ensnare him, and to move out of the dark and into the light, toward a "bright and shining sun."

NOTES

1. "Bloody Harlan" was the site of one of the many workers' battles whose "legendary stories . . . have been handed down in the oral history of mining families"; included among the others are Matewan in West Virginia and Ludlow in Colorado ("Brief" 1). Matewan plays an indirect part in this novel (as my second note details). The Ludlow Massacre of 1914 is briefly mentioned three times in Burke's 1998 Doubleday novel, *Sunset Limited* (153, 209, 308); these references are connected with a fictional union leader whose crucifixion underscores Burke's *Sunset Limited* plot.

2. The violent fictional history of Bee Hatfield echoes, to an extent, the recorded history of Sid Hatfield. In the 1920 skirmish at Matewan, West Virginia, in which twelve men were killed, Chief of Police Sid Hatfield shot down Albert Felts, the company deputy who acted on behalf of mine owners and against mine workers when he fired the first shot of the battle. Sid Hatfield was a hero to miners; he was himself shot down in 1921 by a gunman presumed to be avenging Felts's death ("Matewan" 1).

3. Prior to writing *To the Bright and Shining Sun,* James Lee Burke was a Job Corps teacher (Plummer 116) and worked for the Forest Service in the Daniel Boone National Forest of Kentucky (Stroby 39).

WORKS CONSULTED

"A Brief History of the UMWA." 10 Mar. 1997. <http://www.access.digex.net/miner/hist1.html>.

Burke, James Lee. *To the Bright and Shining Sun.* 1970. New York: Hyperion, 1989.

Clark, William B., and Charlene K. Clark. "James Lee Burke: '. . . always the first inning.'" In *Southern Writers at Century's End,* edited by Jeffrey J. Folks and James A. Perkins, 60–69. Lexington: Univ. Press of Kentucky, 1997.

Levin, Martin. "Reader's Report: *To the Bright and Shining Sun.*" *New York Times Book Review* (9 Aug. 1970): 33.

"Matewan." 10 Mar. 1997. <http://www.access.digex.net/miner/matewan.html>.

Ott, Bill. "James Lee Burke." *Booklist* (15 Dec. 1996): 711.

"*People* Online Hosts James Lee Burke (5/14/96)." 26 Mar. 1997. <http://pathfinder.com/people/interactive/burketrans2.html>.

Plummer, William. "Sober Perspective: James Lee Burke Savors Success Cautiously." *People Weekly,* 7 Oct. 1996, 115–17.

Ross, Nelson D. "James Lee Burke Is No Mystery." 15 July 1998. <http://www.yall.com/culture/quill/burke/>.

Schultz, Rick. "Mr. Showbiz Interview: James Lee Burke." 26 Mar. 1997. <http://web3.starwave.com/showbiz/flash/jpegged/archive/burke.html>.

Stroby, W. C. "Hanging Tough with James Lee Burke." *Writer's Digest* (Jan. 1993): 38–40.

17

Multinarratives and Multiculture in Appalachia

DENISE GIARDINA'S

STORMING HEAVEN AND THE

WEST VIRGINIA MINE WAR

OF 1920–1921

Clarence Wolfshohl

Several months after the explosion at Consol No. 9 in Farmington, West Virginia, I moved into Marion County.[1] The first excursion I made in that new environment was to the village of Farmington and the tipple of No. 9. I recall few details of the area from that first visit except for the gray granite monument to the seventy-eight miners in Farmington. However, I vividly recall winding my way out of Fairmont on the road to Farmington five miles away and noticing all the Italian and Slavic names on the business signs and mailboxes. West Virginia had always conjured up in my mind stereotypical visions of mountaineers with roots stretching back to Daniel Boone's crossing of the Cumberland Gap, so those names seemed alien. That drive to Farmington is symbolic in uniting the Italian and Slavic names, the sound of otherness, with the history of coal mining in West Virginia. With that experience began my education in the multiethnic work force of West Virginia mining; that education continues through history and through fiction in such works as Denise Giardina's *Storming Heaven* (1987).

Giardina's novel traces the conflict in the southern West Virginia coalfields that climaxed in the Battle of Blair Mountain in 1921. The novel weaves the fictional stories of four narrators into the history of Mingo and Logan County coal wars. For example, the historic Matewan (Mingo County) becomes the fictional Annadel (Justice County), and the historic figures of Chief of

Police Sid Hatfield, Mayor Testerman, and Ed Chambers become the novel's Isom Justice, C. J. Marcum, and Albion Freeman. Interestingly, the names of the two Felts brothers killed in the Matewan massacre are not changed in the novel. Despite the change in identities of most of the historical participants, the factual events are fairly accurate. However, I am concerned not with the novel's factual accuracy but with its exploration of different points of view. Giardina uses four narrators—five if we count the afterword written by Dillon Freeman, in which he explains how he compiled the stories of the other four narrators. The narration alternates unevenly among these four: Carrie Bishop narrates eleven chapters; Rondal Lloyd, six; C. J. Marcum, four; and Rosa Angelelli, four. Rosa's chapters are all short (two–three pages) and lyrical in their almost surreal manner. Because these four characters are from different classes, ethnicities, and genders, *Storming Heaven* is a rich multicultural rendering of the turmoil. The novel explores the designation of the other in an exploited region and work force.

Who is the other? In the case of the West Virginia coalfields, answering that question is complex. Those outside the native population, those foreign by some standard, may be considered the other. The novel begins when native West Virginians, like the Marcums, who settled in Justice County in 1801 and who followed the traditional culture, were just being introduced to the outside force of the capitalists who were to become the voice of authority. C. J. Marcum opens the novel's narration with the birth of Rondal Lloyd in 1890 and recalls his grandfather's reference to C. J.'s namesakes (Cincinnatus and Jefferson) as "farmers and freemen" (5), ideals of the native mountaineers in opposition to the "fat, smooth-faced men in black suits" (5), lawyers for the railroads that were buying the mineral rights. Inhabitants and owners of the land, the native West Virginians saw the capitalists and coal operators as the other. However, by 1900, according to David Alan Corbin, these latter, absentee landowners "owned 90 percent of Mingo, Logan, and Wayne counties and 60 percent of Boone and McDowell counties. By 1923 nonresidents of West Virginia owned more than half of the state and controlled four-fifths of its total value" (4). A division developed between owners and inhabitants, and power shifted from the native West Virginians to the coal operators so that the miners and even more so the mountaineers who lived by the old traditions became the other.

In the novel, resident West Virginians split into three groups, each perhaps alien to the others. One group is the miners, exploited and lumped into an antagonistic class by the operators. The narrator Rosa Angelelli, wife of an Italian miner and housekeeper for mine owner Lytton Davidson, reports Davidson's wife's judgment of the miners when Mrs. Davidson says to her husband: "Dirty. . . . How can you stand these people?" (68). A second group is the middle class, with a range of sympathies from pro-company to pro-miners.

Miles Bishop, narrator Carrie Bishop's brother, goes to college and becomes a mine supervisor for Davidson. On the other hand, C. J. Marcum is mayor of Annadel but runs a socialist newspaper and sympathizes with the miners. However, he becomes an outsider to both parties. He is forbidden to visit the Lloyd family in the company-owned miners' quarters because "the company did not like outsiders to be such regular visitors" (20). And later Rondal explains C. J.'s lack of influence with the miners: "he was an outsider because he didn't share their life. He was a businessman; he had money" (73). The smallest and perhaps most alien group is the mountaineers who retreated into or tried to maintain the old culture. Traditionally, the mountaineers farmed and hunted; ginseng and lumber were the bases for any market economy. Corbin reports that the railroads and mines drove the game away and that farms dwindled from an average of 187 acres in 1880 to 47–76 acres in 1930 (7). Dillon Lloyd, Rondal's uncle and C. J. Marcum's boyhood friend, is the specter of the lost culture, appearing for brief moments and then vanishing into the hills, "living the old way" (72).

Giardina focuses on the miners, since the four narrators are connected with them. Rondal Lloyd's father is forced to become a miner because he loses his land, and Rondal becomes a union organizer. Carrie Bishop is from Kentucky, outside the coalfields at the time, but is a nurse in a coal town. She marries Albion Freeman, who is a preacher-miner, and after Albion's death and because of her love for Rondal, she takes part in the Battle of Blair Mountain as a nurse to the union. I have already mentioned C. J. Marcum's and Rosa Angelelli's link to the miners. However, Rosa as a narrator suggests another complexity about designating the other in the turmoil.

Giardina's miners are not just displaced West Virginians, but a multicultural work force. Although Rosa is the only narrator from a nonmountaineer background, the novel affirms the demographic facts of the mine workers. In his study of the ethnic mix of West Virginia miners, Joe William Trotter, Jr., reproduces tables compiled by the West Virginia Bureau of Mines for the race and ethnicity of miners from 1915 to 1929. In 1915, 48.9 percent of the labor force in southern West Virginia were American-born whites, 31 percent were foreign-born whites (mainly Italians and Slavs), and 20 percent were blacks (69). By 1919, the percentages had changed a bit, with foreign-born whites declining to 19.7 percent compared to 55.5 percent American-born whites and 24.7 percent blacks (69).[2] The percentage of foreign-born whites was even greater throughout the entire state. Priscilla Long claims that "after 1900, more and more new immigrants set their sights on the Mountain State, eventually making up half the work force" (126–27). Whatever the actual numbers, not only was the whole mining labor force the other to the mine operators and to most of the established middle class, but the force was itself divided into disparate groups.

Storming Heaven puts us in the middle of the heterogeneous mixture. Emblematic of the mixture is Carrie's description of the coal camp where she has her first nursing position as being "divided into little colonies—Negroes in board and batten shacks down in Colored Bottom, mountain people in squat four-room houses on Tipple Hill, Hungarians in tall thin double houses up Hunkie Holler" (90). Although no African Americans narrate, one of the main characters is Doc Booker (Toussaint L'Ouverture Booker), "the colored doctor" (52) as C. J. Marcum says. Doc reveals the relation between the races to Carrie Bishop. After C. J. dies and even though he and C. J. had been friends, he says, "They's only so far you can go, being friends with a white man. I know that. They's always things a Negro can't say or do, else he'll risk losing that friendship. Now, I'm not married. Suppose, just suppose, that I thought Violet Marcum [C. J.'s widow] was the finest woman in the world, and her a widow lady, needing a husband. Suppose—just suppose now—I took a notion to court her. Me, her dead husband's best friend, a respected doctor, the former mayor. What would Isom Justice say to that, and Violet his mama's cousin? I ain't even sure how C. J. would have took to it" (210). Overcoming this separation among the various groups of miners is one of Giardina's important themes.

Giardina presents Rondal's developing relationship with the non-American whites among the miners. Early in his first narration, he recalls his family's walking past the mining camp's black quarters. He remembers that "the colored people watched us silently from their stoops. Mommy always walked with her head down, never speaking, for she didn't like the colored people" (14). Rondal also remembers being in school with Italian children, studying them and their differences. When Rondal first begins organizing for the union, he is caught by the company guards and forced to watch them throw another organizer, a black man, into a furnace. Finally, Rondal's and Rosa's narratives come together when he saves her from Davidson's burning house and she confuses him for her dead son, and the border between the disparate groups is blurred, if not erased.

Maintaining the border benefitted the coal companies. The multicultural work force historically gave the coal operators the emotional tool of prejudice it wanted to counter the union, the ultimate other for capitalistic America. Priscilla Long states that the operators who brought in foreign workers to end strikes blamed the striking miners and union for bringing "these swarthy foreigners among us" (114). The unions, of course, were linked to socialism and communism. In the novel, Carrie quotes from an editorial in the *Justice Clarion,* condemning the union for trying "to advance its un-American and, ultimately, doomed goals" (212). Shortly thereafter, she confronts her brother Miles when she is trying to get treatment for a frostbitten Hungarian girl, one of the striking miners' children. When Miles snaps at her because of her

brusque response to his inquiries, she explodes sarcastically, "No. I don[']t talk civil no more. I don[']t act civil. I'm a troublemaking red agitator out to tear down civilization and that's what I act like these days" (212).

The miners even resisted the union for a long time. According to Long, the immigrant miners did not plan to stay and mine for their whole lives; thus, many issues such as the nine-hour day were of no concern since the immigrants simply wanted to make as much money as quickly as possible to return home or to bring their families to America (162). In fact, claims Long, "the mountaineers of West Virginia also earned a reputation for resisting the overtures of organizers. They too had a deep, pre–coal-mining connection with their region, and for them mining provided more cash than they had ever seen in the backwoods" (162–63). Corbin quotes an article in the *United Mine Workers Journal,* in which the very miners that the union wished to organize are looked on as alien by the union: "We have often wondered what kind of animals they have digging coal in West Virginia . . . , and have never been able to successfully solve the puzzle. Their ignorance must be more dense, their prejudice more bitter and their blindness more intense than that of any other body of miners we have ever heard of" (25).

Giardina portrays some of that resistance and frustration, but the difficulty comes mainly from the hazardous conditions for union organizers and sympathizers in a world of company thugs and Baldwin-Felts guards. When Rondal tries to organize the Davidson miners, the gun thugs force him to witness the murder of Johnson, the black organizer, as a threat. And despite acknowledgment of racial and ethnic prejudice, such as Rondal's mother's dislike of blacks and Doc Booker's revelation to Carrie about black-white relations even among friends, Giardina portrays the characters struggling with their ignorance and biases.

Individual characters attempt to narrow the range of the other by realizing their commonality in their cause. Early in his first narration, Rondal wonders who *his* people are. C. J. and his teacher talk to him about *his* people, and he says, "I wasn't sure who 'my people' were. Were they my kin, most of them scattered when the land was lost? Were they the old-timers who had been around before the companies came in? What of the Italians and the Poles and the Hungarians and the Negroes, hauled in by the trainload to dig the coal? Were they my people too?" (18). As a child, Carrie is fascinated by geography and "all them outlandish ways folks do" (33). Rondal and Carrie also come to similar realizations about the commonality of all people: Rondal when he sees Johnson thrown into the furnace, and Carrie when the first person whom she ever sees die is a black girl.

Besides the struggles of these individuals, several of the emphatic episodes in *Storming Heaven* bring the various groups of miners together in unity. Although the union movement was not bias free, Trotter states that "in their

violent confrontation with capital, black and white miners developed mutual loyalties, and sometimes their commitment to each other was demonstrated in dramatic ways" (112). The Battle of Blair Mountain is the climactic episode in the novel. Several thousand miners tried to cross Blair Mountain, the natural obstacle dividing Logan County from Boone County and Charleston, the state capital to the north. The expedition was an attempt to wrest control of Logan from Sheriff Don Chafin and the company thugs. This was the ultimate confrontation of miners and establishment. The federal government sent not only 2,000 troops commanded by General Bandholtz (Lee 101) but also the Eighty-eighth Air Squadron (Giardina 259) to aid the operators' large army that controlled the mountain. The miners' army is a multiethnic force, which Carrie describes as follows: "Most were clad in overalls, but some wore faded military uniforms. Each man sported a red bandana tied jauntily about his neck. Some were already armed. One group of rawboned mountain men carried long rifles that Rondal said dated back to the Revolutionary War, and I even saw a Greek with a curved sword. A Ukrainian man wore a faded painting of St. Vladimir on his back, sewn there by his wife as a talisman of good luck. Welshmen, camped along the railroad track, sang of building Jerusalem among dark satanic mills" (251). When a restaurant owner in Danville tries to refuse service to the African Americans in one group of marchers, the miners force him to serve them. As one miner says, "We're all rednecks!" (256). And when Frank Keeney (the actual name of the leader of UMWA, District 17) tries to turn back the miners, Italian miners begin to sing a militant song and assert their desire for freedom (260).

An earlier episode adds another dimension to the novel's multicultural point of view. Two of the narrators are women, Carrie Bishop and Rosa Angelelli; therefore, the multiculturalism is not only ethnic and racial, but also gender related. Before the miners unite to storm, albeit unsuccessfully, Blair Mountain, the wives of the encamped striking miners raid Felco in anger and frustration. The event begins when a black boy dies in the camp. His mother gathers a force of four hundred women—"all of them carrying iron skillets, broom handles, axes, hoes" (217). In the group are Italian women in "black lace hairnets over tightly wrapped buns" (217), other African American women, and hillbilly women. They loot the company store in Felco, taking food and guns, even turning back some company men by firing a machine gun at them. Although Giardina narrates the episode with little exposition, we sense the women's motherly frustration and anger as the cause of their actions.

Giardina's presentation of women from the mining class as well as her multicultural narration is unique among American coal-mining novels. In a survey of the American coal-mining novel from 1876 to 1981 (published in 1988), Stephane Elise Booth concludes that most of the novels were written in ignorance of the actual life of the miners, generally from the reigning

middle-class attitude of the era. She poses the question of how realistically the novels portray the American coal miner and answers it with, "They were most successful in portraying the emotional state of the country toward the worker . . . during each of the time periods examined" (136). Specifically about mining-class women, Booth asserts that "most authors simply ignored situations in which women were very active. . . . Even novelists after 1945 offered a stereotyped presentation of woman's role as mine owner's daughter or wife" (137). Giardina's two female narrators cast aside the stereotype.

Rosa Angelelli is unique among the narrators since she is not a native Appalachian. As an immigrant and worker, she could have been simply Giardina's strategy to show us the physical reality of the life of that group of the mining class as the other narrators do of the Appalachian disinherited. However, the author chose to use a semi–stream-of-consciousness technique for Rosa's narration. From her first chapter of narration, Rosa seems traumatized; she remembers a childhood experience with butterflies in Sicily as she dusts the butterfly cases for Senore Davidson. She also reveals the reason for her being in West Virginia: "Mario [her husband] brings me here. And Papa. Mario comes to West Virginia to dig the coal and be rich. I don't want to go. I don't know Mario very well. Papa says go. I have eight children, he says. How can I feed them all? You are the oldest. You go and send back money. How else can a woman help?" (49–50). From this start, she continues to reveal her isolation in her personal and public lives. Although the priest comes to her house, she cannot talk with him since he is Irish and speaks no Italian. In the streets, she is shunned by the other women, perhaps because she wears a red skirt. She is verbally abused by the American-born children, who cry "Dago, Dago" (50) after her. And Mario hits her for drinking some wine to combat the cold. Both physically and emotionally, Rosa is living in a strange landscape.

And the situation becomes worse when her four sons are killed in an explosion and her husband runs off. Her last narration mixes her delusions with the violence of the striking miners as they burn Davidson's house. She thinks that Davidson, who has fled to Philadelphia to escape the violence, has gone to the hospital to look after two of her sons (who are already dead). She believes that Rondal, who is there to torch the house, is her son Francesco, and once more her attention turns to the butterflies. "The butterflies weep. Let us out, they cry. The glass case is so hot. Mama tugs at my sleeve. Break the glass, she says. Let them go. They have been here so long. I break the glass. I hit with the lamp. The butterflies scream. They are so frightened, but I whisper to them and they are quiet. I cannot carry them all but Francesco helps. We must hurry, he says. When the butterflies are gone this house must burn" (196). In the afterword supposedly written in 1987 by Dillon Freeman, the son of Carrie and Rondal, we learn that Rosa lived the rest of her life in the state hospital.

Although a native of the hills, Carrie Bishop becomes as much an outsider as Rosa. Born in Kentucky before it became coal country, she leaves her home to become a nurse; marries Albion Freeman, who returns to his native West Virginia to preach to the miners; and is outlawed by her love for Rondal Lloyd and her nursing of the miners at Blair Mountain. In fact, although very much at home at the Homeplace and very much loved by her family, Carrie is a natural outsider. Fascinated with *Wuthering Heights* when a girl, she thinks of marrying a Heathcliff who "would come from the outside" because no local boy would marry her since she was "too forward" and "too stubborn" (30). A resourceful and independent mountaineer, Carrie survives the harsh conditions of the mining camps and then the strikers' tent camp. She witnesses the murder of Albion by Baldwin-Felts guards and the defeat of the miners at Blair Mountain. Then she bravely sneaks the wounded Rondal through Logan and Mingo Counties back to the Homeplace.

But as the clarity of Rosa's otherness becomes hazy when she confuses Rondal for her dead son Francesco and when he acts as her son later as he puts her on the train to the Miner's State Hospital, Carrie's outsider status is only in the minds of the establishment controlled politically and economically by the coal interests. Her voice becomes the voice of the miners and perhaps all of exploited Appalachia when she reacts to one of the New York reporters who help her smuggle Rondal off Blair Mountain to Logan. When the male reporter says, "This is a hell of a place you've got here," referring to the violence and mayhem, she snaps back a question that implicates the press as the voice of American middle-class attitude, "Who made it that way?" (282).

I cannot remember much about the television coverage of the explosion at Consol No. 9, but I recently went back to the print reports. In an era when O. J. Simpson's case remains front-page news for over a year or the unsolved murder of one six-year-old girl from an affluent Colorado family is reported almost to obsession, the few paragraphs about Consol No. 9 tucked among the other national coverage of *Time* and *Newsweek* seem a journalistic slight. The reports seem condescendingly sympathetic—the miners and their families are still the other in those paragraphs as if the reporters are those whom Carrie Bishop challenges. But for Carrie, the New York reporters and the authorized America they give voice to are the other. Denise Giardina's *Storming Heaven* forces us to consider whom we designate the other and to recognize what we have in common.

NOTES

1. The Consolidated Coal Co.'s No. 9 (Consol No. 9, Farmington, W.Va.) mining disaster occurred in late November 1968. Seventy-eight miners died in the accident, making it the worst mining disaster since the 1951 explosion at West Frankfort, Ill.,

which killed 119 men. The worst disaster in United States mining history is the 1907 Monogah, W.Va., explosion that killed 361. Monogah is about ten miles from Farmington, both in Marion County, W.Va.

2. The statistics for Mingo and Logan Counties differ from the total percentages for all of southern West Virginia. In Mingo County, American-born whites increased from 61.8 percent (1915) to 68.2 percent (1919), blacks increased from 9.4 percent to 15.4 percent, and foreign-born whites decreased from 28.7 percent to 16.4 percent. In Logan County, American-born whites increased 51.6 percent to 57.3 percent, blacks increased 7.9 percent to 17 percent, and foreign-born whites decreased 40 percent to 25.6 percent (Trotter 70–71).

WORKS CONSULTED

Booth, Stephane Elise. "The American Coal Mining Novel: A Century of Development." *Illinois Historical Journal* 81, no. 2 (Summer 1988): 125–40.

Corbin, David Alan. *Life, Work, and Rebellion in the Coal Fields: The Southern West Virginia Miners, 1880–1922.* Urbana: Univ. of Illinois Press, 1981.

Giardina, Denise. *Storming Heaven.* New York: Ivy Books, 1988.

Lee, Howard B. *Bloodletting in Appalachia: The Story of West Virginia's Four Major Mine Wars and Other Thrilling Incidents of Its Coal Fields.* Morgantown: West Virginia Univ. Press, 1969.

Long, Priscilla. *Where the Sun Never Shines: A History of America's Bloody Coal Industry.* New York: Paragon House, 1989.

Trotter, Joe William, Jr. *Coal, Class, and Color: Blacks in Southern West Virginia, 1915–32.* Urbana: Univ. of Illinois Press, 1990.

18

The Many Autobiographies of a Coal Miner's Daughter

Alessandro Portelli

When I state myself as the Representative of the Verse—it does not mean—
but a supposed person

Emily Dickinson.

There is a scene in Robert Altman's *Nashville* in which a lady singer with long
wavy black hair steps on a stage at Opryland, Nashville's new home of coun-
try music, sings a song and then, as the band starts vamping for the next num-
ber, breaks into a rambling speech, which soon turns into a loose reminiscence
of childhood: "I think there's a storm a-brewing. That's what my granddaddy
used to say before he lost his hearin' and sometimes he'd say, 'Oh gosh,' or
'Durn it,' or 'My word.' . . . My granny, she'd go around the house clickin' her
false teeth to the radio all day. She was a lot of fun and always cooked my
favorite roast beef and she was a sweetheart. She raised chickens, too. She,
uh—in fact, did ya ever hear a chicken sound?" (Tewkesbury 24).

This scene is a dramatized and fictionalized account of the most famous
crack-up in country-music history: that of Loretta Lynn in the early 1970s. An
authorized version of the same episode appears in a later film, Michael Apted's
Coal Miner's Daughter, based on Loretta Lynn's autobiographical book by the
same title. The episode, however, is not discussed in the book. Both films con-
cur in showing the breakdown as an eruption of private memories: a compul-
sive autobiographical act.

The book takes its title, in turn, from Loretta Lynn's best and most suc-
cessful song, "Coal Miner's Daughter." The song appears at first hearing as
another autobiographical act, containing many features of Lynn's later descrip-
tions of her own life: the sentimental cliche ("We were poor but we had love"),
the precise description of background details, the relish in the sound of

vernacular speech. In her book, Lynn says: "I'd always wanted to write a song about growing up, but I never believed anybody would care about it. One day I was sitting around the television studio at WSIX, waiting to rehearse a show. . . . I went off to the dressing room and just wrote the first words that came into my head. It started: 'Well, I was borned a coal miner's daughter . . .' which was nothing but the truth" (Lynn 159).

Before we go on to examine her autobiographies, let us take a quick look at Loretta Lynn's life. In truth, Loretta Lynn was at various times a coal miner's daughter and a coal miner's wife. Both her father, Melvin (Ted) Webb and her husband, Doolittle (Mooney) Lynn worked for various lengths of time for the Consolidated Coal Mining Company in Van Lear, Kentucky. During Loretta's earliest years, her father worked as a farmer. He also worked in the 1930s on road repairs with the WPA program of the federal government. During and after World War II (in the 1940s)—a decade that also saw an increase in the number of Loretta's siblings—the family's chief breadwinner was forced to find more income by working in underground mine work.

Although Loretta Lynn in her autobiography provides few details of her father's or husband's actual work in the mines, her formative years in the Butcher Holler, Kentucky cabin are an unending source of inspiration for her art: "I wrote it [the song, 'Coal Miner's Daughter'] myself, nine verses, and it broke my heart when I had to cut three verses out because it was too long. I could have written a thousand more verses, I've got so many memories of Butcher Holler" (1). When her father died in 1949 at the age of 51 years, Lynn felt some resentment that a combination of high blood pressure, stroke, and miner's black lung disease had taken him away from the family.

Nevertheless, her overall outlook toward the Consolidated Coal Company is a mixture of positive and negative impressions. She describes the coal camp of Van Lear as "a boom town," and it provided "rows of wooden houses" for miners to rent (2–3). The camp also ran a company store as well as a recreation hall where movies were shown. As her family viewed Tarzan and Roy Rogers movies for the first time, Van Lear seemed like a new cultural horizon— like "another world to us" (3). There was also a one-room schoolhouse in the coal camp. She sums up her overall impression of the economic effect of coal on the region: "People make coal camps sound like slavery, but in a lot of ways it was the best thing that ever happened to people—as long as the coal kept running" (3).

While employment brought the family some needed income, working conditions in Consolidated Coal Company Mine Number Five were very difficult. As Lynn explains in detail: "The seam of coal was only three feet high, and you can bet they didn't bother cutting the rock to give the men a place to stand up. That meant the miners had to crawl on their hands and knees and work on their sides or lying on their backs" (12). The physical labor in the

coal mine took its toll on her father's thin physique. Her father would come home "with his knees all cut and sore" (12).

Loretta Lynn left home in 1949 at the age of fourteen. Her husband worked for only a brief time as a supervisor of a crew of five men and as an official who took the collected coal to a station to be weighed and evaluated. He quit the coal-mining business very soon and had no physical sufferings. However, her father's work in the mines continued for several years; the hard labor took its toll as he developed breathing trouble. Her description of his condition is at first matter-of-fact: "Black lung is what you get when you breathe in too much coal dust" (13). However, her bitterness at the coal company's callous indifference becomes plain: "He got laid off when he couldn't work fast anymore. They just said, 'Take your shovel and go home.' No pensions, no benefits, just 'go home'" (13–14). In his final years, her father worked in a factory in Wabash, Indiana. One morning he collapsed while at work in the factory. His daughter's final comment on his death looks back to the Kentucky coal mine: "They said he died of a stroke but I figure the coal mines done it" (67).

Her father's body was moved from Indiana to Kentucky, where he was mourned by Loretta Lynn and her family. They participated in an essential folk custom: the local ritual of mourning. Various studies on coal mining attest to the importance of these rituals for the families. According to Lynn, her father was dressed in a blue suit and was lying in a wine-colored coffin. At the wake, the family "sat up three nights a-praying" (67). The emotional aftereffects on the coal miner's daughter were intense: "For six months afterward, I'd have these nightmares of trying to get to Daddy to tell him I loved him . . . afraid I'd get home too late" (67).

It was more than a year after she first wrote the song before Lynn and her entourage would bring themselves to issue "Coal Miner's Daughter" as a record. The time in which the song was "kept . . . in the can" seems like a metaphor of a repressed autobiographical urge. Lynn says that she didn't think that people would be interested in a song about her life. The first and most important decision in autobiography is accepting that one's life is worth telling in public. Once the song hit the charts, however, all doubts were removed, and the floodgates of autobiography were thrown open. In further songs, interviews, ceremonies, and finally in a book and a film, the story of the coal miner's daughter, the Washington housewife, and the Nashville Opry star was told over and over in a variety of media but with remarkable consistency. She writes: "I was given up to die when I was a baby. I came close to drowning near my ranch a few years ago. I never told anybody about that until now. And the doctors told me that my heart stopped on the operating table when I had chest surgery in 1972. Ever since then, I've wanted to tell my life story" (qtd. in Broan and Thrasher 63).

Autobiography as a response to the threat of death is a standard concept not necessarily to be taken at face value. In fact, the song "Coal Miner's Daughter" was composed before Lynn's surgery. It is true, however, that telling her life story means more to Loretta Lynn than the public relations gesture it is for many other public figures.

In 1974, an interviewer asked her about country music and how it had changed since she came to Nashville. Most musicians would be content to give a perfunctory answer to this professional question. But terms like "change" and coming to a new place start a wholly different chain of associations in Loretta Lynn's mind: "I didn't live in Nashville. Of course I had never been any place except I went to the state of Washington—my husband sent for me and I went on the train. I was pregnant . . ." (Broan and Thrasher 96).

The interviewer comes back to the original question shortly afterwards, asking "How has country music changed?"—and again Loretta Lynn digresses freely, associating autobiographical thoughts: "It seems like everything has changed. When I was growing up . . . like for me to see a loaf of bread. . . . There ain't many people live the way we did in Butcher Holler, and Butcher Holler has changed" (34).

When asked about career and business, Lynn almost compulsively responds in terms of her early life, before she became a professional musician. There is an undeniable degree of sincerity and authenticity in this urge, and as the episode of the breakdown also confirms, an inner need. On the other hand, the autobiographical urge also sells. Within a year after "Coal Miner's Daughter," she had three more singles out with songs of an autobiographical nature, signaling the open floodgates of autobiography, but also the sequels to a commercial hit—from coal mine to gold mine, as it were. "Coal Miner's Daughter" becomes a trademark, designating a song, a best-selling book, a major movie, a publishing company (Coal Miner Music), a band (Lynn's backup group changed names, from the Western "Trailblazers" to the Appalachian "Coal Miners").

On the other hand, some members of the band did come from coal-mining families, and all were supposed to have been factory workers at one time (at least, this is the point she was making at the time her autobiography was written). The same sign, then, designates a commercial gimmick and a factual truth: the constant tension in all of Loretta Lynn's autobiographical image-making and soul-searching. The most obvious example of this process is, of course, her name. Contrary to the practice of many stars, she does not change her real name (which happens to be alliterative, highly prized in advertising); on the other hand, the name increasingly designates objects other than her person—her voice, her image, her records, all the way to Crisco shortening and franchised western-wear stores.

If we look at the front and back cover of a paperback edition of *Coal Miner's Daughter* (in this case, the 1977 Warner paperback), we find there one of the

most concise statements of the nature of autobiography. The two pictures—the glamorous star on the front, the bucktoothed little girl on the back—are the same person, and yet are two different people. The contrast shows the distinction between past and present selves, public and private lives, which creates the inner tension in the autobiographical genre; and it also underlines that this contrast takes place within what remains, after all, one and the same person.

Structurally, this means that autobiography has much in common with metaphor. A metaphor is the discovery of similarity in a context of difference: "Achilles is a lion" makes sense as a metaphor, precisely because Achilles is not a lion. Jean Starobinski has pointed out that in order for autobiography to exist, there must have been a change, a dramatic development in the subject; I would stress the fact that the change is only significant because the subject is still the same. The difference between the narrating self and the narrated self is worth our attention precisely because these two selves happen to belong to the same person.

This is also true at another level. Autobiography is a public performance; but the storyteller is expected to reveal the private self in it. On one level, the autobiographer is supposed to abolish the difference between public and private self; on another, this act is only relevant inasmuch as the reader is constantly reminded that the two selves are logically distinct. "One does not dress for private company as for a public ball," says Benjamin Franklin, the founding father of modern autobiography (9); and Nathaniel Hawthorne muses that "it is scarcely decorous . . . to speak all" (22).

This double metaphorical structure is best expressed in autobiographies of stars. Their success story enhances difference and change, but they always strive to prove continuity and identity insisting that success has not changed them; they build an elaborate public image, but must persuade their fans that it also coincides with their private selves. Country music as a genre claims sincerity to a very high degree, linking it closely with autobiography: "A hillbilly is more sincere than most entertainers," Hank Williams used to say, "because a hillbilly was raised rougher."

In fact, the ideal country star must have been born in a cabin and be living in a mansion, like Loretta Lynn; and, as she does, must travel often between the two, at least in imagination. Most important, stars are expected to live in a mansion as they would in a cabin. They must look dazzlingly glamorous on the stage, declaring distance, but must open their homes to visiting fans and tourists, stressing familiarity. No wonder autobiography is also a thematic staple in so many country songs. Lynn says, "My fans and writers are always making a big deal about me acting natural, right from the country. That's because I come from Butcher Holler, Kentucky, and I ain't never forgot it. . . . We're country musicians; I don't think we could play our kind of music if we didn't come from little places like Butcher Holler" (1).

In her book, Lynn presents herself as a regular housewife (an image doubled by her Crisco commercials), who has some problems with her husband but still understands and loves him, who hangs drapes and even worries about where the money for the children's braces is coming from. "When you're lookin' at me, you're lookin' at country," she sings; "I was Loretta Lynn, a mother and a wife and a daughter, who had feelings just like other women" she says (151). And yet—if she were just like any other wife, mother, and daughter, who would listen to her sing, who would buy her book and see her movie? So then—*who* is she? As in most autobiographies, the answer is blowing somewhere along the continuum of past and present, public and private.

Let us begin with the public and private. *Coal Miner's Daughter* opens in the bedroom; there's another bedroom scene two pages later, and early in the book she describes her wedding night in detail. These, however, are not love scenes. In the opening episode, she has a nightmare and winds up bloodying her husband's nose with her wedding ring: the next thing she mentions is the gun that her husband keeps on the night table. The wedding night scene, though ostensibly humorous, describes a rape: "He finally more or less had to rip off my panties. The rest of it was kind of a blur" (51).

On one level, Lynn is grappling with her inner dreams and deep-seated fears; on another, she is casting herself in the folksy role of the country girl whose mother never told her about the facts of life, and who—"just like other women"—had to find out the hard way. The autobiographical urge merges with the commercial image-making: Lynn takes her fans into her bedroom, but then resents the invasion and hides.

This is also literally true. When she was in the hospital, "the fans heard I was in bed [and] they trooped right into my room and started taking pictures" (163). Every year, Loretta Lynn opens her house to thousands of fans, in a ritual of reunion between the star and her social constituency that blurs the line between where the public ends and the private begins. "[Fans] just pop into my kitchen when we're sitting around. It sounds terrible, but I can't relax in my own home," she complains (87). So she winds up checking into a motel—leaving her private residence to seek shelter in public places. The same process functions in her autobiographies: the need to show and the need to hide establish a constant tension. She displays her inner self to the public, but when the public gets there, she has retired somewhere else—and regrets it, and thinks "it's terrible."

A similar contradiction occurs in the relationship between past and present. Being a coal miner's daughter is both an inner identity actively sought and a mask imposed by business associates and fans. Fidelity to roots is an authentic part of Lynn, but also a role imposed from the outside. Thus, in order to play up continuity she is forced to repress the changes that make her what she is now. She speaks dialect freely and spontaneously; but a critic has

noticed that "from time to time, she will repeat a word she has pronounced correctly, only to repeat it *incorrectly* (as *born* to *borned*), almost as though she were reminding herself" (Hortsman 32).

Thus, the same sets of signs designate truth and fiction, spontaneity and manipulation. Loretta Lynn does artificially what comes naturally—like speaking dialect—and does naturally what comes artificially—like wearing a mask. All the theory and practice of autobiography revolve around the first person pronoun, "I." The question is, what does Loretta Lynn mean, to what exactly does she refer, when she uses that word?

Let us consider the songs first. When she sings, "I was borned a coal miner's daughter," she is using the autobiographical first person; but when she sings "I'm a honky tonk girl," her first hit, she is using the fictional-lyrical first person of popular songs. These two meanings of "I" interact intensively in her work. Because she uses autobiography so much, many songs that are not about her have been taken for autobiography: an exchange favored by the fact that in all her repertoire Lynn consistently projects a character based very much upon herself, the spunky woman who does not question the setup but won't take no nonsense from nobody—"Don't come home a-drinkin' with lovin' on your mind" because "Your squaw's on the warpath tonight."

The interaction of the autobiographical and fictional-lyrical "I" generates intermediate forms: first-person songs, written by herself, but which are not autobiographical and first-person songs, written by others, which are patterned around aspects of her life. She wrote "The Pill," a song about contraceptives, which was one of her most controversial hits, though she says she hardly ever used the pill herself (it would have been harder to write, and sell, a song about her husband's vasectomy, which she writes about in the book). On the other hand, "One's on the way"—a vivid description of a housewife with four kids, a careless husband, maybe twins on the way, the pot boiling over, and the doorbell ringing—is based on recollections of her early married life, but was written by Shel Silverstein. There is even another Shel Silverstein song, called "Hey Loretta," in which Lynn sings to herself as if she were somebody else.

To further confuse matters, there is the problem of performance. Singers—like all oral performers—present even the most impersonal material through their body and their voice, thus making it intrinsically personal. Even when she performs someone else's song, Lynn steps closer to an autobiographical act, although it might not be technically described as such. On the other hand, when Emmylou Harris records Lynn's "Blue Kentucky Girl," the autobiographical overtones are lost.

There are at least four meanings of the word "I," as used in Lynn's repertoire and performances, going from the purely autobiographical to the purely fictional-lyrical, through at least two intermediate forms. Each of

these forms may be transformed into another through the processes of performance and reception.

Much of the same can be said about the book. A capsule definition of autobiography is based on the coincidence between the hero and the narrator inside the book's covers and the author outside: they all have the same name. But if we look at the cover of *Coal Miner's Daughter,* we see that the names on it are split: "by Loretta Lynn with George Vecsey." *Coal Miner's Daughter* is one of those "as told to" autobiographies in which famous people delegate the writing to a professional when they are too busy or unable to take care of it themselves. Although these books are billed as autobiographies, the person who says "I" in the text is not the same person that does the actual writing. Loretta Lynn makes no pretense about it: George Vecsey is frequently mentioned in the text as "my writer," in the third person. In quite a postmodern fashion, Vecsey writes about himself in the third person, about somebody else in the first, and enters his own text as a character in somebody else's story: while he writes his own name, he pretends it is Loretta Lynn talking about him. One assumes that, when the "I" character is different from the author, we are dealing with fiction; *Coal Miner's Daughter,* however, is not supposed to be factually straight at all. The only fiction in it has to do with the uses of the first person.

With the film, we take another step. By definition, there can be no autobiographical film in the strict, formal sense. When a book is turned into a film the first consequence is the disappearance of the first-person narrator: films are always in the third person. In the movie *Coal Miner's Daughter* (whose credits are reproduced on the back cover of the paperback book) the "author's" name on the cover is Michael Apted, filming a screenplay by Tom Rickman based on the book written by George Vecsey as told to him by Loretta Lynn. The face and voice on the screen belong to Sissy Spacek. Yet, the name is still Loretta Lynn: the film is clearly intended as a true statement, largely meant to set the record straight after *Nashville.* Many side characters in *Coal Miner's Daughter* actually play themselves, reinforcing the "documentary" overtones.

We come full circle when we turn to the paperback and discover that the film has been incorporated in the book. First of all, as we have already pointed out, the book displays the film credits, making it look as if the book was a novelization of the film: the written autobiography is somehow validated by having been the subject of a fictional movie. In the second place, the images of the film are also included in the book.

In the book, Loretta Lynn tells her story not once, but three times: with words, with photographs from her family album, and with stills from the movie. The two sets of photographs are almost interchangeable: the family album's captions, however, are in the first person, while the movie stills are in the third. The pictures themselves are sometimes hard to tell apart. The picture of Loretta Lynn in her first stage outfit is so similar to the one of Sissy

Spacek wearing the replica of it that they perform a sort of reversal of the auto-biographical process. While the pictures on the cover portray two widely different people who are in fact the same person, those two photographs inside portray one character who is in fact two different persons. It may not be irrelevant, in the book's rhetorical structure, that the film stills come before the family album: it is made to look as though Loretta Lynn's actual photographs were patterned after Spacek's. Which, of course, has been the problem all along: which of the two, the image or the person, is the real one; which of the two comes first?

In a passage of *The Day of the Locust,* Nathanael West describes the main female character, Faye Greener, as she tries out one identity after another: "She would get some music on the radio, then lie down on her bed and shut her eyes. She had a large assortment of stories to choose from. After getting in the right mood, she would go over them in her mind, as though they were a pack of cards, discarding one after another until she found one that suited. On some days, she would run through the whole pack without making a choice. . . . While she admitted that her method was too mechanical for the best results . . . she said that any dream was better than no dream" (60–61).

Let us compare this to a passage from *Coal Miner's Daughter,* where Lynn describes her belief in reincarnation—a subject clearly related to the question of the mutable and multiple self:

> I once read that you could feel your past lives if you concentrated real hard. So I tried it in my hotel room. I wasn't asleep but kind of in a trance. I lay down quiet and let my mind drift. All of a sudden I was an Indian woman wearing moccasins and a long buckskin dress and I had my hair in pigtails. Even the sounds and smells were vivid to me. All around me there was a huge field with Indians riding horseback. I was standing next to a mounted Indian—I sensed that he was the chief and that he was my husband. I knew he was about to go off into battle, and I was saying goodbye to him. Then a shot rang out, and my husband fell off his horse. In the second such experience, I saw myself dressed up in an Irish costume, doing an Irish dance down a country lane in front of a big white house. (68–69)

Loretta Lynn is part Cherokee, and almost as proud of her Indian (Native American) blood as she is to be a coal miner's daughter. The rest of her ancestry is in the Scots-Irish stock prevalent in Appalachia. As she thumbs through her past lives, she meets her ancestors; the idea that one's past lives are those our ancestors lived is not such a flat banality as one would expect in the autobiography of a star. Like Faye Greener's secondhand dreams, however, Loretta Lynn's earlier selves are fashioned after artificial patterns. The American Indian

warrior chief on horseback is more reminiscent of plains American Indians, of Western movie Sioux, than of a mountain Cherokee. The "big white house" is a plantation house, and in anybody's book an Irish girl in front of a Southern plantation house is named Scarlett O'Hara. "I never pictured myself as Scarlett O'Hara," says Lynn later in the book—but she makes this claim in the context of buying her new house because its "huge white columns" remind her so much of Tara (124). The more she seeks inside to find her true self, the more she encounters someone else's fictions.

The paradox in *The Day of the Locust* is that, by having only masks and no face, Faye Greener gains a sort of purity: she hides nothing, because she has nothing to hide. She is incapable of deceit, because she lives in a world (Hollywood, which is to her what Nashville is to Loretta Lynn) in which deceit is real life and fiction is the only truth. *The Day of the Locust* anticipates many developments which would later be labeled as "postmodern"; it is about the relationship between mass culture, the fragmentation of the self, the erasure of distinctions between image and substance, sign and referent, truth and fiction in a universe where image is the only substance and signs are the only referents of signs.

"In country music," Lynn explains, "we're always singing about home and family. But because I was in country music, I had to neglect my home and family" (140). Let us not be deceived by the sentimental wording: these are the only words she has, but her problem is serious. She is dealing with the disappearance of reality in a sign-dominated universe. Success in country music is based on foregrounding the autobiographical ingredient (one need only think of early Dolly Parton and Merle Haggard), but the more an artist achieves success, the less "life" there is to talk about. In many cases, this erosion of reality turns the autobiographical urge of country music toward the writing of songs about being a country-music singer—metasongs, like self-reflexive postmodern metanovels about novels, composed much for the same reasons.

In Loretta Lynn, we can see the autobiographical impulse grow stronger while her career develops, as if she were groping back toward a time when she was a nobody but knew who she was (or now thinks she did). She lives through some of the basic problems with which many contemporary intellectuals are concerned and deals with them with her limited means and ambitions in the most direct way there is: by trying her level best, over and over, to tell the story of her life.

WORKS CONSULTED

Bernhard, J. M. "Women and Autobiography." *New Boston Review* 5 (1980): 28–30.

Broan, Rick, and Sue Thrasher. "Interview with Loretta Lynn." *Great Speckled Bird*, 23 Feb. 1974, 63.

Bruss, Elizabeth W. "Eye for I: Making and Unmaking Autobiography in Film." In *Autobiography: Essays Theoretical and Critical,* edited by James Olney, 296–320. Princeton: Princeton Univ. Press, 1980.

Eakin, Paul John. *Fictions in Autobiography: Studies in the Art of Self-Invention.* Princeton: Princeton Univ. Press, 1985.

Egan, Susan. *Patterns of Experience in Autobiography.* Chapel Hill: Univ. of North Carolina Press, 1984.

Franklin, Benjamin. *Autobiography and Other Writings.* Edited by Russel B. Nye. Boston: Houghton Mifflin, 1958.

Hortsman, Dorothy A. "Loretta Lynn." In *Stars of Country Music,* edited by Bill E. Malone and Judith McCullo. Urbana: Univ. of Illinois Press, 1975.

Jelinek, Estelle C., ed. *Women's Autobiography: Essays in Criticism.* Bloomington: Indiana Univ. Press, 1979.

Lynn, Loretta, and George Vecsey. *Coal Miner's Daughter.* 1976. New York: Da Capo Press, 1996.

Mason, Mary G. "The Other Voice: Autobiographies of Women Writers." In *Autobiography: Essays Theoretical and Critical,* edited by James Olney, 207–35. Princeton: Princeton Univ. Press, 1980.

Olney, James. *Metaphors of Self: The Meaning of Autobiography.* Princeton: Princeton Univ. Press, 1972.

Schmidt, J. K. "The Other: A Study of Persona in Several Contemporary Women's Autobiographies." *CEA Critic* 43 (Nov. 1980): 24–31.

Stone, A., Jr. "Autobiography and American Culture." *American Studies International: An International Newsletter* 111 (1972): 22–36.

Tewkesbury, Joan. *Nashville.* New York: Bantam Books, 1976.

West, Nathanael. *The Day of the Locust. Novels and Other Writings.* Harmondsworth, Eng.: Penguin, 1997. 11–242.

Winston, E. "The Autobiographer and Her Readers: From Apology to Affirmation." *Women's Autobiography: Essays in Criticism,* edited by Estelle C. Jelinek, 112–32. Bloomington: Indiana Univ. Press, 1980.

19

Blackfaced Rednecks

THE PROBLEM OF BACKCOUNTRY WHITES AS VICTIMS IN JOHN SAYLES'S *MATEWAN*

Ina Rae Hark

In 1987 I returned to my native Charleston, West Virginia, for my twentieth high school reunion. Since graduating I had lived for four years each in Chicago and Los Angeles, with their sprawling inner-city minority neighborhoods, and for twelve years in Columbia, South Carolina, whose 30 percent African American population was disproportionately impoverished, especially in its rural areas. One of our reunion events took place at a state park, accessible only by one of those country roads euphemized in John Denver's famous song about "West Virginia, mountain mama." The mountain mamas, papas, and young'uns I saw on this particular road were sitting, ill-clothed, on the porches of run-down shacks. The first thought to enter my mind was, "I've been away too long. I'd forgotten that white people could be this poor."

During this same year John Sayles's *Matewan* was released. The film, set in West Virginia's Mingo County in 1920, also reminds us that white people can be this poor. It returns to a time during which poor whites were subject to considerable class oppression, and that oppression, and its concomitant human and economic deprivation, were a matter of national concern. By the time the film was released, however, race had more or less obliterated class as the lens through which oppression (and its consequences) were viewed.[1] Doug Henwood remarks in his essay "Trash-O-Nomics": "As class receded in interest, yielding to the now-familiar identities, white became synonymous with privilege, and imperialism overwhelmingly a matter of race. White workers, once the focus of Old Left attentions, became, in the eyes of the New Left

and its heirs, the warmongering, bigoted junior partners of empire" (178). The historical particulars of the mine wars in southern West Virginia in 1920 and 1921 provide Sayles an opportunity to reexamine the workings of both race and class in tandem. The most ticklish challenge he must confront is how to reposition the "backcountry" white male—whom the emphasis on racial politics since the Civil Rights Movement of the 1960s has, not without some basis in fact, cast as ignorant, bigoted, and violent—as instead a victim of class oppression deserving a liberal audience's empathy.

The coal miners who for the first third of the twentieth century had sought the right to unionize through strikes and violent confrontations in Mingo County and elsewhere in the state were made up of longtime West Virginia residents, immigrants from Eastern and Southern Europe, and blacks from the South. (A 1909 report from the West Virginia Department of Mines, reporting the ethnic origins of 33,202 miners in 207 mines, listed 10,910 native white miners, 8,750 black miners, 7,728 white ethnic immigrants, and 5,814 whose ethnicity was unknown [Lewis 132].) They acted as a collective governed by their oppressed class status as miners, not their racial and ethnic differences. Ronald Lewis asserts that "by the end of World War I southern West Virginia operators would lock horns with a people unified by a class consciousness which at least temporarily rendered race and nationality insignificant to the larger cause" (157). Historian John Williams adds that "it was one of the union's great achievements to have forged a degree of unity among a heterogeneous working population thrown together only recently and under adverse circumstances" (Savage xv). This fact is a central theme of Sayles's approach in *Matewan*. He cites the documented policy of "judicious mixture" that operators adopted because they believed such a situation would guarantee that the miners "never rise above their basic prejudices to resist collectively" (Sayles 15), and his film portrays the paradoxical result: "The ironic fruit of this policy was that within a generation black and white miners had not only accepted equality as a democratic ideal, at least in rough outline, but had come to identify along class lines in economic questions. This was, of course, the foundation of the interracial unity that united the southern West Virginia miners against the operators. Thus did the seeds of judicious mixture grow to entangle the companies that planted them in the remoteness of central Appalachia" (Lewis 164).

To leave no doubt about this point, Sayles depicts the miners of Matewan as homogeneously white and native prior to the strike, with blacks and Italians brought in by train as scabs to break the strike.[2] Then, in a stirring scene, the natural leader of the black miners, Few Clothes Johnson (James Earl Jones), throws down his shovel, and the multiethnic scabs join the white mountaineers in the walkout. Many subsequent scenes in the film deal with the mutual prejudices of this group and their families being overcome through

shared hardship and devotion to the union. While this makes for great drama, the integration of the workforce was neither so sudden nor so completely controlled by the owners as *Matewan* would have us believe. *Matewan* intentionally telescopes a quarter century of the region's history into just a few months. By 1920, 12 percent of Mingo County miners were African Americans. One of the key union organizers, Frank Ingham, was black and had long been a union man and an advocate against his fellow blacks serving as strikebreakers. The in-place striking miners and their scab replacements were *both*, in fact, racially heterogeneous groups. While black leader T. Edward Hill, unlike Ingham, saw the Mingo strike as an opportunity to obtain more mining jobs for African American workers, he urged the operators to avoid strict racial demarcations. He later reported with satisfaction, "The coal companies that are bringing in workers are having them sent in bunches of not more than 25 and in all crowds brought in to date there have been whites as well as negroes" (Trotter 116).

Even as early as the strikes of 1912–1913 in the Paint Creek and Cabin Creek fields of Kanawha County, "the strike did not polarize around race, because blacks had been accepted as legitimate members of society, and their economic interests had been absorbed into the broader aspects of class warfare against the operators and their supporters. Black strikebreakers confronted a significant number of hostile black union men every bit as determined to prevent scabs of any race from taking their jobs as were the white strikers" (Lewis 140). (It was also during this strike, not the one in Mingo County eight years later, that "Few Clothes," whose real name was Dan Chain, achieved the status of folk hero.)

Sayles prefers to present the native white, black, and immigrant miners as initially far less integrated into the workforce than they were at the time because he is here reading 1920 from the perspective of 1987. As he observes in his chronicle of the making of *Matewan*, titled *Thinking in Pictures,* "but people still go underground to mine coal, people with power still pit races and ethnic groups against each other to keep them from taking control of their own lives . . ." (27). The film comes in the wake of renewed struggles for organized labor in the Reagan era. When Sayles was asked, "Certainly *Matewan* was your most political subject to date and was made at the height of Reaganism. Did that place you in an oppositional position?" he replied, "Yeah. I think it was important for people to remember why there were unions. One of the first things Reagan did when he got in was bust the Air Traffic Controllers Union" (Smith 123). Tom O'Brien's review in *Commonweal* notes that "Sayles addresses the forgetful contemporary audience, many of them tempted by conservative propaganda to reduce unionism to scandal" (627). Stephen Brier speaks of the film's audiences "commenting about how nice it is to see workers portrayed so positively in the Age of Reagan" (126).

Also central to the film's oppositional stance is the phenomenon of the GOP "Southern strategy," inaugurated during Richard Nixon's 1968 Presidential campaign, which has succeeded in turning working-class white Southern Democrats into conservative Republicans by playing up the alliance between African Americans and liberal Democrats. Since then the American political scene has often foregrounded the pitting of one group of disenfranchised workers against another on the basis of race. A classic example was the infamous television ad used by North Carolina Republican Senator Jesse Helms to defeat African American opponent Harvey Gantt: it showed a frustrated white worker crumpling up the rejection letter that denies him the job that the announcer assures us was given to a minority candidate. That both workers have little clout against the true powers in U.S. business and government, whose jobs are in no jeopardy from affirmative action, is conveniently omitted from the conservative pitch. Liberals, in turn, would rather ignore the displaced white worker's genuine, if mistakenly focused, anger and dwell on the hateful speech or actions such carefully cultivated racial resentment can produce. Ironically, the Southern strategy never worked in West Virginia, which has remained steadfastly Democratic in national politics, but Sayles's comments clearly indicate that the events of *Matewan* function as an analogy for the racial politics of the 1980s.

The historical presence of African Americans among the striking miners at Matewan serves another ideological aim for Sayles as well: the southern West Virginia coalfields operated by a system suspiciously akin to plantation slavery, although European serfdom was the analogy more frequently evoked at the time. On assignment to cover the mine wars, *New York Times* reporter Winthrop D. Lane wrote in 1921: "No one owns his own house. . . . No one is free to decide to-day that he will change his occupation tomorrow, because there is no other occupation than coal mining; the only way he can change his occupation is to move to some other region. . . . The essential characteristic of a coal-mining civilization, in West Virginia as well as in some other parts of the country, is the extent to which the employer, the company, controls things. It is a paternalistic, in some ways a feudal, civilization" (22). The company provided the miners with all the necessities for both job and domestic life, billing the inflated expenses against their upcoming paychecks. There was no comparison shopping. All goods were mandated to come from the company store to which the miner is said to owe his soul in the Tennessee Ernie Ford song "Sixteen Tons." Some of the wages were not even paid in U.S. currency but in company "scrip," good only at company-owned venues. And indeed most venues were company-owned: "For more than twenty years, coal operators had controlled their very being; had arranged for their homes and towns, churches, schools, and recreation centers; had provided doctors and teachers and preachers; had employed many of their law officers; had even selected the

silent motion picture shows that were beginning to appear in theaters; had told them, finally, where and how they were to live and discharged those who did not conform" (Savage 15). Moreover, if miners were discharged from their jobs because of union activity, coal companies immediately and without due process evicted them from company housing, and there usually was no other housing in the area. The opposition to such forced evictions, which the brutal Baldwin-Felts private detectives carried out, by Matewan Police Chief Sid Hatfield was the issue that prompted the showdown leading to the "Matewan Massacre," a turning point in the mine wars and the climactic event of Sayles's film.

Hatfield may have had the moral high ground on this issue, but the West Virginia courts had said that the coal companies were not required to follow the usual due-process procedures for evicting tenants because, as the coal company attorneys argued, the relationship was not that of landlord and tenant but of master and servant. Lane notes that it was the union that pointed out the iniquity of such twentieth-century "serfdom": "The conception of master and servant used in the coal company's argument arose at a time when 'servants' were not freemen. They could not vote and were persons of very inferior status. . . . To apply that conception now to the workers in a great American industry is, the union contends, to turn back the clock of civilization centuries" (51).

Sayles is determined to have us read this generalized servant status of the miners specifically through the experience of enslaved American blacks. The scene in which one of the operators explains how the "semifeudal" system works involves his orientation of the scab African American miners only. Later one of these men, Tom (Tom Wright), remarks: "We just slaves up here. They owns our black asses." Responding to a wounded black miner's query as to whether a Kentucky doctor sympathetic to the union will treat him, Elma Radnor (Mary McDonnell) replies, "If he treats union, he'll treat colored." Visually aiding a *Matewan* spectator in making this analogy is the fact that coal miners, at the end of the day, "emerged black-faced with the sun behind the mountains" (Savage 12). Both the opening and closing shots of the film show white miners (Sephus, Danny), their faces smeared with coal dust, working underground.

That the film seems to find it necessary to read the class oppression of these rural white men through the racial oppression of black men speaks volumes about representations of poverty in America from the 1920s to the 1980s. During those decades when the mainstream media generally effaced the effects of white racism on the economic status of blacks, their depictions of poverty generally had a white, rural face. One thinks of Walker Evans's Great Depression era photographs or the portrayal of the Okies in Steinbeck's *The Grapes of Wrath*. Even in the prosperity of the post–World War II era, Appalachian white poverty proved an intractable problem frequently

highlighted by the national media. Poverty in West Virginia became a specific focus of network news specials and the covers of national magazines (*Newsweek, Life*) in the first half of the 1960s because President John F. Kennedy's win in the 1960 West Virginia primary propelled him to the Democratic nomination, and Kennedy singled out the state for Federal attention.

From the late 1960s on, however, the problems of racial discrimination and of poverty became more and more conflated in public representation. One way to interpret Sayles's black/white parallels is as a reminder that class oppression has been and still is a thing separate from, if often linked to, race and ethnicity. This is the whole point of the scene in which the white, native miners object to Few Clothes's interest in joining the union. After Few Clothes lashes out at the native who has called him a "nigger" and a scab ("I been called nigger and I guess that's the way white folks is, but I never been called no scab and I ain't gonna start up now"), Joe Kenehan (Chris Cooper) insists that the world according to the union divides in only one way, those who work versus those who do not: "You think this man is your enemy? This is a *worker.* Any union keeps this man out ain't a union it's a goddam *club!*"

But the parallels also function to separate two contradictory views that the film holds of the native, white miners. While there is sympathy with those elements in their situation and character that align them with other oppressed groups, the film is less comfortable with their eagerness to fight the "Baldwins" with their own weapons, as well as the legacy of feuds and violence endemic to the southern West Virginia hills and hollers. When the showdown in Matewan is at hand, Sayles pointedly has Few Clothes warn his fellow blacks to stay away from town because "you know how white fokes is when they gets all excited."[3] Had Sayles wished to draw an analogy to people of color more closely allied to the "natives'" intrinsic culture, rather than their economic status, he might have chosen the Native Americans, who lived tribally, had a strict code for the display of violence toward enemies, fostered extended kinship networks, and waged guerrilla warfare against the moneyed, white interests that sought to seize their land. Indeed West Virginia–born union official Frank Keeney told reporter Lane, "We don't propose to get out of the way when a lot of capitalists from New York and London come down here and tell us to get off the earth. They played that game on the American Indian. They gave him the end of a log to sit on and then they pushed him off that" (Lane 88).[4] And in fact one of the Baldwins in the film tells a new recruit that the company seeks reinforcements every time "the natives get restless"; Sayles similarly writes in his foreword to Savage's book: "When a colonized people learn they can fight back together, life can never again be so comfortable for their exploiters" (viii).

Sayles wishes to attribute the miners' violence solely to their exploitation by the coal operators. He is quite aware how male violence, whether in rural

hollers or urban ghettoes, is an inevitable by-product of such class manipulation, which inevitably tribalizes the oppressed and turns the fighting internecine while the owners continue to reap the profits. The showdown at Matewan was, he says, a face-off between "monopoly capitalism at its most extreme versus American populism at its most violent" (Sayles 10). When the film's Elma Radnor complains, "He said he got his licks in. Seems to be all the men here care about. Wives and kids is starvin' but as long as they got their licks in. . . ." Joe Kenehan, although himself completely opposed to the use of violent means, responds, "It's just frustration is all. When you can't take care of them you care about," winning Elma's about-face agreement: "I know. It ain't their fault." Sayles likewise speaks of the "cycle of blood feuds and meaningless revenge" among the miners as fostered by the company (Sayles 19).

Ultimately for the writer-director, however, tribal feuds and revenge, whether redskin or redneck,[5] must be disavowed, in favor of the pacifism preached by the film's one genuine Red. For, besides pointing out the historical oppression of the miners, Sayles has another objective in mind: to convey a liberal ideology of the brotherhood of man and the impossibility of fighting violence with violence. His fictional protagonist is union organizer Kenehan, a conscientious objector and member of the IWW,[6] "a guy trying to preach turning the other cheek in the land of an eye for an eye" (Sayles 16). Since historically the miners made violence a linchpin of their campaign to unionize, and since the film itself climaxes with the Matewan Massacre in which Police Chief Sid Hatfield, the real-life folk hero of the mine wars, supported by a group of miners, shot it out with the Baldwin-Felts detectives sent to enforce the will of the mine operators, Joe is doomed to fail. When he cautions Sephus against seeking vengeance for the brutal killing of Hillard Elkins by the Baldwins because shooting is just what the mine owners want, Sephus (Ken Jenkins) replies, "Maybe it's what we want too. . . . You're still after that one big union. Most of us can't see past this holler." When the men go to town to face the Baldwins with Sid, Joe runs onto the main street shouting, "No!" and dies in the crossfire. Only by converting the young boy Danny (Will Oldham)—an erstwhile Baptist preacher, who concludes that Jesus would have revised the parable of the workers in the vineyard if he'd seen how the mine owners did business—to a belief in the universal union man and the futility of violence does he have any lasting impact at all.

Meanwhile, Sayles knows that he is fighting the genre expectations the historical events produce because they "resemble the classic American Western so closely" (Sayles 16). How can he keep the audience's sympathies more with Joe, the pacifist who does much good but is ultimately destroyed by the reciprocal violence, than with the charismatic lawman, Hatfield, particularly since Hatfield, whose distinctive costume of derby with down-turned rim, giant badge and guns belted over a suit coat makes him a visual combination

of Wyatt Earp and a Keystone Kop, becomes the film's most vivid characterization, a presence simultaneously courtly and menacing? (The role was a career-maker for longtime Sayles repertory member David Strathairn.)

Partly history is with Sayles, for Hatfield's triumph was short-lived. Despite being acquitted of all charges brought in connection with the massacre, he was fifteen months later shot down in cold blood on the McDowell County courthouse steps by, among others, Baldwin-Felts spy C. E. Lively, who was in turn acquitted and died peacefully in Huntington in 1962. And after a year and a half of a violent, armed miners' uprising, amounting to a de facto civil war in southern West Virginia, the union forces surrendered when federal troops were brought in, only, according to Savage, because their grievances were intensely local and they were not prepared to "make war against their own country" (148). The Mingo County strike finally collapsed, and the membership in the United Mine Workers of America in West Virginia, which had stood at 50,000 in 1920 had dwindled to 600 by 1929. Only the more favorable labor climate that accompanied the New Deal allowed the UMWA to become the significant force it later was in the region (Savage 166). By casting Hatfield (Strathairn) and Lively (Bob Gunton) as similar physical types, both having black hair and olive complexions, Sayles emphasizes a similarity beneath their ideological oppositions. And allowing the older Danny Radnor in voice-over to recount the results of the conflict that followed the Matewan Massacre gives Joe the upper hand after all: "That were the start of the great Coalfield War, and us miners took the worst of it, like Joe said we would. 'Hit's just one big union the whole world over,' Joe Kenehan used to say. And from the day of the Matewan Massacre that's what I preached. That was my religion."

Matewan does a superb job of delineating the shadings of masculinity in this border town in southern West Virginia, its tribal loyalties and vendettas, its fundamentalist religion, its fierce provincialism and sense of place, where one holler is not like another, and "foothill" people have to be distinguished from "genu-ine hill" people. It also evokes the sui generis nature of this mountain culture, neither quite Southern, Eastern, or Midwestern, in a film that "has some of the pace of a long, sad mountain ballad, a song of fate and revenge and transcendence" (Sayles 117). In the end, however, Sayles cannot accept the ambiguities of the culture he so lovingly depicts. While he can embrace the plight of the miners as long as he can equate it with that of racial and ethnic minorities, he cannot continue to identify with them as white folks who've gotten all excited and suggest at best the Western gunfighter and at worst the Klan and modern day right-wing militia groups. As the title and theme of a film he made a decade after *Matewan* imply, Sayles profoundly distrusts *Men with Guns*.

David Hackett Fischer in *Albion's Seed* has identified characteristics of what he calls "backcountry" culture in those areas of the U.S., including Appalachia,

that were settled predominantly by immigrants from the border areas of Scotland, Ulster, and northern England. These border peoples were characterized by "an ethic of violence formed in ambuscade and border-raiding"; a system of private, retributive justice; and fierce loyalty to an extended kinship network often resulting in family feuds (769, 765). They abided by "the border variant of the golden rule—do unto others as they threatened [to] do unto you" (617) and "have been remarkably evenhanded in their antipathies—which they have applied to all strangers without regard to race, religion or nationality" (650). The native miners in *Matewan* manifest all these characteristics of a culture clearly not ultimately amenable to the universalizing vision of the whole world as one big union of workers united. Although Sayles discredits some of the most negative sentiments about backcountry culture—and slurs like "hillbilly" and "mountain trash"—by putting them into the mouths of the loathsome Baldwins, he can't quite evade the fact that "Bloody Mingo" was the "stompin' ground" of the Hatfields and McCoys, who didn't need the manipulation of evil capitalists in order to start shooting. Thus he invents his fictional saint, Joe Kenehan,[7] because he is unwilling to align his perspective with the violent and ambiguous heroism of the historical Sid Hatfield, a descendant of that feuding mountaineer clan.

It is understandable, and indeed admirable, that Sayles would utilize a hero like Joe Kenehan in the late 1980s, when phallic, white, gun-wielding masculinity dominated movie screens, tacitly encouraged by Reaganite politics.[8] Joe's monologue about the sufferings of the Mennonites imprisoned with him for refusing military service who also refused to compromise their religious beliefs in order to obey prison regulations despite cruel punishment carries a powerful message: "Them fellas, never lifted a gun in their lives, you couldn't find any braver in my book." Unfortunately, however, neither side in the mine wars of 1920–1921 ascribed to such convictions, and since Sayles can't squarely face the more violent proclivities of the victimized miners, *Matewan* turns the troubled and contested history of the region[9] into (in more ways than one) a black-and-white morality play, which, Brier observes, replaced history with melodrama and "flattened out, over-simplified and thus distorted a complex historical event" (127).

Thus abstractions such as "workers," "union men," and "pacifists" become the locus for viewer identification, and the white "native" miners finally run true to type: the "crazy" and "dangerous" hillbilly, the miners who are "hard people" that "wudn't nobody you wanted to cross."[10] Because of his distaste for allowing us completely to identify with such violent men, for fear this might be mistaken for condoning violent means, Sayles encourages empathy only with white men in blackface, that is, as civilly disobedient victims of oppression, while simultaneously calling upon us to distance ourselves from those same whites when they start acting like rednecks, the only ethnic group

it is still acceptable to demonize in American film and television, whether as the vicious brutes of *A Time to Kill* or the uneducated folk encouraged to talk about their sordid sexual behavior on tabloid television.

NOTES

1. This trend continues. *Time* magazine pointed out in its September 1, 1997, issue that 62 percent of stories on poor people in the three major weekly national news magazines were illustrated with photos of African Americans, while only 29 percent of poor people in America are black ("Numbers" 25). Henwood's figures on the racial and gender makeup of various job categories also demonstrate that "there are plenty of white men and women doing our meanest work" (186).

2. Sayles later admitted to Gavin Smith that this scenario is "based on places other than Matewan" (Smith 122).

3. There was no such racial division on the question of using violent means in real life. In fact, a black miner, Ben Page, was one of the participants in the shootout later indicted along with Hatfield. (The film shows one black miner at the shootout, but he is killed and thus viewed as a victim rather than an aggressor.) As the hostilities continued, Lon Savage reports, a black "leader made speeches along the creek to the black miners: If the white people got guns, he said, blacks had better get them too" (Savage 8).

4. While Keeney uses this analogy to illustrate the miners' justifiable fears of victimization, Maurice Collins in his essay on the Molly Maguires elsewhere in this volume points out that analogies between Irish workers, including miners, and Indians were used to justify repressive and paternalistic treatment of those workers.

5. Traditional usage, including that in the film, tends to employ "hillbilly" as the derogatory term for natives of the West Virginia hills. Yet those involved in the mine wars were frequently called "red-necks" for another reason. Savage reports that a Logan County official censored a reporter's dispatch because he wanted "no sob stuff for those red necks" (158). Lane notes that operators called union organizers "anarchists," "red-necks," and "Bolshevist" (104). The "red-neck" label in fact referred to red bandanas that a large number of the striking miners wore as a gesture of solidarity, but it neatly collapses the miners' ethnic origins and the anticapitalist purpose of the UMWA efforts to unionize them.

6. Savage mentions that only one Wobbly was known to have tried to participate in the mine wars; he met a fate similar to Joe's. No sooner did the man, Comiskey, arrive in Logan County than he was arrested by the virulently antiunion sheriff, Don Chafin. Within thirty-six hours he had been shot by the jailer's son, supposedly for attempting to escape (Savage 140).

7. Neil Isaacs has pointed out in his article "John Sayles and the Fictional Origin of *Matewan*" that a complete plot sketch of the story of Joe and Danny, significantly divorced from any connection with the Matewan Massacre, is contained in Sayles's 1977 novel *Union Dues* when the character Hobie repeats around a campfire the tale "just as Pappy Dan Radnor told it to him" (270).

8. In her book *Hard Bodies,* Susan Jeffords claims that the "hard body" as seen in 1980s action films:

was to come to stand as the emblem of the Reagan philosophies, politics, and economies. In this system of thought marked by race and gender, the soft body invariably belonged to a female and/or a person of color, whereas the hard body was, like Reagan's own, male and white. . . . The depiction of the indefatigable, muscular, and invincible masculine body became the linchpin of the Reagan imaginary; this hardened male form became the emblem not only for the Reagan presidency but for its ideologies and economies as well. To understand the broad function of these bodies as collective symbols, it is important to see them not simply as images for Reagan's own self-projections or idealizations of an outdated Hollywood heroism but to recognize their successful linkage in Reaganism to the national body as well. As such, these hard bodies came to stand not only for a type of national character—heroic, aggressive, and determined—but for the nation itself. (24–25)

9. Rather than being generic victimized workers, the West Virginia miners were uniquely oppressed, even within the category of coal-mine employees, by their specific historical and economic circumstances. With wages depressed by the increased transportation costs for getting coal out of the inaccessible and landlocked hills, with over 80 percent of miners living in company-owned towns (as contrasted to under 10 percent in Midwestern coalfields), it is no wonder, John Williams concludes in the introduction, that "the worst violence—like the worst housing and the worst working conditions in the industry—seemed always to be found in the Appalachian states" (Savage xv).

10. These terms come out in various dialogue exchanges in the film. The conductor advises Joe against getting off the train in Matewan: "You don't want to go there, mister. Ain't nothin but crazy people." Mrs. Elkins corrects Bridey Mae for identifying the mountain hunters who rescue Joe from Hickey and Griggs as hill people because "your genu-ine hill people, they can be dangerous." Pappy's opening narration contains the remark about the miners as hard people. In some ways Sayles presents such statements in an ironic context, to indicate that judging people too quickly for violent actions can obscure the mitigating causes. If Sayles wholeheartedly believed this, however, he wouldn't need to invent Joe Kenehan to get his story told.

WORKS CONSULTED

Brier, Stephen. "A History Film without Much History." *Radical History Review*, no. 41 (Spring 1988): 120–28.

Fischer, David Hackett. *Albion's Seed: Four British Folkways in America*. New York: Oxford Univ. Press, 1989.

Henwood, Don. "Trash-O-Nomics." *White Trash: Race and Class in America*, edited by Matt Wray and Annalee Newitz, 177–91. New York : Routledge, 1997.

Isaacs, Neil. "John Sayles and the Fictional Origin of *Matewan*." *Literature/Film Quarterly* 16, no. 4 (1988): 269–71.

Jeffords, Susan. *Hard Bodies: Hollywood Masculinity in the Reagan Era*. New Brunswick, N.J.: Rutgers Univ. Press, 1994.

Lane, Winthrop D. *Civil War in West Virginia.* New York: Arno, 1969.

Lewis, Ronald L. *Black Coal Miners in America: Race, Class, and Community Conflict 1780– 1980.* Lexington: Univ. Press of Kentucky, 1987.

"Numbers." *Time,* 1 Sept. 1997, 25.

O'Brien, Tom. "Veins That Run Deep: Sayles's *Matewan.*" *Commonweal,* 6 Nov. 1987, 626–27.

Savage, Lon. *Thunder in the Mountains: The West Virginia Mine War 1920–21.* Pittsburgh: Univ. of Pittsburgh Press, 1990.

Sayles, John. *Thinking in Pictures: The Making of the Movie "Matewan."* Boston: Houghton Mifflin, 1987.

Smith, Gavin, ed. *Sayles on Sayles.* London: Faber, 1998.

Trotter, Joe William, Jr. *Coal, Class, and Color: Blacks in Southern West Virginia 1915–32.* Urbana: Univ. of Illinois Press, 1990.

Williams, John. Introduction to *Thunder in the Mountains: The West Virginia Mine War 1920–21,* by Lon Savage. Pittsburgh: Univ. of Pittsburgh Press, 1990.

General Bibliography on Coal Mining in Art, Literature, and Film

Ashton, T. A., and Joseph Sykes. *The Coal Industry of the Eighteenth Century*. Manchester, Eng.: Manchester Univ. Press, 1929.

Asimov, Isaac. *How Did We Find Out about Coal?* New York: Walker, 1980.

Barrell, John, ed. *Painting and the Politics of Culture*. Oxford: Oxford Univ. Press, 1992.

Benson, John. *British Coalminers in the Nineteenth Century: A Social History*. Dublin: Gill and Macmillan, 1980.

Berkovitch, I. *Coal on the Switchback: The Coal Industry since Nationalisation*. London: George Allen & Unwin, 1977.

Berkowitz, N. *An Introduction to Coal Technology*. New York: Academic, 1979.

Boyd, Robert Nelson. *Coal Mines Inspection: Its History and Results*. London: W. H. Allen, 1898.

———. *Coal Pits and Pitmen: A Short History of the Coal Trade and the Legislation Affecting It*. London: Whittaker, 1892.

Brantlinger, Patrick. *The Spirit of Reform: British Literature and Politics, 1832–1867*. Cambridge: Harvard Univ. Press, 1977.

Brown, I. J. *The Coalbrookdale Coalfield Catalogue of Mines*. Ludlow, Eng.: Shropshire County Library, 1968.

Bruere, Robert W. "Our Chained Prometheus: The Coal Problem and Its Solution." *Harper's Magazine*, Oct. 1923, 609–16.

Bureau of Mines. *Basic Estimated Capital Investment and Operating Costs for Coal Strip Mines*. Washington, D.C.: U.S. Government Printing Office, 1976.

Checkland, S. G. *The Rise of Industrial Society in England 1815–1885*. New York: St. Martin's, 1966.

Corbin, David Alan. *Life, Work, and Rebellion in the Coal Fields: The Southern West Virginia Miners, 1880–1922*. Urbana: Univ. of Illinois Press, 1981.

Crafts, N. F. R. *British Economic Growth during the Industrial Revolution*. Oxford: Oxford Univ. Press, 1985.

Crickmer, Douglas F., and David A. Zegeer, eds. *Elements of Practical Coal Mining*. 2d ed. New York: American Institute of Mining, 1981.

Curtis, Tony, ed. *Coal: An Anthology of Mining*. Bridgend, Wales: Seren Books, 1997.

Davis, Bertha, and Susan Whitfield. *The Coal Question*. New York: Watts, 1982.

Dixon, Colin J. *Atlas of Economic Mineral Deposits*. Ithaca, N.Y.: Cornell Univ. Press, 1979.

Duckham, Helen, and Baron Duckham. *Great Pit Disasters: Great Britain 1700 to the Present Day*. Newton Abbot, Eng.: David & Charles, 1973.

Eller, Ronald. *Miners, Millhands, and Mountaineers: Industrialization of the Appalachian South, 1880–1930.* Knoxville: Univ. of Tennessee Press, 1982.

Finley, Joseph E. *The Corrupt Kingdom: The Rise and Fall of the United Mine Workers.* New York: Simon and Schuster, 1972.

Fordyce, W. *History of Coal, Coke, and Coal Fields.* 1860. Newcastle upon Tyne: Graham, 1973.

Foster, John. *Class Struggle and the Industrial Revolution: Early Industrial Capitalism in Three English Towns.* London: Methuen, 1974.

Galloway, Robert L. *A History of Coal Mining in Great Britain.* 1882. Introduction, bibliography, and index by Baron F. Duckham. Newton Abbot, Eng.: David & Charles, 1969.

Galyan, Deborah. "There's No Fuel like an Old Fuel: Searching for New Energy in Indiana Coal Beds." *Research and Creative Activity: Indiana University* 20, no. 3 (Jan. 1998): 5–8.

Gayer, Rod, and Ian Harris, eds. *Coalbed Methane and Coal Geology.* Geological Society Special Publication 109. London: Geological Society, 1996.

Giesen, Carol A. B. *Coal Miners' Wives: Portraits of Endurance.* Lexington: Univ. Press of Kentucky, 1995.

Gordon, Richard L. *World Coal: Economics, Policies, and Prospects.* Cambridge: MIT Press, 1987.

Gray, Douglas, and Michael Regan, comps. *Coal: British Mining in Art, 1680–1980.* London: Arts Council of Great Britain, 1982.

Green, Archie. *Only a Miner.* Urbana: Univ. of Illinois Press, 1972.

Gregory, Cedric E. *A Concise History of Mining.* New York: Pergamon, 1980.

Griffin, A. R. *Coalmining.* London: Longman, 1971.

———. *Mining in the East Midlands, 1550–1947.* London: Frank Cass, 1971.

Hair, P. E. H. "Mortality from Violence in British Coal-Mines 1800–50." *Economic History Review* 2d ser. 21 (1968): 545–61.

Hair, T. H. *Sketches of the Coal Mines in Northumberland and Durham.* 1844. New York: Augustus M. Kelley, 1969.

Hansen, Michael C. *Coal: How It Is Found and Used.* Hillside, N.J.: Enslow Publishers, 1990.

Hustrulid, William. "Mining." *World Book Encyclopedia.* 1993 ed.

International Energy Agency. *Steam Coal Prospects to 2000.* Paris: OECD, 1979.

Jevons, S. *The Coal Question.* London: Macmillan, 1865.

Kenny, Kevin. *Making Sense of the Molly Maguires.* New York: Oxford Univ. Press, 1998.

Klingender, Francis D. *Art and the Industrial Revolution.* 1947. New York: Augustus M. Kelly, 1968.

Korson, George Gershon, comp. *Pennsylvania Songs and Legends.* Philadelphia: Univ. of Pennsylvania Press, 1949.

Kraft, Betsy H. *Coal.* New York: Watts, 1982.

Lee, Howard B. *Bloodletting in Appalachia: The Story of West Virginia's Four Major Mine Wars and Other Thrilling Incidents of Its Coal Fields.* Parsons, W.Va.: McClain, 1969.

Leifchild, J. R. *Cornwall: Its Mines and Miners.* London: Longmans, 1855.

———. *Our Coal and Our Coal-Pits: The People in Them, and the Scenes around Them.* 1856. New York: Augustus M. Kelley, 1968.

Leonard, Joseph W. "Coal." *World Book Encyclopedia.* 1993 ed.

———, ed. *Coal Preparation.* 5th ed. Littleton, Colo.: Society for Mining, Metallurgy & Exploration, 1991.

Long, Priscilla. *Where the Sun Never Shines: A History of America's Bloody Coal Industry.* New York: Paragon House, 1989.

Lubkin, I., and H. Everett. *The British Coal Dilemma.* New York: Allen & Unwin, 1927.

Lunt, Richard D. *Law and Order vs. the Miners: West Virginia, 1907–1933.* Charleston, W.Va.: Appalachian Editions, 1992.

Machin, F. *The Yorkshire Miners: A History.* Vol. 1. Barnsley, Eng.: National Union of Mineworkers (Yorkshire Area), 1958.

Mann, C. E., and J. N. Heller. *Coal and Profitability: An Investor's Guide.* New York: McGraw-Hill, 1978.

Manners, Gerald. "Alternative Strategies for the British Coal Industry." *Geography Journal* 144, no. 2 (1978): 224–34.

———. *Coal in Britain.* London: Allen & Unwin, 1981.

———. "Prospects and Problems for an Increased Resort to Coal in Western Europe, 1980–2000." In *Selected Studies on Energy,* edited by H. H. Landsberg. Cambridge, Mass.: Ballinger, 1980.

McCormick, B., and J. E. Williams. "The Miners and the Eight-Hour Day, 1863–1913." *Economic History Review* 2d ser. 12, no. 2 (1959): 222–38.

McCutcheon, J. E. *The Hartley Colliery Disaster, 1862.* Seaham, Eng.: E. McCutcheon, 1863.

McGhee, Marshall L., comp. *Coal Mining Towns.* 2d ed. Jacksboro, Tenn.: Action Printing, 1995.

Meade, R. *The Coal and Iron Industries of the United Kingdom.* London: Crosby & Lockwood, 1882.

Moss, K. N. *Historical Review of Coal Mining.* London: Mining Association, 1925.

Muir, W. L. G. *Review of the World Coal Industry to 1990.* Wembley, Eng.: Miller Freeman, 1975.

Munn, Robert F., comp. *The Coal Industry in America: A Bibliography and Guide to Studies.* Morgantown: West Virginia University Library, 1965.

Munro, J. E. C. "The Probable Effects of an Eight Hour Day on the Production of Coal and the Wages of Miners." *Economic Journal* (1891): 241–61.

Nef, J. U. *The Rise of the British Coal Industry.* 2 vols. London: Routledge, 1932.

Norris, Randall, and Jean-Philippe Cypres. *Women of Coal.* Lexington: Univ. Press of Kentucky, 1996.

North, F. J. *Coal and the Coalfields of Wales.* Cardiff, Wales: National Museum of Wales, 1926.

North, J., and D. Spooner. "The Geography of the Coal Industry in the UK in the 1970s." *Geography Journal* 2, no. 3 (1979): 255–72.

———. "The Great UK Coal Rush." *Area* 9, no. 1 (1977): 15–27.

————. "On the Coal-Mining Frontier." *Town and Country Planning,* Mar. 1978, 155–63.

Pinchbeck, Ivy. *Women Workers and the Industrial Revolution.* London: Virago, 1930.

Pollard, Sydney. *The Genesis of Modern Management: A Study of the Industrial Revolution in Great Britain.* Cambridge: Harvard Univ. Press, 1965.

Redmayne, R. A. S. *Men, Mines and Memories.* London: Veyre & Spottiswoode, 1942.

Schobert, Harold H. *Coal: The Energy Source of the Past and Future.* Washington, D.C.: American Chemical Society, 1987.

Stone, G. *The British Coal Industry.* London: Allen & Unwin, 1919.

Thompson, E. P. *The Making of the English Working Class.* New York: Vintage, 1963.

Toothman, Fred Rees. "Conveyor Mining in West Virginia." *West Virginia University Bulletin* ser. 47, no. 12-III (June 1947).

Tregelles, P. G. "A Typical Colliery in the Year 2000." *Colliery Guardian Annual Review* (Aug. 1976): 411–16.

Tripartite Group. *Coal for the Future.* London: Department of Energy, 1977.

Trotter, Joe William, Jr. *Coal, Class, and Color: Blacks in Southern West Virginia, 1915–32.* Urbana: Univ. of Illinois Press, 1990.

United States Department of the Interior. *Literature on the Revegetation of Coal-Mined Lands.* Washington, D.C.: U.S. Government Printing Office, 1985.

Vicinus, Martha. *The Industrial Muse: A Study of Nineteenth Century British Working-Class Literature.* New York: Barnes & Noble, 1974.

Wandless, A. M. *The Coalfields of Great Britain: Variation in Rank of Coal.* London: Scientific Department, Coal Survey, National Coal Board, 1960.

"What Future for the Miners?" *New Statesman,* 7 July 1978, 8–10.

Wilkerson, Michael. "Mapping the Future of Coal." *Research and Creative Activity: Indiana University* 20, no. 3 (Jan. 1998): 28–32.

WOCOL (World Coal Study). *Coal: Bridge to the Future.* Cambridge, Mass.: Ballinger, 1980.

Contributors

MARY ROCHE ANNAS is an instructor and Ph.D. candidate at Northeastern University in Boston, and is currently completing a dissertation on Postcolonial Canadian Literature. She has published poetry in journals in Ireland and the United States, and a recent article in *Culture Studies.*

PETER BALBERT is professor of English and chair of the English Department at Trinity University, San Antonio, Texas. He is author of the controversial book *D. H. Lawrence and the Phallic Imagination: Essays on Sexual Identity and Feminist Misreading* (1989). He is also coeditor of *D. H. Lawrence: A Centenary Consideration* (1985) and author of *D. H. Lawrence and the Psychology of Rhythm* (1974). He has published articles on Lawrence in such leading journals as the *D. H. Lawrence Review, Papers on Language and Literature, Studies in the Novel,* and *Twentieth Century Literature.* He also presented papers at international Lawrence conferences and at various national meetings of the D. H. Lawrence Society.

MARSHA BRYANT is associate professor of English at the University of Florida, where she has received three teaching awards. She is author of *Auden and Documentary in the 1930s* (1997) and editor of *Photo-Textualities: Reading Photographs and Literature* (1996).

MAURICE COLLINS received his Ph.D. in English and American Literature from Brown University. He has taught labor literature and the literature of coal mining in Rhode Island, Montana, and Pennsylvania. He is currently an independent scholar in Providence, Rhode Island.

MARTIN A. DANAHAY is associate professor of English at the University of Texas at Arlington. He has published *A Community of One: Masculine Autobiography and Autonomy in Nineteenth-Century British Literature* (1993) and articles on Victorian art, prose, and photography. His most recent publication is a cultural studies edition of Robert Louis Stevenson's *Dr. Jekyll and Mr. Hyde* (1999). His current project is a book on representations of labor in Victorian literature.

PATRICK K. DOOLEY is distinguished professor of English and philosophy at the United States Air Force Academy and professor of philosophy at St. Bonaventure University. He has published *The Pluralistic Philosophy of Stephen Crane* (1993) and *Stephen Crane: An Annotated Bibliography of Secondary Literature* (1992). He has published more than forty articles in philosophical, literary, and American studies journals and edits the *Newsletter of the Society for the Advancement of American Philosophy*.

TOM FRAZIER, professor of English at Cumberland College in Williamsburg, Kentucky, is the author of the recently published essay "From Here to Back Again: Investigating Migratory Patterns in Fiction" and the short story "Blue-Haired Posse." He has presented papers at both the International Popular Culture Conference, Oxford University, and The International Hemingway/Fitzgerald Conference, Paris.

JANET L. GROSE is assistant professor of English and department chair at Union University in Jackson, Tennessee. Her recent work includes a study of Ellen Price Wood to be published in a forthcoming anthology and an essay on Susan Glaspell, forthcoming in the *Tennessee Philological Association Bulletin*.

INA RAE HARK is professor of English at the University of South Carolina. Her research specialities cover nineteenth-century British comic literature, modern British drama, and the representation of masculinity and of politics in Hollywood film. Her books include *Edward Lear* (1982) and, as coeditor, *Screening the Male* (1993) and *The Road Movie Book* (1997).

ED MADDEN is associate professor of English at the University of South Carolina. He has published articles on Radclyffe Hall, Victorian poetry, and psychoanalysis. His book on Tiresias and modernism has been accepted by Fairleigh Dickinson University Press.

DAIVA MARKELIS has recently received her Ph.D. from the University of Illinois at Chicago. Her dissertation deals with the literary practices of turn-of-the-century Lithuanian immigrants in the United States. Her essays and fiction have appeared in *Women and Language, Mattoid, Other Voices*, the *Chicago Tribune Sunday Magazine*, the *Chicago Reader*, and the *Cream City Review*.

THERESA R. MOONEY is assistant director of writing across the curriculum at Loyola University, New Orleans. Her interests include Southern fiction and drama. Her varied publications range from scholarly articles on Lillian Hellman to writing a Harvard Business School case, as well as corporate speeches.

ROBERT E. MORSBERGER, professor of English at the California State University in Pomona, has published nearly two hundred articles and ten books, including *James Thurber* (1964) and *Lew Wallace: Militant Romantic* (1980). He edited the Penguin edition of Steinbeck's screenplay *Viva Zapata!* (1975) and is coeditor of two volumes on American screenwriters in the *Dictionary of Literary Biography* (1984, 1986).

THOMAS E. MUSSIO is adjunct professor of Italian at Fairfield University and SUNY–Purchase. He has written on Michelangelo's poetry and has presented numerous papers on Renaissance poetry. He also has a strong interest in literary theory and has presented work on Benjamin and Blanchot.

ALESSANDRO PORTELLI is professor of American literature in the School of Letters and Philosophy at the University of Rome "La Sapienza," Italy. He is the author of *The Death of Luigi Trasulli: Form and Meaning in Oral History* (1991); *The Text and the Voice: Writing, Speaking, and Democracy in American Literature* (1994); *The Battle of Valle Giulia: Oral History and the Art of Dialogue* (1997), and has published essays in both Appalachian and African American studies.

WILLIAM B. THESING, professor of English at the University of South Carolina, has written, edited, coauthored, or coedited several books, including *The London Muse* (1982), *English Prose and Criticism, 1900–1950* (1983), *Conversations with South Carolina Poets* (1986), *Victorian Prose Writers before 1867* (1987), *Victorian Prose Writers after 1867* (1987), *Mrs. Humphry Ward: A Bibliography* (1987), *Executions and the British Experience* (1990), *Critical Essays on Edna St. Vincent Millay* (1993), *Robinson Jeffers and a Galaxy of Writers* (1995), and *Victorian Women Poets* (1999).

ALEX J. TUSS, S.M., assistant professor of English at the University of Dayton, is the author of the *Inward Revolution* (1992) and articles dealing with Victorian perspectives on literature, periodicals, and masculinity.

TED WOJTASIK is assistant professor of creative writing at St. Andrews College in Laurinburg, North Carolina. His most recent novel is *No Strange Fire* (1996).

CLARENCE WOLFSHOHL is professor of English at William Woods University in Fulton, Missouri. He has published articles on Gilbert White and on the blending of graphic and literary arts.

Index

Idler (periodical), 20, 23–24, 27, 29, 30
Ignatiev, Noel, 166–67, 170, 176, 179, 183–84
illustration: and the Irish, 167, 173–74; Victorian, British, 19–30
imperialism, British, 28
"In a large room sat the little slate-pickers" (Linson; ill.), 190
Industrial Britain (film) xvii, 104–24
industrialization, 14. *See also* machinery
The Industrial Revolution, xi, 5
The Inferno (Dante), 96
The Invasion of America (Jennings), 168–69
Irish in the U.S.: and alcohol, 169, 171–73, 176, 178; and blackness, 167; and class, 166–84; coal miners, 166–84; in illustration, 167, 173–74; and promiscuity, 171–73; and racism, 166–84; and religion, 174–75
Irish World (newspaper), 171
Isherwood, Christopher, 122–23

James, William, 187–88
Jennings, Francis, 168–69
John, Angela V., 64
Johnson, Edgar, 20, 51
Johnson, E. S., xix, 209–17; "Landless Men," 209, 214–15; "The Ticket for Ona," 209, 211–12, 215, 216; "The Wife from Vienna," 209, 215; "Wocel's Daughter," 209, 211, 212, 213; "The Younger Generation," 209, 213, 215
Johnson, "Few Clothes," (Dan Chain), 256–57, 260
Jones, James (*From Here to Eternity*), 206
journalism: descriptions of coal mines, 50–62, 186–98; and racism in America, 170–71, 175; and reform, 50–62

"Keelmen Heaving In Coals by Moonlight" (Turner; ill.), 4
Kehoe, Jack, 159–64, 176, 180–83
"The Kidnappers" (Sime; ill.), 23

Kingsley, Charles (*The Water Babies*), 13–14
Koven, Seth, 106, 122

"Landscape Map, Land of Dreams" (Sime; ill.), 25
Lankovskas-Polubinskas (*Experience and Life Story*), 217
Larkin, Philip, xvii, 129, 131–33, 137, 140, 146n. 9; "The Explosion," 131–32, 137, 140; *High Windows*, 132
The Last of the Mohicans (Cooper), 176–79, 184
Lawrence, Arthur, 96–98
Lawrence, D. H., 89–102, 111, 113–14, 120, 202; "Odour of Chrysanthemums," 89–102, 202; "A Sick Collier," 202; *Women in Love*, 113–14
Lawrence, James, 90
Lawrence, Lydia, 96–98
Lawson, Nigel, 130
Lejeune, Paule, 87n. 6
Leonard, Joseph W., xi
Lewis, John, 223
Linden, Robert J., 160
Linson, Corwin, 186–98; illustrations, 189–91, 194–96
Literature on the Revegetation of Coal-Mined Lands, xii, 33
Llewellyn, Richard (*How Green Was My Valley*), 201
Lloyd, David, 133
London Journal, 50, 51, 63
Loutherbourg, Philippe, Jacques de (*Coalbrookdale by Night*), 6, 7
Lucas, John, 129
lung diseases, 95–96, 191, 192–93, 245–46
Lynn, Loretta: *Coal Miner's Daughter*, xx–xxi, 244–53; "I'm a Honky Tonk Girl," 250

McClure's (periodical), 186–87, 192, 198
McClure, Samuel Sidney, 186
McDiarmid, Lucy, 120

Taylor, Richard, 200
Taylor, Robert, 130
Thatcher, Margaret, 126–27, 129,
130–31, 132, 143–44
Thomas, Dylan, xv
Thomas, Harriet (*Father and Son*),
38–39
Thomas, Thomas Llewelyn ("Coal-
Mines"), xvi, 32–33, 38–47
Times (London), 35–36
The Triumph of Sherlock Holmes (film),
157–58, 164
Turner, J. M. W.: *Keelmen Heaving In
Coals by Moonlight*, 3–5, 14–16; *The
Limekiln at Coalbrookdale*, 6; *Rain,
Steam, Speed*, 5; *Venice*, 5

unions, xx, 61, 72, 80–86, 126–31, 144,
145n. 5, 223–24, 226–34; and
exploitation by coal companies, 205;
in Sayles's *Matewan*, 255–65; vio-
lence, 226–34, 235–42, 255–65; in
West Virginia, 238–39; reference to,
deleted from journalistic account,
192; in U.S., 155–65, 166–84
United Mine Workers of America,
226–34, 262

v., (Harrison), 126–49
Vicinus, Martha, xii, 33, 51, 55
Victoria, Queen, 36, 60, 61
violence, company/union, 226–34,
235–42, 255–65
violence, domestic, 66

Wales, Prince and Princess of, 40

Walker, Philip, 86n. 1, 87n. 6
Walkowitz, Judith, 106, 108, 112
Watson, Robert Spence, 38
Webb, Melvin (Ted), 245–46
Weeks, Jeffrey, 115
Whistler, James McNeill (*Nocturne in
Grey and Gold—Piccadilly*), 15–16
White, Allon, 107
"Whoa, Molly" (Linson; ill.), 195
Wilde, Oscar, 16
Willemen, Paul, 122–23
Williams, Raymond, xx, 219–25; *Culture
and Society*, 220, 221; *The Long Revo-
lution*, 220
Williams, William, 5–6, 8
women: coal miners, 10–13, 64–69; as
domestics, 11–13, 27; in Sidney H.
Sime's illustrations, 26–28; Lithuan-
ian- and Slavic-American, 209–17;
wives and daughters of coal miners,
209–17, 240–42, 244–53
Wood, Archbishop (Philadelphia), 161
Woods, Gregory, 113–15
working-class Britain as "foreign" terri-
tory, 112
Worpole, Ken, 127, 138
Worthen, John, 90–91, 98
Wouk, Herman (*Youngblood Hawke*),
206

Yezierska, Anzia, 216
Young, Alan, 136

Zakarian, Richard, 86n. 1
Zola, Emile (*Germinal*), xvi–xvii, 71–87,
200, 201